MONET

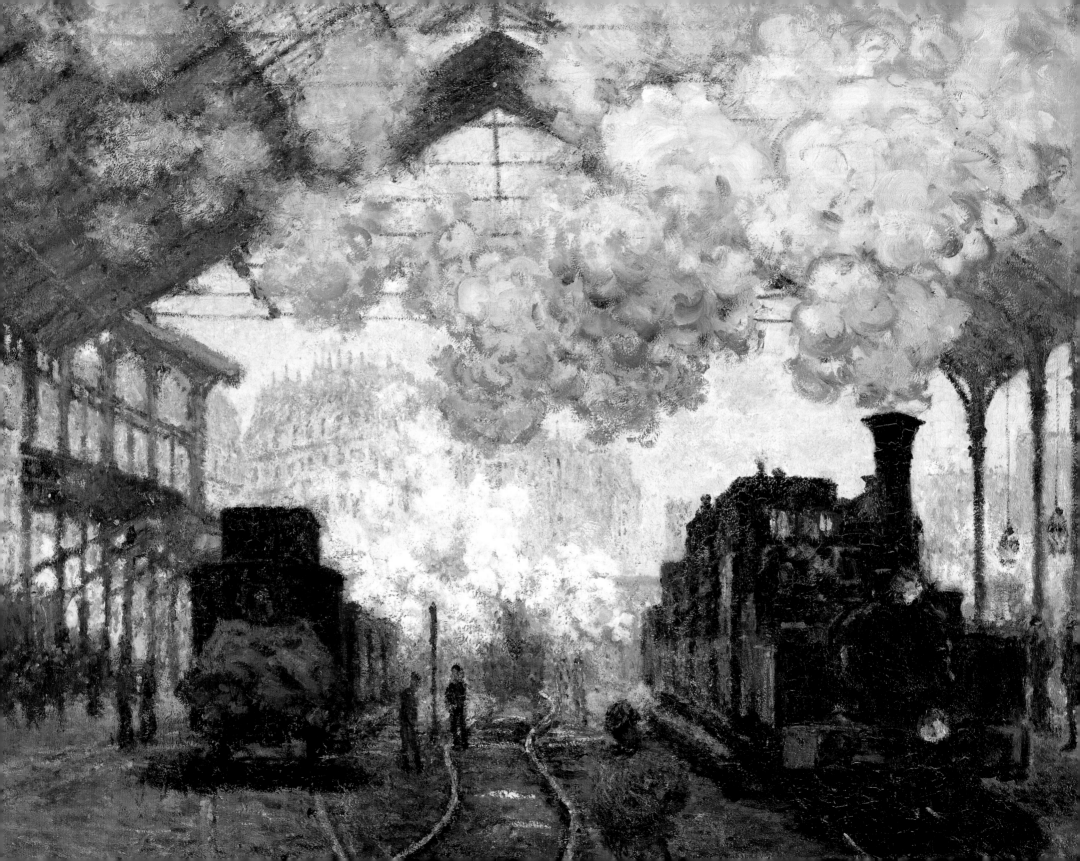

MONET

Janice Anderson

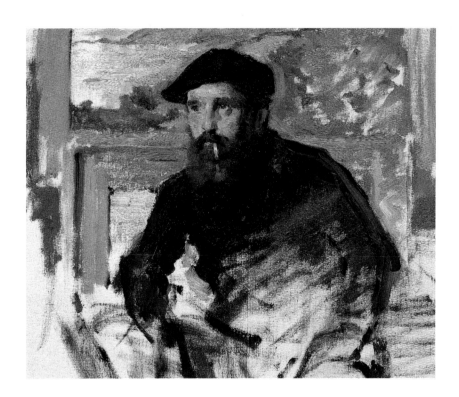

THE WELLFLEET PRESS

Published in 2003 by

Wellfleet Press

A division of Book Sales, Inc.

Raritan Center

114 Northfield Avenue

Edison. NJ 08837 USA

ISBN 0-7858-1715-8

Printed in China by Sino Publishing House Limited

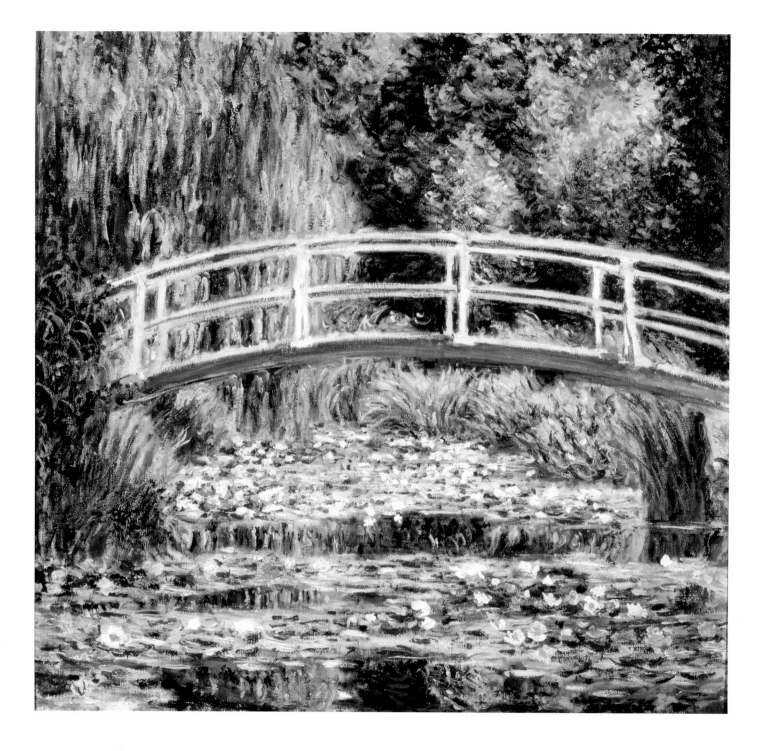

Contents

Introduction

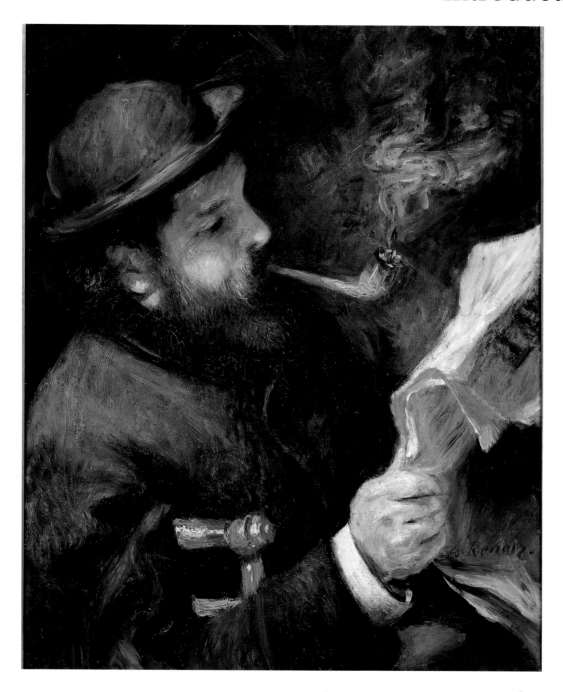

Impressionism is one of the most attractive movements in Western art, seducing us with its vividly coloured and dynamically painted depictions of everyday life. This applies as much today as it did in the late nineteenth century, appealing to societies as diverse in their artistic traditions as America, Japan and Europe. One of the reasons for the wide-ranging attraction of Impressionism lies in the fact that it did not grow out of a homogeneous school of painting, operating within carefully formulated principles. Rather, as one of its leading practitioners, Claude Monet, remarked late in life, it was 'only immediate sensation' and 'a question of instinct'.

Impressionism was the instinctive reaction of a group of artists united in their rejection of the French academic tradition of painting. However, painting out-of-doors, with nature before them, was by no means important to all of them all of the time. Moreover, they did not care for the label Impressionism, which was not of their own invention but a name foisted on their art by sneering critics.

In the early years of Impressionism, the artists who gathered in the cafés of Montmartre and the rue des Batignolles in Paris to engage in heated arguments about the theories and practice of painting, had names like Degas, Pissarro, Monet, Sisley and Renoir, all of them now regarded as quintessential Impressionists. But the name most often put forward as the movement's leader by

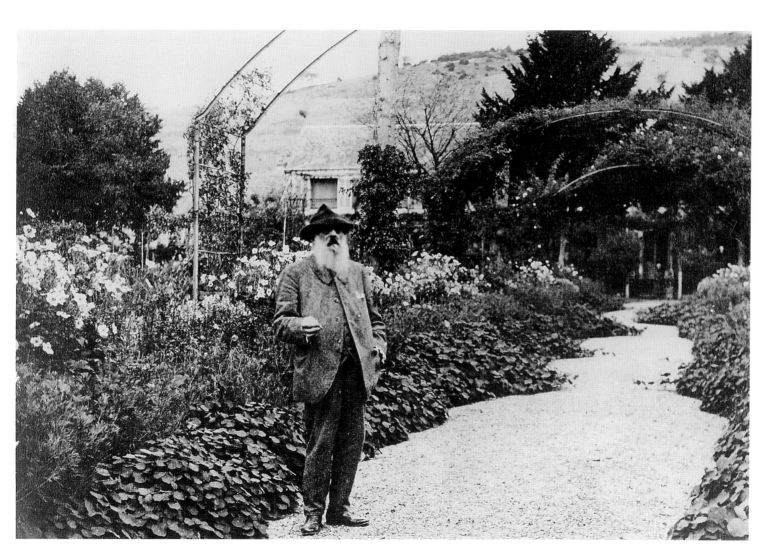

OPPOSITE
Pierre-Auguste Renoir
Claude Monet Reading a Newspaper, 1872
Oil on canvas, 24 x 20in (61 x 50cm)
Musée Marmottan, Paris

Monet was several times painted by his close friend and fellow artist Pierre-Auguste Renoir. Whether depicted indoors reading a newspaper or outside standing in front of his easel in the garden, Monet chose to keep his shallow-crowned bowler hat firmly on his head.

LEFT
Claude Monet in his garden at Giverny, c.1925
Musée Marmottan, Paris

There are many photographs of Monet in his garden at Giverny, this one taken among the flower beds and roses of the garden near the house.

INTRODUCTION

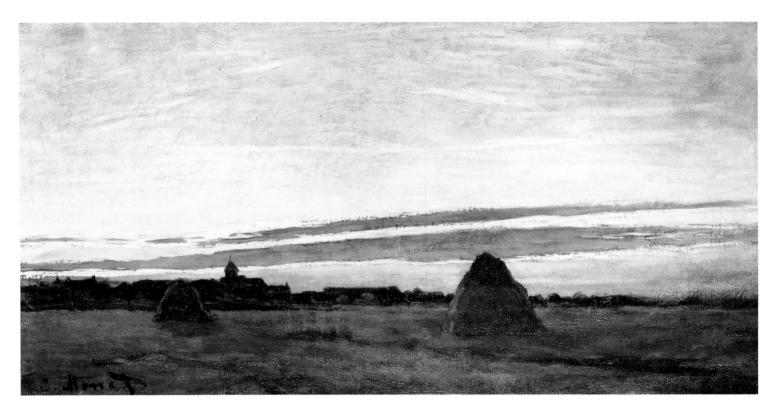

writers and critics at the time was Edouard Manet.

A charismatic figure to whom the younger painters of his generation naturally gravitated, Manet came to Impressionism late and reluctantly, though his controversial paintings, with their sometimes shocking emphasis on naturalism and realism, certainly placed him well outside the establishment. The critics may have been incorrect in referring to Manet as the leader of the Impressionists, but who did fit the role? If asked, most of the younger painters would have probably nominated the vigorous and forceful young man whose name was often confused with that of Manet: Claude Monet.

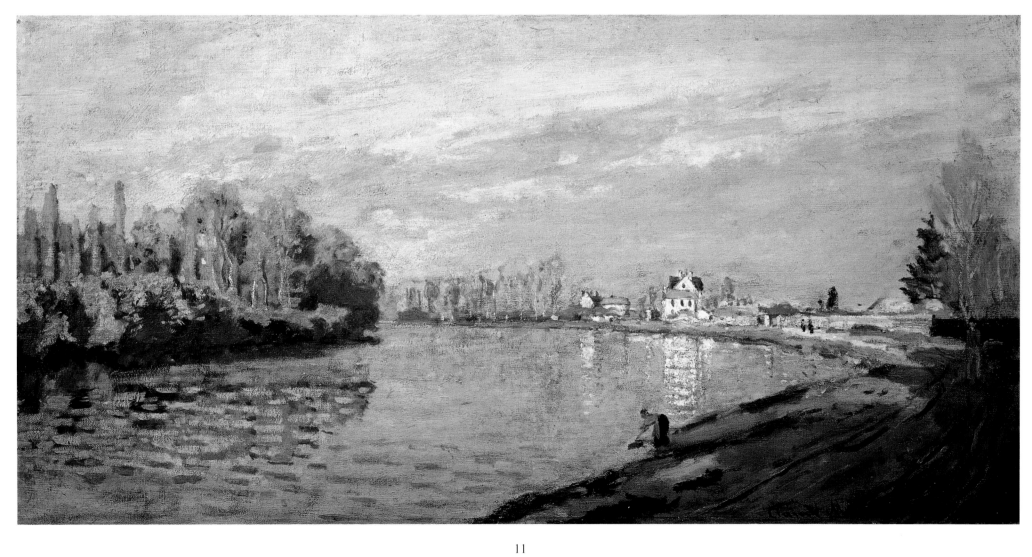

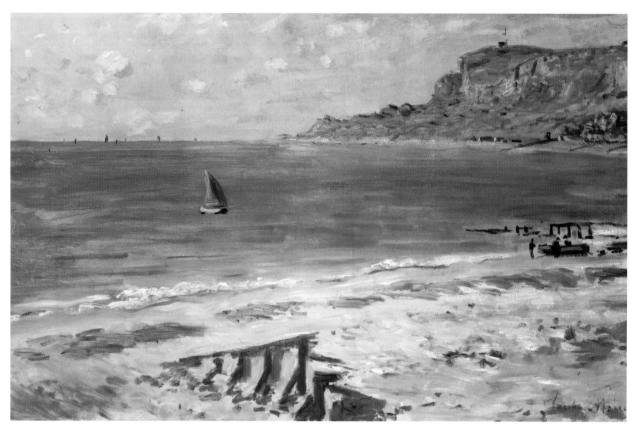

Sailing at Sainte-Adresse, c.1867
Oil on canvas
Christie's Images, London

his paintings, _Impression, Sunrise_ (page 119), and from the way the depiction of the effects of light on water played a key part in his own work, go some way towards summing up his contribution to Impressionism and to art in general.

Paul Cézanne's famous comment that Monet was 'only an eye, but my God, what an eye!', does the artist less than justice because it suggests that he was simply a recorder of reality. But it does emphasize the fact that Monet was no theorist: he painted what he saw. This is not to say that what Monet 'saw' was simply the subject in front of him. As he once said himself, 'For me, the subject is of secondary importance: I want to convey what is alive between me and the subject.'

Monet became a truly great landscape artist and an incomparable painter of light because he faced up to and resolved one of the greatest concerns of every artist: how to reconcile his perception of the three-dimensional effects of his chosen subject with the demands of transferring them to a two-dimensional canvas. Monet's main occupation throughout his long life was to experiment with an ever-expanding range of techniques and effects that would allow him, as he once explained, 'to depict my impressions in the face of the most fleeting effects'. These fleeting effects were, in the main, the result of the movement of light, atmosphere and air around his subject.

Monet, the most prolific of the Impressionists, began

Many titles have been attached to Monet, among them 'Father of Impressionism', 'Painter of Light' and 'the Raphael of Water'. Such labels, deriving from Monet's natural position as a leader of the young artists, whose revolutionary movement would get its name from one of

and ended his long life as a painter of nature. Whenever possible he worked *en plein-air*, at all times of day and in every season of the year, ever intent on capturing in paint those fleeting moments when light and air fluctuate and make nature move and live.

Working outdoors in front of nature was what set Monet apart from academic artists working in their studios on impressively large paintings that followed all the rules of classical art. For Monet, and the half-dozen young artists, Renoir, Sisley and Bazille among them, who were his closest friends in 1860s Paris, the only place to work was outside in the fresh air and in the midst of their subject.

This belief in the essential importance of working *en plein-air* was the core of the art of the Impressionists. It meant that their canvases were small, and their informally composed pictures were painted freely and quickly in clear, bright colours. To those used to classical paintings, with their careful layers of smoothly shaded and varnished paints, the early work of the Impressionists must have looked like crudely daubed sketches.

Monet refused to be cowed or deflected from his chosen path by the often vitriolic criticism hurled at him over many years. He was similarly unmoved by the lavish praise which his work ultimately received, although never so blasé that he failed to keep a close eye on the prices his

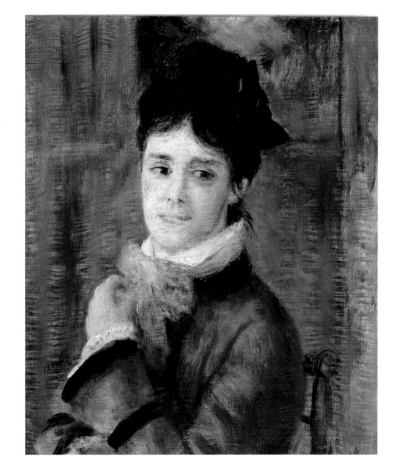

Pierre-August Renoir
Madame Claude Monet (Camille),
1872
Oil on canvas, 24 x 19⅝in
(61 x 50cm)
Musée Marmottan, Paris

paintings commanded, even when his art had already made him a wealthy man.

When Monet died at the age of 86 in 1926, the feeling

INTRODUCTION

RIGHT
Ferdinand Mulnier
Portrait of Alice Monet, aged 35, 1879
Musée Marmottan, Paris

OPPOSITE
Waterlilies, c.1903
Oil on canvas
Private collection

was that his time was past. In the ferment of the movements then shaking the art world to its foundations, Impressionism, when compared with Fauvism, Cubism, Futurism, Expressionism and Surrealism, now belonged to a world that seemed to have largely disappeared. But after the Second World War, other movements succeeded Cubism, Surrealism and the rest: artists working in the fields of Abstract and Abstract Expressionist art began to look again at the work of Claude Monet, seeing in it much that could inspire and from which they could learn.

By the end of the twentieth century the art of Claude Monet had achieved unprecedented levels of popularity and his paintings realized sums undreamed of in the 1870s and 1880s, when the value of the Impressionists' pictures was regarded as little more than the value of the frames that surrounded them.

Claude Monet would have been uncomfortable with such celebrity. He would have retreated to his garden at Giverny, fending off visitors as he fended off a young Norwegian poet in 1895: 'Anyway, what do you want? What can be said about me? What indeed, I ask you, can be said about a man who is interested in nothing but his painting? His garden as well, of course, and his flowers – simple ones – they are so beautiful, so calm.'

Claude Monet's interest in 'nothing but his painting' gave to the world pictures that are not only some of the

most beautiful and moving works of art ever created, but which are so full of energy and vitality that they never fail to inspire the beholder.

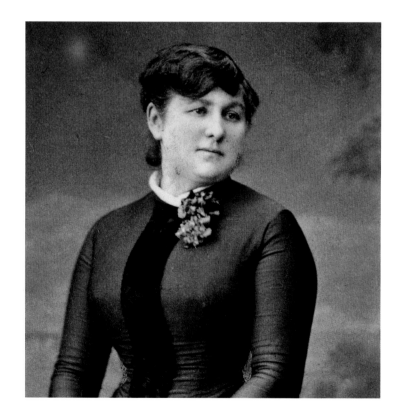

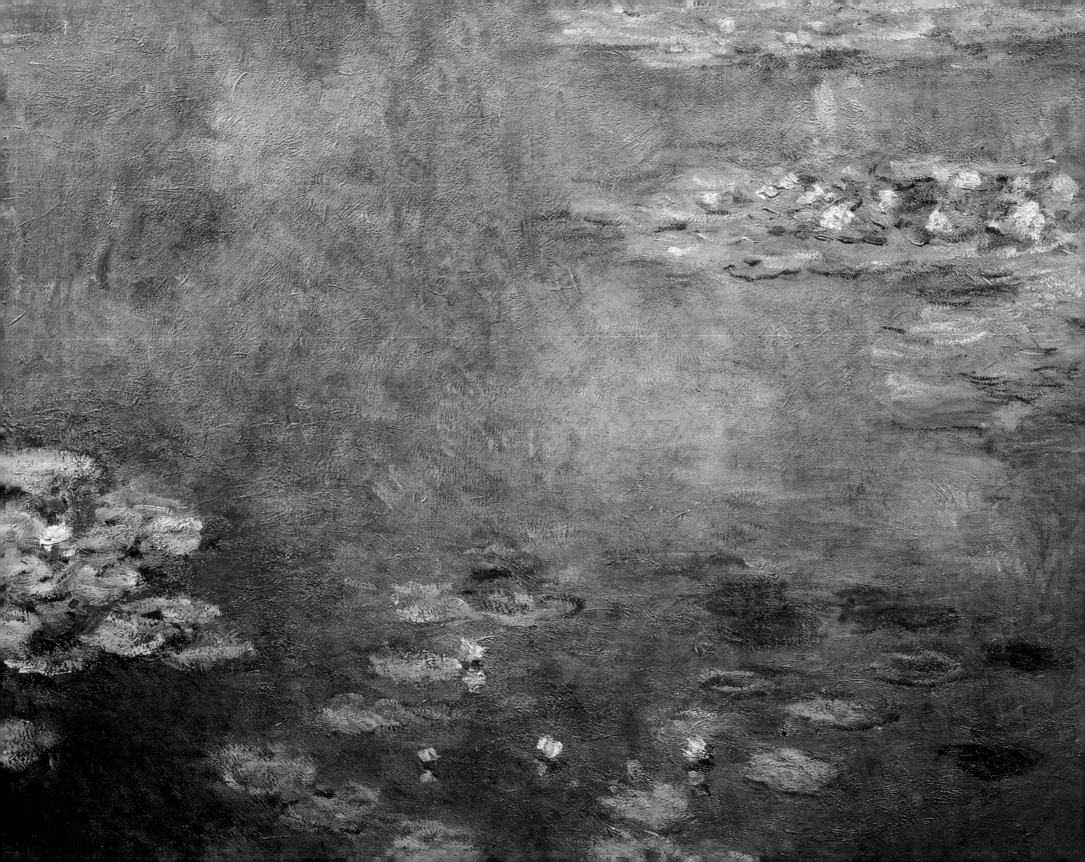

Chapter One
Discovering Art
1840–1861

Claude Monet
Musée Marmottan, Paris

Monet, probably in his 40s, photographed in his gardening clothes and clogs. Although he always employed gardeners when finances permitted, Monet enjoyed working in his garden himself.

The city of Paris, where Claude Monet was born in 1840, was both the political capital of France and the hub of its artistic life. Since the reign of the Sun King, Louis XIV, French art had been very much a state-regulated business. The king's great financial reformer, Jean Baptiste Colbert, had begun the process when he founded the Académie Royale des Beaux-Arts as a neat way of making art the servant of the state. State patronage, controlled by the Academy, served to bind artists firmly to the establishment and make them toe the line.

The French Revolution did not significantly change this essentially medieval guild system of art training, in which would-be artists were apprenticed to a master, working and even living in his atelier. True, the Academy was dissolved in 1793, to be replaced a few years later by an Institute with a fine arts division, one of whose main tasks was to recruit teachers for the Fine Arts School (the Ecole des Beaux-Arts). That within 20 years it had re-named itself Academy was a sign that state desire to control the arts had not diminished with revolution.

By the mid-nineteenth century, the Academy still retained its stranglehold on art in France. It supervised the competitions by which artists made their way up the ladder to success; it obtained and distributed state patronage; and it kept a close eye on the ateliers of the

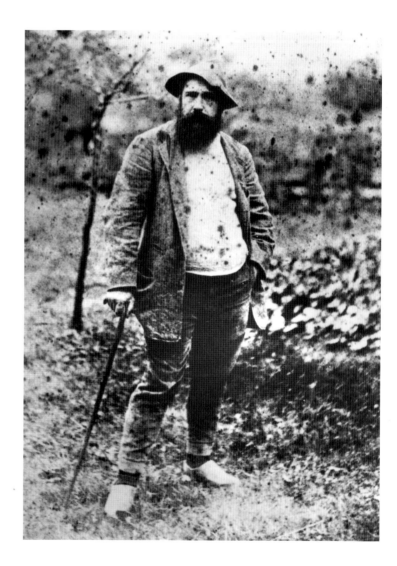

artists who had achieved success. Tradition was all. Not for the Academy the romantic emphasis on originality of ideas and the importance of history, or the belief of Realist writers and artists that they should choose 'real' or 'ordinary' subjects for their pens and brushes, without distortion, and with a genuine, original feeling for nature. To a Realist artist, as the artist-hero of Emile Zola's novel *L'Oeuvre* put it, a pile of cabbages was preferable to the historical bric-à-brac of the Romantics.

None of this seemed of any importance or relevance in the daily lives of Monet's parents. Their eldest son, whom they called Claude Oscar, was born at home on 14 November at 45 rue Lafitte, a street in Paris north of the River Seine that was to see much of Baron Haussmann's rebuilding programme, resulting in the construction of the great boulevards. The circumstances of Claude Oscar's birth may have been of some relevance to his later life. Monet senior was a shopkeeper, more specifically a grocer, and his baby son, called Oscar by his family for several years, would have experienced the strong colours and scents of his environment from an early age. He may also have been taken on Sunday afternoon strolls along the Seine, the river that was to be central to his long life and prodigious output.

Before he had reached his fifth birthday, his parents moved the family to Le Havre, the great port at the mouth of the Seine. M. Monet's business in Paris had not been doing well, and he accepted an offer from his brother-in-law, Jacques Lecadre, to join his wholesale grocery and ship chandler's businesses in Le Havre. Thus, Claude Monet discovered the sea and the windy, often wave-lashed cliffs of the Normandy coast. Although business kept the Monet family in Le Havre during winter, in the summer they would stay with the Lecadres, who had a charming country house at Sainte-Adresse. Consequently, throughout his life, Monet would always regard himself as a Norman rather than a Parisian.

By all accounts, including his own, Claude Monet was not remotely academic as a schoolboy and was the despair of his father. Lessons bored him and he soon found picking up a pencil and drawing his classmates in the margins of his exercise books a good way of passing the time. By the time he was in his teens he was showing a definite talent for drawing, as sketchbooks surviving from the mid-1850s clearly show. One sketchbook of 1857, in the Michel Monet Collection at Giverny, has several pages of very competently drawn sailing boats, their different riggings clearly delineated.

Young Claude was particularly fond of making caricatures of his school friends and the notables of Le Havre. There were also early indications of his later business acumen. He would sell his caricatures for 10 or

RIGHT
Still Life with Bottles, 1859
Oil on canvas, 16¹/8 x 23⁵/8in
(41 x 60cm)
Private collection

Monet painted this still life in traditional style in 1859, the year he moved to Paris to experience the wider artistic world.

OPPOSITE LEFT
Petit Panthéon Théâtral, 1860
Pencil on paper, 13³/8 x 18⁷/8in
(34 x 48cm)
Musée Marmottan, Paris

Monet continued to draw caricatures like these in his early years in Paris. Their sale helped pay the rent and buy food and fuel for the studio stove.

OPPOSITE RIGHT
Young Dandy with Monocle and Cigar, 1857
Black chalk with colour crayon,
9⁷/8 x 6¹/4 in (25 x 16cm)

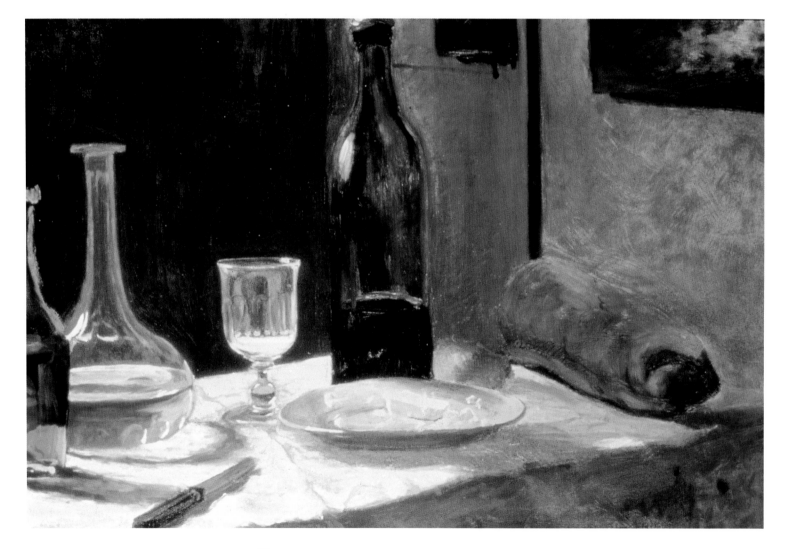

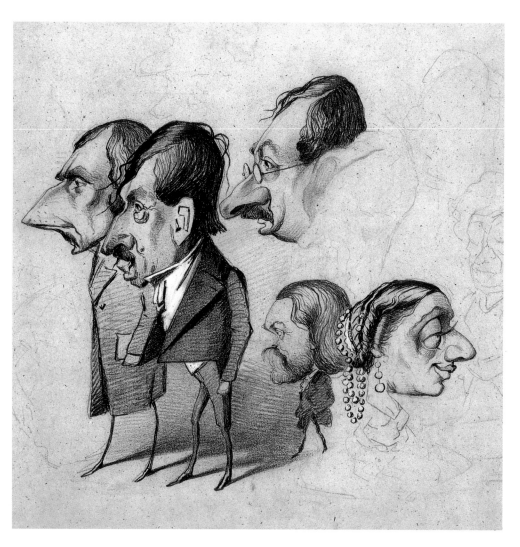

DISCOVERING ART (1840–1861)

20 francs a time, depending on the appearance of each client. They were good enough to persuade a Le Havre frame-maker and print-seller called Eugène Boudin to exhibit them in his shop window. This was in about 1857, when Claude would have been 16. He left school, with 'the rudiments of arithmetic and a smattering of spelling', without taking his final exams.

Boudin, as well as being a shopkeeper, was also a fine landscape artist whose closely observed oil paintings depicted the changing light and fluctuating weather conditions of the coasts and beaches of Normandy with an almost miraculous freshness and lightness of tone. He quickly recognized the talent in Monet's drawings.

The son of a sailor who became a ship's captain, Boudin was born in Honfleur in 1824 and had been interested in art from an early age. He was only 20 when he opened his own shop in the rue de la Communauté in Le Havre, selling prints and pictures, including the work of artists drawn to Le Havre by its accessibility made possible by the new railway, and making frames, perhaps for these same artists. One of them was Jean-François Millet, who was impressed enough by what he saw of the self-taught Boudin's own work to advise him to get proper training. So Boudin went to Paris, won a scholarship to study at the Beaux-Arts, and before long was well-regarded by his peers in the art world, though he was little

known in wider artistic circles. Even before he left Paris to return to Le Havre, Boudin had made it a habit to get out of the studio and paint in the countryside around Paris. As he remarked to the young Monet, everything 'painted on the spot has ... a strength, a power, a vividness of touch that one does not find again in one's studio'.

Boudin was now in his 30s, old enough to have had plenty of experience of the world of art, but not so old that he would have seemed a boring antique to an impetuous teenager like Claude Monet. Many years later, when Monet himself was the Grand Old Man of French art, he recalled the advice Boudin gave one day to 'learn to draw well and appreciate the sea, the light, the blue sky'. This advice, confirmed by many painting sessions that the two undertook together, practising the techniques of *plein-airisme*, or painting in the open air, remained with Monet and informed his work for the rest of his life. Monet later said of the first of these painting expeditions with Boudin that 'it was as if a veil was torn from my eyes; I understood what painting could be'.

The poet Théophile Gautier, coming upon Boudin and Monet on one of their painting sessions, also provided the young man with food for thought, for Gautier, according to an anecdote that Monet recounted to his friend and biographer Gustave Geffroy in 1920, described himself to the two painters as 'a poet who almost became a painter'.

Boudin and Monet had been painting together at Sainte-Adresse, in the shade of a tent out of the sun, when 'a respectable and to all appearances very grand gentleman' came up to them. 'He congratulated us on our bold approach and declared that nature, the open air and high-keyed painting were bound to bring about a renewal in the art of painting … You can imagine how astonished we were when we discovered we had conversed so pleasantly with such a great poet.'

Another influence on Monet at this time that would soon have a great bearing on European art in general was the Japanese print, which had begun to appear in Europe. One of the benefits of the forced opening of Japan to Western trade by the Americans was a sudden interest in Japanese and other Far Eastern ceramics and fabrics in the 1850s. Japanese art, at this time, reached Europe in the form of woodcuts, often used as wrapping paper to protect porcelain and prints. The work of the great Japanese master, Hokusai, was known in Paris by the mid-1850s, but had probably not yet been seen in the provinces.

Monet bought his first Japanese prints – which would probably have been contemporary rather than the work of the great artists, such as Hiroshige and Hokusai – while still a schoolboy in Le Havre. This prompted him to become an avid collector, eventually devoting an entire room to Japanese prints in his house at Giverny. By studying the way in which the great Japanese artists composed their pictures, especially their landscapes, Monet was greatly influenced in his own landscape composition because they suggested patterns, often asymmetrical, in which forms could be laid to best effect onto canvas.

Claude Monet's entry to the world of the professional artist took place in the summer of 1858 when he showed an oil painting, *View at Rouelles, Le Havre* (page 23), in a civic exhibition at Le Havre. The picture, notable for the clarity of its light, is a country landscape. There is a stream situated in well-wooded country, with a line of poplars silhouetted against low hills against a cloudy, blue sky. The young artist was already showing a remarkable ability to capture in paint suggestions of light and movements of air.

Monet Returns to Paris

Claude Monet was obviously a talented youth. What was equally obvious was that he should have to leave the provinces and go to Paris if he wanted to make something of his talent. This he did in 1859, when he was 19, probably with some reluctance, having little taste for metropolitan life. His mother had died two years before and his father, no doubt thinking that his son would join him in his now prosperous business, refused to provide an

RIGHT
Eugène Boudin
Beach Scene, Trouville, 1863
Oil on panel, 10 x 18in (25.4 x 45.8cm)
Metropolitan Museum of Art, New York

OPPOSITE
View at Rouelles, Le Havre, 1858
Oil on canvas, 18¹/8 x 25¹/2in
(46 x 65cm)
Noortman, London

allowance. Perhaps M. Monet, whose family had never shown any appreciable artistic talent, hoped that his son would soon abandon this teenage fantasy and after a couple of months roughing it would return home.

However, the sale of his caricatures had given Monet sufficient money of his own to make the trip, armed with letters of introduction from Boudin and others, including one to Boudin's own former teacher, the landscape artist

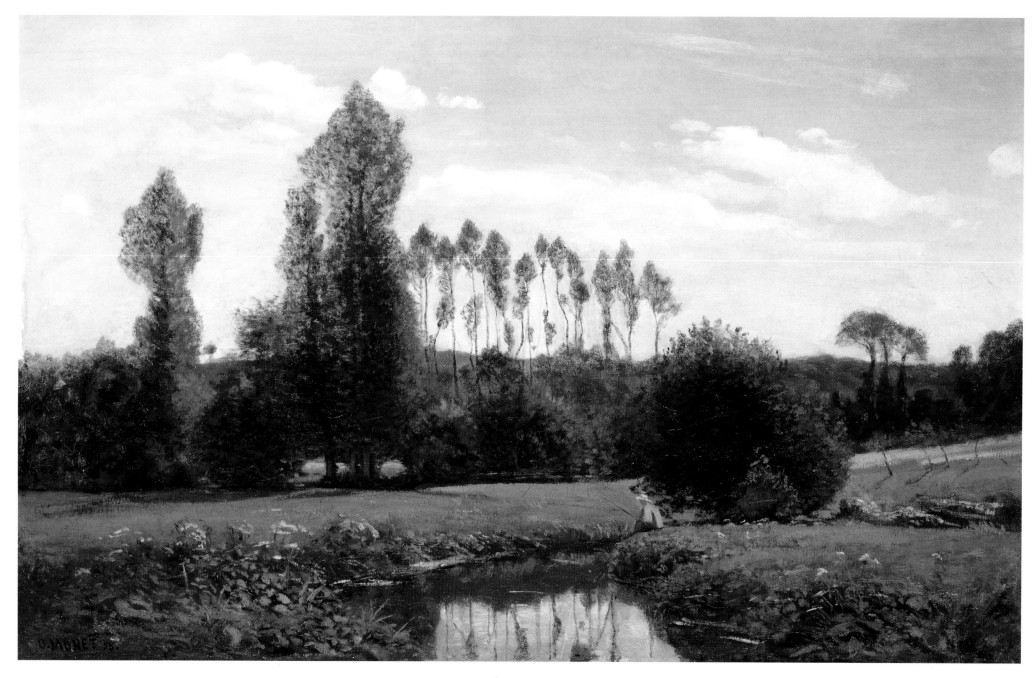

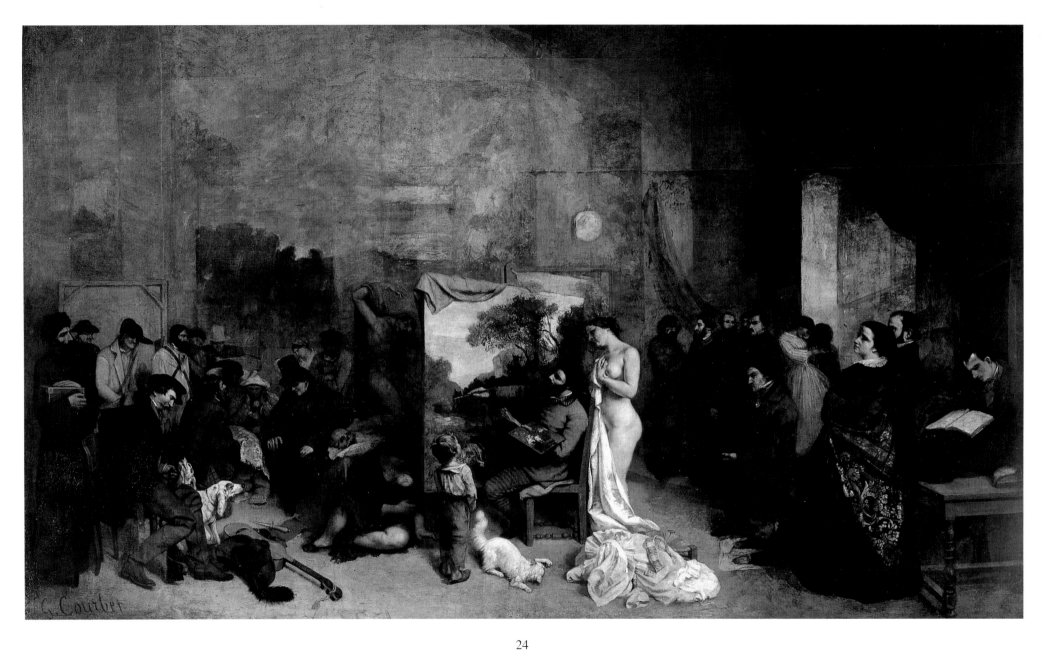

and animal painter, Constant Troyon. Once in Paris, Monet found his way to Troyon's studio, where he was made most welcome, perhaps because the artist retained a considerable affection for his former pupil, whose work Troyon continued to 'find homes for' in Paris.

Troyon's advice to Monet was most helpful, given without 'mincing his words', Monet told Boudin in a long letter written from Paris in May 1859. Monet showed him two of his still lifes and Troyon's reaction was favourable. '…Your colour is all right; the effect is correct. However, you must get down to some serious study, for all this is very fine but it comes very easily to you … If you want my advice and want to go in for art seriously, start by joining a studio which specializes in figure painting … learn to draw: that's where most of you are falling down today.'

Monet's new friendship with Troyon brought him into contact with members of the Barbizon School. This was a group of Realist painters who had established themselves in the village of Barbizon on the outskirts of the Forest of Fontainebleau, where they hoped to give their paintings of natural scenes an immediacy impossible in the studio. Foremost among the Barbizon painters at this time, apart from Troyon himself, were the veteran artists Jean-Baptiste Corot and Charles Daubigny. Millet also lived and worked, usually in

great poverty, in Barbizon, concentrating on recording the lives and works of the poor peasants of the area, though he also painted landscapes and a few marine subjects.

Monet took Troyon's advice and enrolled at the Académie Suisse, which was not strictly an art academy, and certainly not an established artist's atelier. It had been founded by a former artist's model and provided plenty of models and accommodation, but no supervised teaching. Monet, who had had a very provincial education and upbringing, and who had never shown any interest in the art of the Renaissance that filled the Louvre, found himself among kindred spirits at the Académie Suisse. 'I am surrounded by a small group of landscape artists here … they are real painters,' he wrote to Boudin in February 1860.

From the relatively sheltered world of the Académie Suisse, Monet made sorties onto the Paris social scene, frequenting such centres of *la vie bohème* as the Brasserie Andler, known to the artists of Paris as the 'Temple of Realism', because of its association with Gustave Courbet, and the Brasserie des Martyrs. While a great deal of artistic and political discussion went on in these places, so, too, did much womanizing and drinking. It was all very far from the quiet, middle-class life led by Monet's family back in Le Havre and must have

OPPOSITE
Gustave Courbet
The Artist's Studio, 1855
Oil on canvas, 142^{1}/8 x 235^{1}/2in
(361 x 598cm)
Musée d'Orsay, Paris

Gustave Courbet was the great name of Realist art in Paris when Monet arrived in the city in 1859. Courbet's enormous painting, depicting a working day in his studio, in which he has included portraits of such notables of the day as Champfleury and Baudelaire, was rejected by the Salon in 1855. However, Courbet exhibited it in a specially-built pavilion nearby.

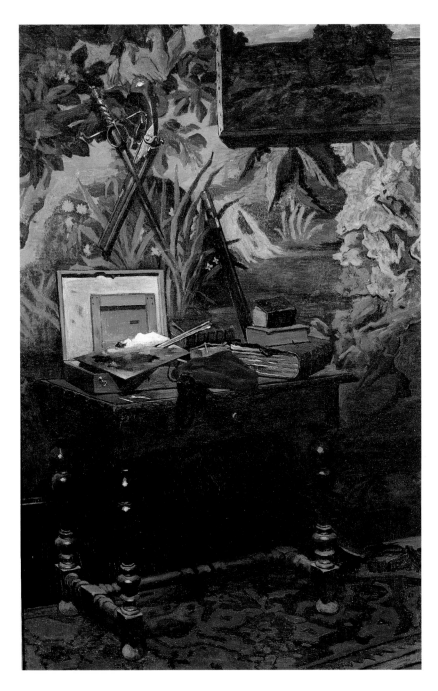

contributed to Monet's sense of himself as his own person, an increasingly sophisticated artist-in-the-making.

In his early weeks in Paris, Monet learned a lot from his visits to the Salon, originally intended as a place to exhibit their works by members of the Académie Royale. The French Revolution was the cause of the Salon losing its exclusivity and in 1791 it was thrown open to all artists, and a system in which both money and medals were awarded was initiated. This, in turn, led to the creation of a jury, which first simply organized the exhibitions, but soon became responsible for selecting the works to be exhibited.

By 1848, the jury was choosing its Salon exhibits from a very restricted list of artists, causing maximum resentment in the art world at large. It was abolished and a hanging committee, chosen by over 800 artists, was set up in its place. But it was unable to get the number of exhibits below an unwieldy 5,000, causing terrible confusion at the Salon. The old jury system was brought back and remained in force until 1870, although the emperor, Napoleon III, instituted changes, including placing working artists on the selection jury, aimed at counteracting the Salon's innate conservatism.

This, then, was the Salon when Monet arrived in Paris. In a city where solo exhibitions were not yet the custom, the twice-yearly Paris Salon was the most important showcase and marketplace for any artist. The Salon was

still the one barricade a young artist must storm if he was to make his way to fame and fortune. Not only was it necessary for the artist to get past the Salon jury, he also had to catch the eye of the pundits, whose all-too-often bitingly critical, even malicious reviews published in such widely-read journals as the *Gazette des Beaux-Arts*, *Charivari* and the *Journal du Rire* had the power to make or break an artist.

One of the first things Monet did after his arrival in Paris was to visit a Salon exhibition. For such a young and inexperienced artist he had some decided opinions on what he saw there. Some artists, like Troyon and Daubigny, were showing works of superb quality, he wrote to Boudin in May, 1859. 'There are some nice Corots and, strange to say, some awful Diazes … Monsieur Lhuillier's picture is way off the mark,' wrote the 18-year-old with all the confidence of youth.

A visit to the studio Lhuillier had borrowed from a fellow artist may not have changed Monet's assessment of his work, but it surely reinforced the importance of the Salon in an artist's life. Despite not yet being able to afford his own studio, Lhuillier was a happy man, able to tell Monet that the 'off the mark' picture had sold for 600 francs, that he was doing another one, and had been commissioned to do several small portraits, for which he would get 100 francs each.

The Académie Suisse Interrupted

While he was at the Académie Suisse, Monet made his first contacts with the artists and writers of the Realist school in Paris, although it would be some time before he met their acknowledged leader, Gustave Courbet. Two works exhibited at the Salon in 1850, *The Stone-Breakers* and *The Burial at Ornans*, had ensured Courbet's place at the head of the Realists. Both paintings, concerned with ordinary, everyday life, conformed to his belief that 'painting is an art of sight and should therefore concern itself with things seen'. According to Courbet, objects seen should be depicted without Romantic sentimentality or the intellectual gloss of Classicism.

The Salon jury did not always see eye-to-eye with Courbet and in 1855 rejected his enormous painting, *The Artist's Studio* (page 24), sub-titled 'Allegory of Realism'. Courbet chose to 'appeal to the people' and built a temporary Pavilion of Realism near the Salon to exhibit his picture. Twenty years later the Impressionists were taking a leaf out of Courbet's book and holding 'alternative exhibitions' of their own Salon-rejected works in Paris.

While he was at the Académie Suisse, Monet may have met Paul Cézanne, a close friend of the writer Emile Zola, who joined the studio from his home in Provence in 1861. He certainly met another young artist, Camille

OPPOSITE
A Corner of the Studio, 1861
Oil on canvas, 71⁵/₈ x 50in
(182 x 127cm)
Musée d'Orsay, Paris

Painted towards the end of his time at the Académie Suisse, this painting shows Monet working in the Realist style, and also demonstrates just how competent an artist he already is. There is a fine differentiation of surfaces – compare the oily moistness of the heap of white paint, the dull gleam of the metal of the weapons and the velvet of the cap, for instance – and there is already a bright light and colour, that would be features of Monet's work in the future, dominating the centre of the picture.

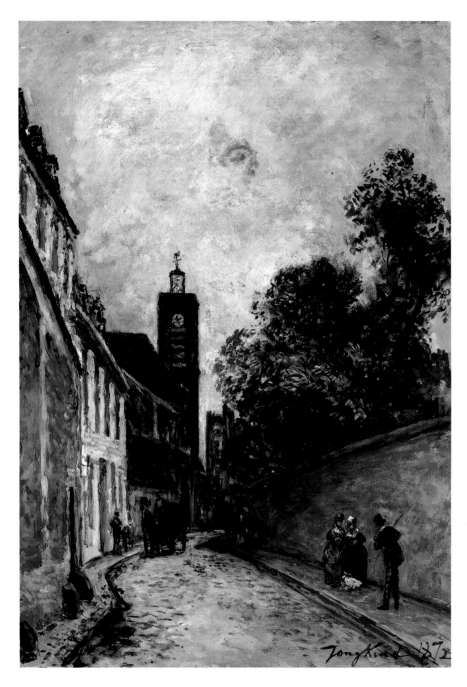

Pissarro, who was to become a life-long friend. Born in the West Indies and sent by his affluent father to Paris to be educated, Pissarro had been at the Académie Suisse since the mid-1850s, having persuaded his father that he had much greater artistic than business abilities. He was soon helping Monet to settle down to the artistic life of Paris.

A survival from this period, a large oil painting called *A Corner of the Studio* (page 26), now in the Musée d'Orsay, indicates that Monet had learned a lot from his time in Paris. The painting, a creditable imitation of the Realist style, even includes a reddish-brown landscape painting in the form of the lower part of an unframed canvas hanging on the studio wall. Below the landscape, and set on a richly patterned carpet, is a table with the artist's paintbox, paint-daubed palette, brushes and a few books piled on it. Everything is painted with great care, and a sense of immediacy is conveyed by the way in which the artist, through texture and light, gives the impression that the paint has been freshly squeezed onto the palette, and that the books have just recently been deposited there.

This emphasis on light – on the brightness of daylight – is the most important feature of *A Corner of the Studio*, and indicates the direction that Claude Monet's art would take in the years ahead. The pile of white paint, freshly

squeezed onto the palette, is significant. It is white lead, and Monet liked to mix it into his pure colours to achieve the brilliant light effects that characterized his work throughout his life.

Early in 1861, his life of an artist came to an abrupt halt when Monet was unlucky enough to draw a number in France's military service lottery. At least he had some say in the location where he would serve and chose to join the Chasseurs d'Afrique in Algeria – 'because of its sky'. He had been in Africa for about a year, just long enough to be struck with what he later described as 'impressions of light and colour', and which influenced his later thoughts on painting, when he was struck down by a bout of typhoid and was invalided home. But he brought back enough drawings and watercolours to show that he had found at least some time for art in the midst of his military duties.

Monet never returned to the army. After a period of convalescence at home in Le Havre, his family bought him out on condition that, should he return to Paris, he would take the more conventional route for a budding artist, via the École des Beaux-Arts. They may also have felt that Claude would be better occupied as an artist in Paris rather than wasting his time in Le Havre with the dubious, often drunk Dutch artist he had met while convalescing and who was clearly having a bad influence on him.

Johan Barthold Jongkind was born near Rotterdam in 1819 and was already afflicted with the psychological problems that would eventually drive him to madness and death in an asylum in 1891. Jongkind had been working in Paris since 1846 and had recently exhibited with members of the Barbizon School. He painted sunlit landscapes and airy, atmospheric seascapes in a relaxed style, indicating the transition from realism to naturalism in art that was leading to Impressionism and that Monet had already encountered in Paris.

Jules Castagnary, a leading art critic and later Minister for the Arts in the French government in the 1880s, wrote of Jongkind's work in *L'Artiste* in 1863: 'I love this fellow Jongkind; he is an artist to his fingertips. I find in him a rare and delicate sensibility. With him everything lies in the impression.'

Monet got to know Jongkind very well in Le Havre, in 1862, and spent much time working with him, seeing for himself evidence of that delicate sensibility that Castagnary had noted so perceptively. Although Jongkind made many sketches and notes outdoors, he did his paintings in the studio.

An apparently insignificant event in Britain in 1840, when flexible tin tubes to hold oil paints were invented, and which were introduced to France in the mid-1850s, encouraged many more landscape artists, apart from Jongkind, to get out of their studios and into the open air.

OPPOSITE
Johan Bartold Jongkind
Rue de l'Abbé-de-l'Epée and the Church of Saint James, 1872
Oil on canvas, 18$\frac{1}{2}$ x 13$\frac{1}{4}$in (47 x 33.5cm)
Musée d'Orsay, Paris

The Dutch-born artist, Johan Barthold Jongkind, had a great influence on Monet, who met him in Le Havre, a favourite painting base for many artists. This street scene, with its delicate light and wonderfully airy atmosphere, is typical of Jongkind's best work.

RIGHT
Trophies of the Hunt, 1862
Oil on canvas, 41 x 29¹/₂in
(104 x 75cm)
Musée d'Orsay, Paris

*This still life is a fine example of the
kind of work that Monet was producing
in the early part of his time in Paris.
Although, like other young artists, he
felt there was more to be gained from
painting the human figure rather than
still lifes, he still painted a good
number of the latter, most of them very
effectively.*

OPPOSITE
A Farmyard in Normandy, c.1863
Oil on canvas, 25¹/₂ x 32in
(65 x 81.5cm)
Musée d'Orsay, Paris

*This delightfully lively scene shows
Monet working in the realistic style of
artists like Troyon and Daubigny,
though with a vigour that is all his own.*

Although artists had been spared the bother of mixing
powdered colours with oil while buffeted by a stiff breeze
on a clifftop since the 1830s, when the mixing process had
been mechanized, the new tin tubes were a great
improvement on the bladders in which the mechanically
mixed paints were first packed.

While Eugène Boudin could be said to have made a
painter out of Monet, it was Jongkind, a considerable
influence on the Impressionists, who made him the kind of
painter he turned out to be. As Monet himself later said of
that meeting with Jongkind in the summer of 1862, 'From
then on, he was my real master; to him I owed the final
education of my eye.'

In the autumn of 1862, Monet, following his family's
advice but surely also influenced by his admiration for the
work that Paris-trained Jongkind was producing, turned
his back on the bracing climate of the coast and returned
to Paris.

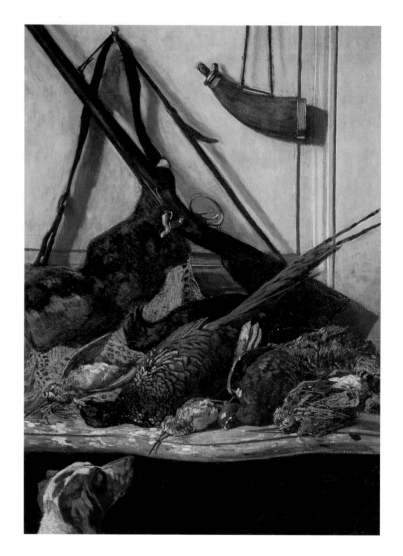

Chapter Two
The Early Years In Paris
1862–1871

When Claude Monet resumed the life of an artist in Paris late in 1862 he did not return to the Académie Suisse, nor did he join the Beaux-Arts academic scene. He remembered Troyon's advice of three years earlier and chose instead to join the independent studio of the artist Charles Gleyre, where the fees were modest, the students were given considerable freedom, and there were plenty of models. The Swiss-born Gleyre had settled in Paris in 1838 and had become an instructor at the Ecole des Beaux-Arts, with which, by the time Monet met him, he still had a good working relationship.

Claude Monet may not have exactly done his family's bidding, but he could still claim to have become part of the academic art scene of Paris. Not that he intended for one moment to behave as a model pupil; Alfred Sisley recalled that Monet established himself as something of a rebel right from the start by objecting to the stool that was assigned to him, and by criticizing the old-fashioned, strictly academic training which was all there was on offer.

Right from the outset, Gleyre and Monet found it difficult to agree. Monet drew a male model as he saw him: short, thickset, and with enormous feet. Gleyre objected to its 'ugliness'. 'I want you to remember, young man, that when one executes a figure, one should always

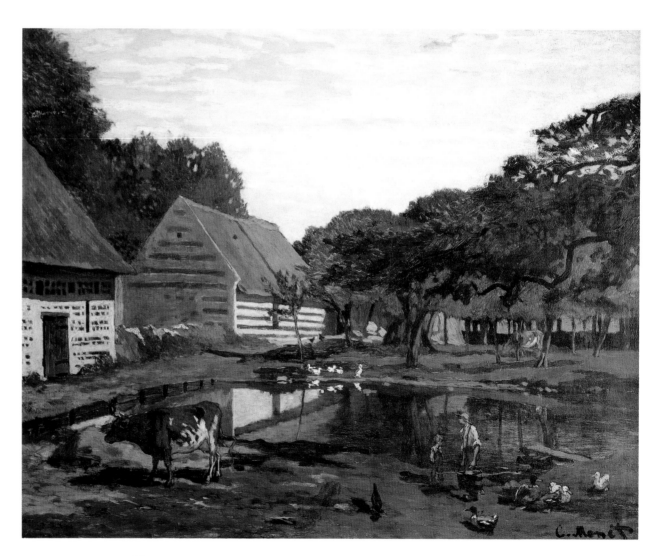

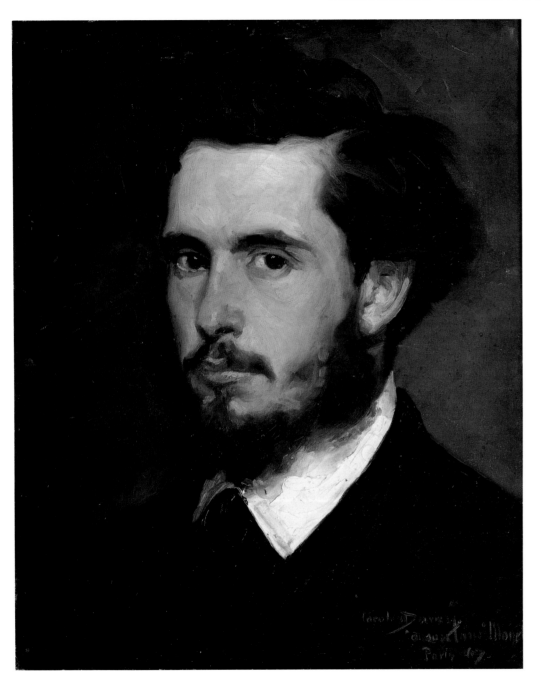

think of the antique. Nature, my friend, is all right as an element of study, but it offers no interest.' For Monet, it was the classical figure, including all those plaster casts of Roman statues that he had been made to draw when he was younger, that held no interest.

Monet, nevertheless, was happy to continue at Gleyre's studio as long as there were plenty of models and plenty of life classes in which to study them. By this time he had come to the conclusion that the way to financial success and to getting noticed by the Salon jury lay in large-format figure paintings rather than straight landscapes, however carefully they had been observed. He realized that if he was to place figures in an outdoor setting, he must first learn to draw them.

Throughout his life, Claude Monet was a vigorous and informative letter-writer, and his letters of this period are full of interesting details of his life and work, though they are not very forthcoming on the amount of time he actually devoted to his studies at Gleyre's studio. He probably remained there, though his attendances became increasingly rare, until Gleyre, whose eyesight was failing badly, closed his studio in 1864.

The most important aspect of Monet's time at Charles Gleyre's studio turned out to be the friendships he made there. He was soon part of an extremely talented quartet, the other members being Frédéric Bazille, from a well-off

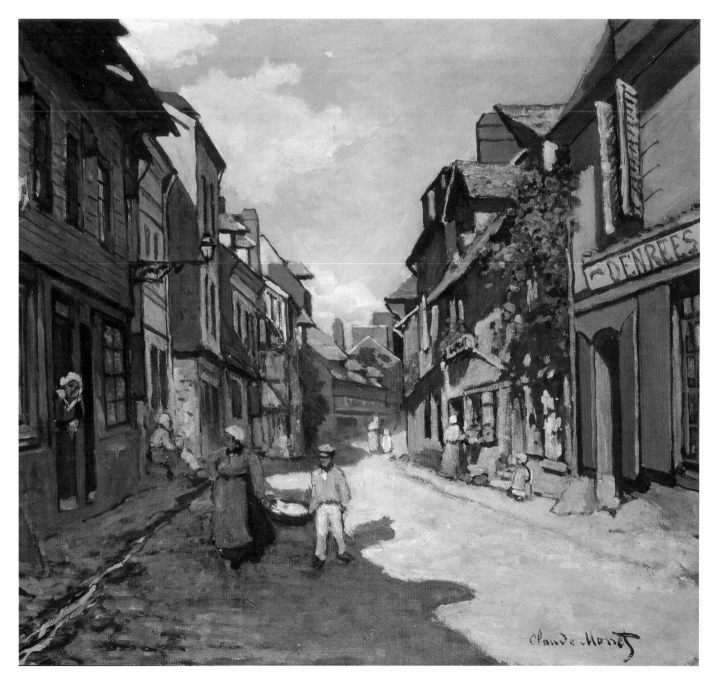

OPPOSITE
Charles Emile Auguste Carolus-Duran
Portrait of Claude Monet, 1867
Oil on canvas, 18$^1/_8$ x 15in (46 x 38cm)
Musée Marmottan, Paris.

Carolus-Duran, born just two years before Monet, abandoned his early idealism in favour of being a successful society artist – a career move which did not find much favour with many of his artist contemporaries. He was a skilled sculptor and a fine portrait-painter, however, as this portrait of the ambitious young artist, Claude Monet, demonstrates.

LEFT
Rue de la Bavolle, Honfleur, 1864
Oil on canvas, 24$^3/_8$ x 24$^3/_4$in (56 x 63cm)
Kunsthalle, Mannheim

Edouard Manet
Le Déjeuner sur l'Herbe, 1863
Oil on canvas, 81⁷/8 x 104¹/8in
(208 x 264.5cm)
Musée d'Orsay, Paris

When Manet set out to paint his Déjeuner he had not intended to cause an uproar that would become part of the folklore of modern painting. He chose a classical theme for his picture, but put it in a contemporary, realistically painted setting. The men and women in his painting, far from being gods and goddesses of the classical world, were clearly people of the 1860s. Consequently, their luncheon on the grass outraged public and art critics alike.

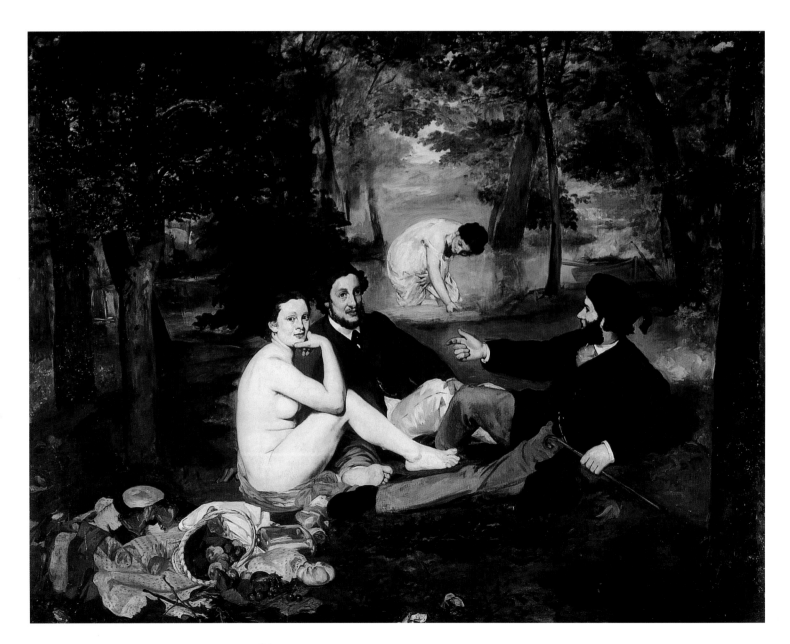

family of wine producers in the Hérault, Pierre-Auguste Renoir, the son of a tailor and a dressmaker who had served an apprenticeship at a porcelain factory and who was the only one of the four to study at the École des Beaux-Arts, and Alfred Sisley, who was born in Paris to English parents, his father being a prosperous businessman. These four, with Camille Pissarro, were to form the nucleus of the Impressionist movement, though Bazille's contribution would be tragically small: he was killed in a minor skirmish in the Franco-Prussian War of 1870.

Of the five, Monet and Renoir were the least well-off. This mattered not a jot to any of them, but it probably explains why Monet and Renoir set up house together, being poor and already accustomed to a bohemian existence. Occasional commissions for portraits and other work, plus more caricatures for Monet, paid the rent, model fees, and provided the fuel for the stove that was essential to keep the models warm. For months, Monet and Renoir lived on beans and lentils that could be cooked on the model's stove, punctuated by the occasional good dinner when Monet was able to wangle invitations.

Aline Charigot, the artist's model and former laundress who was later to become Renoir's wife, once told Berthe Morisot of her first sight of her husband. The thin young man was accompanied by Monet and Sisley. All three wore their hair long, and they caused quite a stir when they strolled along the rue Saint-Georges where she lived.

Despite their poverty, they saw it as the happiest time of their lives, as Renoir told his son many years later. Monet cultivated his image as a bit of a dandy by always appearing in shirts with lace cuffs, even when he was without a *sou* – which was most of the time. A photograph of Monet taken in 1864 indicates the interest he took in his appearance: the young man with thick hair swept back from his forehead, and neatly trimmed moustache and beard, wears a silk tie knotted at the collar, a striped waistcoat peeps out from behind his elegant, high-buttoned coat, and starched white cuffs hang from his sleeves.

The Modern World and the Salon des Réfusés

In 1863, the young men at Gleyre's studio united in their determination to pursue 'modernity' in their work: they now intended to concentrate on modern man and the world that surrounded him. Moreover, during the course of that year an essay appeared that seemed to confirm that their decision was the right one: 'The Painter of Modern Life', a study of the work of the graphic artist and war correspondent Constantin Guys by the influential writer, poet and art critic Charles Baudelaire. (It was Baudelaire who once described Eugène Boudin's paintings as

The Road to Chailly, c.1865

*Oil on canvas, 17¹/₈ x 23¹/₄in
(43.5 x 59cm)
Musée d'Orsay, Paris*

*The work of the Barbizon School of
painters first drew Monet to the
Forest of Fontainebleau. In 1865,
while staying at Chailly, a small
village in the forest, he painted
several landscapes, such as this one,
with the same close attention to
nature that was a hallmark of the
Barbizon artists.*

'prodigious enchantments of air and water'.) Guys was greatly admired for his reportage of the Greek War of Independence and the Crimean War for the *Illustrated London News* and for his clever, lively drawings, washed with tone and colour, of contemporary Paris life, from the court to the demi-monde.

Back in 1846, Baudelaire had written that 'many people will attribute the present decadence in painting to our decadence in behaviour … It is true that the great tradition has been lost and that a new one has not yet been established'. Now, in his 1863 essay, Baudelaire advanced the theory for a new tradition.

He wrote that there was no universal beauty; rather that different people and different cultures had their own, individual beauty, and because beauty arose from the emotions, every man inevitably had his own personal idea of it. It was obvious, therefore, that an artist's individuality was an essential part of the beauty he created; suppress or regiment that individuality and the artist's work became banal and emotionally void. Baudelaire contended that the pleasure derived from the present derived from the beauty it possessed, as well as from its essential quality of being the present. 'Modernity is the transitory, the fugitive, the contingent which makes up one half of art, the other being the eternal and the immutable.'

Baudelaire was one of the founders of the 'art for art's sake' school of thinking, rejecting the idea that an artist's work should have a social or moral purpose. He was a friend and admirer of the artist Edouard Manet and his influence is thought to have deflected Manet from an early preoccupation with historical and 'picturesque' subjects, the result of his study of Old Masters at the Louvre and in museums throughout Europe, towards the painting of contemporary life – towards, in fact, Realism, which at this time was considered by traditionalists to be aesthetically and politically dubious. Manet's 1863 painting, *Music in the Tuileries Gardens*, no doubt seen by Monet and his friends, includes Baudelaire among its Paris notables.

Another painting by Manet, now seen as a key work in the development of painting in Europe, was rejected by the 1863 Salon. *Le Déjeuner sur l'Herbe* (page 34), painted in a realistic, 'modern' style, shows two men picnicking with a naked woman and one that is loosely clad, whom Manet makes no attempt to disguise as Greek goddesses; they are contemporary young women, one who has decided to take her clothes off, and the other to paddle in a nearby stream.

In fact, the Salon threw out so many works by other artists that year, including paintings by Whistler, Pissarro and Jongkind, that there was a furious outcry and the

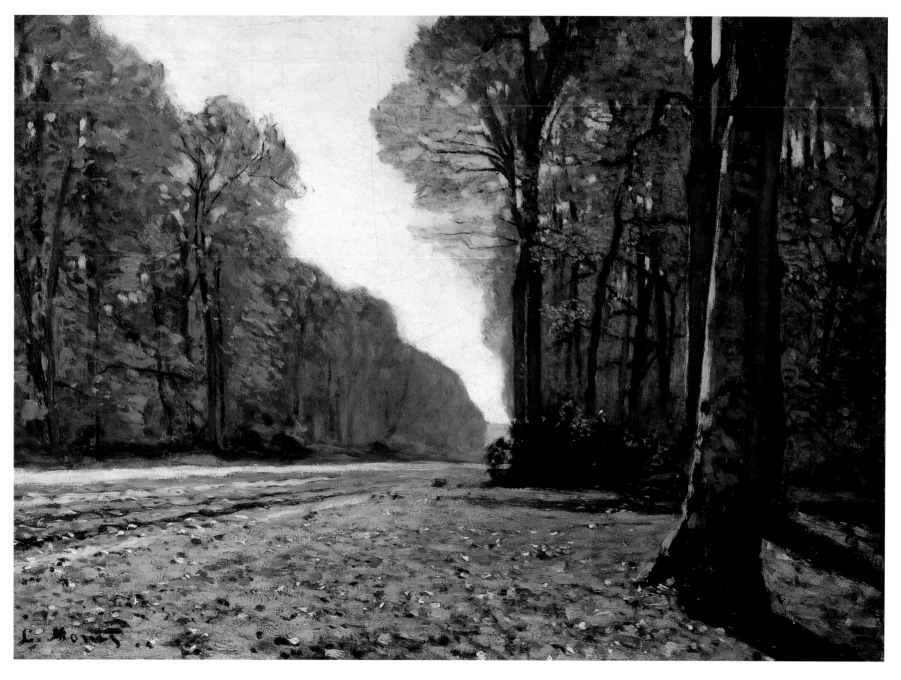

emperor himself had to intervene to calm things down. Napoleon III announced that the public at large should be able to judge whether the Salon jury had been right or wrong, and that the rejected works should be exhibited instead in another part of the Palais d'Industrie. Thus the Salon des Réfusés was born and it was here that Monet first set eyes on Manet's scandalous painting.

Le Déjeuner sur l'Herbe was one of the most noticed, and most criticized, paintings at that first Salon des Réfusés, to which over 10,000 people turned up on 17 May; numbers were maintained on following days, and greatly exceeded visitors to the official Salon. The wonder is that, with such a crowd, anyone saw anything. But everyone, seemingly, saw *Le Déjeuner sur l'Herbe*. The general public laughed and sneered at Manet's painting; it was 'mad' and they did not understand it. Napoleon III described it as 'improper' and most critics failed to see any good in it at all, believing that Manet had deliberately set out to shock. The way in which it was painted, the colours applied in roughly blocked brushstrokes, with nothing smoothed over or varnished, seemed to them coarse and unfinished.

In contrast to the treatment meted out to Manet, works by Jongkind, Pissarro and Whistler (his *White Girl*, which had been rejected by the Royal Academy in London the year before) were well-received at the Salon des Réfusés.

When he saw Manet's painting, Claude Monet did not laugh. He recognized that Manet was searching for a new understanding of the contemporary world, with all its upheavals, social fragmentation and industrial change. Monet thought that *Le Déjeuner sur l'Herbe* was about realism and modernity in painting and the need to break away from outworn traditions, outmoded ways of representing life that he and his friends had discussed endlessly. Manet's painting became something of an exemplar for Monet's own work, so much so that two years later he spent months working on his own *Déjeuner sur l'Herbe* (pages 48–49), which he hoped to submit to the Salon, but which was so monumental in conception that it was never completed.

At this time, Monet had not actually met Edouard Manet. Monet was soon to meet and become very good friends with one of Manet's brothers, Gustave, though it was some time before he made the connection between Gustave and Edouard. Monet was rather irritated by the fact that when they signed their paintings his and Manet's signatures were so alike and one day asked Gustave, 'This Manet, the painter, is he any relation of yours?' 'He is my brother,' Gustave replied.

By this time, Monet, Renoir, Bazille and Sisley were all spending more time away from the city than in Gleyre's studio. Monet was staying at Chailly-en-Bière,

near Fontainebleau, when the Salon des Réfusés opened. In a letter of 23 May, Monet assured his friend, Armand Gautier, that he had not abandoned the studio, neither was he giving up drawing, but that he had found many things to charm him at Chailly, which was so beautiful in spring, when everything was turning green.

Many of Monet's paintings in the next few years show just how much Chailly and Fontainebleau enchanted him, even when summer was coming to an end. *The Road to Chailly* (page 37), painted in around 1865, shows the trees beginning to lose their leaves, which are scattered on the ground beneath. The sky has lost its vivid summer blue and has a misty yellowish tinge. But the sunlight, filtered through the trees, still has the warmth and freshness that attracted Monet and his friends to the forest in preference to the studio.

Now interested in painting outdoor subjects, both landscapes and paintings of the life and work that existed beyond the city, Monet and his friends all preferred to paint directly from their open-air subjects. In itself, this was nothing new. The French landscape artists of the 18th century had regularly made oil sketches and notes while studying outdoor scenes that they would later transfer to canvas in the studio. By following the Barbizon artists out of Paris, moreover, the young French artists were also emulating the great English artist, J.M.W. Turner, who had

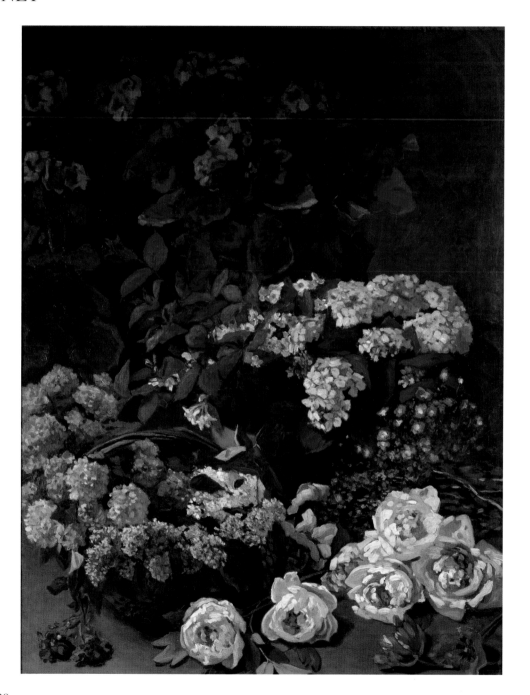

OPPOSITE
Self Portrait in His Atelier
Oil on canvas
Musée Marmottan, Paris

painted hundreds of watercolours and oils of harbours and rivers in England, canals in Venice, and mountain passes in Switzerland. They passionately desired to capture that sense of directness and immediacy that they believed only work done entirely *en plein-air* could achieve.

An Artist's Life in Paris

While for most of the 1860s Monet was to follow the twin paths of painting outdoor pictures, imbued with a realism that was his response to the modern world, and of producing highly finished studio works intended to catch the eye of the Salon jury, he very soon decided that he could no longer endure the conventional, conformist atmosphere of Gleyre's studio. 'There is no sincerity here; the atmosphere is unhealthy. Let's escape,' he is reported to have cried to Bazille, Renoir and Sisley. He probably did say this, or something very like it, for he was the least willing of them all to put up with the *status quo*: Claude Monet knew what he wanted to do and cared neither for social disapproval nor hostility. 'Without my dear Monet, who gave courage to all of us, we would have given up,' Renoir once remarked of those early, difficult days in Paris.

Escape would mean more *plein-air* painting out in the countryside, the artists' life made easier by portable easels, the new collapsible tubes of paint, and a rapidly growing railway system that could transport them quickly and cheaply out of Paris. They would stay at Mother Anthony's Inn at Marlotte, near Barbizon, in the Forest of Fontainebleau. Courbet, Pissarro, Monet, Renoir and Sisley all stayed at Mother Anthony's, dining cheaply and well in the main bar and leaving their caricatures, paintings and drawings behind them to adorn her walls. Among the attractions of Mother Anthony's Inn was a barmaid called Nana and Toto, a white poodle with a wooden leg. Both appear, along with Sisley and Renoir himself, in Renoir's 1866 painting, *Le Cabaret de la Mère Anthony*.

For Monet, another escape route out of Paris was back to Normandy. Here, as in the Forest of Fontainebleau, Monet could enjoy the company of other artists, attracted to Honfleur by the superb painting opportunities offered by coast and countryside. Frédéric Bazille, sweltering in his Paris studio in the summer of 1864, received numerous letters from Monet in Honfleur, urging him to get packing and to come for a fortnight. 'Damn it man … you'd be far better off; it can't be that easy to work in Paris,' Monet wrote to Bazille in July. In Honfleur the painters formed their own pleasant little group and all got along together famously. Among them were Jongkind and Boudin, and another two, Rozias and Charpentier, were 'a bunch of jokers'; Bazille, on the other hand, Monet said sternly,

could not hope to work with playboys like his friend Villa and the others in Paris.

Not that it was that easy to work in Honfleur. As Monet told Bazille, it really was 'appallingly difficult' to produce work complete in every respect. Again and again he would stand back from his work, scrape it off and start again, relying on the strength of his observation and reflection to find a way. 'So we must dig and delve unceasingly …,' he wrote.

In his letters to Bazille, Monet also mentioned a flower painting that he had been working on for some time and which was now framed and varnished and looking a great deal better for such treatment. *Spring Flowers* (page 39), a beautiful, light-flecked, realistically observed still life, which Monet thought at the time was without doubt the best thing he had done up till that time, now hangs, handsomely framed, in the Cleveland Museum of Art in America.

While painting was proving to be a hard battle for the young artist, his relationship with his father was not helping matters. The long summer of 1864 spent in Honfleur brought Claude Monet within range of his father's disapproval, aggravated by his intense disappointment that he would be without a son to follow in his footsteps. Inevitably, summer came to an end and Monet had to return to Paris, with no financial support

RIGHT
Frédéric Bazille
The Artist's Studio in the Rue de la Condamine, 1870
Oil on canvas, 38⁷⁄₈ x 47in
(98.7 x 119.4cm)
Musée d'Orsay, Paris

Like Manet, Bazille could afford a large and comfortable studio in Les Batignolles in Paris. Painted a few months before the Franco-Prussian War and the civil war that followed, Bazille's picture became a memento of a carefree time that was no more.

OPPOSITE
Henri Fantin-Latour
A Studio in the Batignolles Quarter, 1870
Oil on canvas, 80¹⁄₄ x 107¹⁄₂in
(204 x 273cm)
Musée d'Orsay, Paris

In this painting are several of the leading figures of the Realist group of painters and writers who met regularly at the Café Guerbois. Renoir, Bazille and Monet are depicted to the right of the group.

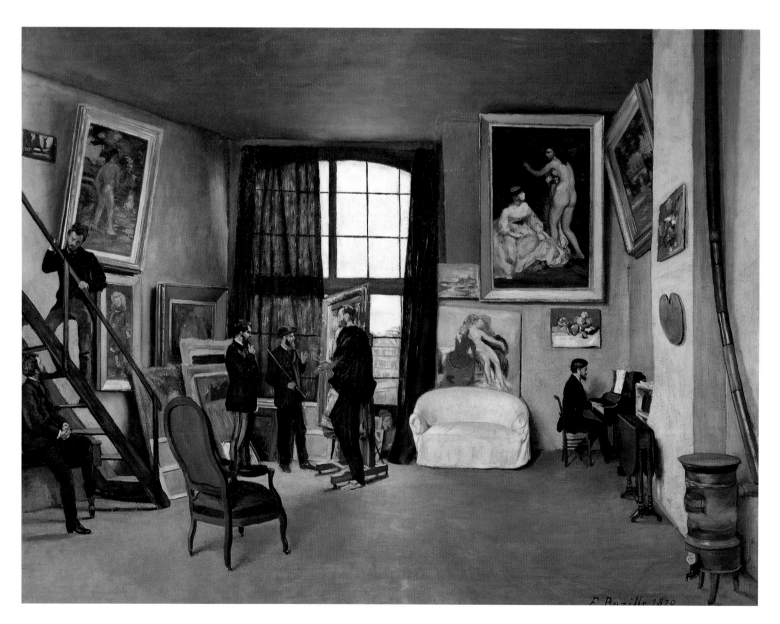

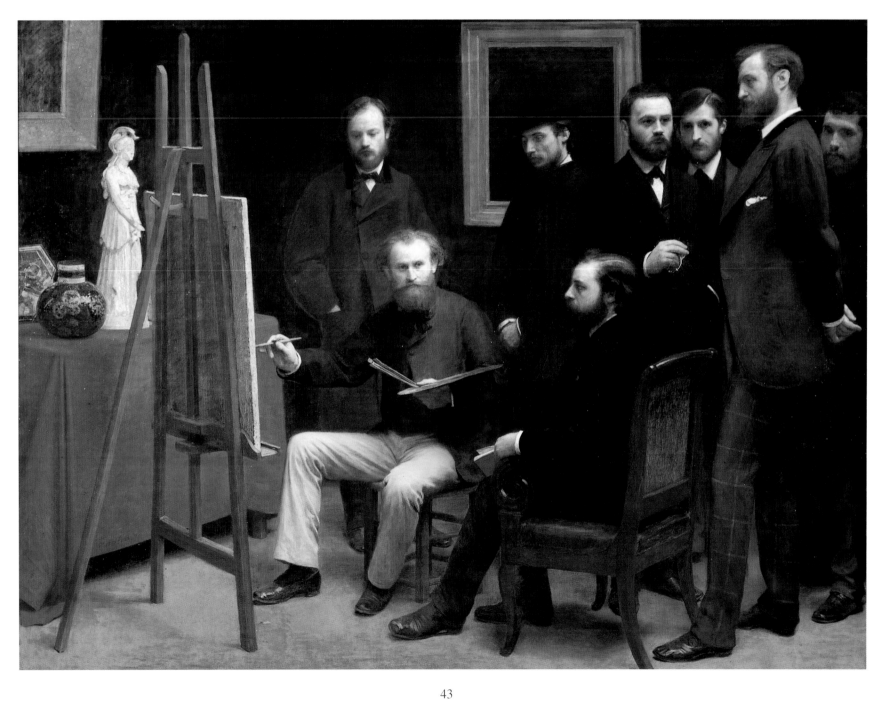

from his father, but with a small allowance from his aunt.

But Paris itself was able to provide a studio-bound artist with an escape route of its own. Paris had changed considerably since 1840, when Monet was born in the rue Lafitte. Georges-Eugène Haussmann's grand design for rebuilding that part of Paris on the right bank of the Seine had been proceeding since the early 1850s. Old, unhealthy warrens of streets, alleys and culs-de-sac were demolished to make way for 85 miles (137km) of broad, tree-lined boulevards lined with large, uniformly-designed apartment buildings. Because these neighbourhoods were intended for the newly affluent bourgeoisie, they were well supplied with parks, monuments, places of entertainment, and good restaurants. Close at hand were the new railway stations and the steam trains that transported the citizens of Paris to all parts of France quickly and cheaply. This was the world portrayed in the novels of Emile Zola, close friend of the artist Paul Cézanne and an enthusiastic habitué of Paris's café society.

Cafés were an important feature of Paris life in the 1850s. Writers and artists were drawn as to a magnet to the lively atmosphere, where heated argument and witty repartee were the order of the day. The most attractive feature of any café was the *terrasse*, which gave a kerb-side view of the ever-changing urban scene, and which begged to be transferred to paper and canvas.

Many, writing about the development of Impressionism, have remarked that it was an art movement that was virtually born in the Paris cafés. In them, innovative ideas and theories were thrashed out, new techniques approved or pulled to shreds, new directions plotted, and exhibitions planned. The Anglo-Irish writer, George Moore, described his favourite café, the Nouvelle Athènes, prominently sited on a corner of the rue Pigalle, as an 'academy of fine arts … the real French academy'.

In his *Reminiscences of the Impressionist Painters*, Moore recalls that Monet and Sisley, 'being landscape painters, only appeared at the Nouvelle Athènes after long absences; they would return suddenly from the country, bringing with them twenty or thirty canvases, all irreproachably perfect, all masterpieces. The method of painting is the same in both; in style their pictures are almost indistinguishable, yet it would be difficult to mistake one for the other. Monet is the more external, there is a little more reverie in Sisley…'.

The Nouvelle Athènes was in a part of Paris that encompassed the avenues and boulevards surrounding the Place Clichy, where many artists lived and worked in the 1860s. In the mid-1860s, the favourite artists' and writers' café was the Café Guerbois, at 11 rue des Batignolles. Writers, musicians and photographers flocked there,

OPPOSITE
La Pointe de la Hève at Low Tide (Sainte-Adresse), 1865
Oil on canvas, 35½ x 59¼in
(90.2 x 150.5cm)
Kimbell Art Museum, Fort Worth, Texas

Monet's beloved Normandy coast provided the subjects for his first two Salon acceptances in 1865. In this one he captures with great assurance the light and shade on sea and sky caused by the sun breaking through the clouds.

especially on Thursdays, where they were able to discuss, argue and put the world to rights with artists like Manet, Monet, Bazille, Degas, Renoir, Alfred Stevens and Constantin Guys and, although not so frequently, Pissarro, Sisley and Paul Cézanne.

In an interview given to *Le Temps* in 1900, Monet recalls the life of the Café Guerbois, which after the 1870 war replaced the Nouvelle Athènes as the main rendezvous of the Impressionists: 'Nothing could have been more stimulating than the … discussions which we used to have there, with their constant clashes of opinion. They kept our wits sharpened and supplied us with a stock of enthusiasm that lasted us for weeks…'.

The artists' own studios were another source of stimulation, places where the discussion and criticism of current work was practical and immediate. Les Batignolles, a district stretching from the Gare Saint-Lazare to the industrialized suburb of Batignolles in the heart of the new Paris created by Haussmann, was popular with writers and artists, many of whom had their studios there.

Several artists recorded on canvas life in the studios. Henri Fantin-Latour's *A Studio in the Batignolles Quarter* (page 43) was intended as a record of the Realist group of artists and writers centred on the Café Guerbois, in which he included fine portraits of Renoir, Bazille and Monet.

In 1870, Frédéric Bazille also painted a lively picture in the Realist style of his Les Batignolles studio, *The Artist's Studio in the Rue de la Condamine* (page 42). Because he was well-off, Bazille could afford a large and comfortable studio, complete with a sofa, chairs, a piano and a large stove. A great music-lover, Bazille often had musical evenings at his apartment, which was also large enough for him to provide a bed for both Monet and Renoir when they had nowhere else to live.

As in Fantin-Latour's painting, the men in Bazille's picture are all respectably bourgeois, with suits, white shirts and shiny shoes (except Bazille who is wearing slippers: after all, he is at home). There is Emile Zola, who stands on the stairs looking down at a seated man who could be either Sisley or Renoir, and a group of three artists – Manet, who has come in from his own studio nearby in Les Batignolles, Monet and Bazille – standing around the easel set by a large window. Seated at the piano is Edmond Maître, a musician and writer and a close friend of Bazille.

Monet is, in fact, twice represented in the painting, once in the portrait of him, heavily bearded and wearing the low-crowned hat in which he later appears in a portrait by Renoir, and again in the form of a still life, hanging above the piano, which Bazille bought from Monet at a time when he was particularly hard-up.

The Seine Estuary at Honfleur, 1865
Norton Simon Museum, Pasadena

This was the second of Claude Monet's pictures to be accepted for the 1865 Salon. The two seascapes greatly impressed the critic Paul Mantz, who wrote in the Gazette des Beaux-Arts *that the artist, though obviously young and inexperienced, possessed qualities that ensured he would not be forgotten.*

RIGHT
Déjeuner sur l'Herbe (Left panel),
1865–66
Oil on canvas, 164^{1}/$_{2}$ x 59in
(418 x 150cm)
Musée d'Orsay, Paris

FAR RIGHT
Déjeuner sur l'Herbe (Central panel),
1865–66
Oil on canvas, 97^{5}/$_{8}$ x 85^{3}/$_{8}$in
(248 x 217cm)
Musée d'Orsay, Paris

*These two canvases are all that are left
of Monet's ambitious plan for his own*
Déjeuner sur l'Herbe, *intended to outdo*
Manet's, *although there was some
thought of paying homage to Manet's
original.*

OPPOSITE
Déjeuner sur l'Herbe à Chailly, 1865–66
Oil on canvas, 51^{1}/$_{4}$ x 71^{1}/$_{4}$in
(130 x 181cm)
Pushkin Museum, Moscow

*A fine painting in its own right, this
was intended as a preliminary oil study
for Monet's planned great* Déjeuner sur
l'Herbe.

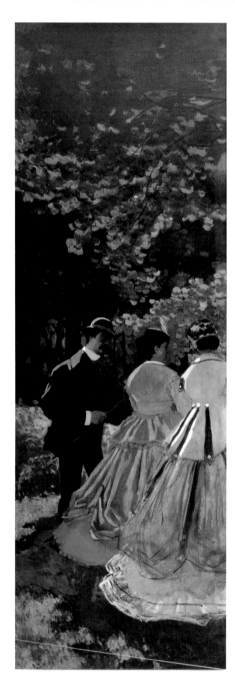
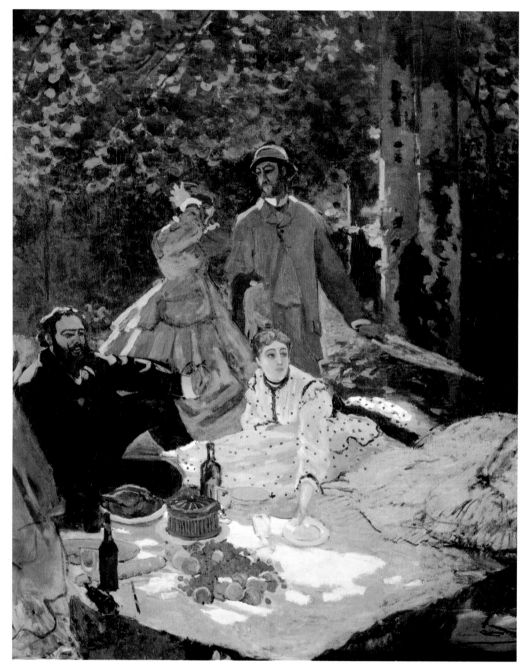

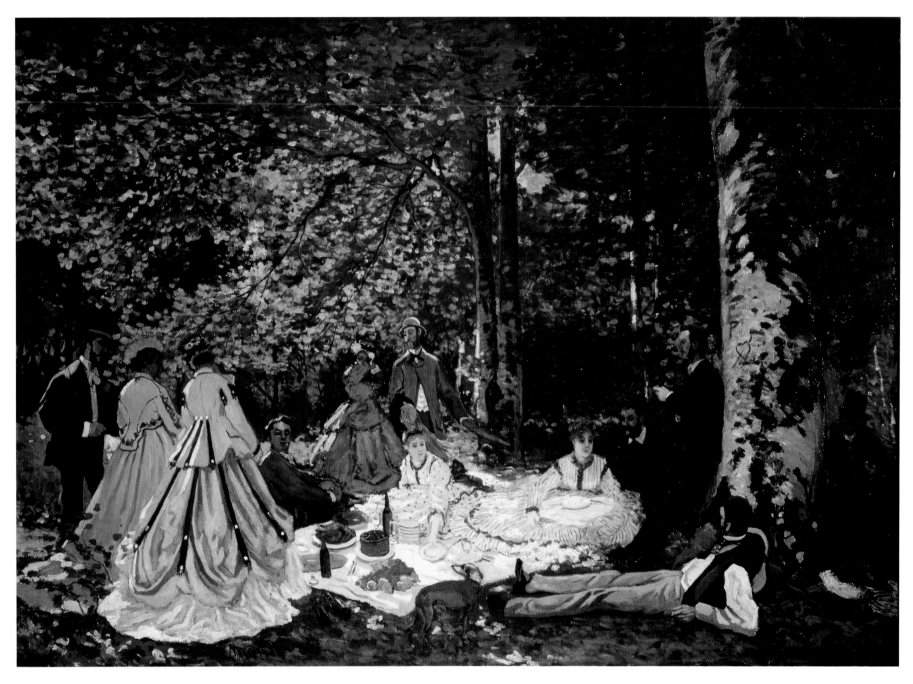

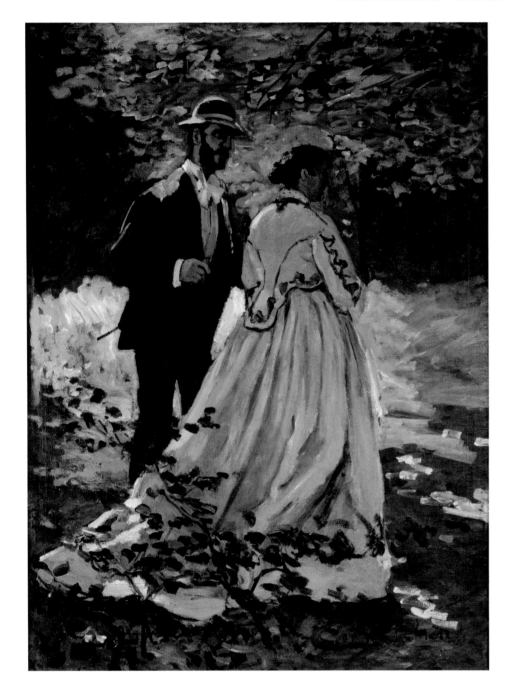

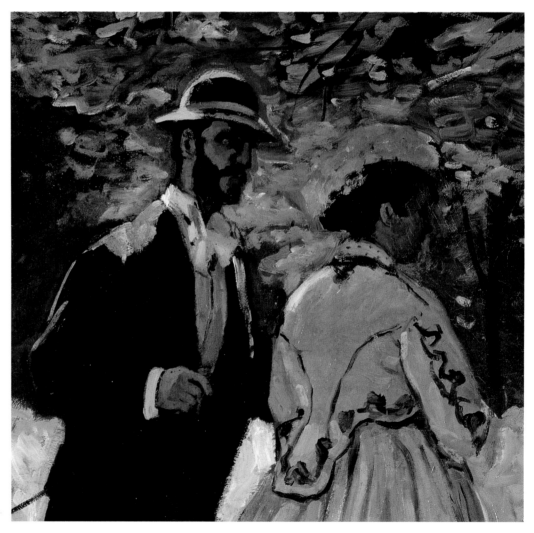

A final, poignant note concerning *The Artist's Studio in the Rue de la Condamine*: the figure of Bazille, rather out of scale, was painted in by Manet because Bazille had not yet got around to placing himself in the picture before he was killed in 1870.

Accepted by the Salon

Claude Monet had his first pictures accepted for showing at the Salon in 1865. Despite his earlier belief that the way to catch the eye of the Salon jury was via figure painting, even in an outdoor setting, Monet's first successful submissions were both seascapes, pictures of his beloved Normandy coast. Both are quite large and both were painted in a Paris studio from the many studies he had made in Honfleur during the summer of 1864. Even though they were packed in on the crowded walls of the Salon, which were usually hung with paintings five rows high, *La Pointe de la Hève at Low Tide* (page 44) and *The Seine Estuary at Honfleur* (page 47) were immediately noticed for the assurance with which they were painted and for the very personal style of the artist.

The art critic of the *Gazette des Beaux-Arts* told his readers in July 1865 that a new name must now receive mention, that of the hitherto unknown Claude Monet. 'These works constitute his debut – and they still lack that finesse which comes with long study. But his feel for

colour harmonies in an interplay of related tones, and indeed his sense of colour values as a whole, as well as … his daring way of seeing and of enforcing our attention … are advantages which M. Monet already possesses in a high degree.'

Another critic, Gonzague Privat, wrote that Claude Monet's two marines were unquestionably the best in the exhibition. 'The tone is frank, the breeze penetrating as that on the high seas and the treatment is naïve and young.'

La Pointe de la Hève at Low Tide shows the beach at Sainte-Adresse, now a suburb of Le Havre, where Monet's aunt had her summer home. It is painted in colours that, for Monet, are relatively subdued. The sky is a mass of dark-grey clouds, with patches of blue sky showing through; the two human figures, the cart and horses, the sailing boat out at sea, and the boats drawn up on the shingle against a wooden breakwater are all worked in dark shades, their forms suggested by the way in which Monet contrasts dark and lighter tones. White is used lavishly to accentuate the foam-crested waves that break on the beach and sunlight picks out areas of the cliffs that back the beach.

Monet's second Salon success of 1865, *The Seine Estuary at Honfleur* (page 47), looks towards the town and its lighthouse from out at sea. Sailing boats, the wings

OPPOSITE
The Promenade (Bazille and Camille), 1865
Oil on canvas, 36⅝ x 27⅛in
(93 x 69cm)
National Gallery of Art, Washington, DC.

This painting, a charming study of Frédéric Bazille and Camille Doncieux walking in the woods near Chailly, was one of many oil paintings Monet intended as preliminary sketches for the Déjeuner *painting. The couple appear at the left-hand side of the large oil sketch of the painting on page 49.*

RIGHT and OPPOSITE
Woman in a Green Dress, 1866
Oil on canvas, 89³/4 x 58⁵/8in
(228 x 149cm)
Kunsthalle, Bremen

In setting Camille against a dark, neutral background, Monet ensures that the viewer's attention will be all on the model's face and her magnificent green silk dress. The result is a most striking portrait that was an immediate success when exhibited in the 1866 Salon.

of seabirds, and myriad foam-crested waves give the picture a wonderfully breezy atmosphere, so that the viewer can almost smell the fresh salt air.

Neither painting, unlike Boudin in his own pictures of Le Havre, makes the seaside the focus of social life. Not yet for Monet the fashionable crinolines, parasols and beribboned bonnets of a typical Boudin scene, even though Monet liked pretty women. Once, in his early days in Paris, he brashly remarked that he only slept with duchesses or maids – 'the ideal would be a duchess's maid'. Soon, however, he was to meet a pretty model, Camille Doncieux; perhaps it was this, along with observing the fashionable set which thronged the boulevards and cafés of Paris, that prompted Monet to move the figures in his landscapes decidedly up a class or two.

Monet began to think about pictures for the next Salon almost as soon as his 1865 pictures were on the Salon's walls. In May, he moved out of Paris to the Golden Lion inn at Chailly, intending to spend the summer there developing the idea that had been in his mind ever since he saw Manet's *Déjeuner sur l'Herbe* at the Salon des Réfusés in 1863. Now, in the glorious Fontainebleau forest, he would begin work on what would be the foundation of his own version. It was to be a very large scene in a forest, with at least half a dozen fashionably

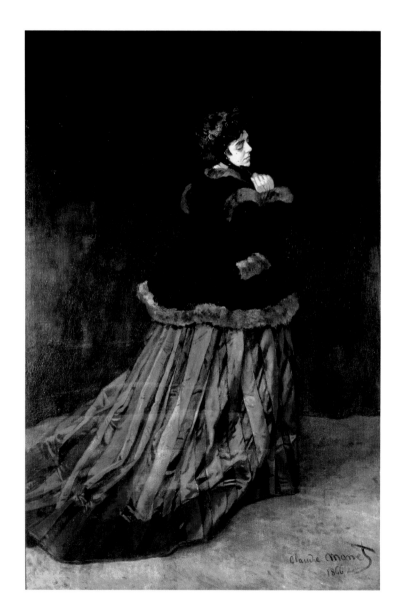

dressed people relaxing on the grass around a picnic cloth. It would be necessary for Monet to make many preliminary sketches and studies for it.

Throughout his life Monet preferred to use his family and friends as models for his paintings, quite probably because it was simply cheaper. This time, however, he placed a professional model called Camille Doncieux in pride of place next to the main male figure, who was to be the tall and handsome Bazille. By the summer of 1865, Camille was Monet's mistress and Bazille, unfortunately, had returned to his family in the south of France. Monet, never one to put other people's wishes before his own needs, wrote him increasingly exasperated letters requesting his immediate return to Chailly, as his picture depended on Bazille's presence. 'I think only of my painting, and if I were to drop it, I think I'd go crazy,' Monet wrote to Bazille at the end of July.

Eventually, Bazille, growing tired of his family's blandishments that he should return to his medical studies, suddenly turned up and in September 1865 Monet got down to a major oil sketch, based on the many studies he had done in the spring and summer. The sketch for *Le Déjeuner sur l'Herbe* (page 49), now in the Pushkin Museum of Fine Arts in Moscow, measures a relatively modest 130 x 181cm. It is a wonderfully spontaneous and fluent painting, full of dappled light that falls on the

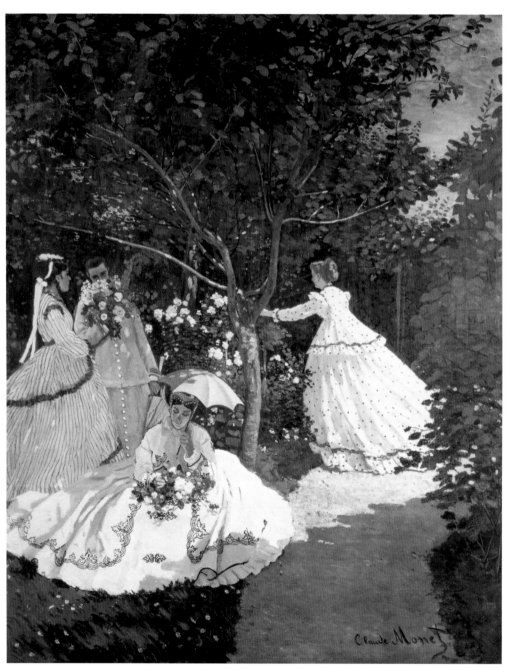

leaves and branches of the trees and illuminates the figures – now numbering a dozen – which are casually gathered below. All are fashionably but informally dressed, and there are no signs of the scandalous nudity that made Manet's painting so notorious.

From the fragments that remain of the major work, which Monet began in the studio he was sharing with Bazille in Paris in the autumn of 1865, it is clear that he was having trouble reconciling it with the relaxed and happy spontaneity of the sketch. Size was probably the reason; Monet's ambition required a monstrous canvas measuring about 13 x 20ft (4.5 x 6m). All that is left of it are two fragments, a left-hand panel and a central portion. While they lack the freshness and immediacy of the sketch, they still show the directness of vision and firmness of handling that are hallmarks of Monet's work.

What defeated Monet in the end was his inability to transfer the same sense of light into his great painting that he had captured with such ease in the smaller sketch. The short, single brushstrokes that Monet used (rather than the traditional *chiaroscuro* technique which involved the careful merging of areas of paint from dark to light) were extremely difficult to handle over a large canvas. Despite working on his picture throughout the winter of 1865–66, Monet at last admitted to himself that he would never

OPPOSITE
Women in the Garden, 1867
Oil on canvas, 100³/8 x 80³/4in
(255 x 205cm)
Musée d'Orsay, Paris

Another large-scale work planned to fulfil Monet's ambition to stun the Salon, this painting was at least finished, unlike his Déjeuner sur l'Herbe. *The Salon jury was not impressed by it, perhaps because it lacked the spontaneity and charm of* Woman in a Green Dress, *and rejected it for the 1867 Salon.*

LEFT
Purple Poppies, 1866
Oil on canvas
Museum Boymans-van Beuningen, Rotterdam

The Artist's Son Asleep, 1867–68
Oil on canvas, 16³/4 x 19⁵/8in
(42.5 x 50cm)
Ny Carlesberg Glyptothek, Copenhagen

This is Monet and Camille's son Jean,
who was born in Paris during Monet's
absence on 8 August 1867.

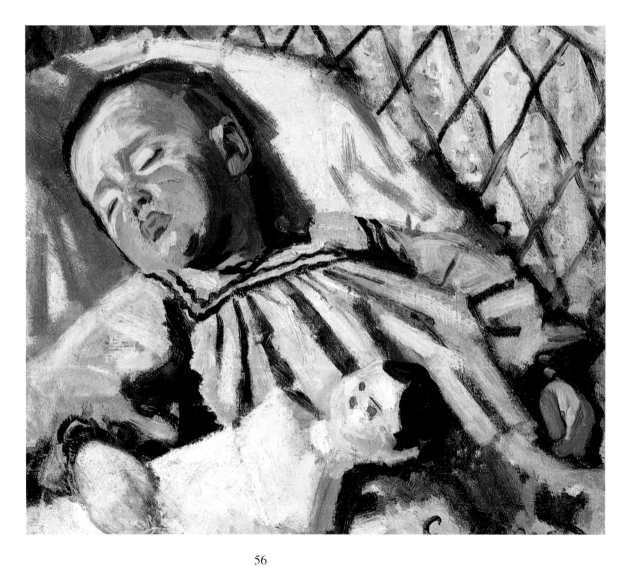

finish it in time for the 1866 Salon. The work was eventually handed over to his landlord in lieu of several months' rent (it was probably the rent money that had paid for the expensive canvas in the first place) and it was some years before Monet was able to reclaim it. By this time, the painting had been badly damaged by damp and portions of it had been eaten by rats. The two fragments now in the Musée d'Orsay in Paris are all that remain of Monet's great work.

Not quite all, of course, for there remain many of the works that Monet did in the Forest of Fontainebleau in 1865 in preparation for the major work. As well as the *Déjeuner* in the Pushkin Museum, there is another charming study of Bazille and Camille, usually called *The Promenade* (page 50). In it, Bazille stands very much in the position he occupies in the left-hand fragment of the big picture and Camille wears the full-skirted white dress with black embroidery (or perhaps frogging) that was to appear again and again in Monet's paintings of the late 1860s. It was a handsome gown, but its repeat appearances over so many years was possibly an indication of the real poverty endured by Monet and Camille during these years.

But all was not lost as far as the 1866 Salon was concerned, for two other works submitted by Monet were accepted. One was a study of the Forest of Fontainebleau, The Road to Chailly (page 37). The second was something much more daring. In a great hurry – though perhaps it was a longer time than the four days legend allows for its painting – Monet produced *Camille*, or *Woman in a Green Dress* (pages 52 and 53). This full-length, life-sized study of a woman wearing a striped green silk dress, her back turning as she walks away from the viewer, was one of the great successes of the 1866 Salon. Monet intended his painting to be a study of a Parisian woman of the period, and not a portrait, but 40 years later, when the painting was bought by the Kunsthalle, Bremen, Monet remarked to the gallery's director that the resemblance to Madame Monet, his first wife, was striking.

Although some critics and commentators disliked the portrait, thinking its unusual pose deformed, many others raved over the life-like figure of Camille, frozen in mid-movement, and the way in which Monet had caught the sheen and rustle of the silken fabric of her dress: 'as dazzling as the stuffs of Veronese'. Emile Zola was loud in his praise, extolling the vitality and realism of *Woman in a Green Dress*. He wrote that it was 'a window open on nature' and that its painter was a 'temperament … a man amid this crowd of eunuchs'.

Other critics compared Claude Monet to the old masters – and to Edouard Manet. 'Monet or Manet?' asked

OPPOSITE
The Terrace at Sainte-Adresse, 1867
Oil on canvas, 38¹/2 x 51¹/4in
(98 x 130cm)
Metropolitan Museum of Art, New York

PAGE 60
Garden in Flower at Sainte-Adresse, c.1866
Oil on canvas, 25¹/2 x 21¹/4in
(65 x 54cm)
Musée d'Orsay, Paris

PAGE 61
Rough Sea at Etretat, 1868–69
Oil on canvas, 26 x 51¹/2in
(66 x 131cm)
Musée d'Orsay, Paris

La Lune's art critic, opting for Monet, but adding, 'We have Manet to thank for Monet. Bravo, Monet! Thank you, Manet!' Manet was a little piqued at the thought of this young upstart snatching his style and his name, but soon came round, and within a short time of their first meeting (some time in 1866), the two were good friends.

From around this time until well into the 1880s, critics and writers on art, who usually referred to artists by their surnames only, began to refer to Monet by his full name. In this way they ensured that readers, skimming over an article, would not confuse him with Manet, who, being older and much better known, had no need of an identifying forename.

The later history of *Woman in a Green Dress*, as outlined by Monet to the director of the Bremen art gallery, is an interesting commentary on the changes in his fortune and his art. In 1868 Monet sold the painting to Arsène Houssaye, a former director of the Comédie Française, who was at the time an inspector of national museums. Houssaye kept it with the intention of later bequeathing it to the Musée du Luxembourg, when the state might be more inclined to accept it. But, recalled Monet, he died 'before public opinion changed' and his son, a member of the Académie Française, quickly sold it on for a 'derisory sum'. Now, in May, 1906, Monet was glad to know it was in the Bremen gallery and was also very flattered into the bargain.

Given the critical acclaim for Monet, which included the remark from an essay on the 1866 Salon by P. Martial that 'the painters of nature and life [including Monet] are above all praise … and [are] for the truth in everything and always', it is all the more extraordinary that this was Monet's last big Salon triumph and that he showed there on only two more occasions during his lifetime.

Realism to Impressionism
Fired by his success at the 1866 Salon, Monet kept to his plan to conquer the Salon with large figure-paintings, but moved outdoors again, spending the summer and autumn of 1866 at Sainte-Adresse and Honfleur. For his next Salon *tour de force*, not only the preliminary studies but also the final work were painted out of doors. *Women in the Garden* (page 54), using Camille as the model for all four women in the painting, was planned on a slightly more manageable scale than *Déjeuner sur l'Herbe*. Even so, it exceeded 8 x 6ft and was so high that Monet, who was quite a short man, had to dig a trench in the garden to stand the canvas in it so that he could reach the top.

Many of Monet's artist friends found it hard to hide a smile at the sight of their intensely serious friend working away on his entrenched painting. They probably also admired and were even a little in awe at the fearlessness with which Monet tackled his painting, particularly when

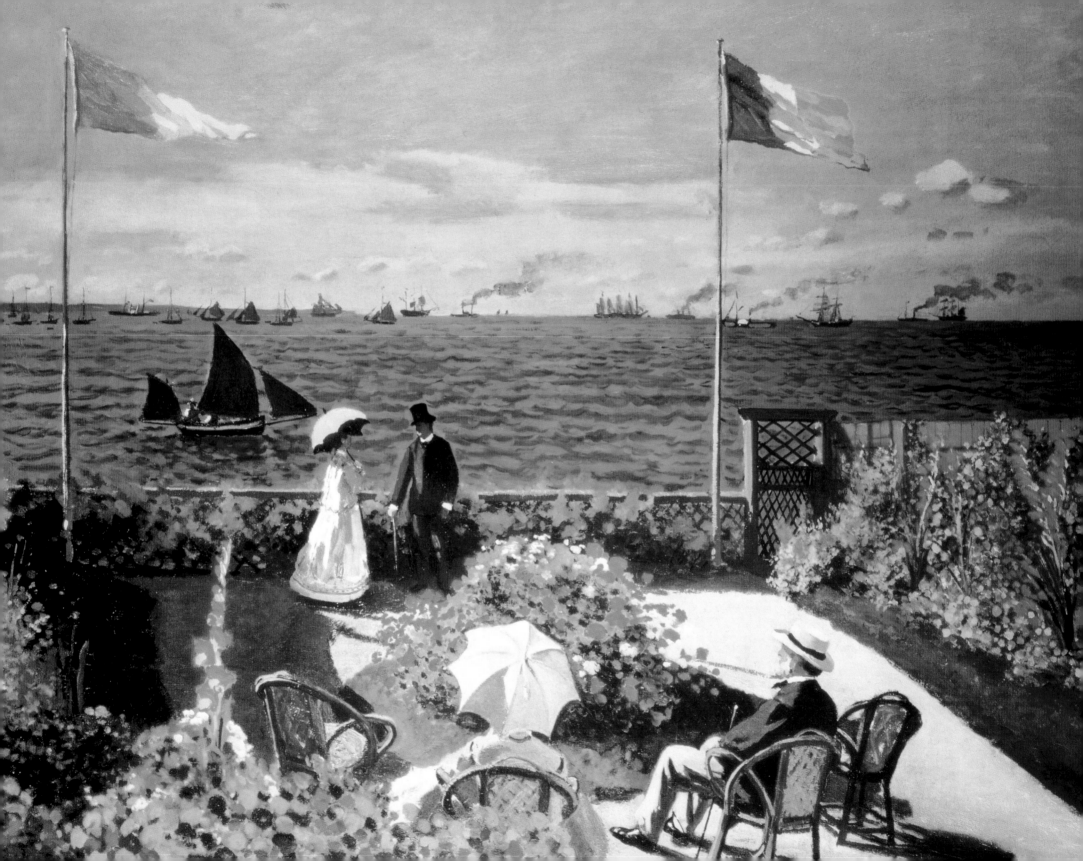

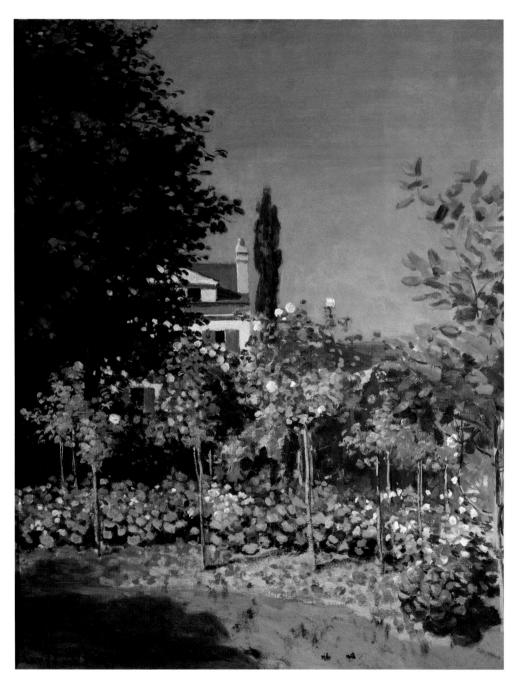

it was so technically difficult. Courbet, in particular, was given something to think about. Coming upon Monet sitting apparently day-dreaming by his trench, Courbet remarked that Monet should not be twiddling his thumbs when there was still so much to do to the picture. Monet shook his head. 'I am waiting for the sun,' he said. A cloud had passed in front of it, altering the intensity of light falling on the picture.

Unfortunately, the Salon jury did not share the amusement and admiration of Monet's artist friends. Nor were they impressed, and *Women in the Garden* was rejected for the 1867 Salon. With hindsight, critics might say that the jury was right in deciding that Monet's painting was not up to the standard he had set for *Woman in a Green Dress*. The painting lacks the narrative appeal that would have made it acceptable to the traditionalists on the Salon jury. The women seem set apart from the garden, frozen unnaturally in their poses; they do not appear to have any reason, any psychological motivation, for what they are doing. It is as if Monet had decided to paint a few of the fashion plates that were then so popular in Paris.

On the positive side, *Women in the Garden* is a wonderfully light-filled painting, with a dazzling band of sunlight falling across the garden and the women's dresses (including that black-embroidered white one

The Luncheon, 1868
Oil on canvas, 75¹/₄ x 49¹/₄in
(191 x 125cm)
Stadelsches Kunstinstitut, Frankfurt

Here, the distressingly poor Monet is recording a very French, very middle-class scene, perhaps in hopeful expectation that one day he will be able to enjoy such a life himself. The table is set for a meal we might call brunch, with wine, grapes and the ingredients for a salad on the table beside the morning paper and breakfast egg.

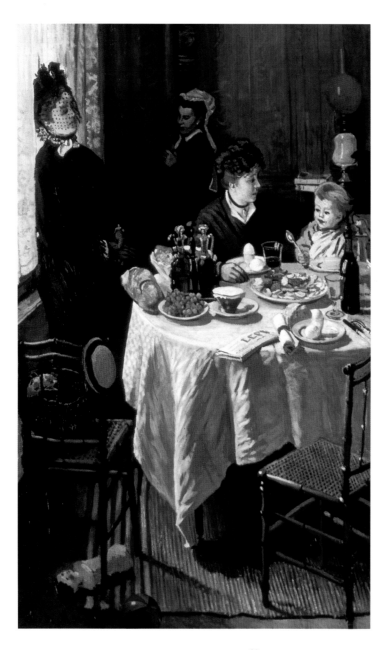

again), while sunlight and shadow emphasizes the whiteness of the flowers and lends a delicate sheen to the women's faces.

The main lesson Monet learned from this failure was that painting on a grand scale was incompatible with working entirely *en plein-air*. For the remainder of the 1860s he painted many outdoor subjects, most of which were executed on the spot and often in conditions far from ideal (*On the Beach at Trouville*, page 77, still has grains of sand, blown by the wind, stuck to the paint), and kept the studio for his Salon attempts, continuing to believe until well into the 1870s that for an artist to achieve financial success he must first receive official recognition.

With his outdoor paintings, Monet achieved a loose, informal structure in his compositions, allied to a crisp realism of line and a mastery of bright, clear colours. There is also evidence of a certain detachment from the subject in many of them, a sign that Baudelaire's 'art for art's sake' approach was still of influence. Also influential was the life and culture of the period. Photography, printed fashion plates and colour prints, especially the immensely popular Japanese prints, all had an impact on Monet's work.

Monet himself admitted that he was inspired by devices often used by Japanese artists, such as a high

The Beach at Sainte-Adresse, 1867
Oil on canvas, 29⅞ x 40⅜in
(75.8 x 102.5cm)
Art Institute of Chicago

There are clear signs of a change in Monet's painting technique in the paintings he did at Sainte-Adresse in the summer of 1867. In many of them, as in this one, his brushstrokes have become more broken, especially on the beach and sky, as he applies the paint to the canvas with shorter, vigorous strokes of colour.

On the Seine at Bennecourt, 1888
Oil on canvas, 32 x 39⁵/₈in
(81.5 x 100.7cm)
The Art Institute of Chicago

With its striking fusion of light and colour, this satisfying harmony of sky and trees, boats and houses, reflected in the limpid waters of the Seine, comes very close to Impressionism at its most accomplished. This is one of the first pictures in which Monet explores the effects of reflections in water.

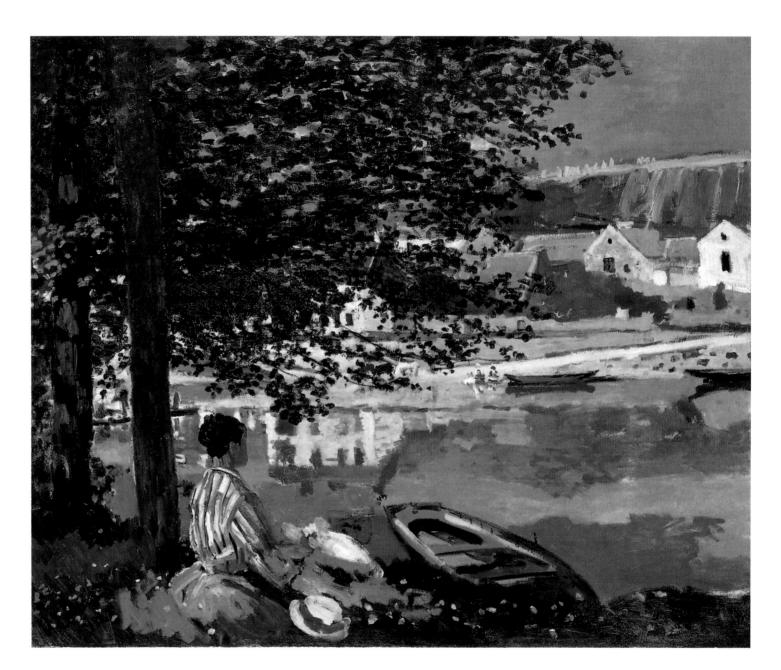

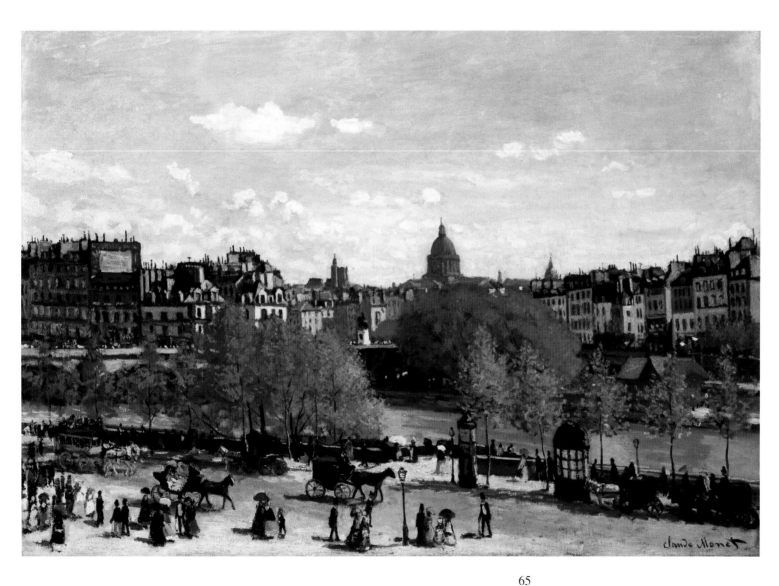

The Quai du Louvre, Paris, 1867
*Oil on canvas, 25^1/$_2$ x 36^5/$_8$in
(65 x 93cm)
Haags Gemeetemuseum, The
Netherlands*

*In the spring of 1867, Monet was
given permission to set up his easel in
the Colonnade on the east front of the
Louvre museum in Paris. This painting
is one of three that survive from the
work he did there and shows how he
was seeking a way to depict rapid
movement in street scenes in equally
rapid, sketch-like movements of his
brush.*

FAR RIGHT
Portrait of Madame Gaudibert, 1868
*Oil on canvas, 85^1/$_2$ x 54^1/$_3$in
(217 x 138cm)
Musée d'Orsay, Paris*

BELOW
Pierre-Auguste Renoir
La Grenouillère, 1869
*Oil on canvas, 23^1/$_4$ x 31^1/$_2$in (59 x
80cm)
Pushkin Museum, Moscow*

OPPOSITE
Bathers at La Grenouillère, 1869
*Oil on canvas, 28^3/$_4$ x 36^1/$_4$in (73 x
92cm)
National Gallery, London*

*Their easels set side by side, Monet
and Renoir spent many happy hours
working on paintings of La
Grenouillère, a bathing and lunching
place at Bougival on the Seine.*

viewpoint, a grid-like layout and a certain formality of pose, when he planned *The Terrace at Sainte-Adresse* (page 59), a study of his father in a garden near Le Havre. In this painting, daring for its time, Monet links the sea and the sailing craft with the garden and the flowers, all precisely delineated and coloured and brightly sunlit, within the grid of a wooden fence and flagpoles. The figures, including his father and aunt, her head masked by her parasol, in the foreground, and a cousin and male friend in the background, are fashionably dressed and formally posed.

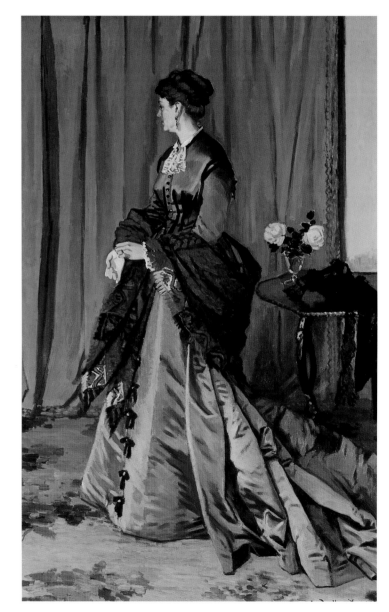

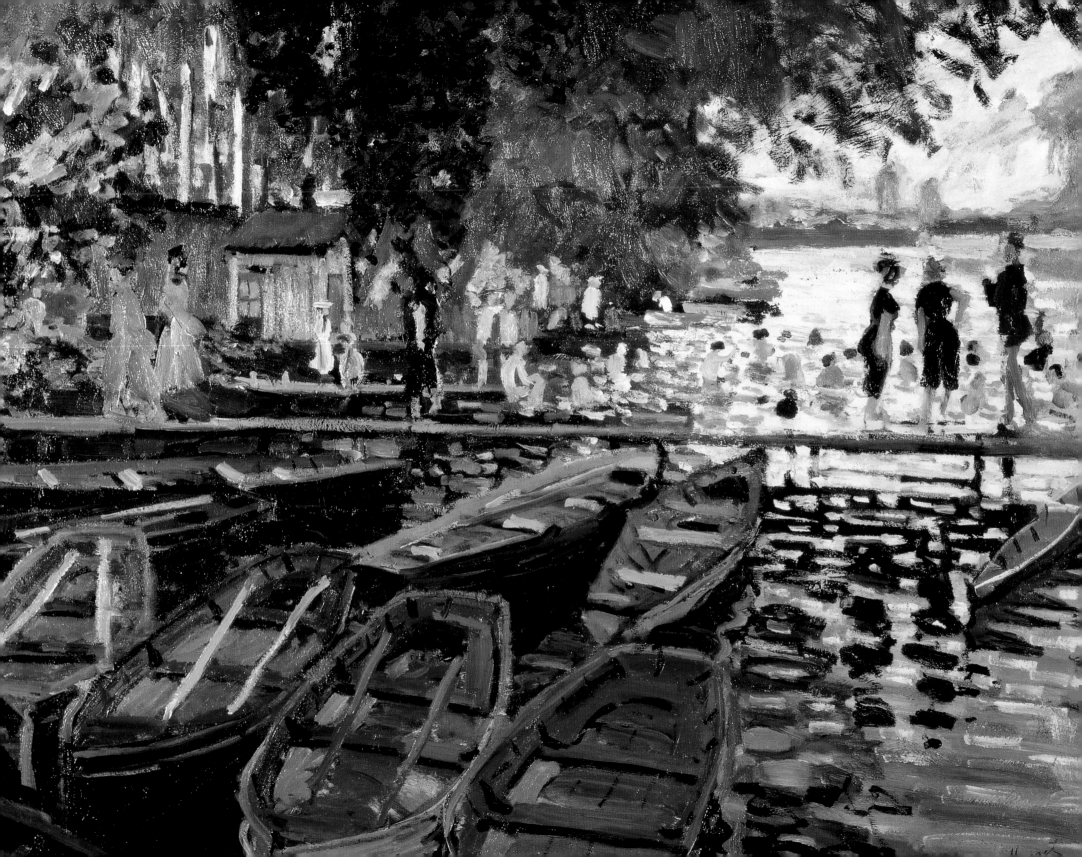

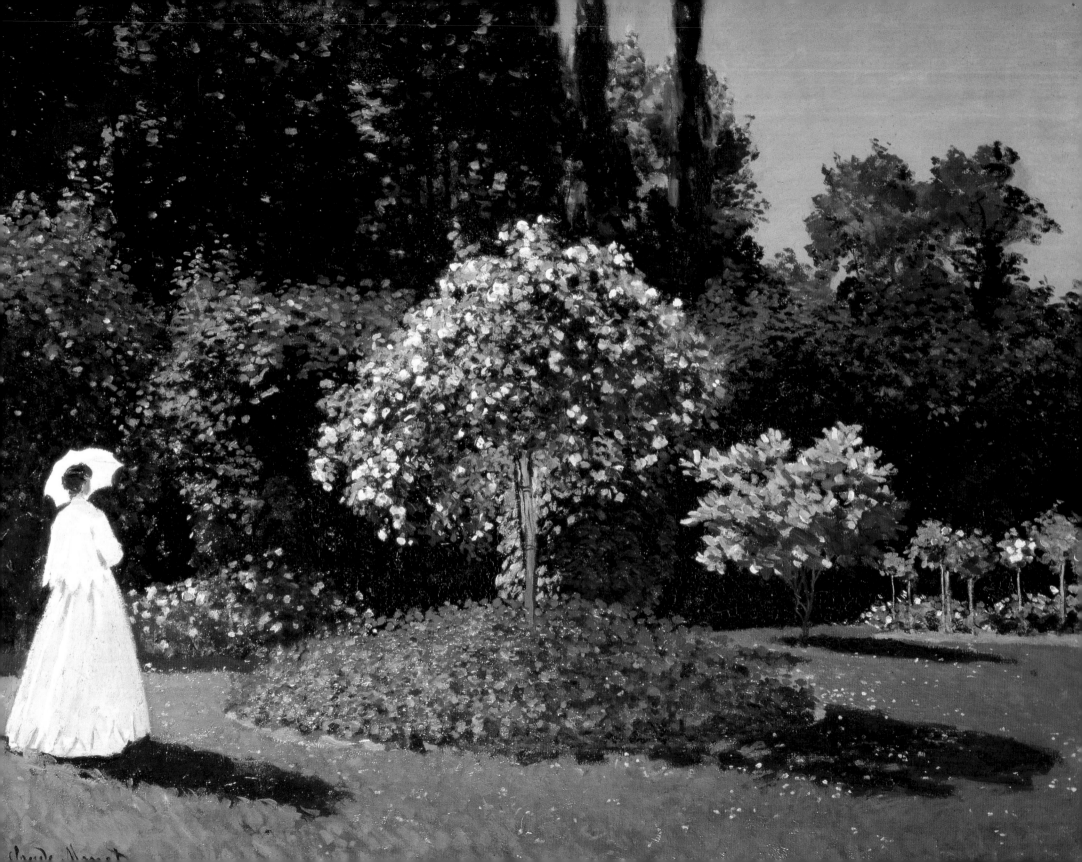

While *The Terrace at Sainte-Adresse* and the similarly luminous *Garden in Flower at Sainte-Adresse* (page 60) are still fine examples of Realist art, there are signs in them that Monet was beginning to move away from strict Realism and into a style that by the end of the decade would become looser, more abstract, and with more emphasis on the nature of shadow. In paintings like *Rough Sea at Etretat* (page 61), *On the Seine at Bennecourt* (page 64), and *The Red Cape* (page 74), Monet seems no longer to be concentrating on catching the strict reality of the scene before him, but in creating a more abstract impression of a moment in time.

As for the work he did in the studio, and which was intended for 'official' approval, Monet retained a more realistic style. In *The Luncheon* (page 62), for example, although the paint is broadly handled and the composition is asymmetrical, the detail is painted with precise realism. Not that this helped Monet, for the Salon jury rejected the picture in 1870.

Throughout this period, Claude Monet's private life was in turmoil. His family disapproved of his relationship with the humbly-born Camille, despite the fact that Monet's own father had had a clandestine relationship with a maid from which a child was born. When Camille became pregnant late in 1866, Monet did not dare to tell them; indeed, he pretended that he and Camille had

separated when he went to stay with them in the summer of 1867, leaving Camille alone in Paris and where their first son, Jean, was born on 8 August.

One of Monet's most faithful supporters at this difficult time was Frédéric Bazille. He shared his studio with Monet and even bought *Women in the Garden* for the very generous sum of 2,500 francs, handing over the payment in monthly 50-franc instalments. It was Bazille who looked after Camille, left behind in Paris, for which Monet and Camille were so grateful that they chose him as godfather for their son. Eventually, Monet had to

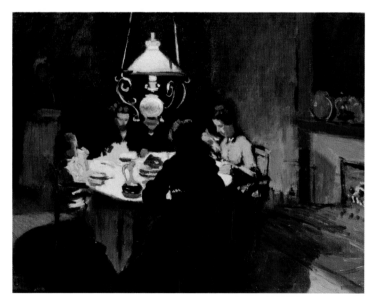

OPPOSITE

Jeanne-Marguerite Lecadre (Lady in a Garden), 1866
Oil on canvas, 31$^{1}/_{2}$ x 39in (80 x 99cm)
Hermitage, St. Petersburg

Monet's paintings, made at his family's home at Sainte-Adresse in the summer of 1866, all indicate his major preoccupations at the time: setting figures naturally in a landscape and painting flowers and foliage in all the exuberance of their summer glory. The young woman in the picture was a great-niece of his aunt, Marie-Jeanne Lecadre.

LEFT

The Dinner, 1868–69
Oil on canvas, 19$^{7}/_{8}$ x 25$^{3}/_{4}$in (50.5 x 65.5cm)
Buhrle Collection, Zurich

Monet's family at dinner: a quietly domestic scene, far removed from the middle-class opulence of The Luncheon *(page 62), a painting that Monet had hoped would be accepted by the Salon.*

RIGHT
The Seine at Bougival, 1869
Oil on canvas, 24⁷/8 x 35⁷/8in
(63 x 91cm)
The Currier Gallery of Art, Manchester,
New Hampshire

OPPOSITE
Red Mullet, c.1870
Oil on canvas, 12¹/4 x 18¹/8in
(31.1 x 46cm)
Fogg Art Museum, University of
Harvard Museums

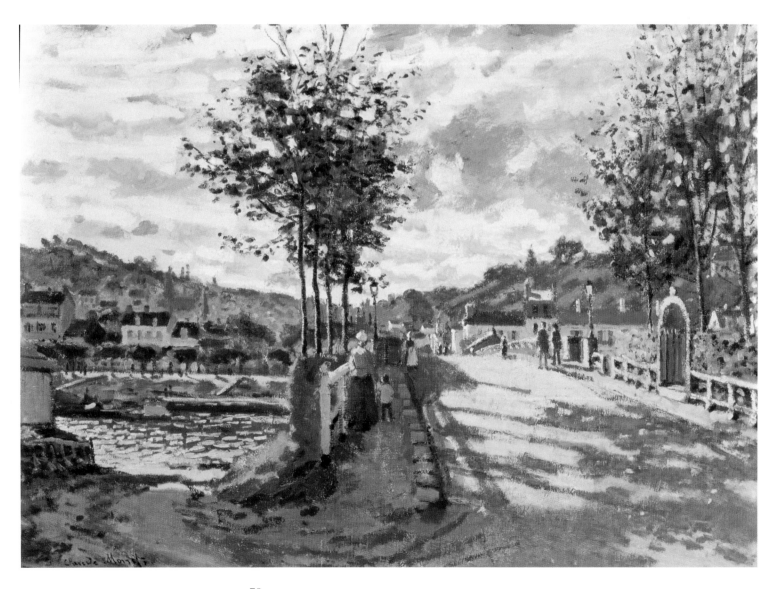

return to Paris to face official rejection and the hard struggle simply to survive as an artist. Time and again, as his letters show, Monet was forced to approach Bazille for money.

Matters eased a little in the autumn of 1868 when Monet met a Le Havre shipping magnate and amateur painter called Louis-Joachim Gaudibert. Gaudibert was impressed enough with Monet's work to buy back several paintings that Monet had pawned and to make him an allowance. In 1868, Monet and his family were therefore able to rent a cottage on the coast. Among the paintings that resulted from this stay was the splendidly vivid *Rough Sea at Etretat*, in which a group of people, lashed by strong winds, gaze across white-capped breaking waves towards the cliffs; cliffs would be a dominant motif in Monet's paintings in the 1880s.

Although Monet found life in Paris stimulating, especially the artistic debates in the cafés, he was able to work more easily away from the capital. He remarked in a letter to Bazille that the work he was producing in his cottage on the coast was like no one else's, 'because it will simply be the expression of my own personal experiences'.

Unfortunately, Gaudibert's allowance was not enough, and Monet and his family suddenly returned to Paris early in 1869, leaving a large number of paintings

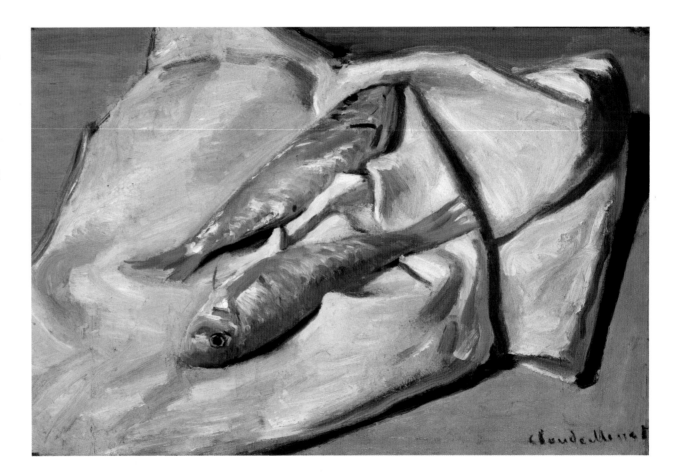

RIGHT
La Porte d'Amont, Etretat, c.1868–69
Oil on canvas, 31¹/8 x 38³/4in
(79 x 98.4cm)
Fogg Art Museum, Harvard University
Art Museums

PAGE 74
The Red Cape (Madame Monet),
c.1870
Oil on canvas, 39³/8 x 31¹/2 in
(100 x 80cm)
Cleveland Museum of Art

PAGE 75
The Poppy Field, 1870
Oil on canvas, 20⁷/8 x 28³/4in
(53 x 73cm)
Private collection

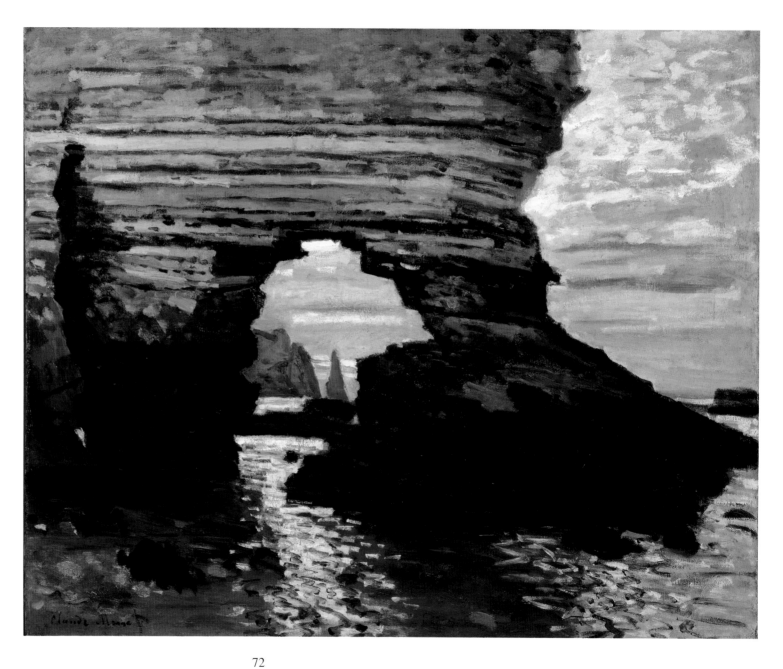

behind for creditors in Le Havre. However, a second allowance from Gaudibert allowed the Monets to return to Le Havre for a few months in 1869. During this time, Monet did a portrait, commissioned by Gaudibert, of his daughter-in-law, the striking *Portrait of Madame Gaudibert* (page 66). In contrast to the energy inherent in the figure of *Woman in a Green Dress*, there is a lack of animation in the dignified figure of Madame Gaudibert, the painting gaining its vitality from the way Monet has applied the paint in a patchwork of rich colours. There are also signs of much more elaborate preparation and attention to the composition of the scene than in either *Woman in a Green Dress* or the much later and more relaxed *Portrait of Madame Hoschedé-Monet* (Monet's step-daughter and daughter-in-law, Blanche).

But life in Paris at the end of the 1860s was not all gloom and a struggle to make ends meet. Even poor artists could afford the train fare out into the countryside, or to one of the attractive riverside villages such as Argenteuil, Bougival or Asnières on the Seine, just a short distance from Paris. This was when Monet discovered the river which, over the next decade, would be as important to him as his time on the French coast.

Near Bougival, on the Ile de Croissy, was a bathing and boating place with a café called La Grenouillère ('the Frog Pond') that was popular with the Paris working classes: the fact that *grenouille* was also a slang term for 'prostitute' indicates that one would not expect to find the Paris bourgeoisie there. Monet and Renoir took themselves and their painting equipment to La Grenouillère late in the summer of 1869. Their intention was to paint Salon pictures – sunny Arcadian idylls featuring gods and goddesses – or at least people got up as gods and goddesses, which had long been a feature of traditional French art. Renoir never got beyond small-scale paintings in this vein, and so never submitted anything to the Salon; the painting that Monet is thought to have made and submitted to the Salon, but which was rejected, has been lost.

Judging by studies for the Salon pictures made by the two friends in this charming spot, they set their easels up virtually side-by-side. Both artists produced wonderfully atmospheric pictures: Renoir's has a sun-dappled, airy haziness, and Monet's, full of broad-brushed energy and vivacity, has the brightness of the sun reflected in the ripples of water.

Renoir's *La Grenouillère* (page 66) emphasizes the human aspect of the scene and includes modishly dressed people whose clothes are delicately hued and sunlit; the figures in Monet's La Grenouillère studies (page 67) are energetically sketched in with two or three brushstrokes and no attempt at close detail. Monet was more

concerned than Renoir with the problem of transcribing the visual scene before him onto canvas. Monet called his studies 'bad sketches'; in fact, like Renoir's, they show natural effects – the water and the sunlight on the trees – with considerable freedom and great skill.

In his book *Landscape into Art*, the art critic and essayist Kenneth Clark firmly identifies the café at La Grenouillère as the birthplace of Impressionism. This, wrote Clark, was where Monet, with his unquestioning belief in the power of visual sensations to fuel his art and his close friend Renoir, who believed that by following the traditions of the old masters with sufficient skill and application he could achieve much, came together for the first time to work on the same motif: the sparkle and reflection of light on water. From the union of Monet's 'complete confidence in nature as perceived through the eye and his remarkable grasp of tone' and Renoir's 'brilliant handling and rainbow palette', the most revolutionary art movement of the 19th century was born.

In paintings done later that summer and in the winter of 1869–70, such as *The Seine at Bougival* (page 70) and *Road at Louveciennes in the Snow*, Monet used his new looser, broader style of brushwork with increasing assurance and with varying touches over the canvas to indicate the variety to be found in nature. The same approach, which was to be a characteristic of early

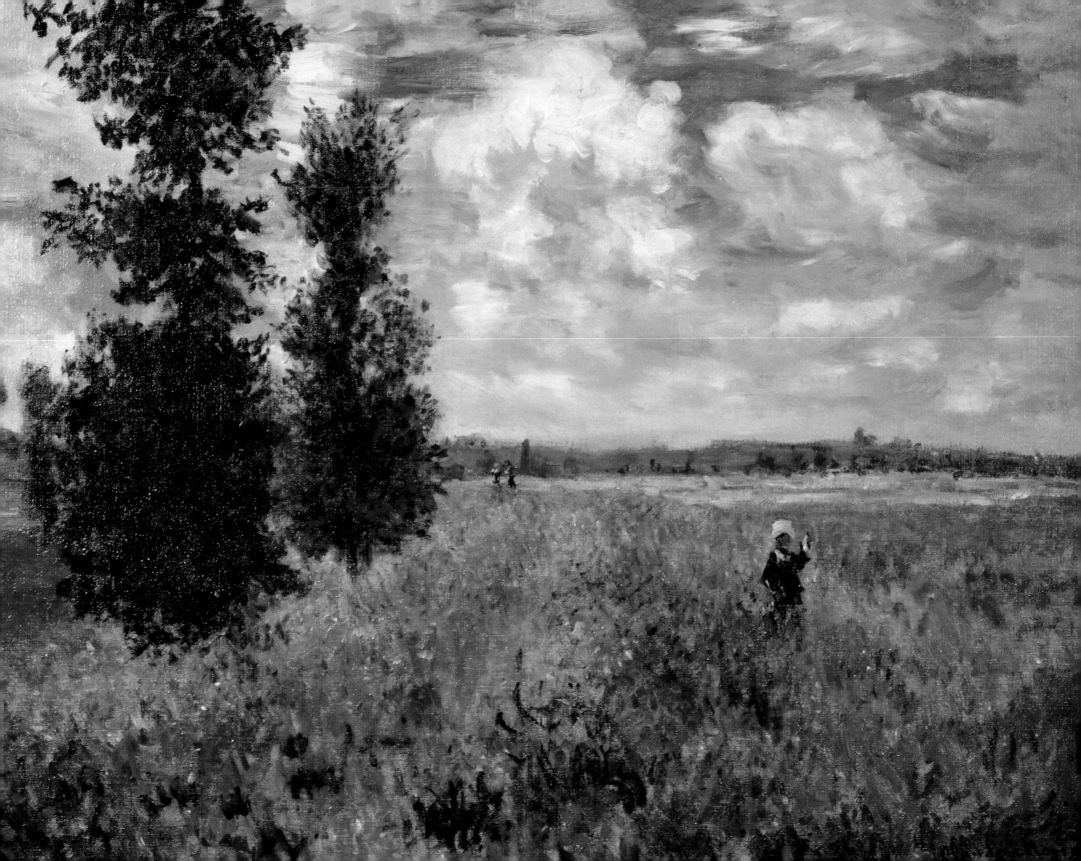

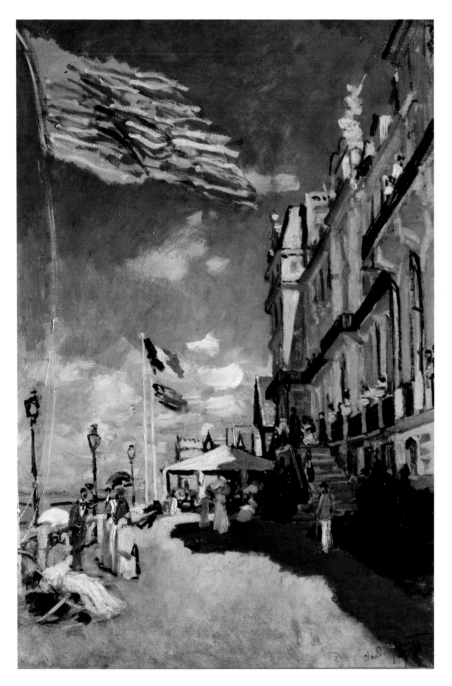

Impressionist painting, can be seen in the work of other artists from around that time, notably Sisley and Pissarro.

In June 1870 Claude Monet married Camille Doncieux and the whole family went to Trouville for the honeymoon. Their time there, much of it spent with Boudin and his family and during which time Monet produced some now-famous paintings, including *On the Beach at Trouville* (opposite), came to an end shortly after the Franco-Prussian War broke out in July. Monet, who had already done military service, and was a Republican rather than a Monarchist, was so afraid that he might be conscripted that in September he left France (and Camille and Jean), and went to England; Sisley and Pissarro also left France about this time, while many of Monet's artist friends, including Bazille, Degas, Manet and Renoir, chose to stay in France and enlist. Monet's family and friends in France were left to care for Camille and Jean until arrangements could be made for them to be reunited. Monet had been in London for only a short time when the terrible news of Bazille's death in the war reached him.

Monet spent much of his time in London visiting museums and art galleries with Camille Pissarro, exiled with his family in London. Monet probably did not see much of the work of England's two great artists, J.M.W. Turner and John Constable, because there were not many

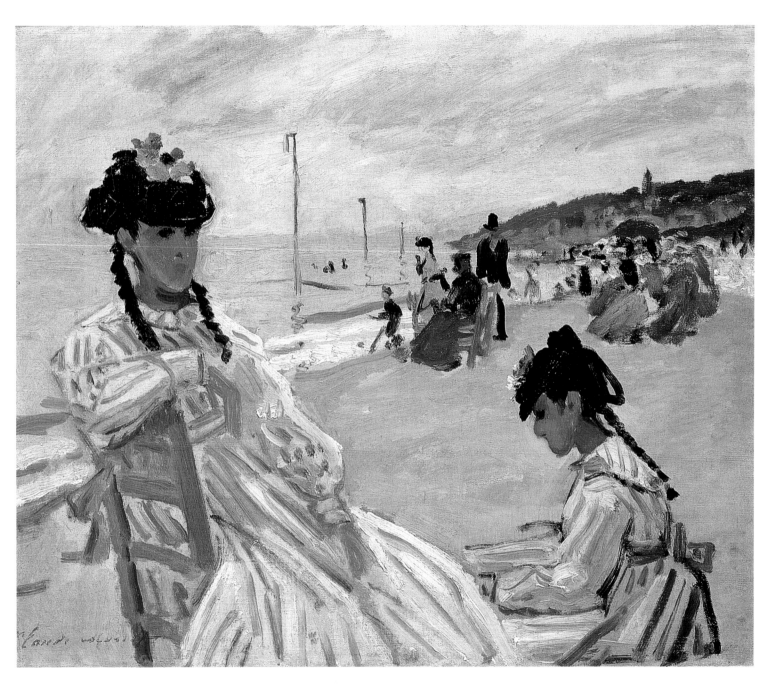

OPPOSITE
The Hotel des Roches Noires at Trouville, 1870
Oil on canvas, 31⁷/8 x 23in (81 x 58.5cm)
Musée d'Orsay, Paris

LEFT
On the Beach at Trouville, 1870–71
*Oil on canvas, 15 x 18¹/8in
(38 x 46cm)
Musée Marmottan, Paris*

Monet's paintings from the summer spent at Trouville in 1870 are carefree, breezy and filled with the brilliant light of high summer. In them, Monet moved away from his earlier seascapes, which concentrated on sailing boats on the water or fishing boats drawn up on the shore, to depict the social life of the seaside, as Eugène Boudin had been doing for many years. Monet's style is more informal than Boudin's, his figures rapidly sketched in and with a minimum of formal detail.

RIGHT
The Jetty at Le Havre, Bad Weather, 1870
Oil on canvas, 19⅝ x 23⅝in
(50 x 60cm)
Christie's Images, London

OPPOSITE
Argenteuil, Late Afternoon, 1872
Oil on canvas, 23⅝ x 31⅞in
(60 x 81cm)
Private collection
(See also page 97)

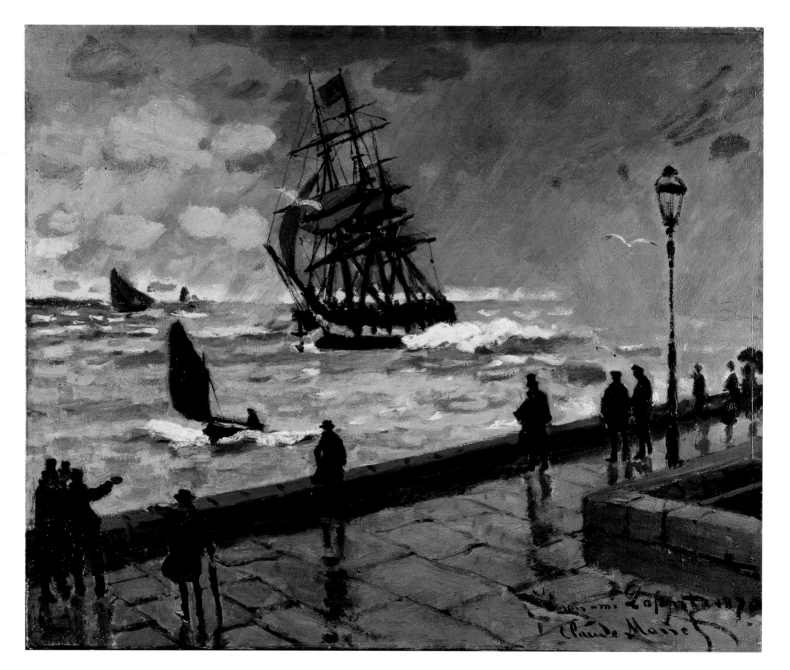

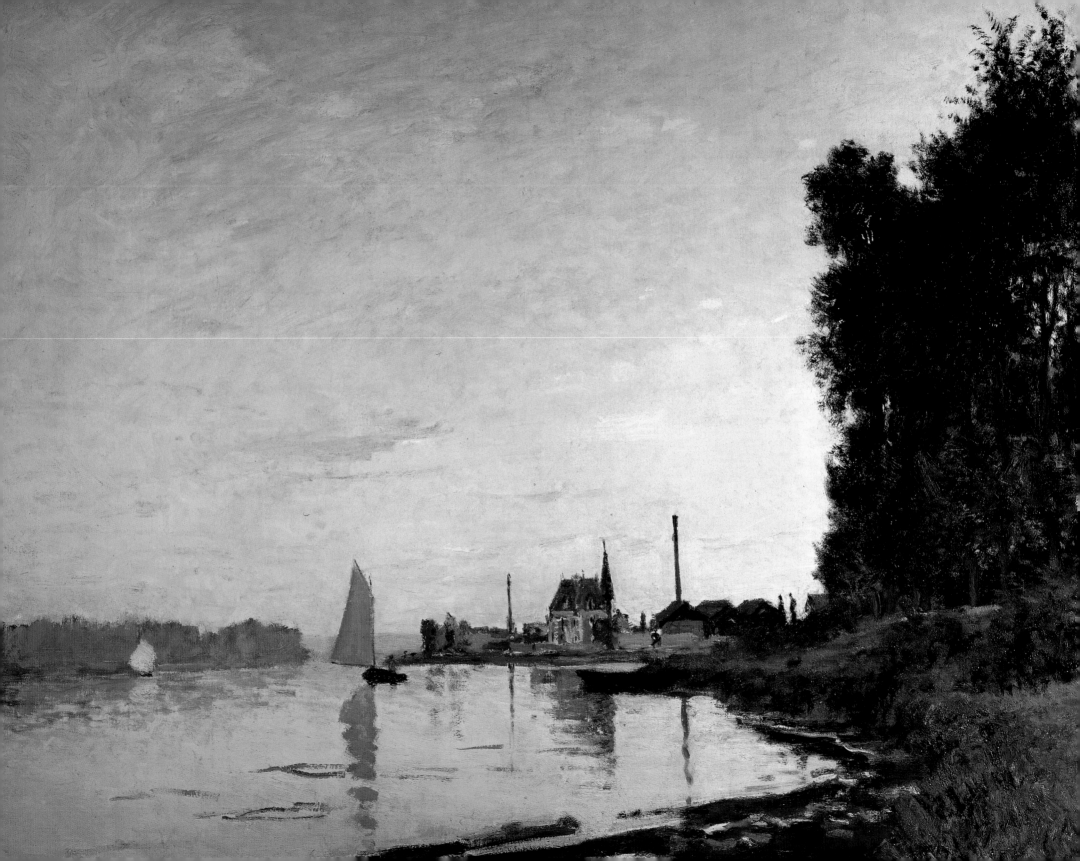

Hyde Park, London, 1871

Oil on canvas

Museum of Art, Rhode Island School of Design

examples of their work in London at that time. He saw enough of Turner, however, to be able to form his own opinion of his work; it is probably fair to say that although Monet admired many aspects of Turner's paintings, he never saw him as a major influence on his own work. Although he is not thought to have met Whistler at this time, he did see some of the latter's work and admired it, especially his atmospheric paintings of the Thames.

A much more significant moment for Monet came when the French artist, Charles Daubigny, whom Monet first met at Trouville in the mid-1860s and who was also seeing out the war in London, introduced him to a French art dealer, Paul Durand-Ruel. Within a year or so Durand-Ruel, who was ten years older than Monet, would become one of the most important and successful promoters of Impressionism. Durand-Ruel included works by both Monet and Pissarro in an exhibition he was holding in his New Bond Street gallery late in 1870, though both artists had been rejected by the Royal Academy earlier in the year.

Both in England and in Holland, which he visited on his way home to France in 1871, once the war and the terrible privations of the Commune that followed it were at an end, Monet concentrated on painting outdoor scenes, including water. There are delightfully fresh and informal views of London's parks and his painting, *The Thames and the Houses of Parliament* (opposite) is an example of how he deals with a new phenomenon: the effect of the unique London fog that would become important in his later work, and which would bring him back to the city several times at the end of the century.

It is possible that Monet's friend, Alfred Sisley, was

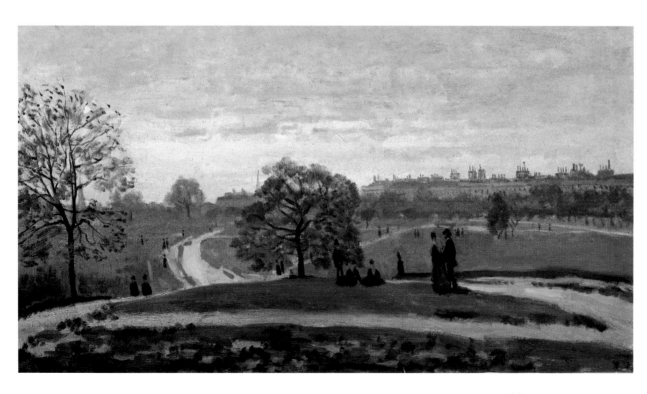

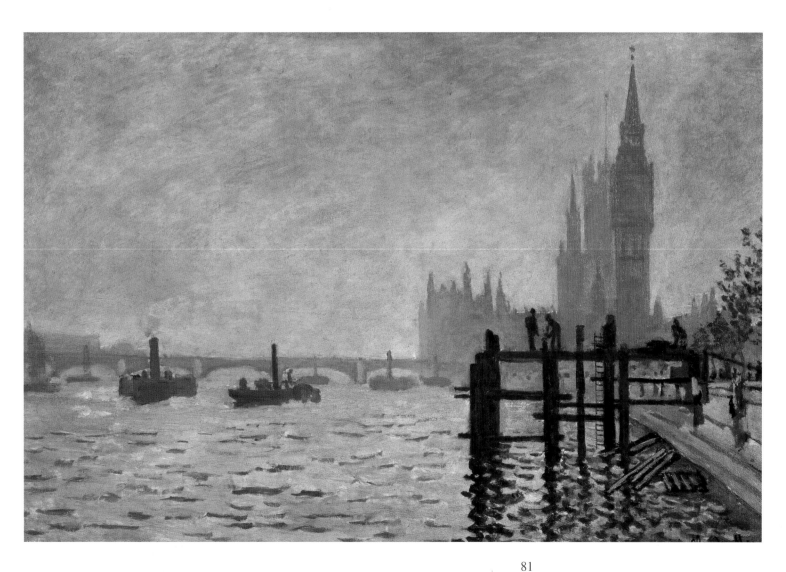

The Thames and the Houses of Parliament, 1870–71
Oil on canvas, 18¹/₂ x 28³/₄in (47 x 73cm)
National Gallery, London

During his time in London, where Monet went at the outbreak of the Franco-Prussian War, he was able to continue painting, supported by the help of other Frenchmen in London. Some of his paintings, including at least one from Trouville and the painting of Hyde Park (opposite), were exhibited in London. Others, such as the view of the Houses of Parliament reproduced here, provided the inspiration for many superb river scenes that Monet would produce in the future.

Train in the Country, c.1870
Oil on canvas, 19⅝ x 25½in
(50 x 65cm)
Musée d'Orsay, Paris

This painting of a double-decker train on the Paris–Saint-Germain line, moving through an English-style park, is Monet's earliest treatment of a subject that would become dear to him: a steam train moving across a railway bridge.

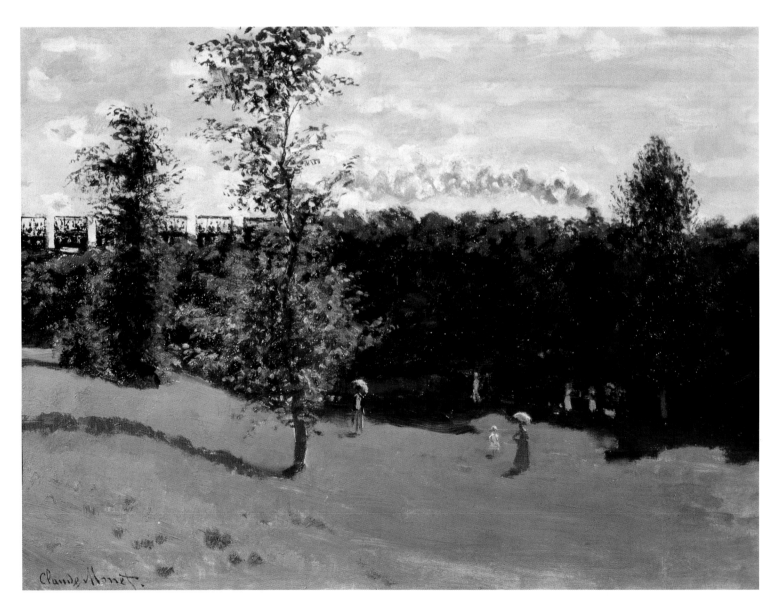

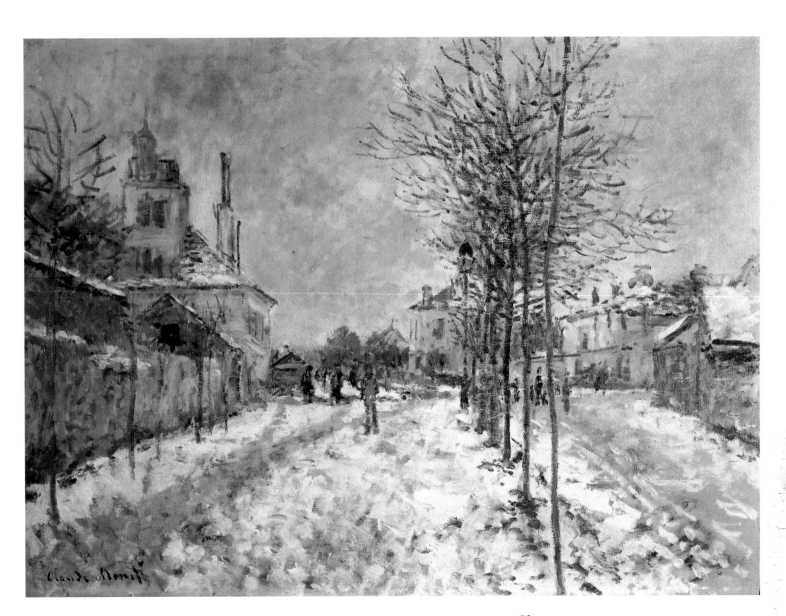

Snow Effect, c.1874
Oil on canvas
Kunstalle, Basel

Influenced, perhaps, by Courbet's paintings of landscape under snow, Monet began painting the countryside around Le Havre in the mid-1860s, and several fine snowy landscapes by Monet date from the severe winter of 1866–67. The effects of a covering of snow on the landscape and in towns (Snow Effect portrays Monet's street in Argenteuil) continued to interest the Impressionists in the 1870s. Monet, Alfred Sisley and Pissarro all produced some excellent snow scenes – to the delight of present-day Christmas card manufacturers.

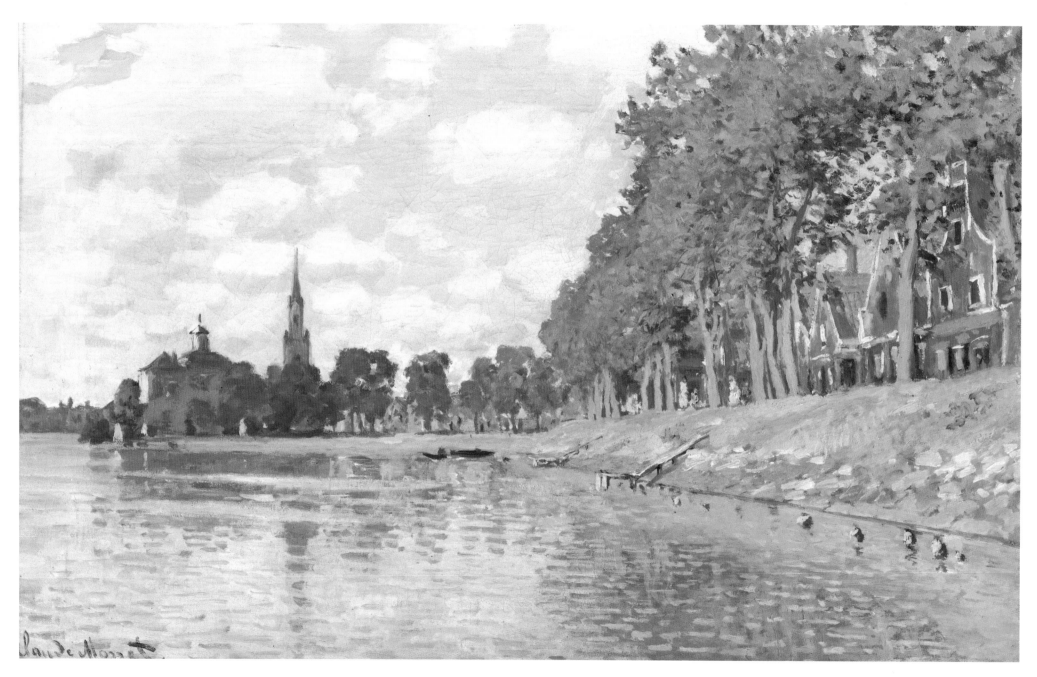

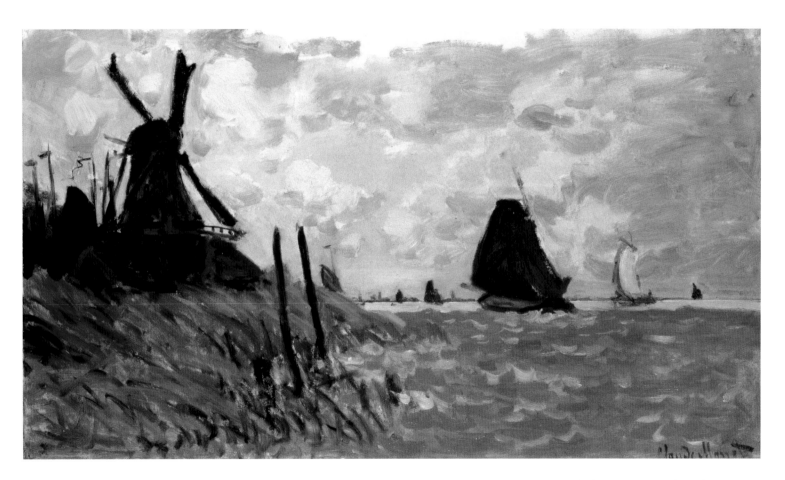

Once the troubles in France following the Franco-Prussian War were over, Monet returned to Paris by way of Holland, staying for some weeks in the picturesque town of Zaandam, close enough to Amsterdam to allow several visits to the city's great museums. Monet also painted energetically in Zaandam, Amsterdam and the surrounding countryside, paintings of serene stretches of water reflecting the typically Dutch architecture, and the windmills that dominated the landscape.

working alongside Monet when he painted *The Thames and the Houses of Parliament*. Sisley is thought to have been in London with other members of his family in 1871 and his *View of the Thames at Charing Cross Bridge* was originally dated 1871 in an early catalogue of his work. Monet is thought to have introduced Sisley to Durand-Ruel in London, and the latter certainly included some paintings by Sisley in his London exhibition of 1871.

Both artists returned to Paris in 1871, Monet choosing to go via The Netherlands. He spent five months there, painting many atmospheric outdoor scenes, including

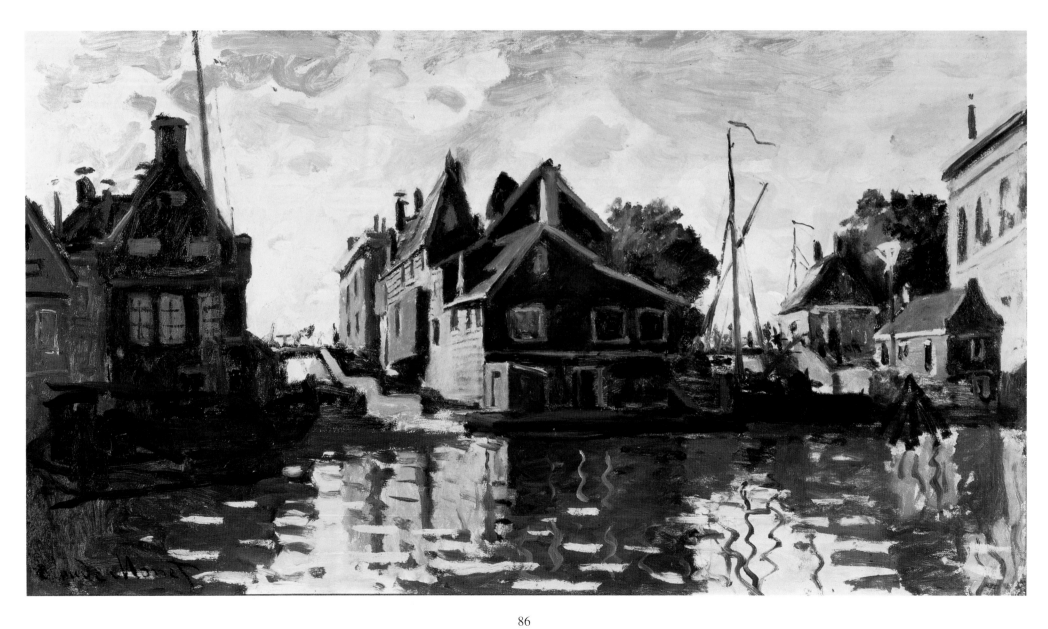

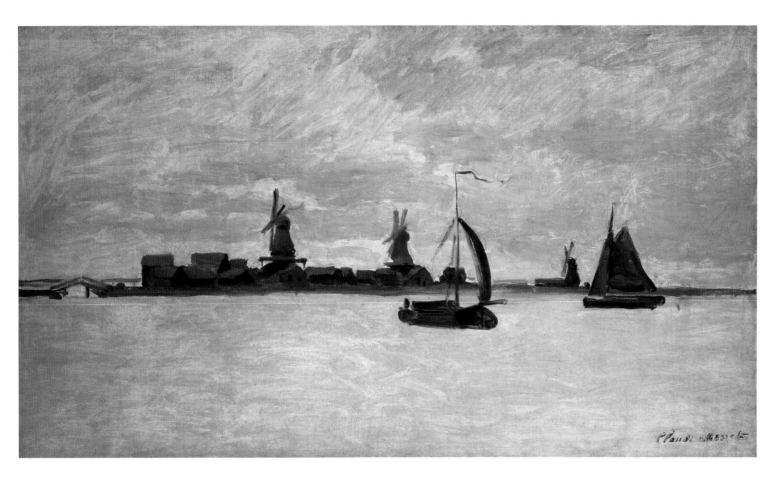

OPPOSITE
Zaandam, 1871
Oil on canvas, 15³/₄ x 28¹/₃in
(40 x 72cm)
Private collection

LEFT
The Outer Harbour at Zandaam, 1871
Oil on canvas, 15¹/₃ x 28in (39 x 71cm)
Noortman, London

many versions of the picturesque port of Zaandam, north-west of Amsterdam. Here, the old waterfront houses, the port itself, and the windmill-dotted countryside that surrounded the port, gave Monet plenty of material for some bold studies in tonal contrasts.

More than a year after his precipitate departure, Monet returned home to be reunited with family and friends and to resume his life as an artist of France.

Chapter Three
The 'High Impressionist' Years
1871–1882

Claude Monet's father died in 1871, leaving his son a small legacy. Marriage had also brought Camille a dowry, so that suddenly the Monets were modestly well off. They decided to take a house with its own garden at Argenteuil, on the Seine downstream from Paris, abandoning the capital for their new home towards the end of 1871. Thus began a happier time for the family, and a great deal of hard but enjoyable work for Monet.

Although nowadays it is a rundown, bleakly commercial part of Paris, Argenteuil in the 1870s was a delightful riverside village with plenty of activity on and off the river and just a few signs of the early industrialization that would make it interesting to young artists attracted to modernity. In the coming years a stream of paintings poured from the hands of Monet and his friends: of the life of the river, its regattas and boating parties; its ever-changing vistas of sunlit waters and tree-lined banks in summer and winter; its busy riverside life, from the coal delivery boats to the railway and road bridges that crossed it.

Monet liked entertaining and having his friends to stay; indeed, his pink house with green shutters on the boulevard Saint-Denis seems to have been open to all. Renoir, Sisley, Pissarro, Manet, Daubigny and others were always there or thereabouts. Monet and Sisley both painted views of the boulevard Héloïse and the square at Argenteuil, while Monet and Renoir both immortalized the local duck pond on canvas in paintings so similar that 40 years later neither could be sure who had painted which. Manet and Renoir both painted the Monet family in the garden of the boulevard Saint-Denis house. Manet, who was converted at Argenteuil to *plein-air* painting, would mischievously look at Renoir's painting and whisper to Monet, 'That fellow doesn't have much talent. You're his friend, why don't you tell him to give up painting?'

Another frequent visitor to the house was a near-neighbour, a well-off young man called Gustave Caillebotte, also a painter of considerable talent, whom Monet had not known in Paris but who became part of the circle at Argenteuil. In these early years of their friendship, Caillebotte's greatest contribution was to stimulate Monet's interest in gardens, for Caillebotte, as well as being so enthusiastic a sailor that he designed his own yachts, was a great gardener. At Argenteuil and in every house he rented up to his final move to Giverny in 1883, Monet always ensured that the garden was a riot of colour, and included blue Chinese porcelain pots that came with him from house to house, and provided more subjects for his painting.

In the years ahead, Caillebotte was to become one of the Impressionists' most important patrons. His large

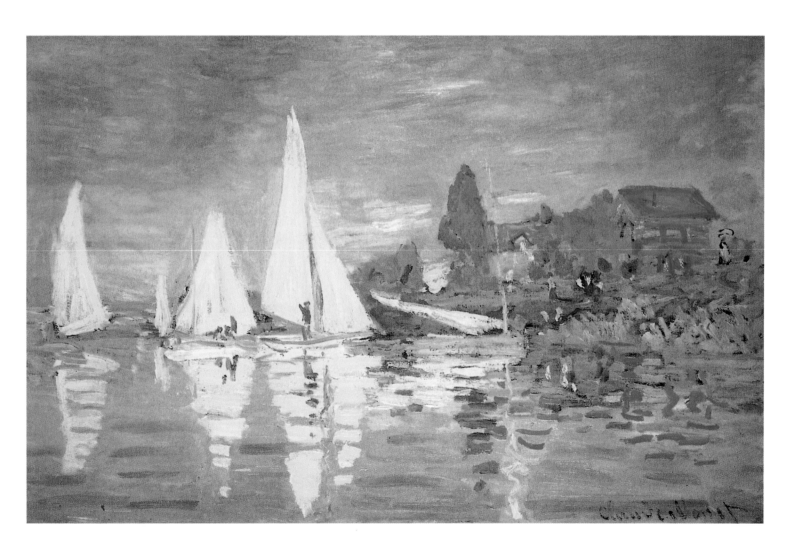

Regatta at Argenteuil, 1872
Oil on canvas, 18⁷/₈ x 29¹/₂in
(48 x 75cm)
Musée d'Orsay, Paris

Elements of this view of the Seine, looking from Argenteuil over to the right bank of the river at le Petit-Gennevilliers, featured in many of the paintings Monet produced during his years in Argenteuil. The road bridge, just sketched in on the horizon, the houses with their skylights and dormer windows and, of course, the sailing boats on the sparkling water, became familiar motifs in Monet's Argenteuil paintings. Regatta at Argenteuil belonged to Gustave Caillebotte and it was among the paintings he left to the French state on his death.

collection, given to the state when he died in 1894, became the foundation of France's Impressionist collection, the major part of which is in the Musée d'Orsay in Paris. It is still a matter of some embarrassment to the French art establishment that the Caillebotte bequest, which included 16 paintings by Monet, including *Regatta at Argenteuil* (page 89), *The Luncheon* (page 98), and several other Argenteuil pictures, were hidden away unexhibited for some years. Even more embarrassing is the thought that the state actually refused some paintings in the Caillebotte bequest, including three by Paul Cézanne.

Monet's interest in bold, vibrant flowers found full expression in the garden of the house on the boulevard Saint-Denis. In Renoir's fine study of Monet in front of his easel in the garden, *Monet Painting in his Garden at Argenteuil* (1873), the neighbouring houses in the background give a good indication of just how small and suburban the garden actually was. Even so, at this time Monet had enough money coming in to hire a gardener to take over some of the work involved. Manet did a lively study of Monet, trowel in hand, working in his garden while Camille and Jean sit quietly near him. In many of Monet's own paintings of this idyllic period, there is a strong feeling that the Monet family has become surprisingly bourgeois and well-off.

Take *The Luncheon*, for instance. The table that has been set up under a shady tree in the garden has a gleaming white cloth on which sits a silver coffee pot, a cup and saucer, a compote of fruit and wine glasses. A neatly dressed little boy plays with a toy on the path and two ladies clad in cool summer frocks walk forward, perhaps to pick up the bag and parasol left lying on the bench. There is another, younger, child at Camille Monet's feet as she sews in the garden in the tenderly intimate *Madame Monet with a Child in the Garden* (1875). The child in this sunlit scene probably belonged to a friend, for the Monets' second son, Michel, was not born until 1878.

There are two exquisite paintings of Madame Monet reading (pages 100 and 103). *Meditation* (c.1871) is an indoor picture and was probably painted in winter, for Camille wears a dark, heavy gown against which the book held on her lap glows red. A pale, wintry light, seeping through the muslin curtains, falls on the patterned rug, the chintz-covered daybed, and her still, quiet face. *A Woman Reading* (1872), is very different. Now, Camille is out in the garden in summer. She sits on the flower-strewn grass, her filmy white gown spread out around her; a white, pink-ribboned bonnet shades her face from the sunlight, which filters through the leaves of the trees onto the grass. The book open on her lap is also a creamy white. The light is

OPPOSITE
The Fourteenth of July (Bastille Day), 1872
Oil on canvas, 23⅝ x 31⅞in
(60 x 81cm)
Christie's Images, London

RIGHT

The Stream of Robec, Rouen, 1872

Oil on canvas, 19⁵/8 x 25¹/2in

(50 x 65cm)

Musée d' Orsay, Paris

OPPOSITE

Pleasure Boats, Argenteuil, c.1872–73

Oil on canvas, 19¹/4 x 25¹/2in

(49 x 65cm)

Musée d' Orsay, Paris

The Seine at Argenteuil, 1873
Oil on canvas, 19⁷/₈ x 24in
(50.5 x 61cm)
Musée d'Orsay, Paris

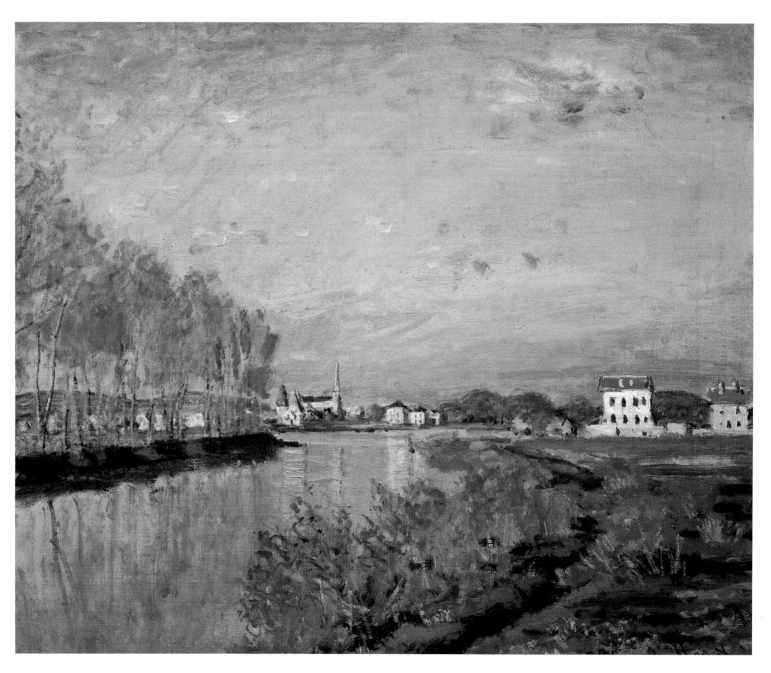

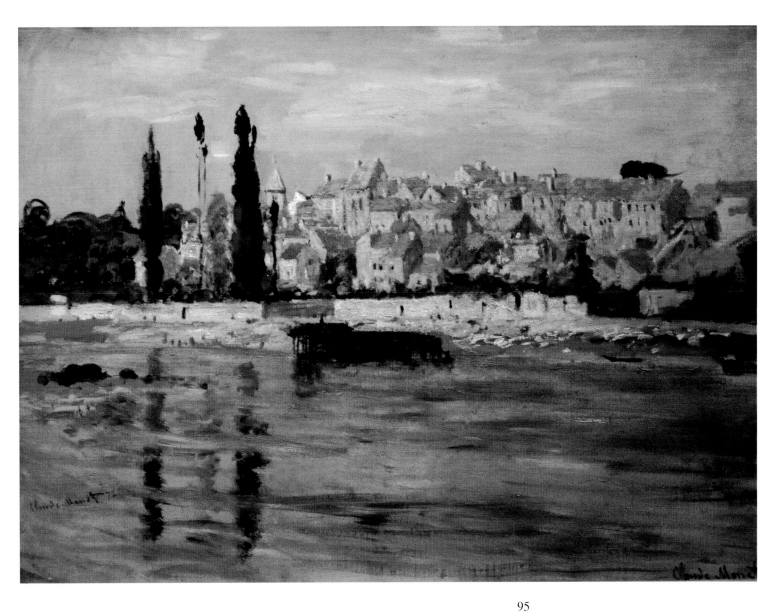

Carrières-Saint-Denis, 1872
Oil on canvas, 24 x 31⁷/₈in (61 x 81cm)
Musée d'Orsay, Paris

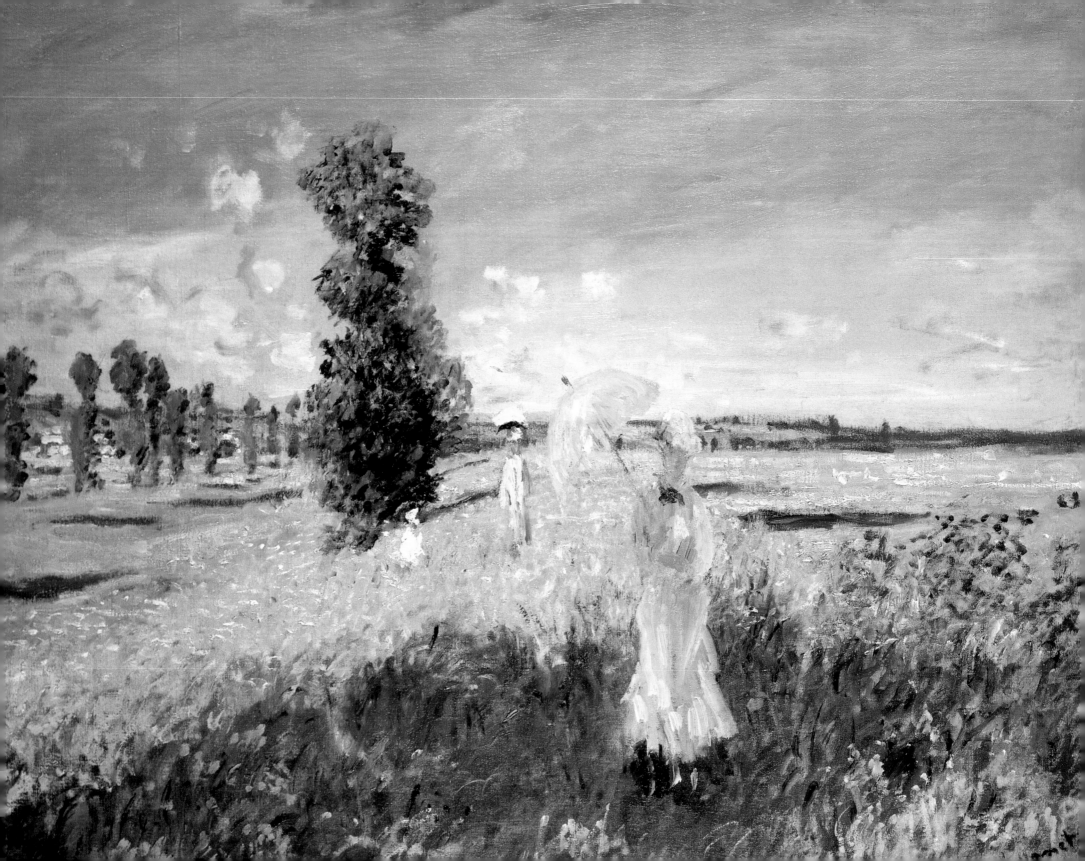

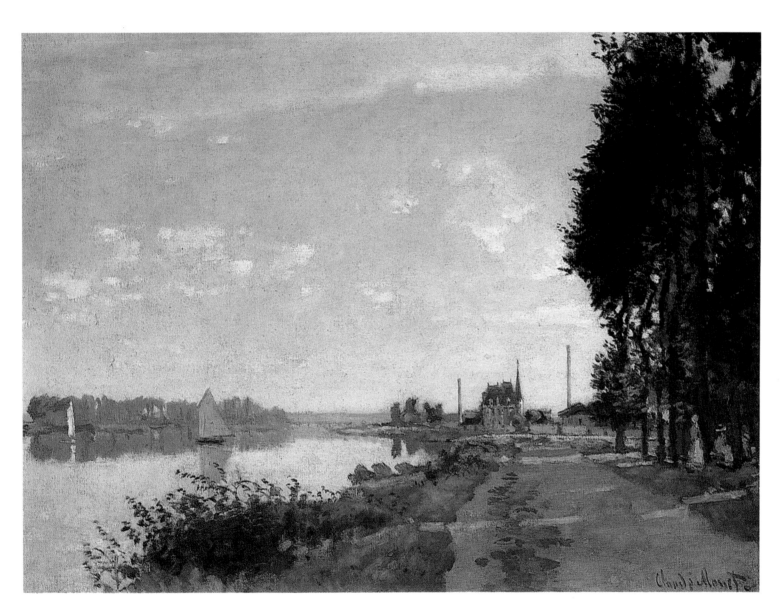

OPPOSITE
The Walk (Argenteuil), c.1872
Oil on canvas, 23⅝ x 31½in
(60 x 80cm)
Private collection

The River Seine, the towns and villages on its banks and the lovely countryside surrounding it, provided Monet with plenty of motifs for his paintings during the seven years he and his family lived at Argenteuil. At all times of the day and in every season of the year, Monet could be found somewhere in the vicinity, easel set up in front of him, and another beautiful painting coming into being.

LEFT
Argenteuil, 1872
Oil on canvas, 23⅝ x 31⅞in
19⅞ x 25⅝in (50.4 x 65.2cm)
National Gallery of Art, Washington, D.C.

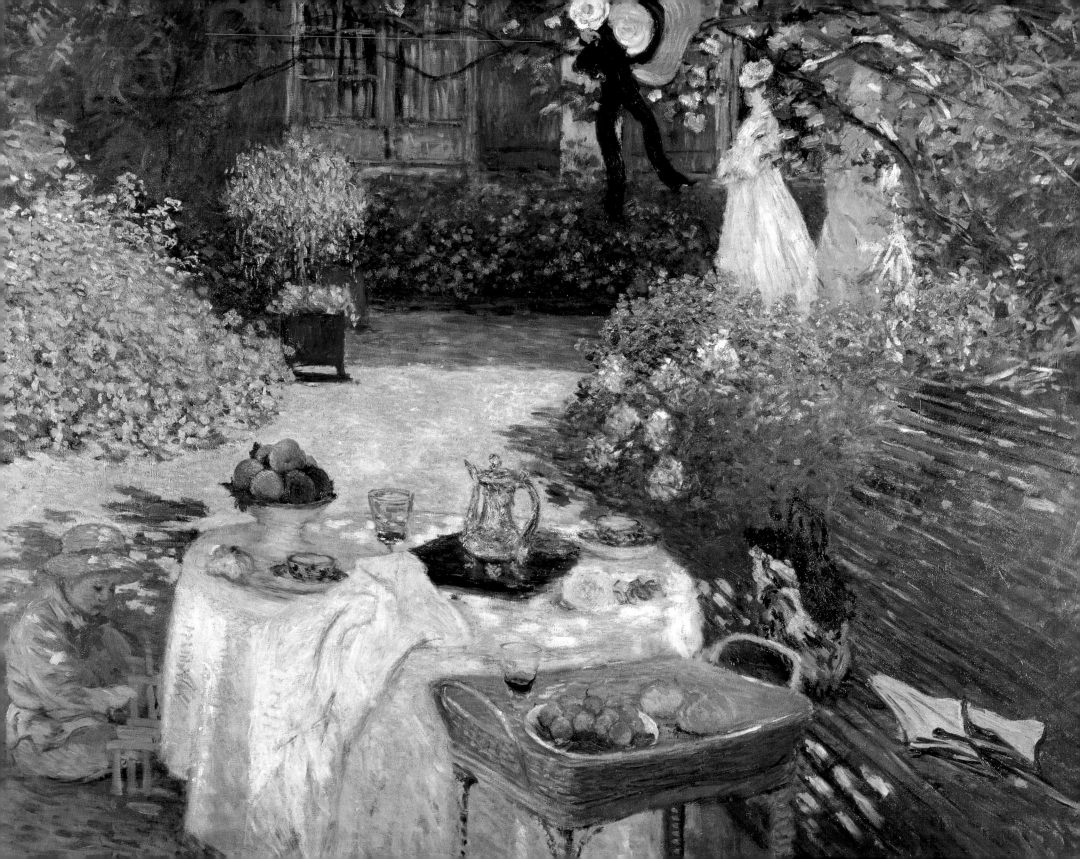

OPPOSITE
The Luncheon (Monet's Garden at Argenteuil), 1873
*Oil on canvas, 63 x 79¹/8in
(160 x 201cm)
Musée d'Orsay, Paris*

Monet paints a middle-class luncheon table again, five years after The Luncheon *of 1868 (page 62). This time the table, with its cool white napery and expensive silverware and table porcelain, is his own and it is set up in his garden rather than in a formal dining room. Monet exhibited this painting at the second Impressionists' Exhibition in 1876.*

LEFT
Camille and Jean Monet in the Garden at Argenteuil, 1873
*Oil on canvas, 51¹/2 x 38¹/4in
(131 x 97cm)
Private collection*

To judge from his many paintings, Monet's family spent a lot of time in the gardens of their houses in Argenteuil. There are several pictures of Camille in the garden, playing with Jean, sewing in front of a colourful border of flowers, or reading in the shade of a tree.

soft, gentle and warm, and the colours are applied in flecks with short, broken brushstrokes. The contrast between this painting and the bright, rather hard-edged, primary-coloured realism of such paintings of the 1860s as *Women in the Garden* (page 54), *Garden in Flower at Sainte-Adresse* (page 60) or *Jeanne-Marguerite Lecadre in a Garden* (page 68) is marked.

Though an extra expense, Monet decided to buy himself a boat, hardly surprising given his proximity to the river, and that he was no stranger to water. From early childhood he had lived by the sea and had drawn boats of all shapes and sizes since he was a schoolboy. But perhaps he was thinking of his friend, Charles Daubigny, who had painted views of the Seine from a small boat, called a *botin*, some 20 years before when he bought a broad-keeled rowing boat, added a small cabin with an awning to keep off the sun, and took to the water.

In his studio boat, floating low on the waters of the Seine, Monet felt that he could paint pictures that had water at their centre, rather than water viewed from land. Artists call this approach to their work as painting *sur le motif* – literally, sitting on or in the middle of what is being painted – and Monet used the technique to great effect, bringing a memorable immediacy to his paintings, whether a regatta on the river, a bridge spanning the river or, away from water, a field of poppies, as in *Wild Poppies near*

Argenteuil (page 109) or a room in his house, as in *A Corner of the Apartment* (page 108).

Monet made several studies of his studio boat floating on the river, but the best picture we have of it, of Monet at work on board, is Manet's *Monet Painting on His Studio Boat* (page 114). Manet depicts Monet as a man short of stature and rather stout (he liked his food, often spending more than he could afford on it; in his 30s, he already possessed something of a paunch), his feet up under his easel and his palette and brushes in hand. He wears a white shirt with a black tie around the collar, and a red-trimmed, bell-shaped hat keeps the sun off his head. Camille sits quietly in the doorway of the cabin, keeping her husband company while he is intent upon his work.

Monet spent many days from dawn to dusk in his studio boat, 'keeping a sharp eye out for the changing effects of light', as he later recalled. From it, Monet painted some of his best-known works, including *Regatta at Argenteuil* (page 89) and *The Red Boats, Argenteuil* (page 111).

For *The Seine at Argenteuil, Autumn* (page 110), he moored his boat where there was a branch in the Seine and painted the view downstream towards the mainstream, which appears as a streak of bright blue across the painting. Dominating the left half of the canvas are trees, their autumn foliage composed of a

OPPOSITE
Meditation (Madame Monet on the Sofa), c.1871
Oil on canvas, 18⁷/₈ x 29¹/₂in
(48 x 75cm)
Musée d'Orsay, Paris

OPPOSITE

A Woman Reading, 1872

Oil on canvas, 19⅝ x 25½in

(50 x 65cm)

Walters Art Gallery, Baltimore

Winter in England and early summer in France: the differences of season and country are clearly marked in these two paintings (pages 100 and 103), each of which depicts a woman, probably Camille in both pictures, with a book. There are other differences, too. Meditation is an interior, an unusual subject for Monet, and is painted with a greater regard for detail and finish than was usual with Monet. A Woman Reading, in contrast, is much more of a quickly completed sketch in the 'unfinished' style that so upset early critics of the work of the Impressionists.

dense mass of orange, yellow and pink brushstrokes.

There was also plenty to see and paint from the Seine's banks, most notably, in Monet's eyes, the two bridges that linked Argenteuil to Paris. One of his first paintings of these, *Argenteuil, the Bridge Under Reconstruction* (1872), concentrated on the road bridge, which was in the course of being rebuilt after its destruction in the Franco-Prussian War. In later paintings, the bridges provide strong architectural features and, especially the railway bridge, which is usually depicted with a train steaming across it, intimations of busy modernity in pictures where the other main elements are lighter and timeless, such as the masts and rigging of sailing boats, the ripples on the water of the river, and the clouds in the sky.

Two paintings, *The Railway Bridge at Argenteuil* (page 116) and *The Road Bridge at Argenteuil* (page 117) both show the juxtaposition, and therefore the contrast, between the timeless flow of the river and the busy whirl of modern life. In *The Seine Bridge at Argenteuil* (page 118), Monet gets both bridges into the picture; beyond the main arch of the road bridge can be seen one of the fertile hills of the Seine valley, and through the right-hand arch there is a glimpse of the new concrete and iron railway bridge.

In these pictures, however, neither element, that which

has always existed and that which is encroaching on it, is given any particular significance: everything is interesting. Critics like Baudelaire could approve of this approach to art, but traditionalists deplored Monet's failure to value one thing above another.

Monet made two trips away from Argenteuil during 1872: the usual summer trip to the Normandy coast was one of them, during which Monet painted several quick oils of the port and harbour at Le Havre. The other, made at Daubigny's persuasion, was a trip back to Holland; Daubigny later bought from Monet *Canal in Zaandam*, one of the paintings that resulted from the trip

The Impressionist Exhibitions

Even though Paul Durand-Ruel had bought a large selection of his paintings in 1872, Monet was becoming increasingly worried about money. The public was not buying the work of Monet and his friends, which Monet considered was due to the consistent rejection by the Salon of their submissions. The whole Salon system had been modified after the war, and there were now no more Salons des Réfusés at which to show their work. Some other way of reaching the public would have to be found.

Back in 1867, Frédéric Bazille had written to his parents outlining his idea for 'a dozen talented people … to rent a studio each year where we will show our works'.

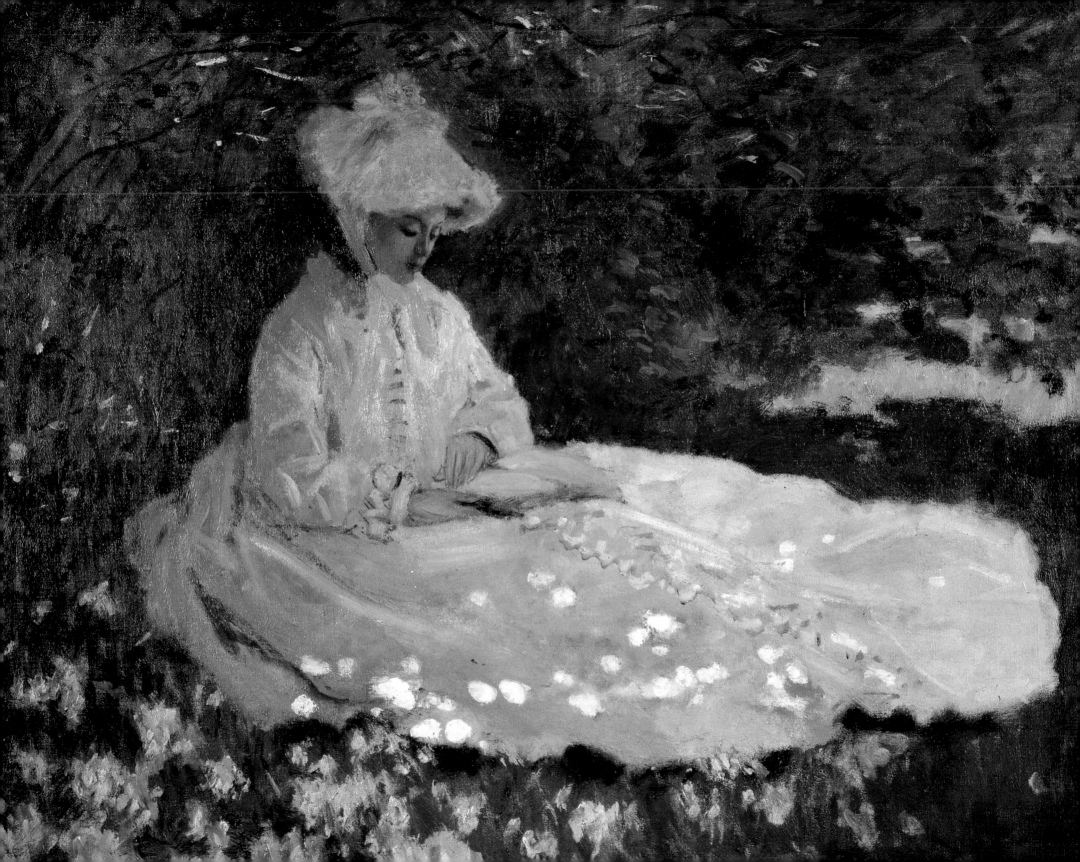

OPPOSITE
Fog Effect, 1872
Oil on canvas, 18⁷⁄₈ x 30in (48 x 76cm)
Private collection

The effects of mist and fog on the landscape fascinated Monet and he painted several pictures depicting buildings, trees and geographical features emerging, ghostlike, from wreaths and wisps of fog.

LEFT
The Marina at Argenteuil, c.1872
Oil on canvas
Musée d'Orsay, Paris

This animated scene recalls Monet's earlier paintings of beach scenes at Sainte-Adresse and Trouville and at La Grenouillère, the bathing place at Bougival. There is also a place for bathing here, for the cut-off notice at the right-hand edge of the painting is drawing attention to the warm baths establishment beneath it.

OPPOSITE
The Seine at Rouen, c.1872
Oil on canvas
Private collection

LEFT
The Seine Below Rouen, c.1872
Oil on canvas
Private collection

RIGHT

A Corner of the Apartment, 1875
*Oil on canvas, 32 x 23³/₄in
(81.5 x 60.5cm)
Musée d'Orsay, Paris*

Monet's son, Jean, stands on the parquet floor of the family's apartment in Paris, gazing at the pot plants, whose splendid blue-patterned pots he usually sees outdoors in the garden of the Argenteuil house in summer. More than a simple interior, A Corner of the Apartment *is essentially a study of the effect of air and light on an interior scene.*

OPPOSITE

Wild Poppies near Argenteuil, 1873
*Oil on canvas, 19⁵/₈ x 25¹/₂in
(50 x 65cm)
Musée d'Orsay, Paris*

This picture of Camille and Jean (in the foreground) and another couple walking through a field of wild poppies near Argenteuil has become one of the most celebrated of all Impressionist paintings. And with good reason. Its relatively small size lends a delicate charm, enhanced by the attractiveness of the subject.

OPPOSITE
The Seine at Argenteuil, Autumn, 1873
Oil on canvas, 21⅝ x 29⅓in (55 x 74.5cm)
Courtauld Gallery, London

A dense mass of short pink, yellow and orange brushstrokes defines the autumn tints of the trees in this vividly atmospheric painting. To get this view of the Seine at Argenteuil, which shows as the blue band across the centre of the picture, Monet moored his studio boat upstream on a side branch of the river.

LEFT
The Red Boats, Argenteuil, c.1872
Oil on canvas, 25½ x 22in (65 x 56cm)
Musée de l'Orangerie, Paris

In this tranquil scene sailing boats, sails down, are moored near the Petit-Gennevilliers bank of the Seine. Their masts, reflected in the water, make a series of verticals across the canvas, which Monet set against a softly cloudy sky and a gentle spread of water to ensure they did not break up the picture. He has also painted much of the canvas in short touches and flecks of paint to give it a shimmering quality of luminosity.

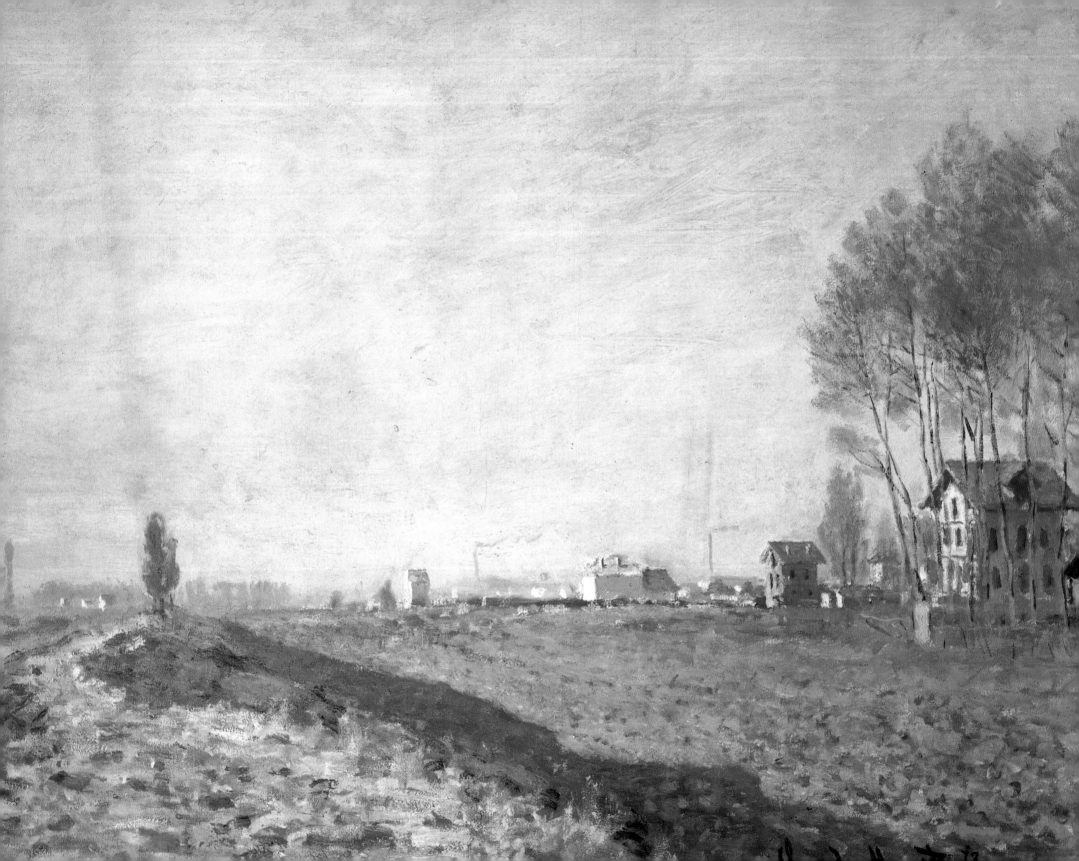

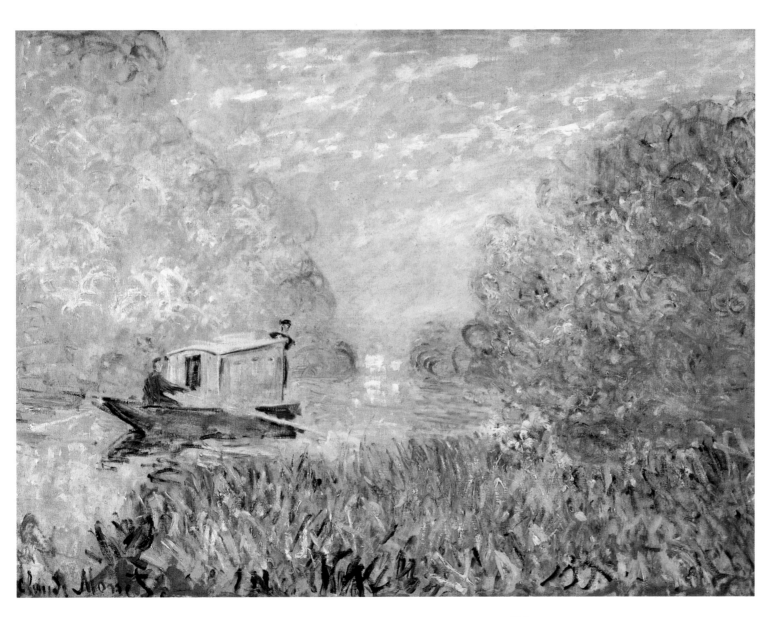

OPPOSITE
The Plain of Colombes, White Frost, 1873
Oil on canvas, 21⁵/₈ x 28³/₄in
(55 x 73cm)
Private collection

LEFT
The Boat Studio on the Seine, 1875
Oil on canvas,
Private collection

Edouard Manet

Monet Painting on His Studio Boat, 1874

Oil on canvas, 32½ x 39½in
(82.5 x 100.5cm)
Neue Pinakothek, Munich

Monet spent many hours in his studio boat painting his river scenes at Argenteuil, giving his friend Edouard Manet plenty of time to make this study of the artist at work, with Camille keeping him company. The background in Manet's painting is almost identical with that of The Red Boats, Argenteuil *(page 111) and the picture opposite, except that Monet has omitted the smoking factory chimneys; perhaps he did not wish to introduce any more verticals into the picture.*

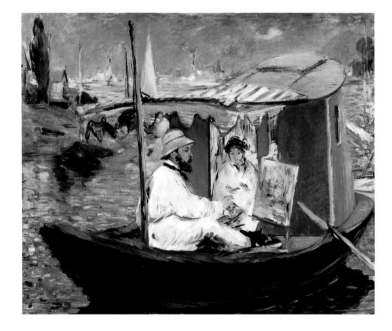

By 1873, no doubt due to the fact that an economic downturn meant that Durand-Ruel was no longer buying paintings, the idea of forming a company or corporation that would hold group exhibitions was once more in the air.

Art critic Paul Alexis, a good friend of Zola and Cézanne, supported the idea in an article in *L'Avenir National* of 5 May. Two days later Monet sent him a note to the effect that a group of friends gathered at his house in Argenteuil had read the article with pleasure and hoped that they could depend on the support of the journal when 'the Society we are in the process of setting up is fully established'.

The society that Monet, Pissarro and other members of the so-called Batignolles group were already discussing took some months to organize. Pissarro, who had at one time belonged to a sort of artists' provident society, wanted to establish a formal organization to adminster the exhibitions, putting forward the bakers' union of Pontoise, where he lived and worked, as a suitable example. Renoir and others didn't warm to the idea of something that sounded so formal.

Eventually, a compromise was reached, and the Société Anonyme des Artistes, Peintres, Sculpteurs, Graveurs, etc. was formed, the agreement setting it up being signed on 27 December 1873. The society was a joint stock company, the capital of which would be replenished by members paying to it ten per cent of their sales from exhibitions; day-to-day costs would be met, it was hoped, by members' subscriptions.

The list of the society's original members sounds like a roll-call of all that was most exciting in French art in the late nineteenth century. Monet, Renoir, Degas, Sisley and Pissarro were all there, as was Berthe Morisot, whose first showing at the Salon had been in 1864 and whose work was greatly admired by Manet. Edouard Béliard, who had

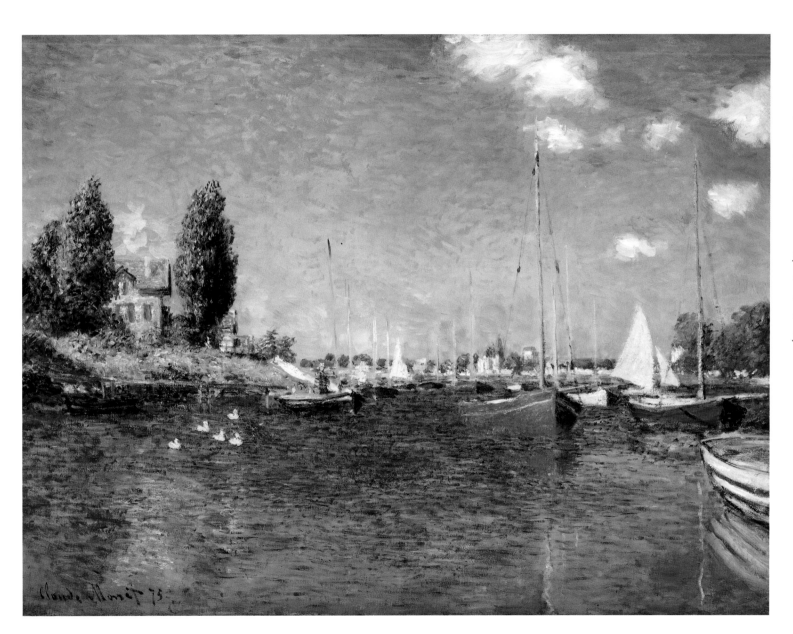

Argenteuil, 1875
*Oil on canvas, 23$\frac{1}{2}$ x 31$\frac{5}{8}$in
(59.7 x 80.3cm)
Fogg Art Museum, University of
Harvard Art Museums*

*Yet another painting of Monet's
favourite section of the Seine at
Argenteuil, done from his studio boat.
Its familiar motifs are painted as freshly
as if the artist were seeing them for the
first time.*

RIGHT
The Railway Bridge at Argenteuil, c.1873
Oil on canvas, 21⁵/8 x 28¹/3in
(55 x 72cm)
Musée d'Orsay, Paris

OPPOSITE
The Road Bridge at Argenteuil, 1874
Oil on canvas, 23³/4 x 31¹/2in
(60.5 x 80cm)
Musée d'Orsay, Paris

The railway bridge and the new road bridge were important motifs in many of Monet's paintings. The two bridges were quite different in style and character and Monet made the most of the differences in his paintings. He saw the railway bridge as a fine example of the engineering and technological skills that characterized the modern age and emphasized its iron strength and size. The stone road bridge, which was a toll bridge with an attractive brick tower-like structure at each end, crossed the river in a series of arches, the undersides of which reflected the shimmering water of the river. The bridge gave an architectural strength in a gently romantic style to many of Monet's pictures of the Seine at Argenteuil.

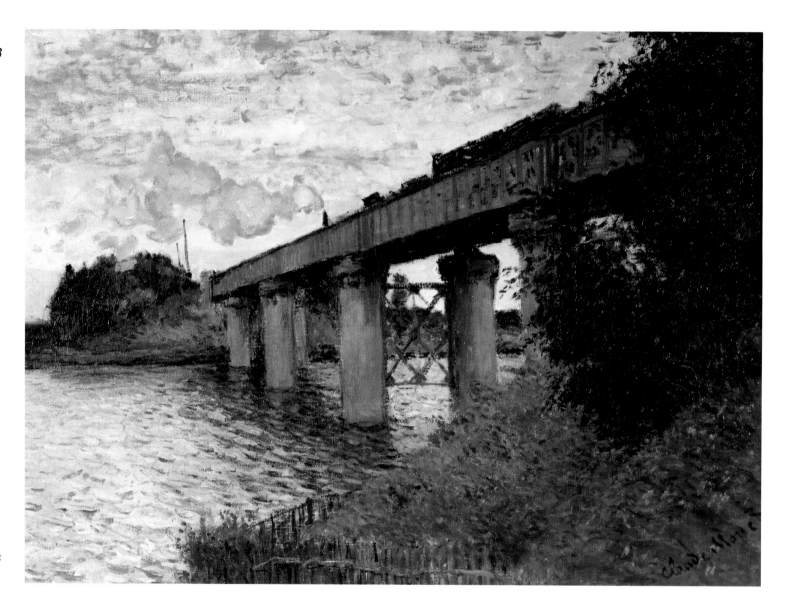

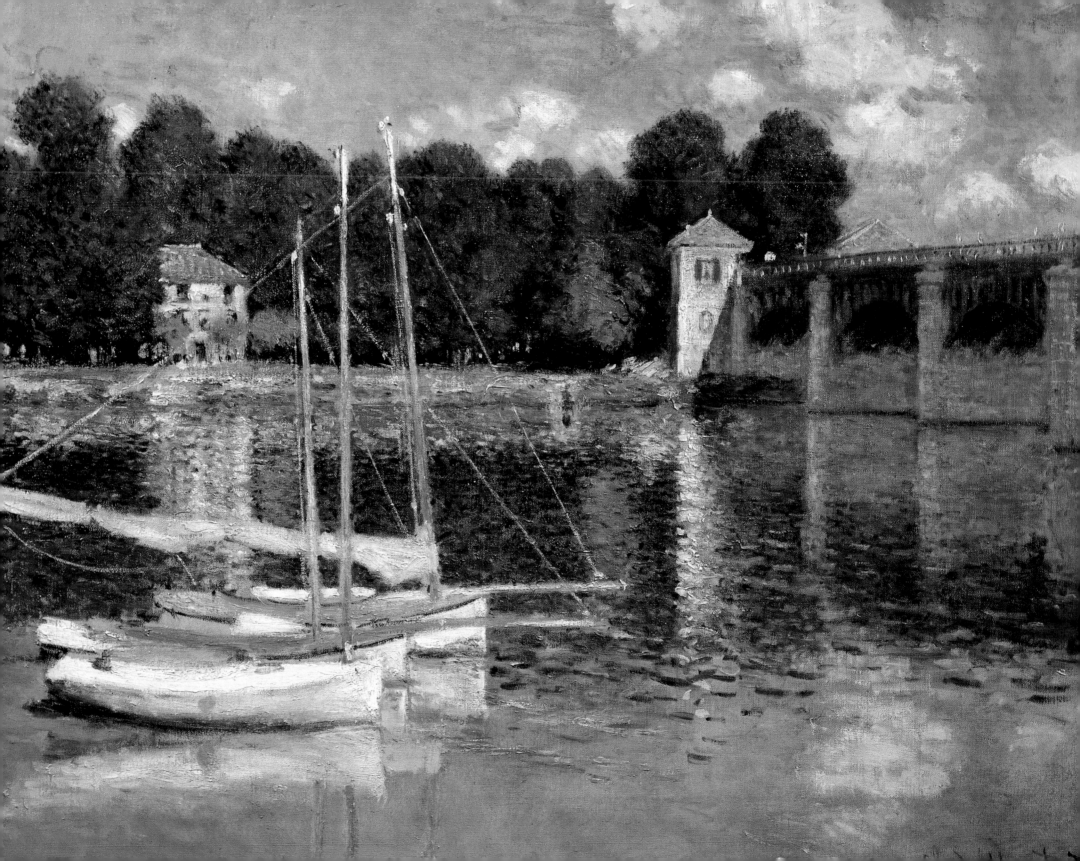

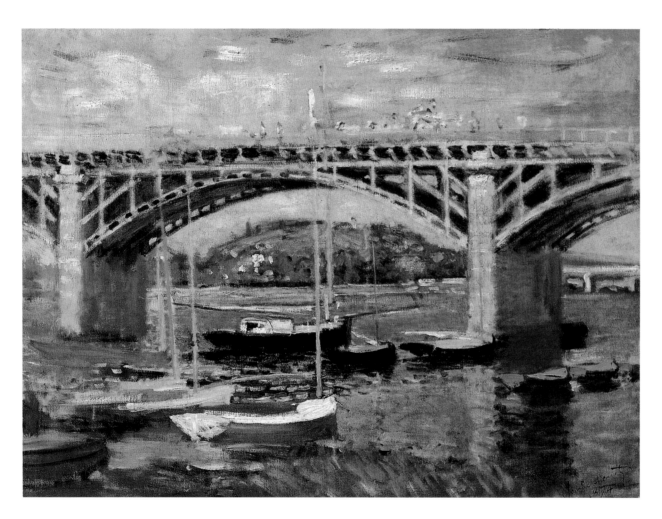

been at Gleyre's studio and was a friend of Pissarro, found himself helping Renoir with the society's finances. Also on the list were Armand Guillaumin, who turned out to be the longest-lived Impressionist, surviving Monet by a year; the sculptor Auguste Ottin; the wealthy but not particularly talented Vicomte Ludovic-Napoléon Lepic; and Henri Rouart, who should be better known than he is because he gave much financial help to the group and bought many of their paintings.

The Society's first group exhibition was held in the former premises of the famous photographer, Nadar, at 35 boulevard des Capucines in Paris, opening on 15 April 1874 at 10am in the morning. As well as the artists named above, the 30 participants, who between them offered more than 200 works for sale, included Eugène Boudin and Paul Cézanne. The latter's presence was enough to keep Manet, who could not abide Cézanne or his work, out of the exhibition. Manet was also influenced in this decision by the thought that such an exhibition would be seen by the art establishment as subversive, a feeling shared by Fantin-Latour, who did not exhibit either.

Among the paintings Monet chose to show was one depicting the boulevard itself. *Boulevard des Capucines*, (page 124), views the busy street from above (Monet set his easel up at an upper-floor window where Nadar lived) in hazy, snowy winter weather. The hurrying figures

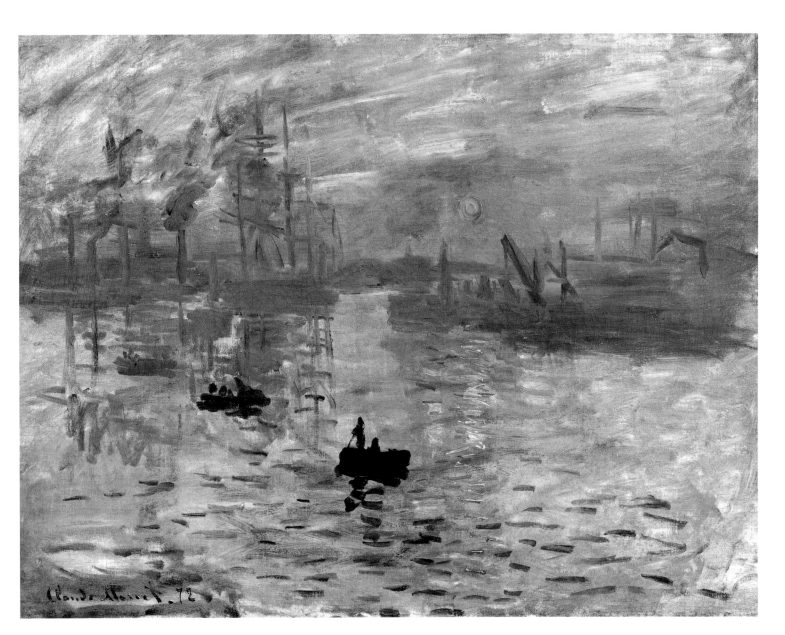

OPPOSITE
The Seine Bridge at Argenteuil, 1874
Oil on canvas, 23⁵/8 x 32in
(60 x 81.3cm)
New Pinakothek, Munich

Monet gets both bridges into the picture; beyond the main arch of the road bridge can be seen one of the fertile hills of the Seine valley, and through the right-hand arch there is a glimpse of the new concrete and iron railway bridge.

LEFT
**Impression, Sunrise
(Impression, soleil levant), 1873**
Oil on canvas, 18⁷/8 x 24⁷/8in (48 x 63cm)
Musée Marmottan, Paris

This painting, quickly painted by Monet from his window in Le Havre early one morning, was one of the most noticed and most heavily criticized works shown in the first Impressionist exhibition in Paris in 1874. This was the work that gave the most influential art movement of the 19th century its name.

Edouard Manet
Head of a Man (Claude Monet), 1874
Pen and ink on paper, 6⁵/8 x 5¹/2in
(17 x 14cm)
Musée Marmottan, Paris

crowding the pavements are depicted in Monet's characteristic undetailed style, two or three brushstrokes sufficing for each figure. Another choice, one of his Le Havre paintings, was hastily titled *Impression, Sunrise* because his list was urgently wanted for the catalogue.

The exhibition was not a great success. There were few visitors and fewer sales. Manet had been right in thinking that the art establishment would not warm to this bid for independence, and the critical reviews showed all too clearly the depth of hostility the traditional art world felt towards it. Monet and Cézanne were singled out for particularly violent attacks.

The critic and genre painter, Louis Leroy, writing in *Le Charivari*, probably thought himself very witty when he demanded of Monet, 'Are you telling me this is what I look like when I stroll along the boulevard des Capucines? The devil take it! Are you taking the mickey?' Turning his attention to *Impression, Sunrise* (page 119), Leroy told his readers exactly the sort of impression the painting had made on him: 'What freedom and ease in the brushwork! A preliminary drawing for a wallpaper pattern is more finished than this seascape!' At least one man disagreed with Leroy: the collector Ernest Hoschedé paid 800 francs for the painting.

Leroy's piece in *Le Charivari* was headed 'Exhibition of the Impressionists'. It was intended as a sneer, but

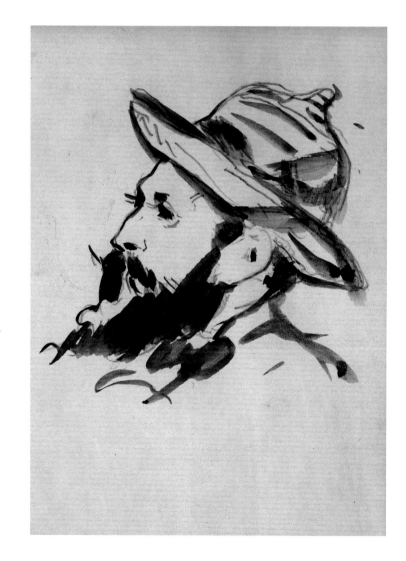

within a few days the word 'impressionist' was being used by people more kindly disposed to the artists showing in the boulevard des Capucines. One critic wrote that if the aims of the artists were to be summed up in one word, then 'impressionist' would do as well as any other. 'They are Impressionists in that they do not reproduce a landscape but convey the impression it makes on the beholder.'.

And this is certainly true of *Impression, Sunrise*. In it, Monet shows the port of Le Havre early in the morning, the sun glowing orange in the mist. With a few deft strokes, painted over a thinner wash of diluted colour, he contrasts the orange of the sun's reflection in the water with the greys that colour the rest of the scene. Ships' masts, dockside cranes and smoking factory chimneys provide the verticals and diagonals that give the painting structure. It was a rapidly-painted picture, but as a record of the visual impact of a moment's glance at a scene, it remains one of the true masterpieces of Impressionism.

Although the Société Anonyme was wound up at a meeting in Renoir's apartment in Paris at the end of 1874 because of its overwhelming financial liabilities, seven more 'Impressionist' exhibitions were mounted, in 1876, 1877, 1879, 1880, 1881, 1882 and 1886, though the name was not always attached to them. Where only about 3,500 people in all visited the first exhibition, which was open

for a month, Caillebotte, now enthusiastically involved, reported triumphantly that 500 visitors were coming every day to the second exhibition, which was held in the rue Le Peletier in April 1876.

This second exhibition came in the wake of a disastrous auction of the work of Monet, Sisley, Renoir and Morisot at the Hôtel Drouot in 1875, Paris's leading auction house. Paul Durand-Ruel had been finding it difficult to interest more than a handful of people in the paintings he had been buying over the past few years and landscapes were particularly difficult to sell. He was persuaded by Renoir to organize the sale, and 73 paintings were selected, 20 each from Sisley, Monet and Renoir, and a dozen from Morisot. Durand-Ruel put 'superb' frames around each and offered them at the much-publicized auction.

Years later, Durand-Ruel recalled the event as one of the most harrowing of his long career as an art dealer. 'The insults that were hurled at us, especially Monet and Renoir! The public howled, treated us as madmen, as people with no sense of decency … Afterwards, it seemed that I was about to be taken to a lunatic asylum.'

A few pictures were sold, but for very low prices, and Renoir had to buy back several of his own paintings to preserve their market value. The economic climate of the time was clearly responsible: works by Sisley, for

RIGHT
Promenade near Argenteuil, 1873
Oil on canvas, 23⅝ x 31⅞in
(60 x 81cm)
Musée Marmottan, Paris

Monet's paintings, inspired by the countryside around Argenteuil, drew the comment from Manet that his friend was trying to import into the country the social life of the town. What perhaps he was hinting at was that Monet was not yet ready to paint pure landscapes; he needed to have people, or at least a women with a parasol, to provide focal points in his landscapes.

OPPOSITE
The Boats: Regatta at Argenteuil, 1874
Oil on canvas, 23⅝ x 39⅜in
(60 x 100cm)
Musée d'Orsay, Paris

Squally weather adds drama to this painting of sailing boats taking part in a regatta on the Seine. Much more than Regatta at Argenteuil (page 89), this painting conveys the excitement of seeing boats, their sails filled, pitted against one another in fierce competition.

instance, that sold for less than 150 francs in 1875, when the frames around them probably cost 100 francs, were bought for 15,000 francs by the turn of the century. There was no mistaking the strong feelings of antipathy towards the paintings the artists were producing.

While *Le Charivari*'s comment on the sale of the work of 'four audacious individuals' from the boulevard des Capucines show of 1874 was typical of this antipathy, it is interesting that just a year after the first exhibition, the artists from that show were accepted as 'a group called the school of the Impressionists'. Not that *Le Charivari*'s commentator thought much of them, their work, as yet, having 'made no impression on the public. This style of painting, which is both vague and brutal, strikes us as an affirmation of ignorance and a negation of the beautiful as well as of the true ... it is only too easy to attract attention by producing trashier works than anyone else dares.'

In the face of such spiteful invective, the young artists could have been forgiven for giving up. But it seems that Monet, as much as anyone else, kept the fight going. Renoir, recalling those difficult days, said that he himself had never had the temperament of a fighter and 'should several times have deserted the party if old Monet, who certainly did have it, had not lent me his shoulder'.

The tide began to turn at the second exhibition in 1876, with Berthe Morisot entering some 20 pictures. In a letter to one of her aunts she admitted that newspapers popular with the respectable public, such as *Le Figaro*, had shown little enthusiasm for the exhibition. 'On the other hand, we have been praised in the radical papers, but these you do not read. Anyway, we are being discussed, and we are so proud of it that we are all very happy ... Speaking of success, my brother-in-law [Manet] ... has just been rejected by the Salon, he takes his defeat with as great good humour as possible.'

Berthe Morisot did not tell her aunt that her husband, Eugène Manet, had come close to fighting a duel with Albert Wolf, whose piece on the exhibition in *Figaro* began 'Five or six lunatics, of whom one is a woman ...'.

Monet, another of the 'lunatics', attracted some good reviews from the 'radical' papers for his 18 works, which included landscapes and *Woman with a Parasol* (page 128) a rapidly executed, wonderfully light-filled study of figures in a landscape, for which Camille and their son, Jean, were the models.

Alexandre Pothey told readers of *La Presse* that M. Monet's series of landscapes painted directly from nature 'are all marked by the freshness of their execution, their real feeling and the beautiful light which they display'. He was enthusiastic but perhaps a little bewildered by *La Japonaise: Madame Monet in Japanese Costume* (page 129), which Monet 'had painted to prove that he could do

OPPOSITE
Boulevard des Capucines, 1873
Oil on canvas, 24 x 31¹/₂in (61 x 80cm)
Pushkin Museum, Moscow

Although this painting was criticized for its 'unfinished' look when it was shown at the first Impressionist exhibition, more thoughtful critics realized that the rough lack of finish of Monet's paintings actually gave them freshness and vitality. The critic Ernest Chesneau was fully aware that in Boulevard des Capucines *Monet was capturing a moment in time. 'Never has the elusive, the fleeting, the instantaneous character of movement been caught and fixed in its wonderful fluidity as it is in this extraordinary, this marvellous sketch,' he wrote. Note the word 'sketch': Chesneau seems to have assumed that Monet would one day progress to more finished works.*

OPPOSITE
Sailing at Argenteuil, c.1874
Oil on canvas
Private collection

Monet's title for this painting 'Canotiers (Boaters) à Argenteuil' drew attention to the rowers as well as the sailors, reminding us that the river at Argenteuil was a popular spot for recreation of all kinds. For the painting, he set up his easel on the Petit-Gennevilliers bank, so that he could include the riverside promenade at Argenteuil on the opposite bank. This popular walk is depicted in The Marina at Argenteuil *(page 105).*

other things as well [as landscapes] … He has produced a life-size portrait of the most startling kind. It is a young Parisienne, with a roguish look on her face, and blond hair, dressed in a Japanese robe of exceptional richness … Art lovers who are on the lookout for solid colouring and emphatic impasto will find this rather strange figure a real feast for their eyes'.

The painting is, perhaps, rather overwrought to our way of thinking, with a cloying insistence on the Japanese style: the kimono is heavily decorated, there is an overemphasis on fans, and why turn Madame Monet into a coquettish blonde? But it found a buyer at the exhibition, earning Monet a much-needed 2,000 francs. Monet later dismissed the picture as rubbish, and it is certainly a departure from the style he was working on developing at that time; he did not repeat it.

The poet and writer, Stéphane Mallarmé, whose Batignolles apartment was a meeting place for many of the literary and artistic figures of the day, was much more temperate than the *Figaro* critic. In the influential essay, 'The Impressionists and Edouard Manet', he wrote for the *London Art Monthly Review*. These artists '... use simple colour, fresh or lightly laid on, and their results appear to have been attained at the first stroke, that the ever-present light blends with and enlivens all things. As to the details of the picture, nothing should be absolutely fixed, in order

that we might feel that the bright gleam that lights the picture, or the diaphanous shadow which veils it, are only seen in passing.'

Monet exhibited in five of the shows, choosing not to take part in 1880, 1881 and 1886, though Durand-Ruel put several of his Monet pictures in the 1886 show. Sisley, Caillebotte and Renoir were also absent from the 1886 exhibition, Renoir having decided, like Monet, that it was time to establish links with dealers other than Paul Durand-Ruel, though he had backed the exhibitions from the start. In all, 118 of Monet's pictures were shown at the exhibitions, his most memorable participation being the third exhibition, in 1877, when among the 30 pictures he showed, eight were of Gare Saint-Lazare and its environs. This was the Paris railway station from which trains departed for Argenteuil and Le Havre.

Visitors to the 1877 exhibition were given an intriguing contrast of styles to ponder, because both Monet and Caillebotte showed paintings of the Pont de l'Europe, the great viaduct overlooking the Gare Saint-Lazare. Monet's view of the bridge (page 135), painted in 1877 from the railway tracks, was a quickly-executed work, the lightly brushed-in smoke and steam a microcosm of the Impressionist vision. Human involvement in the scene was reduced to figures sketched in a couple of brushstrokes. Gustave Caillebotte's

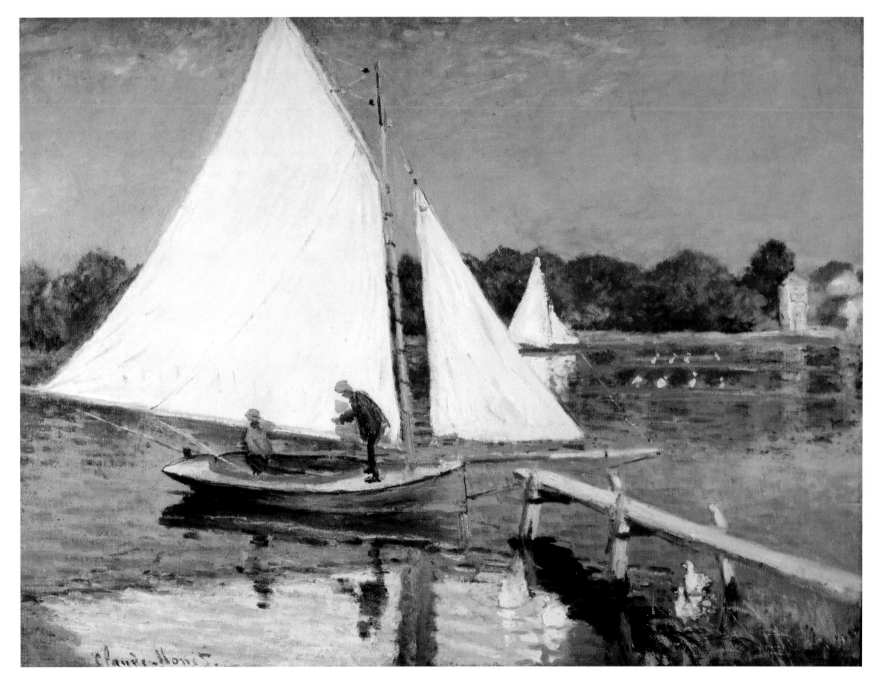

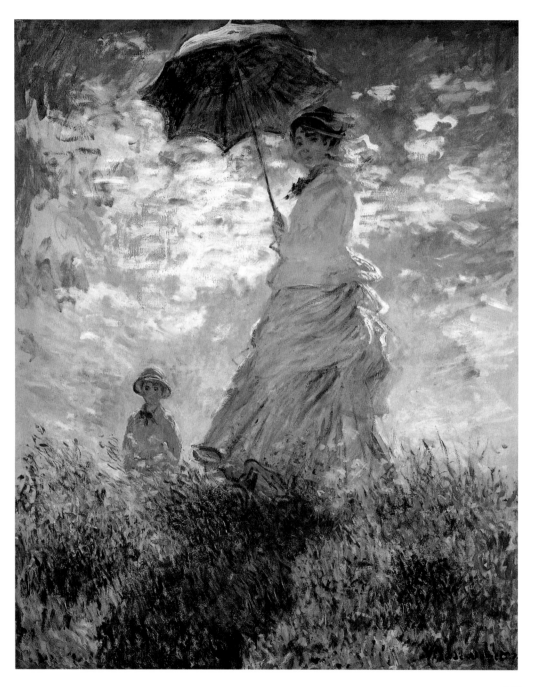

intriguingly detailed *Le Pont de l'Europe*, painted from the bridge itself, includes people crossing it and a smock-clad workman leaning his elbows on the bridge rail as he looks down on Gare Saint-Lazare. His painting is detailed and much more precisely finished than Monet's.

By the time of the third exhibition, which Gustave Caillebotte organized, a split into two factions had taken place among the 18 participating artists. One faction, centred on Monet, still held to landscape painting and the use of broken brushwork; the other, influenced by Degas, was more concerned to paint the urban scene and had moved away from 'impressionist' techniques to more realistic ones. The hot question being debated among the artists was whether an artist could show both at the Salon and at the independent exhibitions.

Knowing that at the third Impressionist exhibition, in 1877, Monet exhibited his Gare Saint-Lazare paintings, it is easy to understand and even share the despair and hurt the artists felt at some of the criticisms hurled at them. Take Roger Ballu reviewing the exhibition in *La Chronique des Arts et de la Curiosité*: 'MM. Claude Monet and Cézanne …have exhibited; the first 30 canvases, and the second 14. One must see them to imagine what they are like. They provoke laughter yet they're pitiable: they reveal the most profound ignorance of drawing, of composition, of colouring …'.

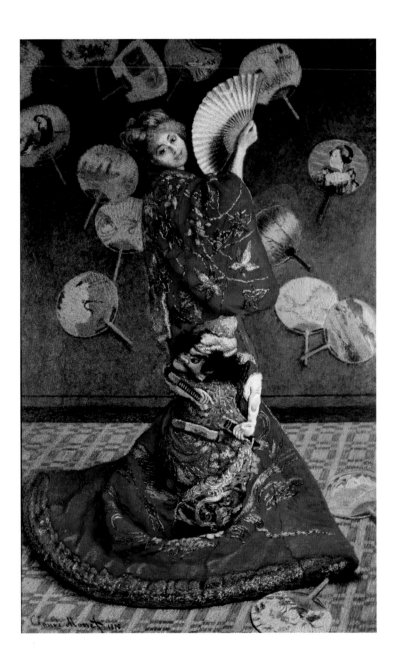

Monet decided only very reluctantly to take part in the fourth exhibition in 1879. He was in a highly depressed state when he wrote to friend and patron Georges de Bellio in March 1879 that he was giving up the struggle and abandoning all hope of success. He was aware that his friends were planning another exhibition but knew that he would not be participating because he had nothing worth showing.

By this time, Monet had also come to believe that group exhibitions weakened his independence as an artist and he was still hoping to show again at the Salon, which he did in 1880, when Renoir and Sisley also had offerings accepted. He was also clearly unhappy at the way in which the small, closely-knit group of friends with whom he had set out on the great adventure had been taken over by a great crowd of people unknown to him. He was reported in *La Vie Moderne* in 1880 as remarking that 'the little clique has become a great club which opens its doors to the first-come dauber'. In the end, Caillebotte found 29 of Monet's paintings well worth showing in the fourth exhibition, turning it into something of a mini-retrospective for the artist. This time, Monet was appearing with only 15 other artists, two of whom, Paul Gauguin and Mary Cassatt, were first-timers, but clearly not 'daubers'.

Monet's work at the seventh Impressionist exhibition

OPPOSITE
Woman with a Parasol (Madame Monet and Her Son), 1875
Oil on canvas, 39³/8 x 31⁷/8in
(100 x 81cm)
National Gallery of Art, Washington, D.C.

LEFT
La Japonaise: Madame Monet in Japanese Costume, 1876
Oil on canvas, 91 x 56in (231 x 142cm)
Museum of Fine Arts, Boston

RIGHT
The Riverbank at Gennevilliers,
c.1875
Oil on canvas, 23⁵/₈ x 31¹/₂in
(60 x 80cm)
Private collection

OPPOSITE
Still Life, c.1876
Oil on canvas, 20⁷/₈ x 28³/₄in
(53 x 73cm)
Museu Calouste Gulbenkian, Lisbon

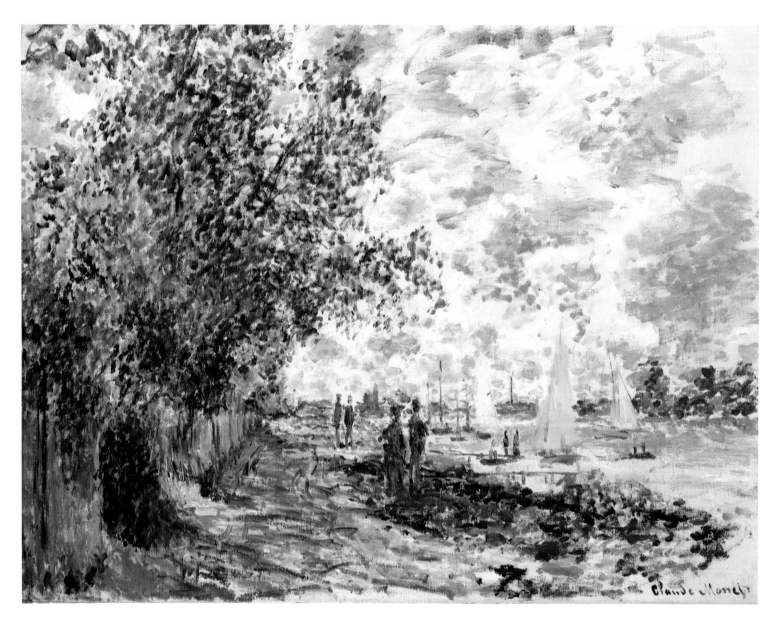

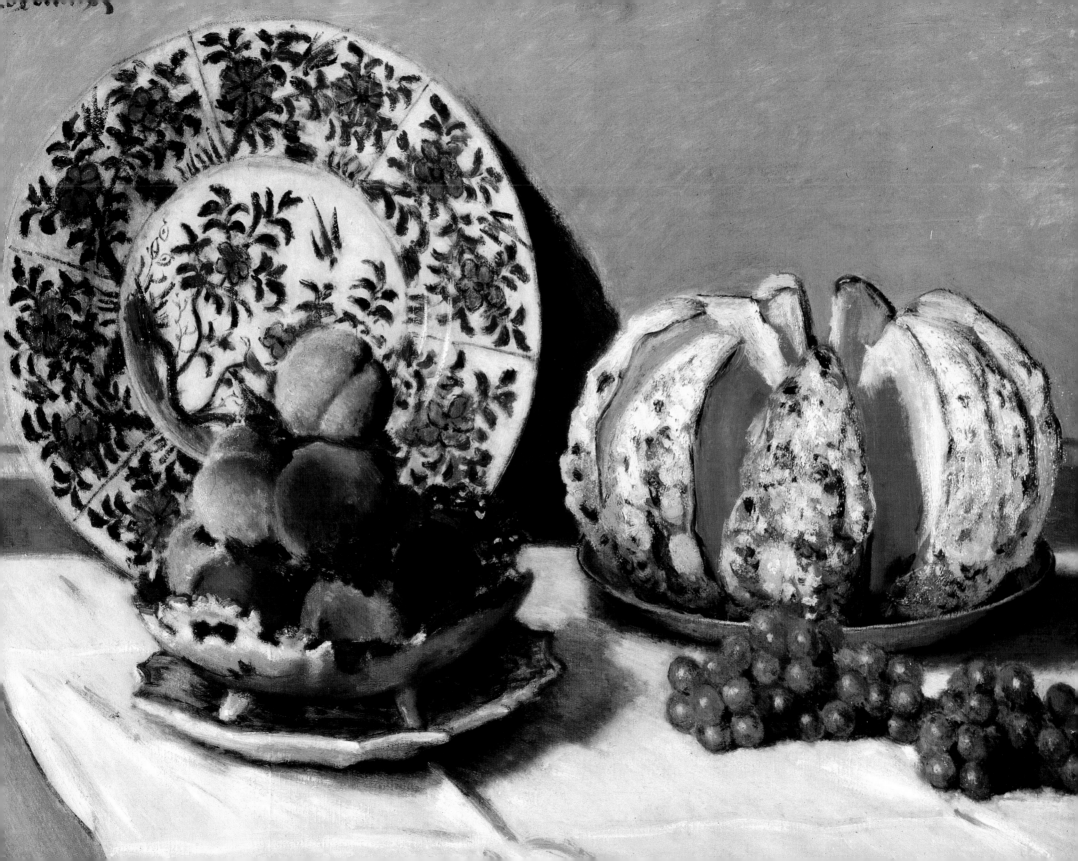

in 1882, in which he was persuaded to participate by Durand-Ruel, was not much noticed, the critics' praise being largely reserved for Renoir and Sisley. Berthe Morisot, whose contribution to the exhibition was organized by her husband, Eugène Manet, was in Nice and had to rely on him for reports on the works being shown. Eugène told his wife that Monet showed some 'weak things side by side with some excellent ones, particularly winter landscapes – ice drifting on a river – which are quite beautiful'. One of Monet's works, *Grainval, near Fécamp* (1881) found a place near the foot of a page of satirical cartoons based on paintings from the exhibition published by the artist Draner.

The last exhibition, mounted in 1886 largely at the instigation of Berthe Morisot and her husband, showed very clearly how far the Impressionists had travelled in the 12 years since the first exhibition. Monet, Renoir, Sisley and Morisot were coming to be seen as part of the 'romantic old guard' of Impressionist painting. Art, thought Pissarro, had become more 'scientific', with the Pointillism of Seurat and Signac pointing the way ahead rather than Monet's pure Impressionism. Certainly, 27-year-old Georges Seurat's *A Sunday Afternoon at the Ile de la Grand Jatte* (1884–86), a massive, complex and carefully planned work on show at the 1886 exhibition, showed a very different approach to painting than the

intuitiveness of *Impression, Sunrise*. Artists like Manet and Renoir, Pissarro told his son Lucien in 1886, were gentlemen who, 'despite their talent', were unable to appreciate the 'something new' that Seurat had to contribute.

Looking back from our own day, when exhibitions of the work of Monet draw admiring crowds in such numbers that there are day-long queues to see them, it is not easy to understand the vilification and invective that Monet and his friends suffered from critics and public alike at the first of the Impressionist exhibitions. Contrary to *Le Charivari*'s comment of 1875, the painters had not formed a school of painting deliberately at odds with the established art world. Rather, they were building on ideas and theories that had been discussed and practised by other artists over several decades. Nor was there anything particularly revolutionary in the Impressionists' subject matter; there was a conscious sense of modernity in the portraits of the working lives of ordinary people, such as Monet's *Unloading Coal* (opposite) or Caillebotte's *The Floor Strippers*, both of which were painted in 1875, that may have offended delicate bourgeois sensibilities.

Three things concerning the Impressionist's approach to painting, all of them very much to the fore in Monet's work, were difficult for lovers of traditional painting to

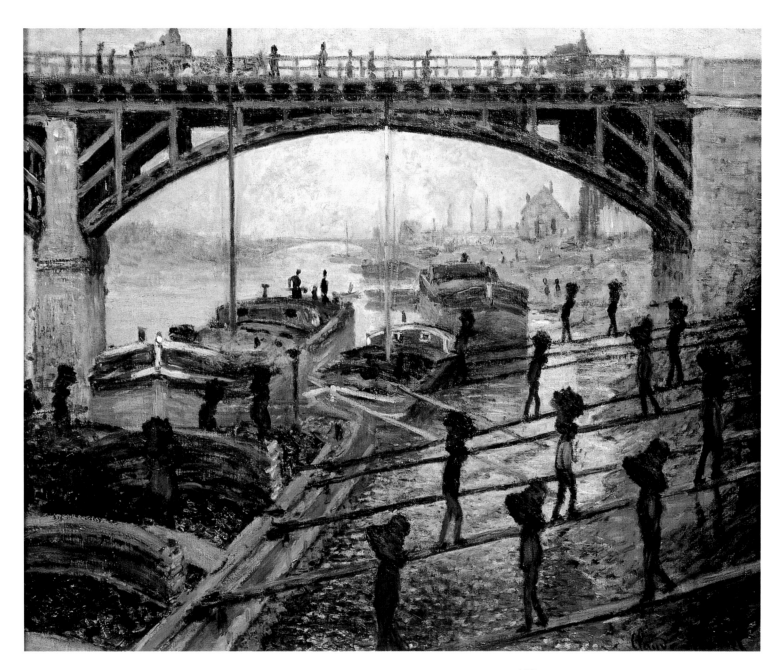

Unloading Coal, 1875
Oil on canvas, 21⁵/8 x 25¹/2in
(55 x 65cm)
Musée d'Orsay, Paris

Critics have recognized the influence of Japanese woodcut artists, whose prints Monet collected assiduously, in this painting's grid-like composition. As in many Japanese prints, the subjects of the painting – the coal barges, the walkways and the figures on them – are all placed off-centre and a grid of diagonal lines establishes a strong rhythm across the canvas.

come to terms with. The most obvious were the brushwork and the use of paint, techniques the Impressionists evolved so that they could effectively capture the fleeting effects of light and shade out in the open air. Paint was applied to the canvas in short, light brushstrokes or jabbing dabs, and bright colours were set against contrasting or darker ones, without any shading off or with intermediate shades modulating the startling effect. This meant that, to eyes used to carefully controlled and constructed Salon paintings, those of an Impressionist could seem like an unskilled, rough and even vulgarly over-coloured sketch (or impression), rather than a smoothly finished work.

The third aspect that offended many was the Impressionists' approach to the human figure. To a true Impressionist, which Monet said in 1880 that he still was, and intended always to be, the human figure could be painted in terms of light and shade, colour and movement, just as any other object in nature; it was not necessary to carefully paint in every finger on every hand, or every ribbon on a dress. Thus, Monet's carefully produced Salon painting, *Woman in a Green Dress*, was highly praised, and his *Boulevard des Capucines*, despite the wonderful immediacy and topicality of the picture, was equally highly criticized.

The Business of Painting

The decade of the 1870s started out well enough for Monet, but once the legacy and dowry had gone in mid-decade, which was a period of financial distress for all artists, not nearly enough of his paintings were being sold to keep the family in the modest style to which it had become accustomed. By this time, most of the indoor servants and the gardener had gone, and Monet was back in the old routine of borrowing money where he could, pawning his wife's jewellery, buying on credit at the

OPPOSITE
The Tuileries, 1875
Oil on canvas, 19⅝ x 29½in
(50 x 75cm)
Musée d'Orsay, Paris

LEFT
Le Pont de l'Europe, Gare Saint.-Lazare, 1877
Oil on canvas, 25¼ x 31⅞in
(64 x 81cm)
Musée Marmottan, Paris

RIGHT

The Gare Saint-Lazare: Arrival of a Train, 1877

Oil on canvas, 31⁵/8 x 38⁵/8
(80.3 x 98.1cm)
Fogg Art Museum, Harvard University
Art Museums

OPPOSITE

The Gare Saint-Lazare, 1877

Oil on canvas, 29³/4 x 41in
(75.5 x 104cm)
Musée d'Orsay, Paris

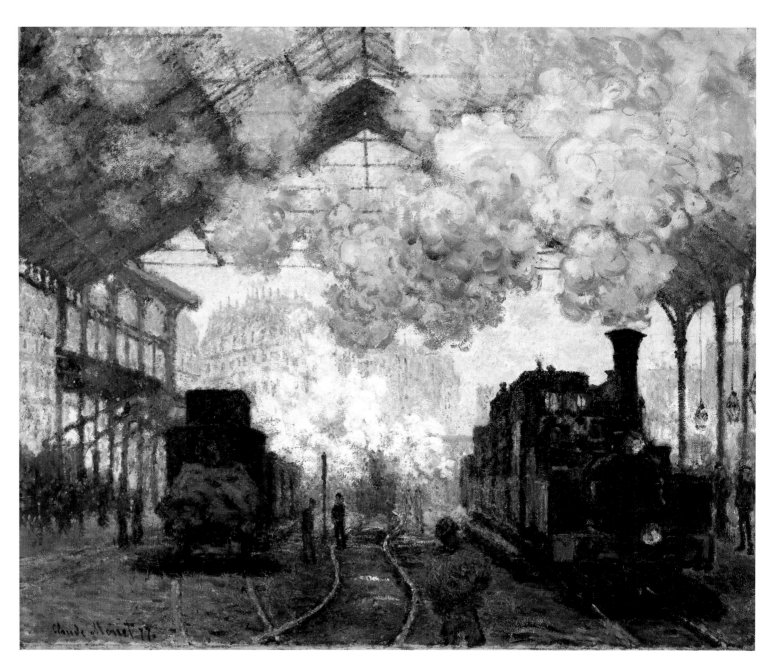

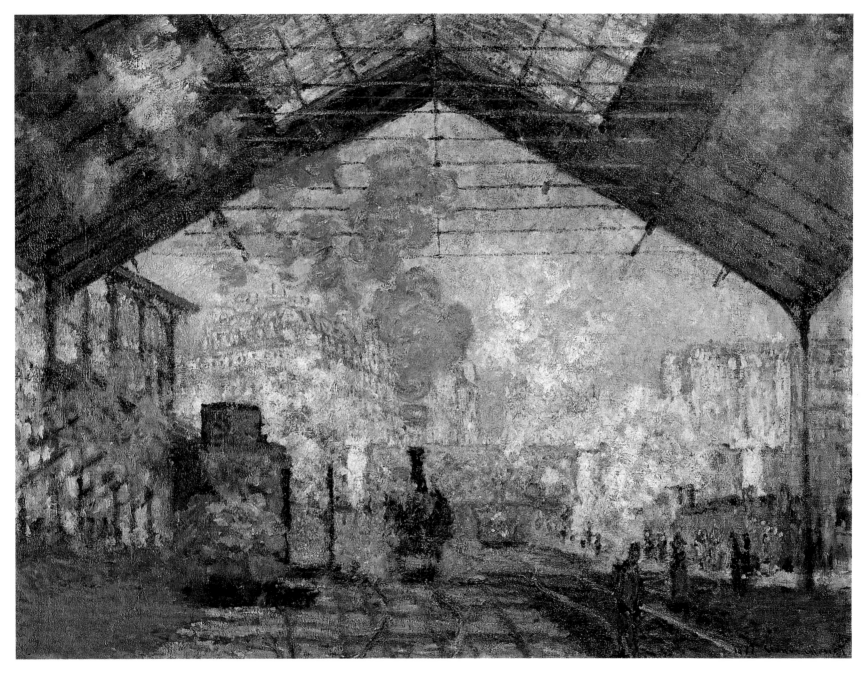

Snow Effect with Setting Sun, 1875
Oil on canvas, 20⁷/8 x 25¹/4in
(53 x 64cm)
Musée Marmottan, Paris

Winter in Argenteuil early in 1875 was cold and snowy. The conditions were ideal for Monet to paint several studies of the effects of the snow on ground, buildings and trees and of the changing effects of the winter light at different times of day. In this picture, the sky at the end of the day has a pale yellow glow from the setting sun that is reflected in the snow on the ground and the bare branches of the trees.

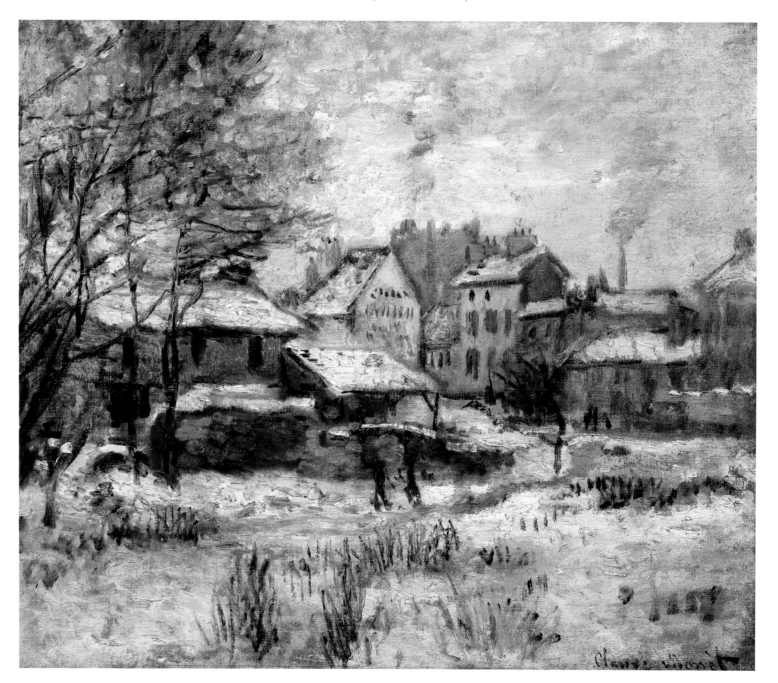

butcher's and baker's, and giving paintings in lieu of rent.

Nothing stopped him painting, however, mostly out of doors and in all seasons. Outstanding among his work in the later 1870s, partly because of its implications for the future, was his series of paintings of the Gare Saint-Lazare of 1877 (pages 135–137). Renoir told his son Jean of how Monet persuaded the managers of the railway station not only to let him paint there but also to organize things as he wanted them; this included having trains moved onto the right tracks according to the suitability of the light, closing platforms, and having engines generate steam at the right moment.

The railwaymen must have thought that a Napoleon of the art world had descended upon them, for Monet, as Renoir later recalled, wore his best clothes for the preliminary meeting, shooting his lace cuffs and flourishing his gold-topped cane as he handed his card to the director of the Western railways. 'I am the painter Claude Monet. I have decided to paint your station.' Greatly impressed, the director agreed to this unusual request, and Monet set himself up at the station where, for days 'amidst universal awe', he painted.

The 19th-century railway station resembled a cathedral of the modern age, its entrance and splendid pillared concourse built in imposing, even pretentious style. For Monet, the attraction of the railway station lay beyond all this grandeur, to where the smoke and steam of the engines and their lines of carriages and tangle of tracks lay beneath the massive glass dome.

Monet was eager to capture the atmosphere created by sunlight filtering through the great roof and merging with the steam and smoke of the trains. In his paintings, puffs, clouds and shreds of dusty blue smoke, some opaque, some dissolving into a transparent mist, hang over the station and the mighty engines, shrouding the linear structures – station pillars, girders and roof, the engines themselves, and the buildings of Paris beyond the station – in an iridescent haze.

Monet based himself in a studio, which Caillebotte helped him find, in the nearby rue d'Edimbourg while he was painting the Gare Saint-Lazare pictures. In three months he had finished as least eight, all of them very different from one another in composition, viewpoint and degree of finish. Some were very thinly sketched; in others, the paint was laid across the canvas in thick swirls.

Critical response was varied. Georges Rivière, writing in *L'Impressioniste* in April 1877, praised their amazing variety and 'that skill in arrangement, that organization of the canvas that is one of the main qualities of Monet's work'. Other critics failed to see any personal vision or emotional sensibility in Monet's pictures. 'One looks in vain for a mind and a soul', wrote one. When Cézanne

PAGE 140
Gladioli, c.1876
*Oil on canvas, 22 x 32^1/$_2$in
(55.8 x 82.5cm)
Detroit Institute of Arts*

PAGE 141 LEFT
The Shoot (The Avenue in the Park, Montgeron), 1876
*Oil on canvas,
Private collection*

This was one of four pictures commissioned by Ernest Hoschedé to hang in the grand salon of his château, Rottembourg, at Montgeron.

PAGE 141 RIGHT
The Studio Boat, 1876
*Oil on canvas, 28^1/$_3$ x 23^1/$_2$in
(72 x 59.8cm)
The Barnes Foundation, Merion*

Early morning on the Seine and the mists have not quite cleared away. The boat is moored in a quiet backwater, far from the busy life of the river.

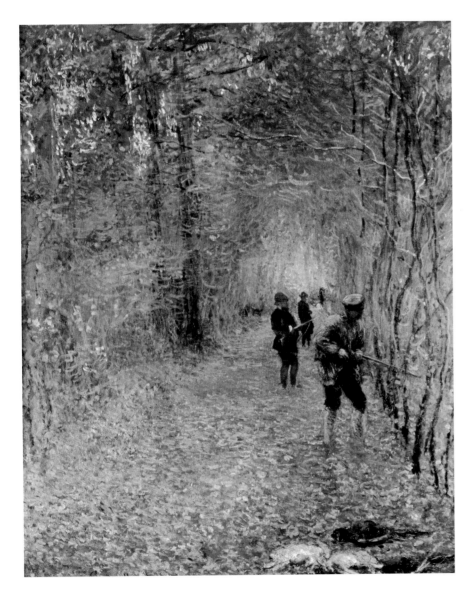

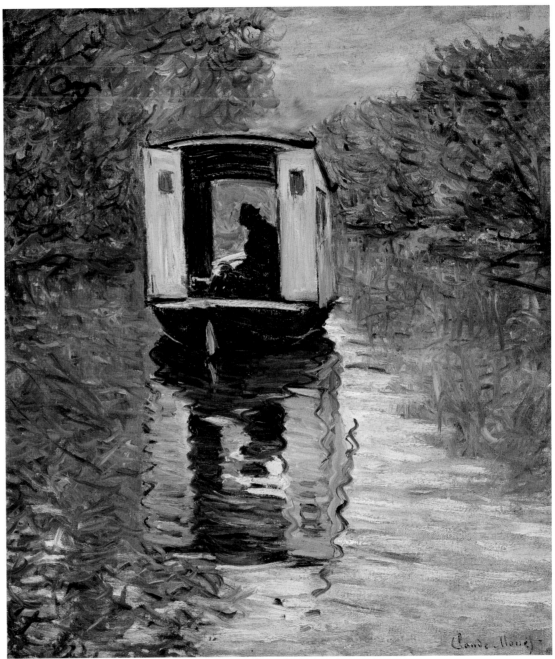

OPPOSITE

Spring, 1875

Oil on canvas, 23⁷/₈ x 31⁷/₈in
(60.5 x 81cm)
Johannesburg Art Gallery

Monet has felt no need to add a human figure to this springtime landscape. He has kept his palette quite restricted, too, relying on green tones, flecked with yellow for the trees and grass and clear delicate blues, again with touches of yellow among the blue-white of the clouds, for the sky. The luminosity of the scene and the sense of a lightly stirring breeze attest to Monet's increasing skill at depicting light and air on his canvases.

commented that Monet was 'only an eye – but, my God, what an eye!', he was saying that, in the art of Claude Monet, the mind and soul were of lesser importance.

The Gare Saint-Lazare paintings were Monet's first attempt at making a series of related works based on one subject. Where they emphasize the diversity of the city scene, his later series, such as Rouen Cathedral and the poplars on the River Epte, concentrated on a single viewpoint. The subject remained the same; only the light and the time of day changed around it.

In the 1870s Monet, always the shrewd businessman, began seriously to involve himself in the business aspects of an artist's life, pursuing dealers and the committed supporters whose patronage was extremely important to the Impressionist artists. Paul Durand-Ruel's financial difficulties in 1874, when he was obliged to close his London gallery and stop buying works by his stable of French artists, caused Monet to look around for other support. One possible patron, he discovered, was Victor Chocquet, a high-ranking civil servant who had some years previously begun to collect the work of Delacroix, then progressed to Renoir, whose paintings in the 1875 Hôtel Drouot sale had greatly impressed him, and who introduced him to Cézanne.

It was through Cézanne that Monet gained an introduction to Chocquet, and Monet invited him to lunch

at Argenteuil early in 1876. 'If you are not put off by the prospect of a very frugal meal, it would give me great pleasure, since I would be delighted to make your acquaintance,' Monet wrote, adding a postscript that 2 Boulevard Saint-Denis was the pink house with green shutters opposite the railway station. The lunch was a success, and Chocquet started to buy Monet's work; when Chocquet died in 1891, his collection, sold off at the Hôtel Drouot, contained 11 works by Monet.

Another contact whom Monet hoped would benefit him was Georges Charpentier, a publisher and early collector and commissioner of Impressionist art: Renoir's portrait, *Madame Charpentier and her Children* (page 145), was a highlight of the 1879 Salon. Charpentier's influential magazine, *La Vie Moderne*, was published from an impressive office on the boulevard des Italiens that was also used as a place of exhibition. Here, Monet had his first one-man show in 1880; however, only one picture was sold – at a reduced price to Madame Charpentier. The show's failure put the cap on a bad year, for 1880 was also the last year that Monet made an assault on the Salon. One of his two submissions, a studio-painted version of an outdoor study entitled *Lavacourt*, was accepted, but was badly hung, and the other, *The Ice-Floes* (page 148), was rejected.

Of far greater influence in Monet's life, though not

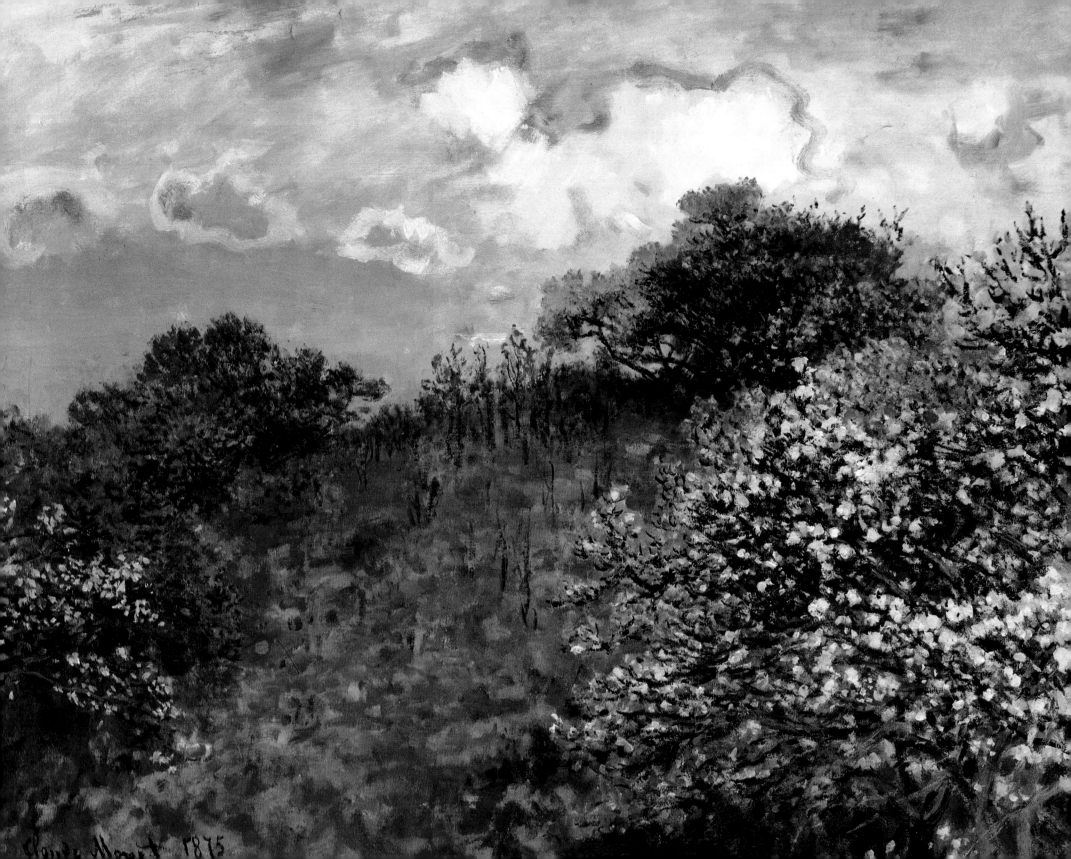

Claude Monet 1875

The Turkeys, 1876

*Oil on canvas, 68³/4 x 67³/4in
(174.5 x 172cm)
Musée d'Orsay, Paris*

This painting was one of four large panels produced by Monet in the late summer of 1876 while staying at Ernest Hoschedé's imposing residence, the Château of Rottembourg, at Montgeron, near Paris. This was the first time Monet had been commissioned to paint wall decorations, as distinct from paintings, and he tackled the task with enthusiasm. Given the style and elegance of the Hoschedé property, Monet's decision to paint something as inelegant and ordinary as a lifesize flock of turkeys was an audacious one, and he retained an interest in the picture and the various people who owned it throughout his life.

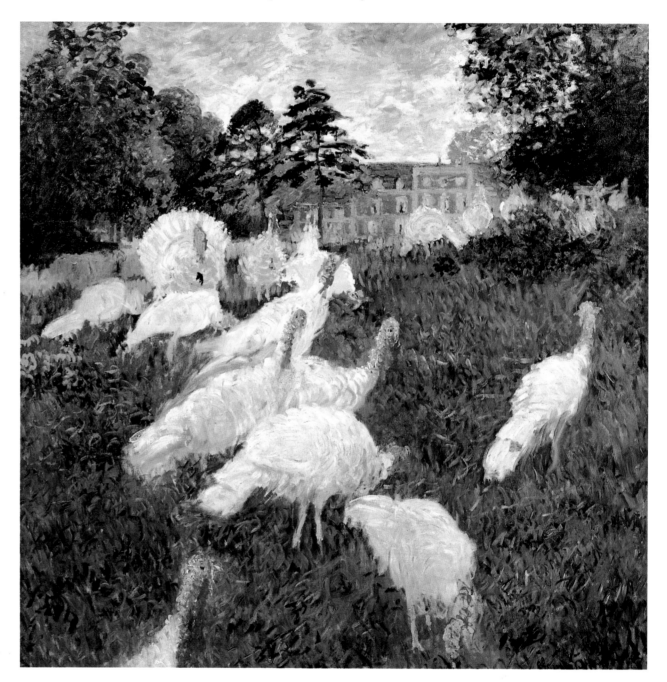

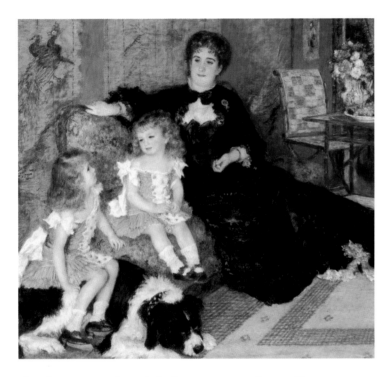

him. Monet and Camille were invited to Rottembourg where Monet spent the late summer painting landscapes and panels for a room in the house, all commissioned by Ernest Hoschedé.

In was an ideal situation for Monet who, as recently as July 1876, had been so short of money that he had written to Georges de Bellio, another faithful patron of the Impressionists, asking him to come to Argenteuil and choose the two sketches he had already bought and paid for, while the Monets were still in their 'dear little house'. Monet's creditors were proving impossible to placate and it looked as though they were about to be turned out of the house in boulevard Saint-Denis. At Montgeron, Monet was able to work in the Hoschedés' garden untroubled by creditors and without wondering where his family's next meal was coming from.

Out of this period of relative stability came many delightful garden paintings, including a celebrated study of the turkeys which ran about the garden. George Moore, in describing *The Turkeys* (opposite) in his *Modern Painting*, noted that the tall grass at which the turkeys were nibbling 'is flooded with sunlight so intense that for a moment the illusion is complete'. The lake at the Hoschedés' Montgeron house, which features in *Rose Beds at Montgeron* (page 149) and others of the paintings Monet did there, may well have given him the idea of

for the reasons he might have expected, was Ernest Hoschedé, a textile merchant and director of a large department store in Paris. Hoschedé began buying from the Impressionists as early as 1871 and many of them were invited to stay at his imposing country estate, Rottembourg, at Montgeron. He bought Monet's *Impression, Sunrise* in 1874, and when he finally met the artist in 1876, he and his wife, Alice, immediately liked

Pierre-August Renoir
Madame Charpentier and her Children, 1878
Oil on canvas, 60⅝ x 75in
(154 x 190.5cm)
Metropolitan Museum of Art, New York

Monsieur and Madame Georges Charpentier were very helpful patrons of Pierre-Auguste Renoir, and must have been very pleased with Renoir's superb portrait of Madame Charpentier and her children, which was a great success at the 1879 Salon. Unfortunately, the Charpentiers' patronage did not help Monet to sell his paintings.

RIGHT
Through the Trees, 1878
Oil on canvas
Private collection

OPPOSITE
The Seine at Châtou, near Argenteuil, 1878
Oil on canvas
Christie's Images, London

went bankrupt in 1878. The magnificent house at Montgeron had to be sold and his entire collection, which in 1878 contained 16 paintings by Monet, including *Impression, Sunrise*, was auctioned off. There were so many pictures that prices were inevitably low; the auction was seen as another great disaster for the Impressionist painters, whose prices, which had been slowly rising, now fell to an all-time low.

After Argenteuil

For the Monet family, this meant the end of life in the little pink house with the green shutters at Argenteuil. In the summer of 1878 they moved to a much more modest house at Vétheuil, a remote and largely unchanged village on the Seine between Médan and Giverny, much further out of Paris than Argenteuil. The strong allusions to modern life that had been prominent in much of Monet's work at Argenteuil now disappeared and his paintings, in subject matter if not in treatment, became closer to those of more conventional Salon artists. It was not until the end of the century, when Monet visited London, that the modern world again played an important part in his work.

Monet was in such financial straits when he left Argenteuil that he had to borrow cash to pay the removal men. The man who helped him out was Dr. Paul Gachet, another admirer of the Impressionists' work, who is now

making a lake when he eventually settled down in his last property at Giverny.

Unfortunately, the pleasant life at Montgeron turned out to be an illusion that quickly dissipated. Ernest Hoschedé, whose financial dealings had already led to an unfortunately timed sale of his paintings in 1874, including works by Monet, Sisley, Degas and Pissarro,

OPPOSITE
The Ice-Floes, 1880
Oil on canvas, 20^1/$_2$ x 28in (52 x 71cm)
Musée d'Orsay, Paris

This painting was executed in Monet's studio from a smaller oil sketch done by the river. He painted it for the 1880 Salon, but it was rejected.

LEFT
Rose Beds at Montgeron, 1876
Oil on canvas, 68^1/$_8$ x 76in
(173 x 193cm)
Hermitage, St. Petersburg

When Ernest Hoschedé invited Monet to his country house at Montgeron, he asked him to paint, as well as the four panels intended for room decoration, pictures of some of the loveliest spots in his garden. This painting of the early autumn tints beginning to show among the rose beds near the lake was one of the several non-panel paintings that Monet did in the garden at Montgeron.

OPPOSITE LEFT
Chrysanthemums, 1878
Oil on canvas, 21 x 24¹/4in
(53.5 x 61.5cm)
Private collection

OPPOSITE RIGHT
La Rue Montorgueil; Fête du 30 Juin,
1878
Oil on canvas, 31¹/2 x 19in
(80 x 48.5cm)
Musée d'Orsay, Paris

LEFT
Landscape, Vétheuil, 1879
Oil on canvas, 23⁵/8 x 29in
(60 x 73.5cm)
Musée d'Orsay, Paris

Apple Trees in Blossom, 1879
Oil on canvas, 25^{1}/$_{3}$ x 30^{3}/$_{4}$in
(64.3 x 78.1cm)
Museum of Fine Arts, Budapest

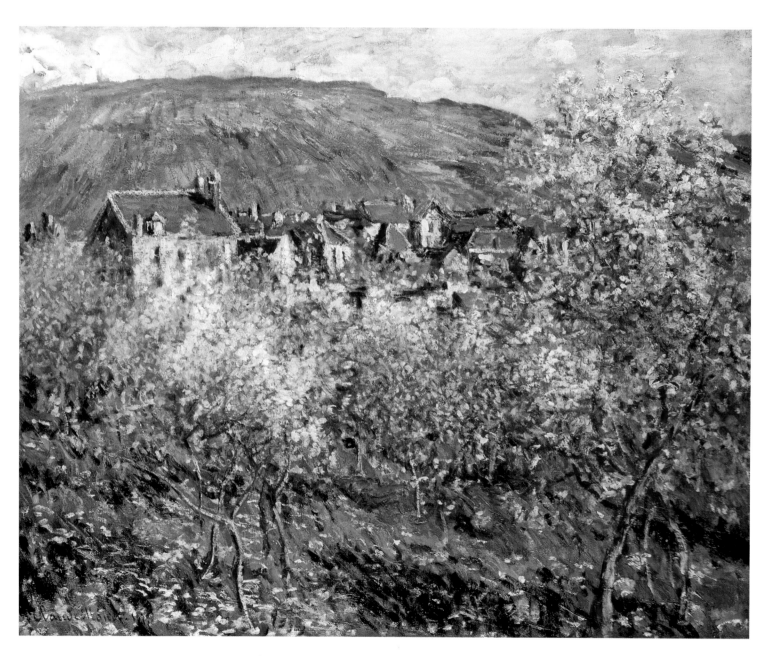

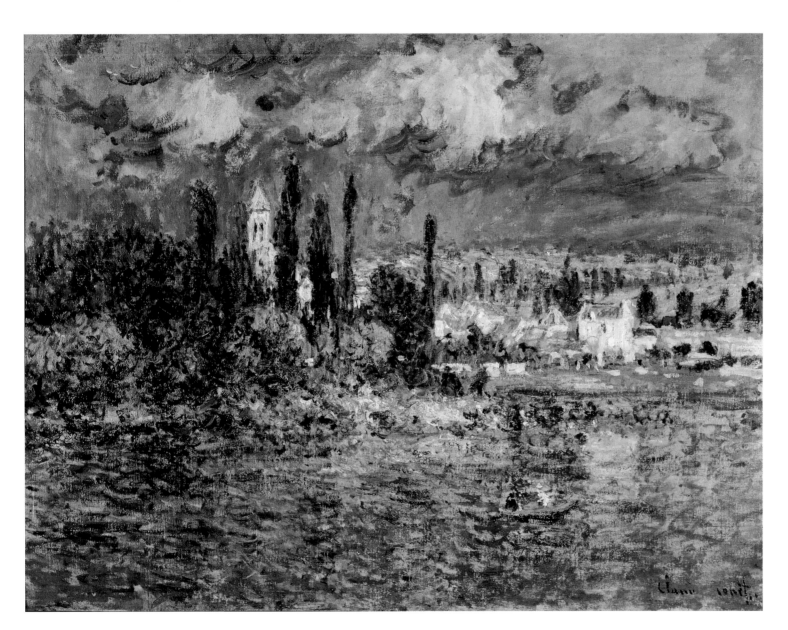

Landscape with Thunderstorm
Oil on canvas
Folkwang Museum, Essen

PAGE 154
The Artist's Garden at Vétheuil, 1880
Oil on canvas, 59⅝ x 47⅝in
(151.4 x 121cm)
National Gallery of Art, Washington,
D.C.

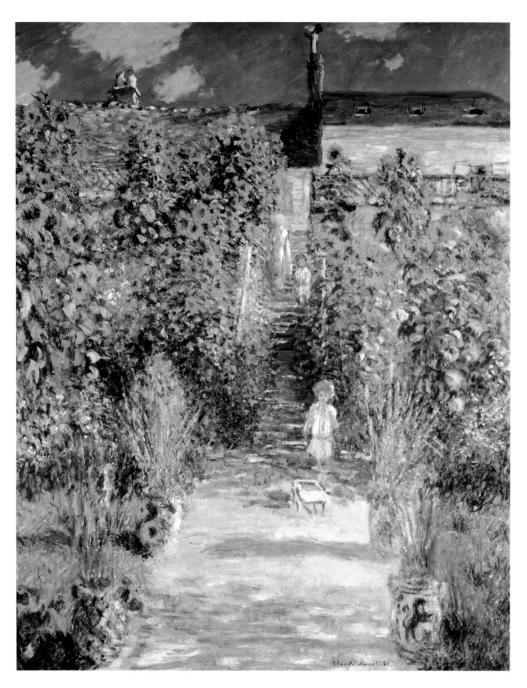

best known for taking Vincent van Gogh under his wing at Auvers-sur-Oise in the final months of the artist's life. Dr. Gachet's great collection of paintings, including several by Monet, was, like Caillebotte's, one of the foundation stones of France's Impressionist collection, now in the Musée d'Orsay.

By this time, Monet seems to have become closer to Alice Hoschedé than was advisable for a married man. Perhaps he became attracted to her because Camille, who had given birth to their second son, Michel, early in 1878, was never well afterwards and may, in fact, have had cancer. This intimacy, if that is what it was, resulted in the now bankrupt Hoschedés and their six children (four daughters and two sons) joining Monet at Vétheuil. Camille's illness meant that all the children in the household inevitably came under Alice Hoschedé's care.

Although he may not have realized it at the time, the move to Vétheuil marked the end of Monet's interest in Paris as a subject for his painting. His last important painting of the city, *La Rue Montorgueil, Fête du 30 Juin* (page 150), the street decked out in flags, was painted in 1878 while the family was still living in the rue d'Edimbourg, where Michel was born. It was one of two pictures Monet did of the celebrations, marking the first Fête Nationale to have been held in France since the Commune, and illustrates wonderfully well the dynamism

that fired the best Impressionist painting. The picture is spontaneous – Monet was walking along the street with his painting equipment and was so taken by the scene he rushed up the stairs to an apartment and asked permission to use the balcony – and it is pulsating with life: an interlacing of flags and awnings, sunlight and shadow, people and parasols.

For a time, Monet, despite finding himself in a household of four adults and eight children, was satisfied with his new life at Vétheuil. The house, though small, had a good-sized garden, the main features of which, to judge by such paintings as *The Artist's Garden at Vétheuil* (opposite) and *The Steps at Vétheuil* (page 172) were a steep flight of steps and great clumps of sunflowers. The area around was 'enchanting' and from his studio boat Monet was able to paint many pictures of the scene on the riverbank and of the two villages, Vétheuil and Lavacourt, that faced one another from opposite banks of the river.

Monet made two particularly fine paintings of Vétheuil seen from his studio boat on the river. *Vétheuil in Summer* (right) has the village and the sky above reflected and even dissolving in the limpid waters of the river. In *Vétheuil in Winter* (page 156), the village and the snow-covered hill behind make a backdrop for a river scene that includes two boatloads of people picking their way across the icy water.

But soon Monet's constant indebtedness, and the

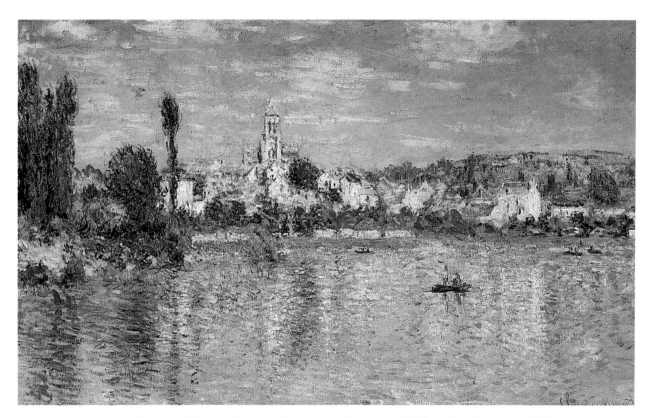

feeling that he was living off Ernest Hoschedé, who had managed to save enough from the wreck of his fortune to pay the expenses of the house in Vétheuil, wore him down and the need to endlessly beg from and pester buyers reduced him to a state of depression.

As 1879 wore on, Camille became weaker and weaker

Vétheuil in Summer, 1880
Oil on canvas, 23⅝ x 39¼in
(60 x 99.7cm)
The Metropolitan Museum of Art, New York

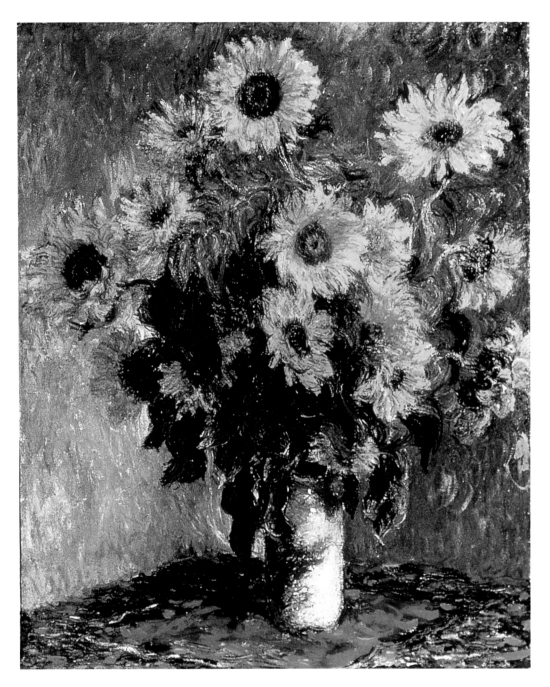

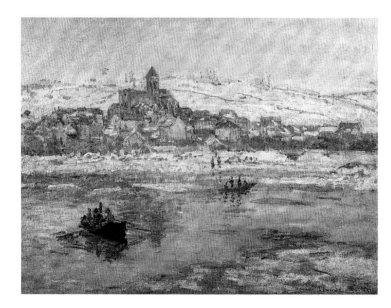

and Monet spent many hours indoors with her, even taking up still life painting again rather than be idle. Monet's still lifes of this period, which he continued to do until 1882, were mostly bouquets of flowers and arrangements of fruit or game, and were informal compositions, freely painted. They had a strong influence on still life painting in France: Vincent van Gogh, in particular, was greatly struck by their dynamism and vibrancy when he saw them in Paris in the mid-1880s. Van Gogh must surely have seen this wonderfully fresh and lively *Sunflowers* that Monet painted in 1881!

MONET

By August, 1879, as Monet wrote to Georges de Bellio from Vétheuil, even painting was denied him because he had neither canvas nor colours with which to paint. The money that Monet would have spent on painting materials – 4 or 5 francs each for brushes, a franc a tube for basic colours, and anything up to 10 or 15 francs for a tube of a rare colour, with about 33 francs for a standard 120-size canvas – had gone on medicines for Camille and food for the family. He asked Bellio if he could help 'out of his own pocket', by going to Monet's studio in Paris and taking a few of the canvases there for 'whatever price you like'.

On 5 September 1879 Camille, who had been his only model and his muse, the inspiration for some of his loveliest paintings, died. She was 32. Monet was distraught. He was also rather shocked that, even as his wife lay dying, he could look at her and notice the different colours and planes of her face, and the way that death brought changes and different nuances of colour. In the early hours of the morning, as the first rays of the sun were entering the room, he took up his brush and painted Camille on her death bed. There is sunlight warming the edge of the pillow on which Camille's head rests, but nothing can warm the icy colour of death on her face.

On the day of Camille's death, Monet had one more favour to ask of Bellio. He sent him a pawn ticket and

OPPOSITE LEFT
Sunflowers, 1881
*Oil on canvas, 39³/4 x 32in
(101 x 81.3cm
Metropolitan Museum of Art, New York*

OPPOSITE RIGHT
Vétheuil in Winter, 1878–79
*Oil on canvas, 27 x 35³/8in
(68.6 x 89.9cm)
The Frick Collection, New York*

The village of Vétheuil had a particularly attractive setting on the right bank of the Seine. Monet called it 'ravishing' and proceeded to paint the village and its fine church in all weathers and at all seasons of the year.

LEFT
Camille Monet on Her Deathbed, 1879
*Oil on canvas, 35³/8 x 26³/4in
(90 x 68cm)
Musée d'Orsay, Paris*

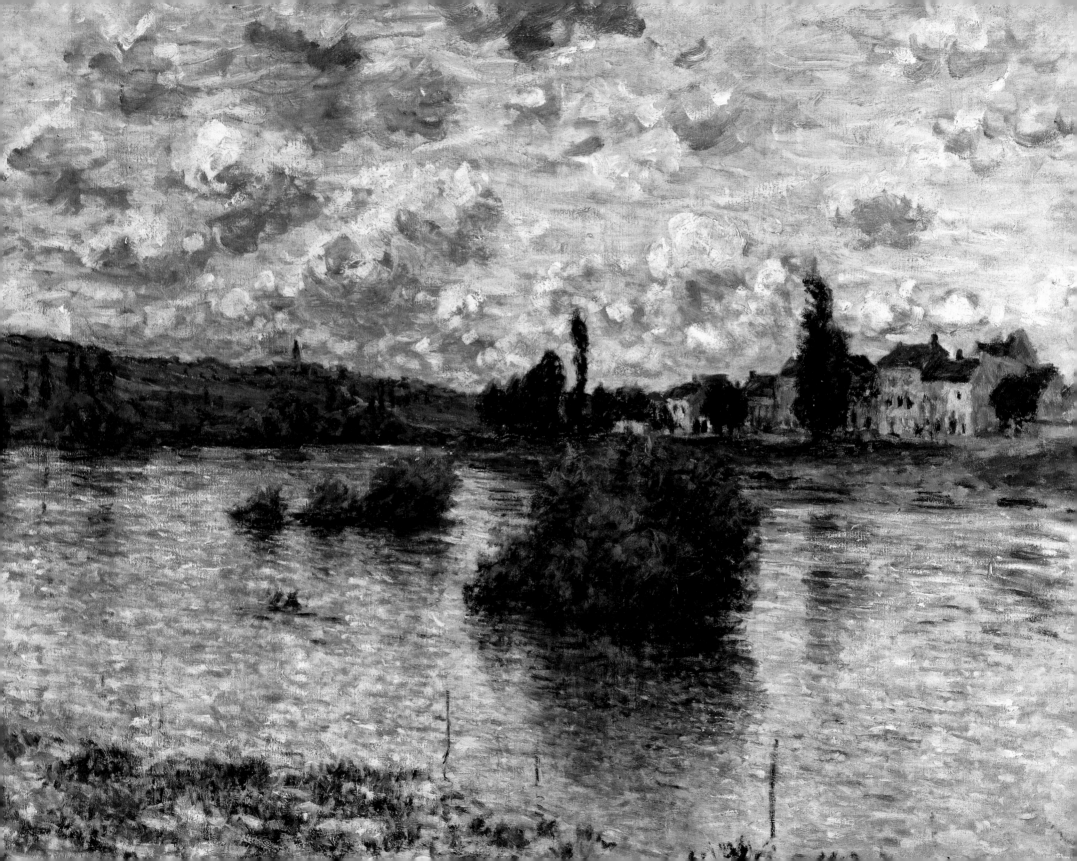

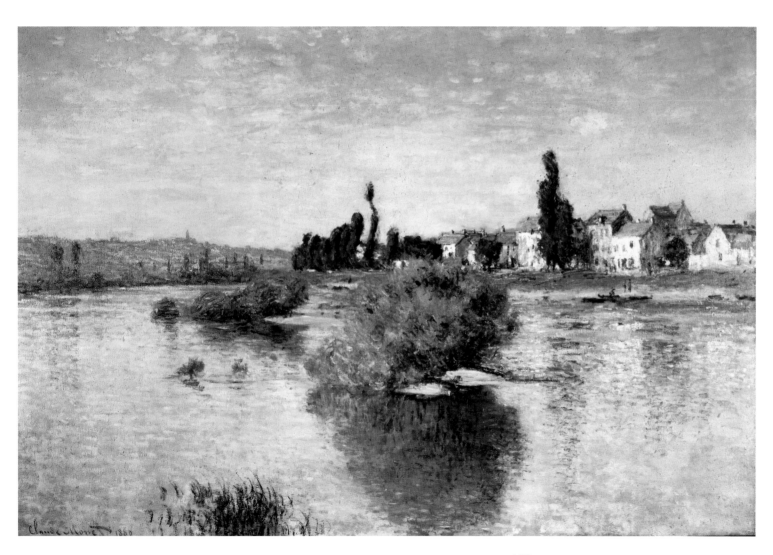

OPPOSITE
The Seine at Lavacourt, 1880
Oil on canvas, 24 x 32in (61 x 81.2cm)
Fogg Art Museum, Harvard University
Art Museums

LEFT
The Seine at Lavacourt, 1880
Oil on canvas, 38³/4 x 58³/4in (98.4 x
149.2cm)
Dallas Museum of Art

asked him to retrieve Camille's locket, the only keepsake she had managed to retain, so that he could put it round her neck before her burial.

Monet's bleak mood extended to his painting in the months that followed Camille's death. That autumn, he painted several pictures of mist and river fog over Vétheuil in which, unlike earlier pictures, such as *The Thames and the Houses of Parliament* (page 81), the forms in the pictures almost disappear into the mist. He sold one of them, *Vétheuil in the Fog*, to his important patron, the singer Faure, who apologetically returned it after a few weeks, saying that his friends were making fun of him for buying a picture with so little painted on it. Monet kept the picture for the rest of his life, exhibiting it frequently in the late 1880s as an example of the ephemeral effects he was constantly seeking to achieve in his work.

In the cold winter that followed that misty autumn, Monet went out into the harsh, icy world and painted pictures with nothing of the snowy, Christmas-card attractiveness of such pictures at *The Magpie* (1869) or *Boulevard Saint-Denis, Argenteuil in Winter* (1875) about them. Now his paintings were bleak, with no birdlife, and no people either. *Floating Ice near Vétheuil* (page 162) and *The Ice-Floes* (page 148), both painted in 1880, are cold, bleak scenes, dominated by skies that look as though they will never see summer again.

From this period, Monet began to loosen the close ties that had once bound him to the other Impressionists. It may have been in the natural order of things that the painters, all becoming middle-aged and all with families and other commitments, should have drifted apart. But Monet's life, now spent beyond the artistic circles of Paris and all too obviously living with a woman who was not his wife and whose husband was still alive, did not find it as easy to relate to his old friends as he had before.

By the early 1880s, Ernest Hoschedé had moved to Paris, where he lived estranged from his wife for the rest of his life. Alice became Monet's 'partner', to use a modern term, and her children became as important to Monet as his own two sons, her eldest daughters, Blanche and Suzanne, growing particularly close to their 'stepfather'. After Ernest Hoschedé died in 1891, Monet and Alice were married, and Monet began to travel, secure in the knowledge that his family was safe at home with Alice, to whom he sent a constant stream of notes and letters describing his activities. While travel was certainly a source of inspiration for this work, it also kept him away from Paris and the artistic life of the city.

After 1880, Monet never again submitted paintings to the Salon. The works he showed that year prompted some strong criticism from Emile Zola, even though the critic was an admirer of the Impressionist's work. He accused

OPPOSITE
Still Life with Pears and Grapes, 1880
Oil on canvas, 25¹/₂ x 31¹/₂in (65 x 80cm) Kunsthalle, Hamburg

The still lifes, mostly fruit and flower pieces, that Monet painted around 1880 were loosely arranged and allowed to spread casually across the canvas. They were widely admired and sold well. He himself was not greatly interested in still life painting, and once the burst of enthusiasm he felt at this time had waned, he painted very few.

Floating Ice near Vétheuil, 1880
Oil on canvas, 38^1/4 x 59^1/2in
(97 x 151cm)
Shelburne Museum, Vermont

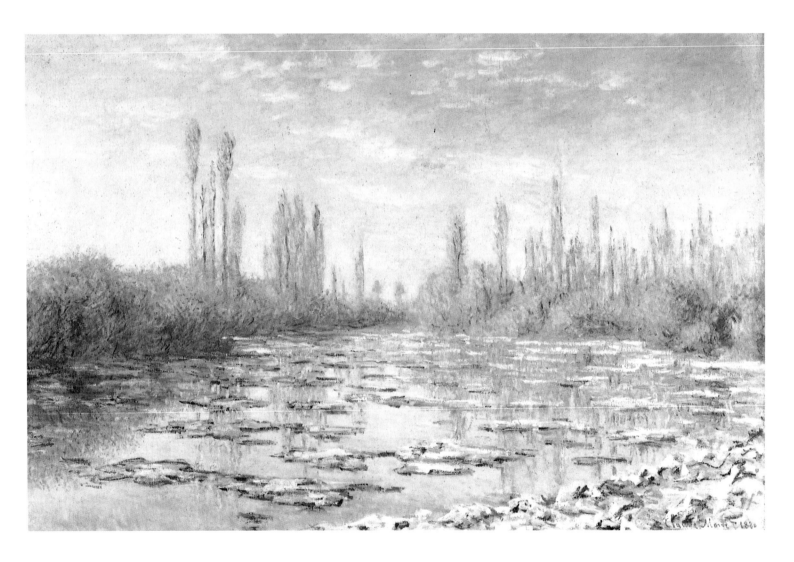

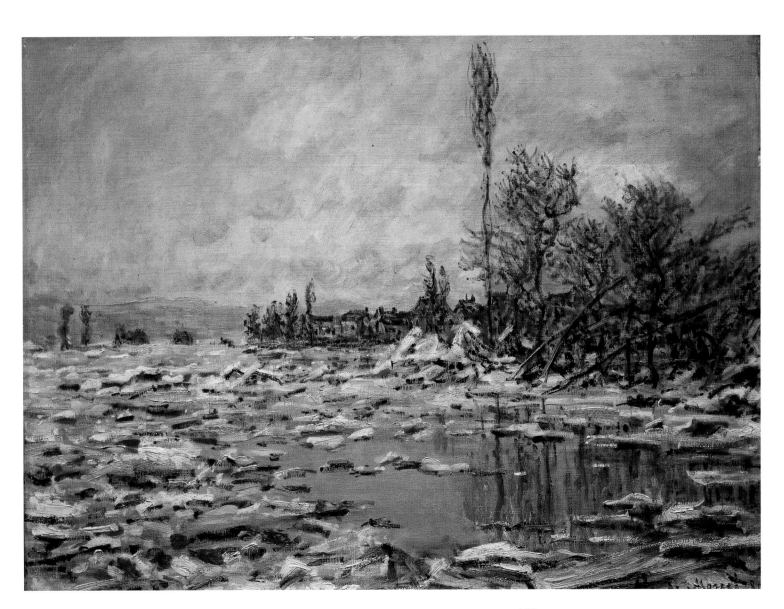

LEFT
Break-up of Ice, Lavacourt, 1880
*Oil on canvas, 26³/4 x 35³/8in
(68 x 90cm)
Museu Calouste Gulbenkian, Lisbon.*

*There was plenty of drama when the
exceptionally harsh winter of 1879–80
caused the Seine to freeze over in many
places. A sudden thaw in early January
broke up the ice and large blocks of it
were sent floating down the river.*

PAGE 164
Frost Near Vétheuil, 1880
*Oil on canvas, 24 x 39³/8in
(61 x 100cm)
Musée d'Orsay, Paris*

PAGE 165
The Thaw on the Seine, 1880
*Oil on canvas
Musée d'Orsay, Paris*

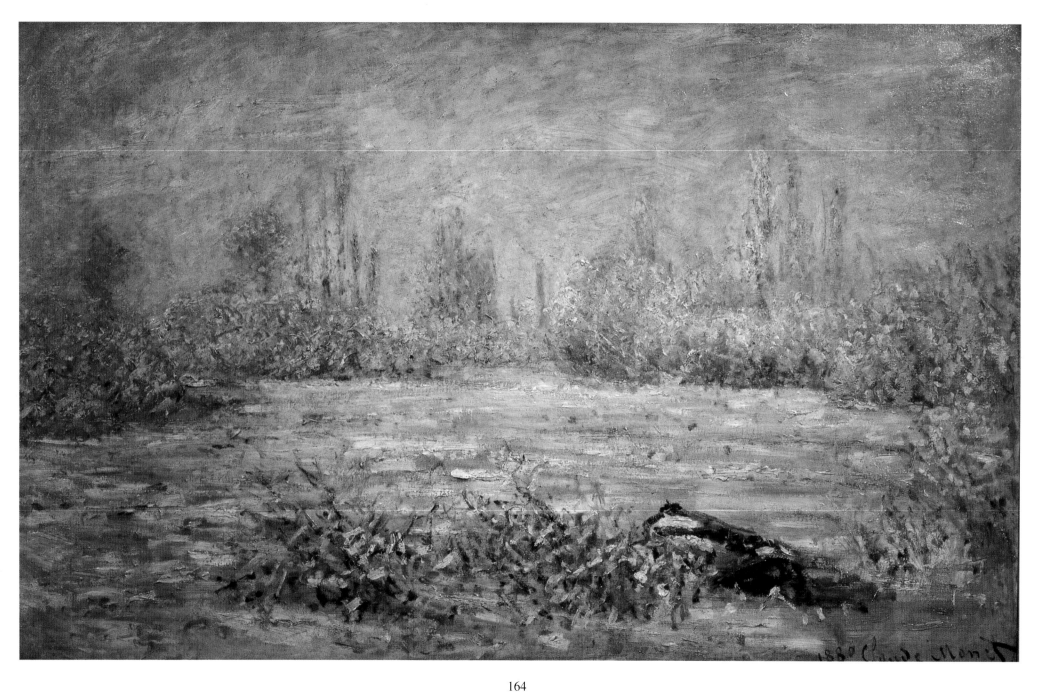

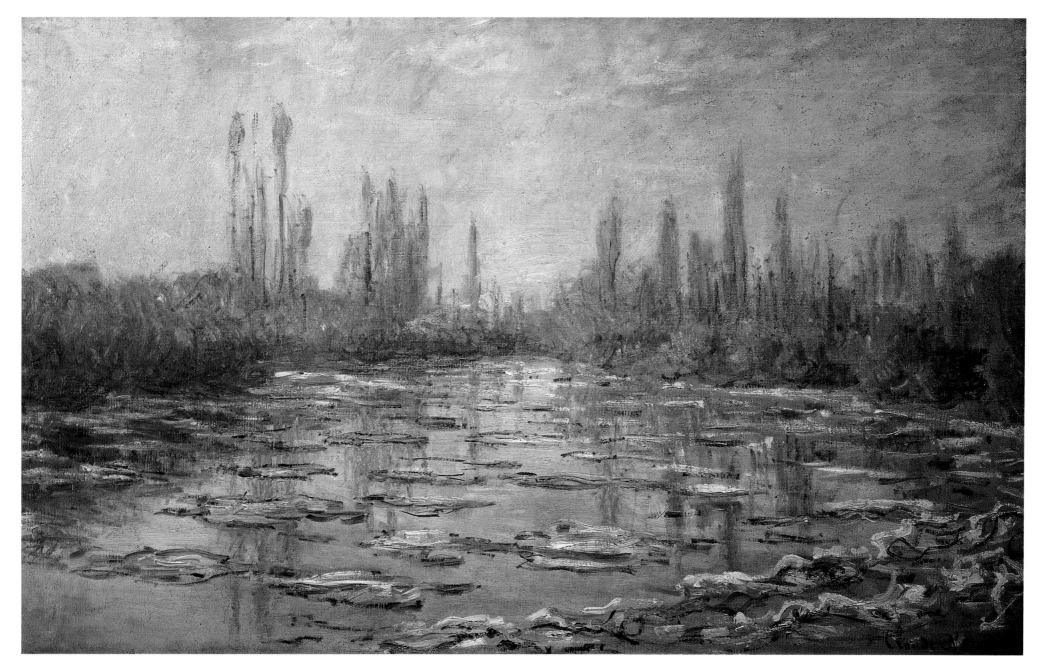

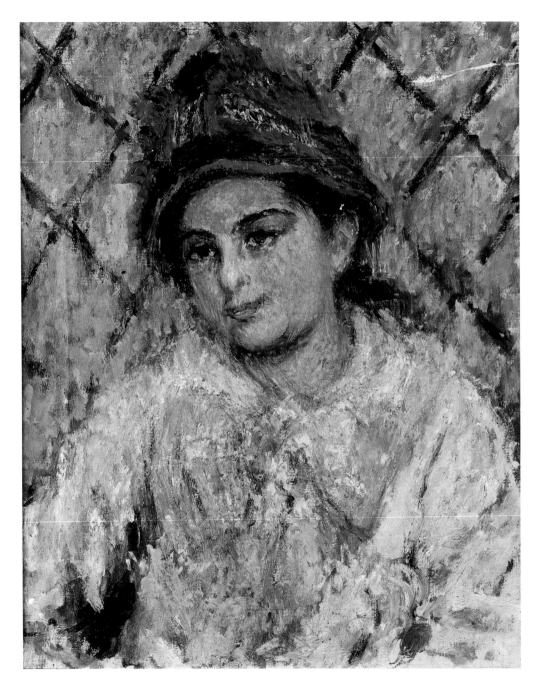

the Impressionists, and Monet in particular, of relying too much on a facile sketchiness and informality and of not finishing their paintings. He advised them to be more ambitious in their approach, because producing single, highly-finished paintings would do more to express their personalities. He could also have pointed out that such an approach would make the dealer's task of selling their work that much easier.

From then on, Monet chose to show his work as much as possible, not in group shows, but in one-man exhibitions arranged by dealers. He felt that all the collective exhibitions his friends kept organizing were more likely to stultify public curiosity than excite it. He was, perhaps, encouraged in this view because Paul Durand-Ruel, with whom Monet had developed a strong relationship, began buying his work regularly again in 1881, a year in which he also funded Monet's travels, so that Monet could now feel more financially secure. The question of group versus one-man shows rumbled on for some years, however, because even Monet could see some sense in Alfred Sisley's point that if all his friends put on one-man shows, one after the other, the whole business could drag on for ever. Moreover, there would be arguments about who should go first.

Monet made no strong objections to Durand-Ruel's inclusion of his paintings in group exhibitions of

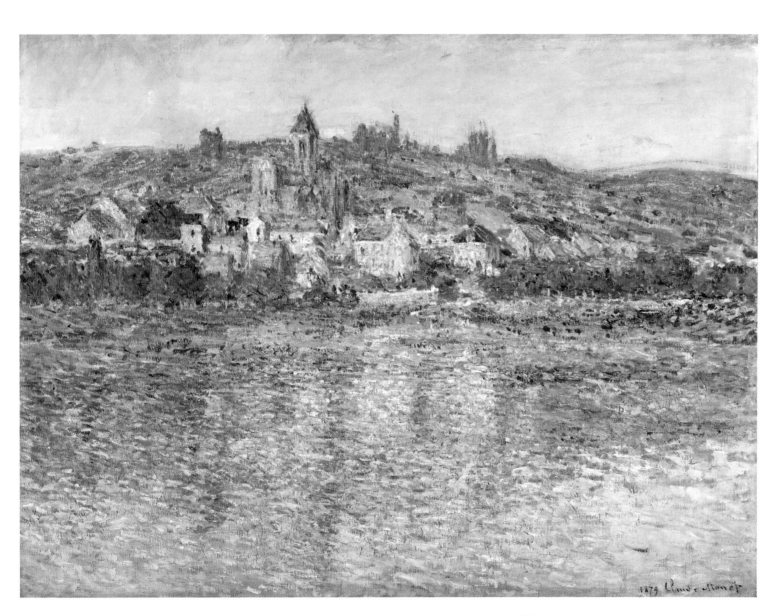

OPPOSITE
Portrait of Blanche Hoschedé as a Young Girl, c.1880
Oil on canvas, 18¹⁄8 x 15in (46 x 38cm)
Musée des Beaux-Arts, Rouen

Blanche Hoschedé married Monet's elder son, Jean and eventually became Monet's housekeeper after the death of Alice.

LEFT
The Seine at Vétheuil, 1879
Oil on canvas, 26³⁄4 x 36⁵⁄8in
(67.9 x 90.5cm)
Art Gallery of Ontario, Toronto

Monet painted numerous pictures entitled Vétheuil, many of them summer scenes. They differed greatly in their qualities of light, especially sunlight, and the times of day that Monet depicted in them. But they were technically similar, in that the broken touches of colour that Monet had started to use some years before were now being applied to his canvases in a jumble of small mounds of colour, like 'curly wool', as one commentator described it.

Michel Monet Wearing a Bobble Hat, 1880
Oil on canvas, $18^1/8$ x 15in (46 x 38cm)
Musée Marmottan, Paris

Michel was Claude and Camille Monet's second son. Born in 1878, he hardly knew his mother, who died when he was not quite 18 months old, and was brought up by Alice Hoschedé.

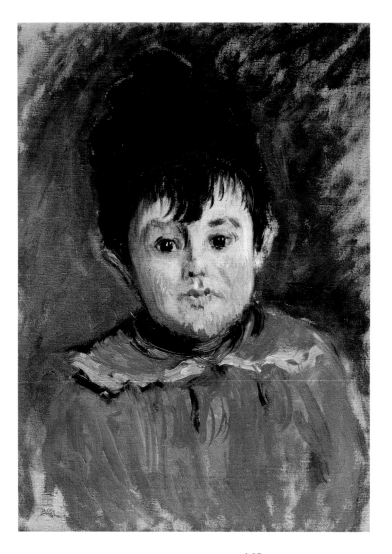

Impressionist work he organized in London in 1882 and 1883. The second exhibition was quite a large affair, held in a New Bond Street gallery; Durand-Ruel had possibly been encouraged to push the boat out by the several favourable reviews received for the smaller 1882 show, which had been mounted in King Street, St James's. A review in *The Standard* concerning the 1882 show recommended readers to see it, both because several of the pictures in it were excellent, and because the French Impressionists were at this time little known in England. The writer of the review paid particular attention to the work of Degas and 'his highly accomplished pupil', Mary Cassatt. Renoir and Sisley both came in for moderate praise and Claude Monet, 'not for a moment to be confused with Manet, the figure painter', was said to be at his finest in *Low Tide at Varengeville*, 'a coast picture of cliff, and beach and sky, full of glowing colour and liquid light'.

At the end of 1881, Monet and his family left Vétheuil and moved to Poissy, a town nearer Paris in the Forest of St.-Germain. Monet had never felt much drawn to Poissy, even though he had spent many months of the year away from his home there. A major flood of the Seine in December 1882 was probably the last straw: Monet wrote to Paul Durand-Ruel that for the time being he was not a painter, but a lifesaver, rower, removal man etc. Their

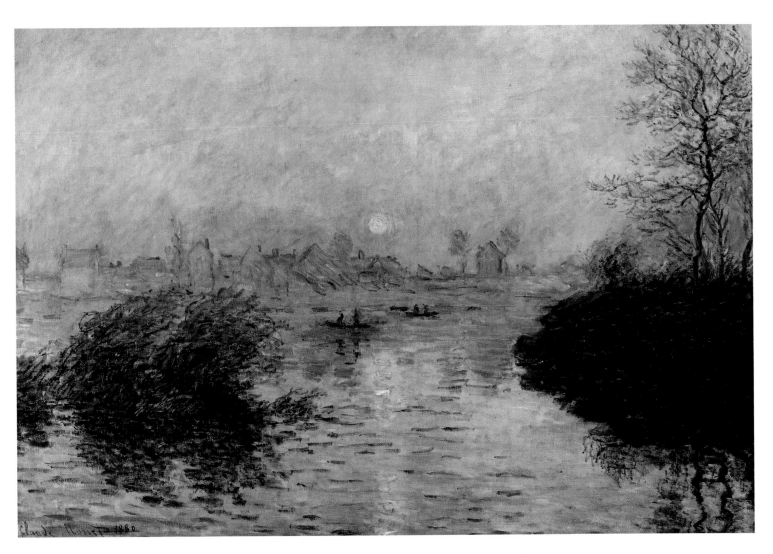

Sun Setting over the Seine at Lavacourt, Winter Effect, 1880
*Oil on canvas, 39³/4 x 59in
(101 x 150cm)
Musée de la Ville de Paris, Musée du
Petit-Palais*

*Unlike others of his Lavacourt pictures
of 1880, including two that Monet
hoped to get into the Salon, this winter
scene, and the one on the following
page, is a quite sketchy 'impression'.
The reflection of the orange sun in the
waters of the Seine recalls the famous*
Impression, Sunrise *that gave*
Impressionism *its name.*

Sunset, 1880
Oil on canvas
Private collection

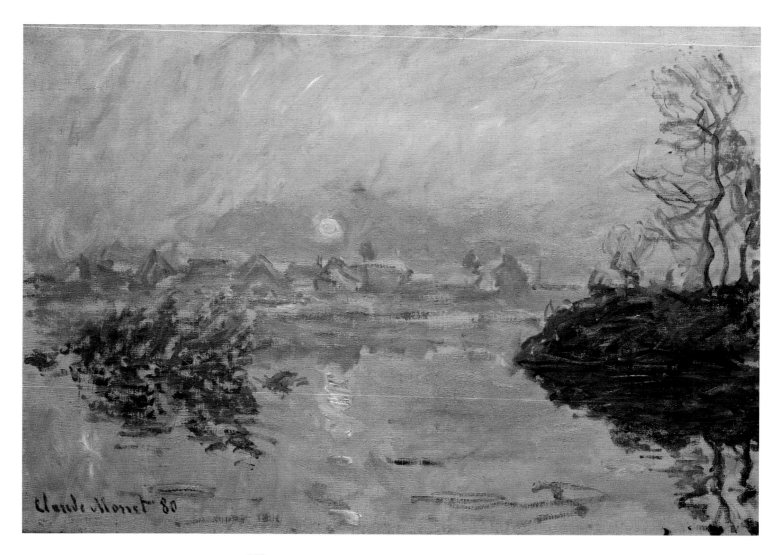

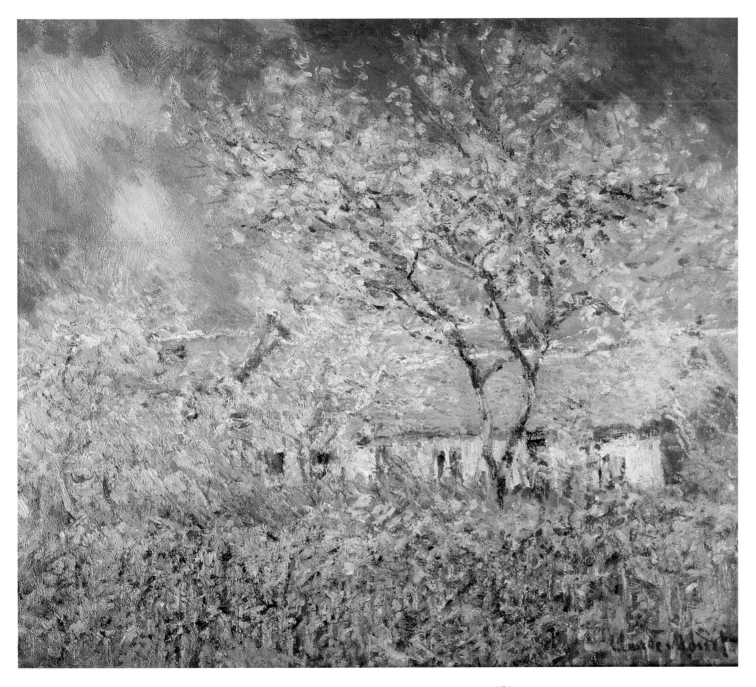

Springtime at Giverny, 1880
Oil on canvas
Christie's Images. London

The spring that followed the extremely cold winter of 1880 was particularly beautiful, and Monet refused to move from his home in Vétheuil so that he could work on canvases such as this delicately lovely picture of the Seine, seen through the branches of a tree just bursting into bud.

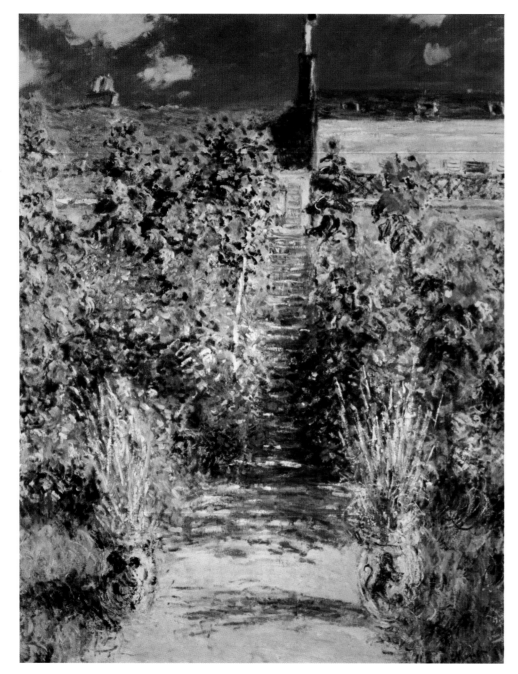

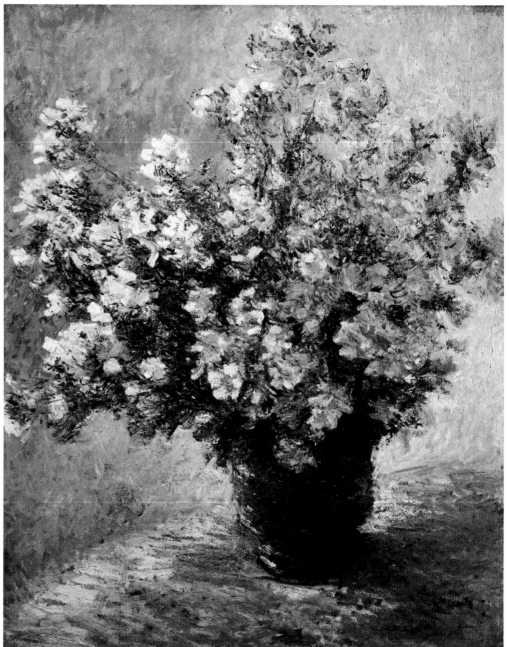

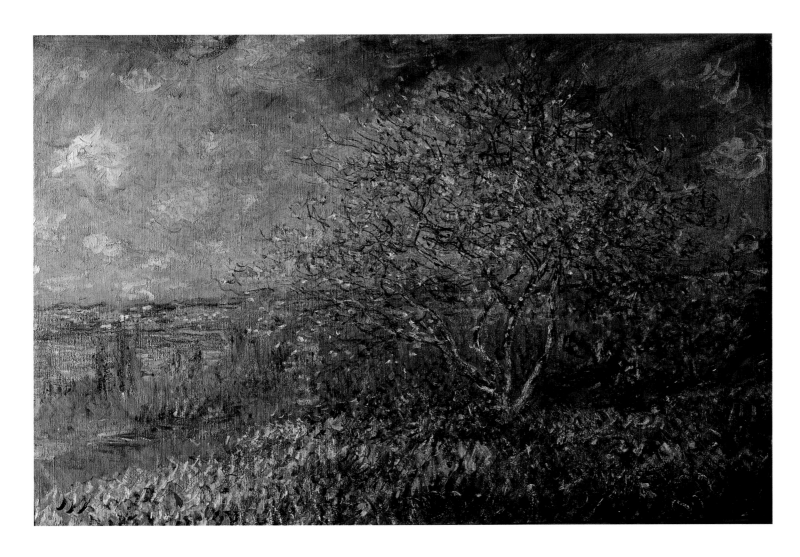

OPPOSITE LEFT
The Steps at Vetheuil, 1881
Christies Images, London

The two main features of Monet's garden at Vétheuil (see also page 154) – a flight of steps and large clumps of sunflowers – are prominent in this painting. The blue pots are also familiar; they first appeared in Monet's paintings in the happy days at Argenteuil.

OPPOSITE RIGHT
Vase of Flowers, c.1881
*Oil on canvas, 39^1/$_2$ x 32^1/$_4$in
(100.4 x 81.8cm)
Courtauld Gallery, London*

A bunch of mallows thrust casually into a vase makes a delightful still life subject.

LEFT
Spring, 1880–82
*Oil on canvas, 23^5/$_8$ x 31^7/$_8$in
(60 x 81cm)
Musée des Beaux-Arts, Lyon*

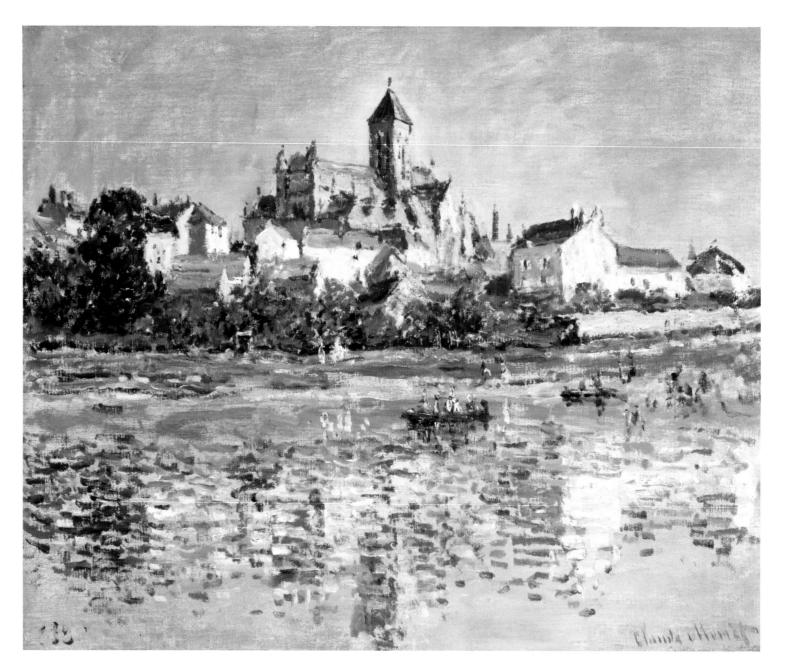

The Church at Vétheuil, 1880
Oil on canvas, 19⁷/₈ x 24in
(50.5 x 61cm)
Southampton City Art Gallery, England

Installed on his studio boat in the river, Monet had a fine view of Vétheuil and its superb old church – a favourite motif – for this lively summer scene. Although the church is the focus of Monet's picture, he also hints at village life by sketching in people enjoying the riverside scene.

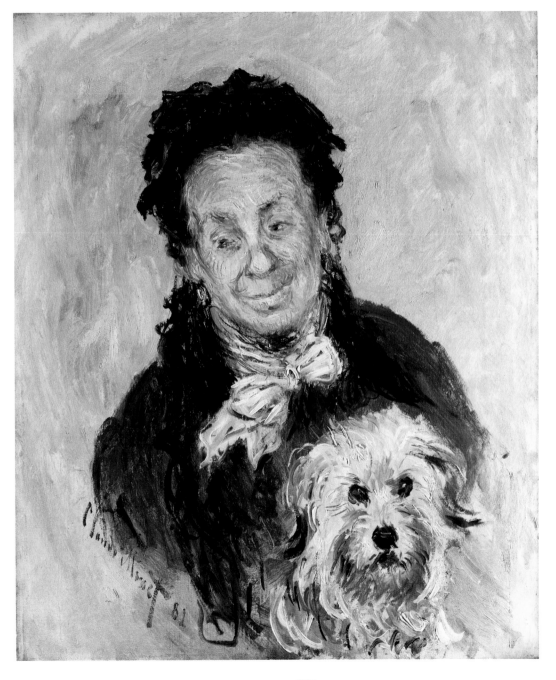

Portrait of Eugénie Graff (Madame Paul), 1882
*Oil on canvas, 24⁷/₈ x 20⁷/₈in
(63.1 x 53cm)
Fogg Art Museum, Harvard University
Art Museums*

Madame Paul was the wife of Père Paul, the owner and skilled chef of the hotel-restaurant where Monet lived during a working stay at Pourville, near Dieppe, early in 1882. Monet also did a fine portrait of Père Paul himself, his chef's cap set at a jaunty angle on his head.

RIGHT
View over the Sea, 1882
Oil on canvas, $25^1/4$ x $32^1/4$in
(64 x 82cm)
Nationalmuseum, Stockholm

OPPOSITE
The House of the Customs Officer,
Varengeville, 1882
Oil on canvas, 24 x $29^1/2$in
(61 x 74.9cm)
Fogg Art Museum, University of
Harvard Art Museums

Monet spent several weeks in 1882
painting around the towns of Pourville
and Varengeville near Dieppe on the
Normandy coast. Favourite motifs on
this trip were rocky sea-coasts, cliffs
and hills and many of his paintings
emphasized the dramatic nature of his
subjects. The customs officer's house at
Varengeville, set on a point with a good
view of the shipping out at sea, featured
in many of the paintings.

The Sea at Fécamp, 1881
Oil on canvas, 25^1/$_2$ x 31^1/$_2$in
(65 x 80cm)
Private collection

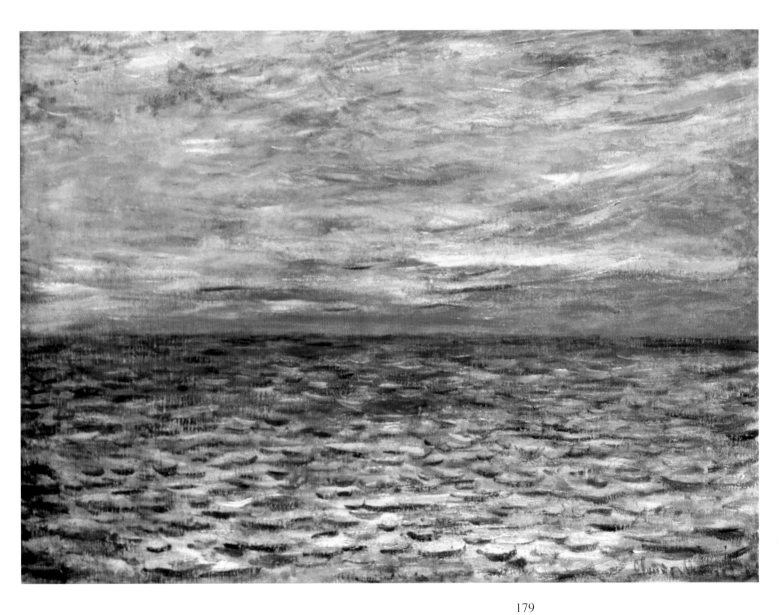

Sunset on the Sea at Pourville, 1882
Oil on canvas, 21¹/₄ x 28³/₄in
(54 x 73cm)
Private collection

house was now in the water and the family had to take refuge on the first floor. It was a pity that painting was out of the question, Monet wrote, for 'there would be some very curious things to do'. Perhaps he was thinking of the great series of paintings Sisley had done in 1876 when the Seine flooded at Port-Marly.

The next year, 1883, began badly for personal reasons. Alice Hoschedé's relations with her husband reached some sort of crisis in February when she decided that she must return to him, or at least leave Monet. She sent a telegram to Monet at Etretat, where he was working on paintings for an exhibition to be held in Paris in March, asking him to return to Poissy at once; this was apparently so that she could explain to him why they must part. Monet wrote a long letter in reply, assuring Alice of his great love for her, and that the thought of having to live without her made him very, very sad.

The crisis blew over, but must only have added to the gloom Monet already felt when the Paris exhibition, organized by Durand-Ruel at his gallery, resulted in the usual poor sales. At least this time, reviews were more favourable.

At the end of April, Monet again moved house, this time, as it turned out, for the last time. He had found a house to rent at Giverny, back down the Seine beyond Vétheuil. The family moved in two phases, once Durand-Ruel had sent 200 francs to cover the cost of the carrier, Monet taking some of his children one day and Alice following the day after with the others. Monet also asked his long-suffering dealer to send him some money once he got to Giverny, as he would not have a *sou* when he got there.

Two days later Monet, greatly distressed, had to write to Durand-Ruel again for funds, this time to cover the cost of a mourning suit and a trip to Paris. Edouard Manet, who had been ill for some time, died on 30 April, and Monet was asked by Manet's brother, Eugène, Berthe Morisot's husband, to be a pallbearer at the funeral.

Manet, who was only some eight years older than Monet, had been a forceful and charismatic figure in the world of French art, and had been regarded as virtually the leader of the Impressionists, even though he did not really accept the concept until he was almost 50. His shockingly early death seemed to mark the end of an era, both in Claude Monet's life and in the history of Impressionism.

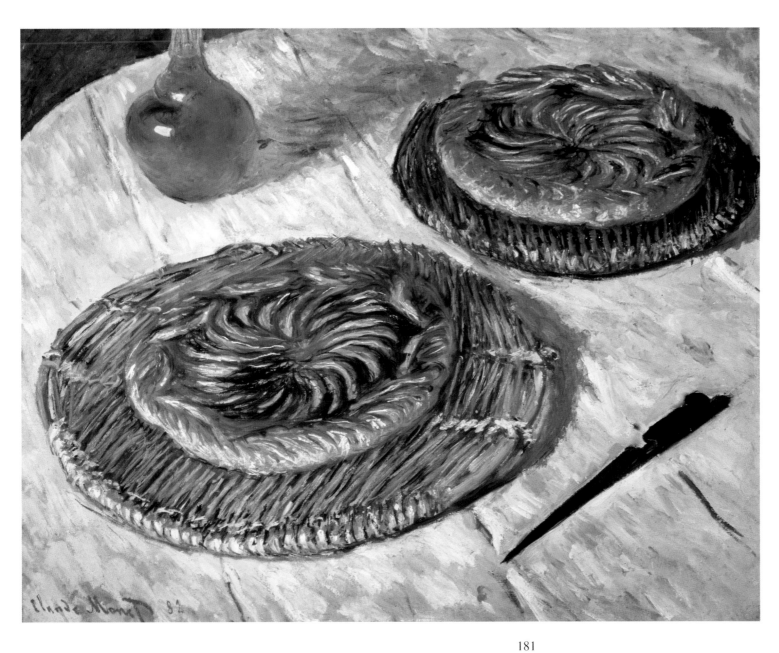

Fruit Tarts, 1882
Oil on canvas, 25¹/₂ x 31⁷/₈in
(65 x 81cm)
Private collection

Chapter Four
Monet, Master of Impressionism
1883–1899

Claude Monet, c.1900

Musée Marmottan, Paris

This fine photographic portrait of France's leading Impressionist painter was taken at the turn of the century, when he still had a third of his painting life ahead of him. Outside the months of high summer, Monet usually wore a heavy three-piece suit like the one in this photograph, with just the high top button of the jacket buttoned.

Giverny, the small village some 38 miles (60km) from the great cathedral city of Rouen, to which Monet and his family moved in 1883, was close to the Seine but separated from it by flat, wide-reaching water meadows. The small river at Giverny was the Epte, a tributary of the Seine, and there were other streams in the neighbourhood; water, so essential to Monet's art, was around him in abundance. The countryside, mostly well-cultivated farmland and orchards set in a lovely, verdant landscape ringed by low hills, was so much to his taste that it inspired many of his most famous and memorable paintings, including his haystacks and poplars series, to the end of the century, when his own carefully cultivated garden superseded them as the mainspring of his inspiration.

The 1880s, during which Monet spent almost as much time travelling in search of subjects and motifs as working at Giverny, saw many changes to and much refining of his art. The work Monet exhibited during the decade is remarkable for the diversity of the subjects he chose to paint and the ways in which he painted them. Still something of a Realist, as well as an Impressionist, Monet did not paint from memory. He said, time and again, that he could only paint what he could see. 'I have never seen an angel so I shall never paint one,' he once remarked.

The Seine at Port-Villez, 1883
Oil on canvas, 23⁷/₈ x 39¹/₂in
(60.5 x 100.5cm)
Private collection

The theme that was to occupy Monet more than any other at Giverny – the way in which light affected reflections in water – is perfectly realized in this painting of a section of the Seine just upstream from Giverny.

MONET, MASTER OF IMPRESSIONISM (1883–1899)

The River Epte at Giverny, 1883
Oil on canvas, 23⁷⁄₈ x 32in
(60.5 x 81.5cm)
Private collection

So vibrant with life is this painting that it is easy to imagine the sound the light-flecked water makes as it tumbles over the rocks on the riverbed. Monet's intense visual experience of the river's mood has resulted in a strongly felt painting.

He was becoming ever more intent on painting objects as if he were seeing them for the first time. It was as if, having been blind, he was suddenly given an instant of sight when he was able to see an object in its purest form, uncluttered by previous experience. Light, and the way light created atmosphere around the object, was the essential element that Monet knew he must get right in a painting if it was to 'work'.

Monet, when assessing a potential painting subject, was looking for what he called its 'envelope' – the particular light and atmosphere unique to it. In a letter to the journalist and art critic Gustave Geffroy in 1890, Monet explained that what he was looking for in all his work was '"instantaneity", the "envelope" above all, the same light spread over everything'.

He was not denying the place of what artists called the 'motif' in painting. What he was saying was that the motif – the extra value that a subject gained from its historical and poetical associations or from that particular, picturesque form that an artist could explore in his painting – was less important than the inspiration an artist could gain from studying the variations of light and colour falling on the subject. What Monet liked best about London, for instance, was not the city and its buildings, with all their historical and cultural associations, but the fog. The fog not only gave London

beauty, it also gave it a marvellous breadth of vision.

In 1895, Monet told an interviewer in Norway that the motif of a painting was an insignificant factor. 'What I want to produce is what lies between the motif and me … I want to paint the air in which [the subjects] are to be found – the beauty of the air around them.' He admitted that he was pursuing the impossible.

Monet had by now given up all thought of beginning and finishing every painting in the open air. Many days were spent working on a painting in its proper 'envelope', but time was also spent on the finishing touches away from the scene in the quiet of his studio at home, particularly when the weather made outdoor painting impossible. The finishing touches that Monet applied in the studio took several forms and could almost entail a repainting of the whole surface of the picture. This was partly a result of the way in which Monet replaced the dynamic, even dramatic use of paint in his earlier works with more muted, uniform brushstrokes that reflected his search for atmospheric unity. He might also choose to give greater definition to features of a painting that now, at home, seemed unclear; or he might decide to heighten the colours in a painting. In fact, much of his time was spent harmonizing the overall effects of brushstrokes and colour juxtapositions in his paintings.

In letters to Durand–Ruel, Monet apologized again

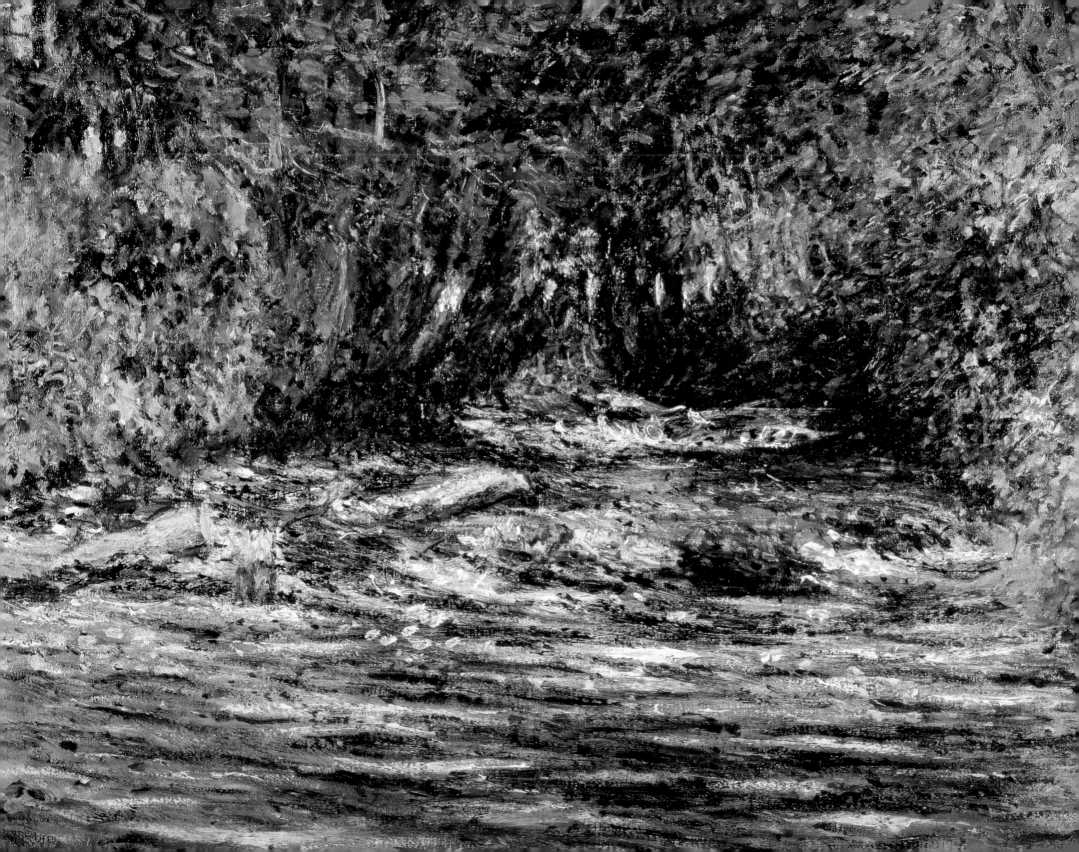

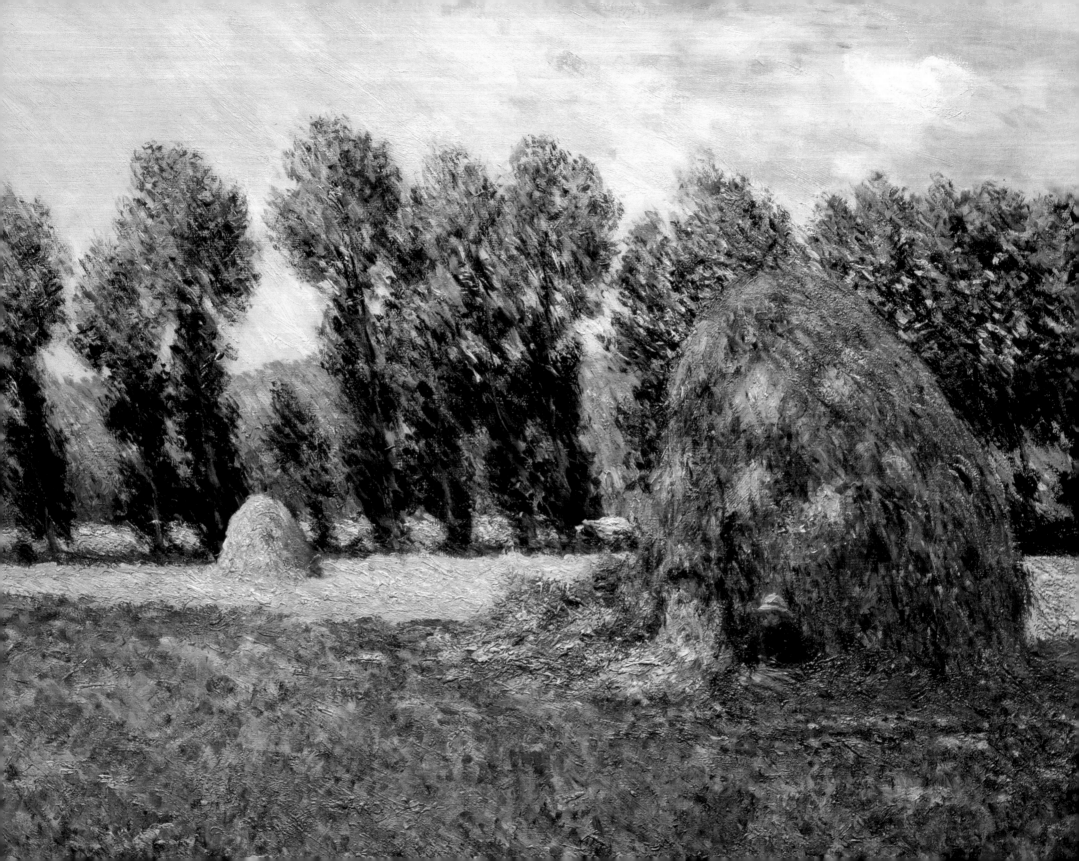

and again for keeping the dealer waiting for paintings. While the 'finishing touches' might have seemed insignificant to an outsider, to the painter they were hard work and always full of problems. Even when no effort had been spared to paint from nature, Monet would later see more things that needed to be done to them, even to the ones that he knew were already very good. As Monet wrote to Durand-Ruel in April 1884, he did not want to turn into a 'mere painting machine', burdening his dealer with a pile of incomplete work that would deter even the most enthusiastic of art collectors. Durand-Ruel had every reason to be pleased that Monet took this approach to his work, since the dealer knew that it was easier to sell obviously finished works than ones in the more typically Impressionist style. Many of his customers had not yet learned to see true Impressionist paintings as anything other than unfinished sketches.

In Monet's view, the paintings not only needed to be finished in themselves; they also needed to conform to the sense of unity of vision over his whole output that Monet held in his mind. His search for what he believed to be the true 'envelope' of each painting often reduced Monet to almost suicidal despair and his letters of the period are full of his doubts and misgivings. He tells Durand-Ruel constantly that he had done nothing worth sending him, that everything he had done recently was

bad, had been scraped off and begun again. Monet may have been a perfectionist, but so, indeed, was Durand-Ruel. He was responsible for saving many a painting from the bonfire that Monet had thought irredeemable, but in which the dealer had seen much to admire.

Creating the Gardens at Giverny

In the second half of the 20th century, Monet's house and gardens at Giverny became a place of pilgrimage for lovers of art. They came in their hundreds of thousands, entering the garden via a doorway on what is now the rue Claude-Monet, convinced that the gardens, carefully restored to Monet's original plan after years of wartime neglect, held the secret to everything that had inspired Monet's art in the second half of his life.

In fact, the large but unpretentious house set in a Normandy apple orchard, which Monet rented in 1883, was for him at first the place where his family lived and from where he sallied forth throughout the decade on his travels in search of new subjects. Although he said in 1883 that he was 'ecstatic' about Giverny, which was 'a marvellous place for him', he was not so attached to it at this time that he could not tear himself away, and much of his time throughout the 1880s was spent far from his home painting on the French coast as far south as the Mediterranean.

OPPOSITE
Haystacks, 1885
Oil on canvas
Private collection

This is an early painting of the haystacks Monet saw every summer in the fields around Giverny. Unlike the later series of haystack paintings, this one is very much a landscape, with recognizable natural features. Although the sunlight is casting shadows on them, they are still real haystacks, not almost abstract forms affected by atmospheric variations.

RIGHT
The Red Road, 1884
Oil on canvas, 25^1/$_2$ x 31^7/$_8$in
(65 x 81cm)
Private collection

OPPOSITE
**The Seine at Port-Villez in Winter,
1885**
Oil on canvas, 28^3/4 x 36^5/8in
(73 x 93cm)
Private collection

*Almost the whole of France separates
these paintings geographically, but just
a few weeks separates the time of year
in which they were painted. Monet went
out of his house at Giverny in the depths
on winter to paint the snow-covered
hills near the Seine at Port-Villez. It was
still only January or February when he
painted this view of the Corniche near
Monaco in the south of France.*

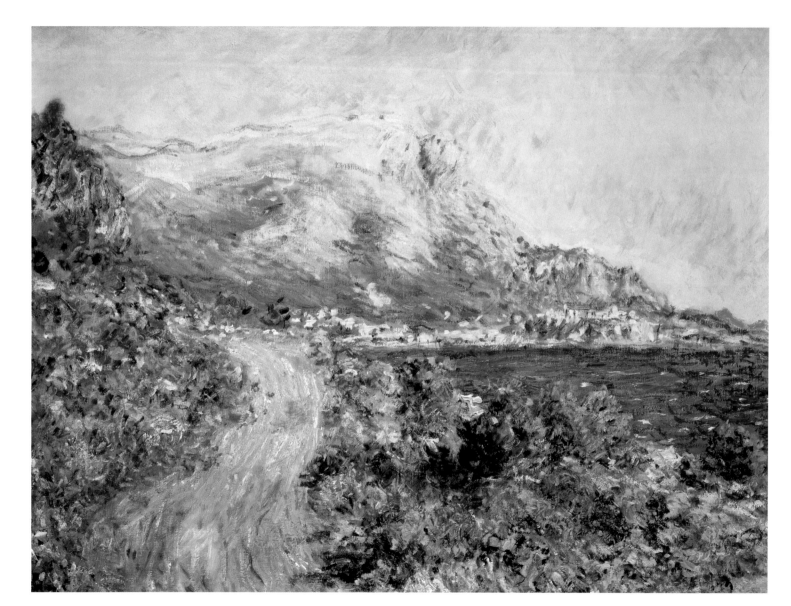

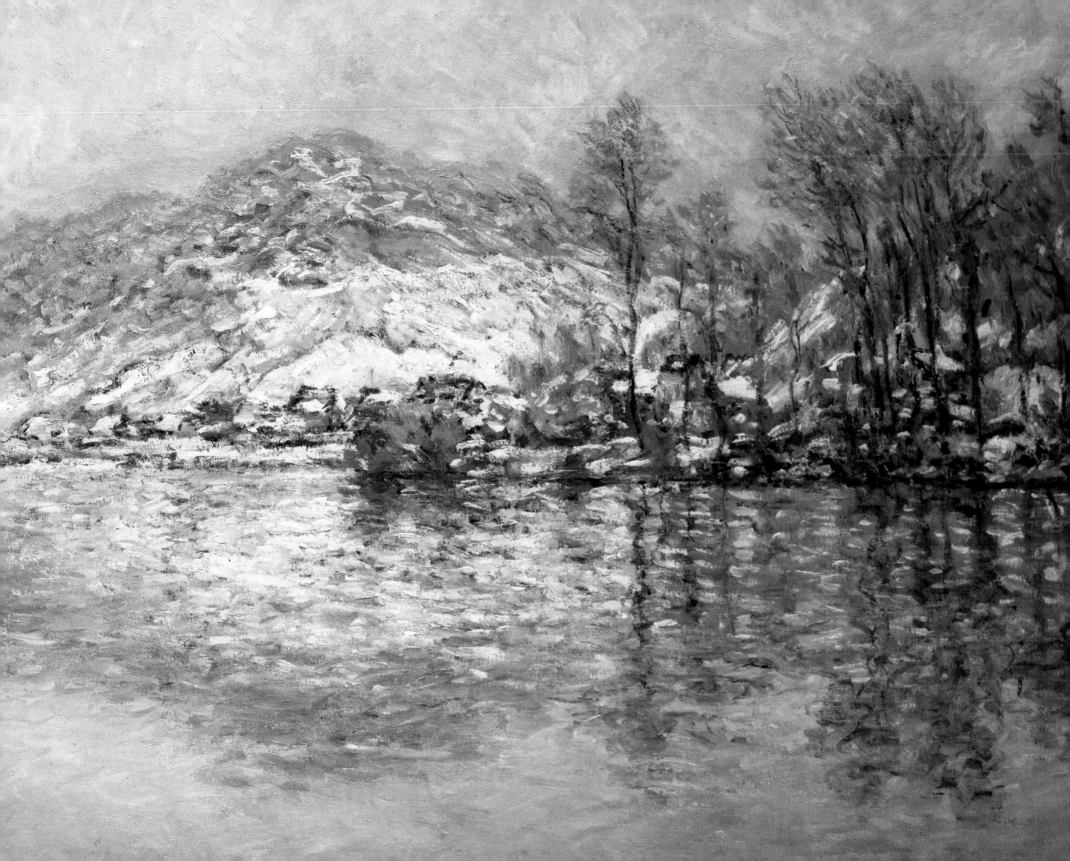

Spring, River Bank of the Epte, 1885
Oil on canvas, 25^1/2 x 32in
(64.7 x 81.3cm)
Private collection

Monet divides his canvas into broad
horizontal bands, broken by the
verticals of many slim tree trunks, for
this wonderfully atmospheric depiction
of early spring by the river. The delicate
tints of the trees' first leaves almost
merge with the pale sky in this
evocation of that time of the year when
winter gives way to spring.

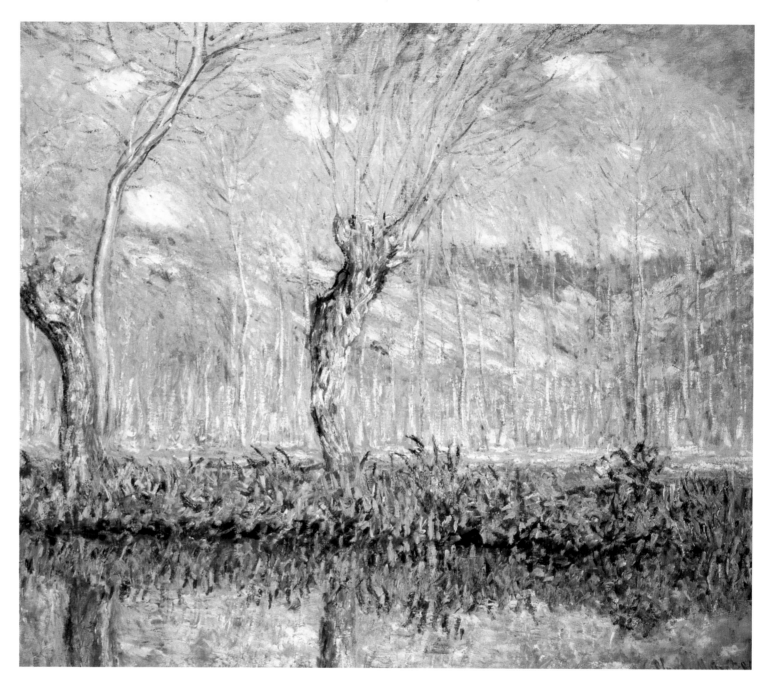

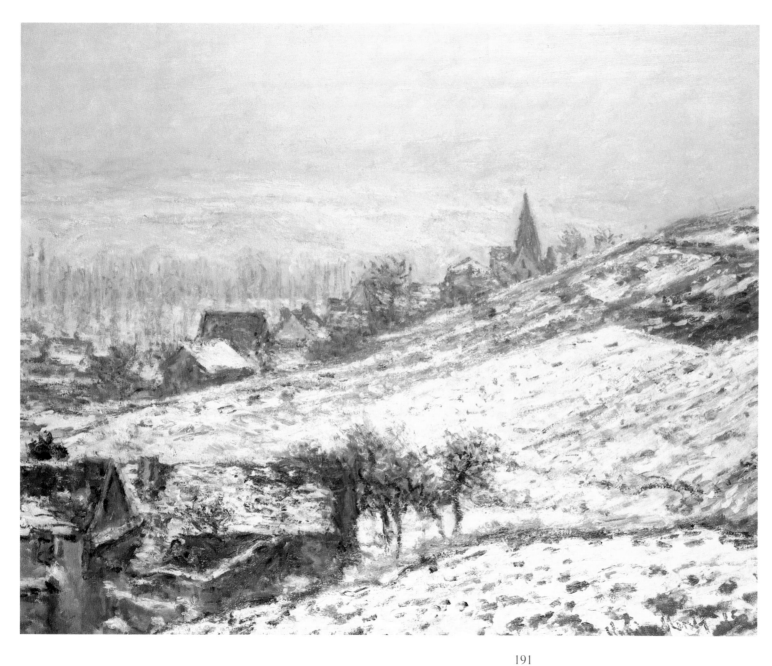

Winter at Giverny, 1885
Oil on canvas, 25³/₈ x 34⁷/₈in
(64.5 x 88.5cm)
Private collection

*Somewhere in the cloud-laden sky there
is a wintry sun, casting a creamy glow
over the damp, misty, snow-covered
countryside at Giverny. Monet uses a
palette of very muted colours to convey
perfectly the atmosphere of a winter day
in northern France.*

OPPOSITE
Poppy Field near Giverny, 1885
Oil on canvas, 26 x 32in (66 x 81.5cm)
Musée des Beaux-Arts, Rouen

Although Monet always said that he only painted what he could see, he was always more than just an observer of the natural phenomena in front of him. He experimented with his painting techniques in order to convey the differences in atmosphere that surrounded the natural objects he was painting. In the summer of 1885 he spent many hours painting the poppies that grew in vivid patches of colour in the fields around Giverny. This and the following two paintings, which were all in work at the same time, demonstrate how the time of day, the amount of sunlight and the strength of the wind blowing clouds across the sky could all radically effect the overall atmosphere of a painting.

This said, some of his finest work of the 1880s and 1890s emerged from the countryside surrounding Giverny, where within weeks of his arrival he was making sure that there were ample flowers in the garden that he could paint when the weather kept him at home. The garden itself played no significant part in Monet's output until the late 1890s.

Beyond the garden gate was quite another matter; Monet mystified the local farming community, which did not know what to make of this unconventional man. They would see him, setting off very early in the morning, sometimes just as dawn was breaking, often accompanied by a tribe of children pushing a wheelbarrow laden with canvases, paints and easels and probably a folding stool and a large umbrella. They would stride across the fields to his chosen site – perhaps a field of poppies, an orchard in blossom, a haystack or two, or a line of poplars on the riverbank – and unload the paraphernalia essential to an artist who needed to have several canvases in work at the same time, particularly when he was involved in his series paintings, when he might spend only seven or eight minutes at a time on any one canvas.

Monet's paintings of poppy fields, such as *Poppy Field near Giverny* (opposite), *Poppy Field in a Hollow near Giverny* (page 194), and *Field of Poppies, Giverny* (page 195), all dated 1885, were probably all in work at

the same time, and were returned to again and again over the time it took to complete them. Suzanne Hoschedé, model for the pair of paintings, *Woman with a Parasol* of 1886 (page 198), one of which shows her turned to the left, the other to the right, appears to be wearing the same dress and scarf-trimmed hat in each picture, suggesting that they were painted together. These paintings, reworkings of *Woman with a Parasol (Madame Monet and her Son)*, page 128, marked the last time that Monet tackled life-sized figure-painting in the open air and he must surely have thought of Camille, who had modelled for the original a decade before.

Local farmers, perhaps, thinking that they might deter this difficult man, tried charging him a toll for crossing their fields, and would dismantle haystacks and even cut down poplars while he was painting them. This must have been very irritating to an artist who so disliked the aspect of any picture he was working on being changed in any way that he usually felt the picture was 'done for', and would never be completed.

In May 1889, when Monet was working on five paintings at Fresselines, in the Creuse river valley, begun the previous winter and in which an oak tree figured, he went to the trouble of getting permission for two local men with long ladders to come to the ravine where the tree grew and remove all its leaves. The owner of the tree

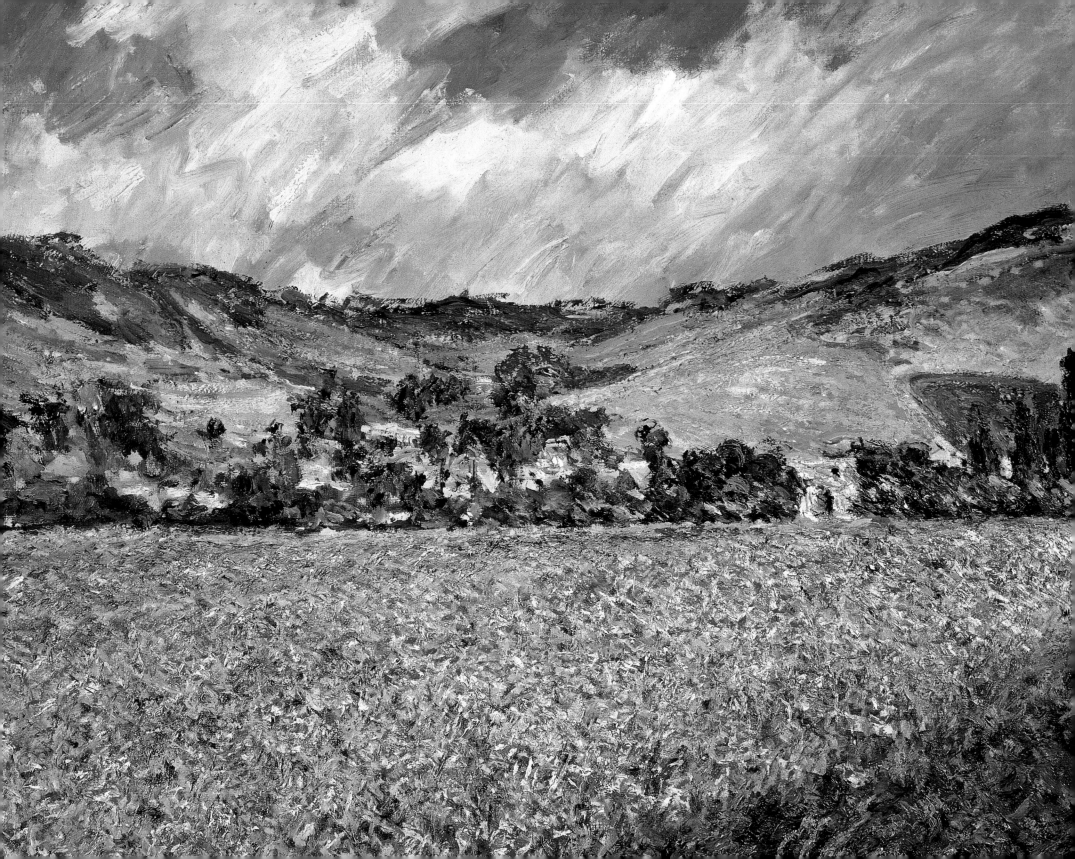

Poppy Field in a Hollow near Giverny, 1885

Oil on canvas, 25⁵/₈ x 32in
(65.2 x 81.2cm)
Museum of Fine Arts, Boston

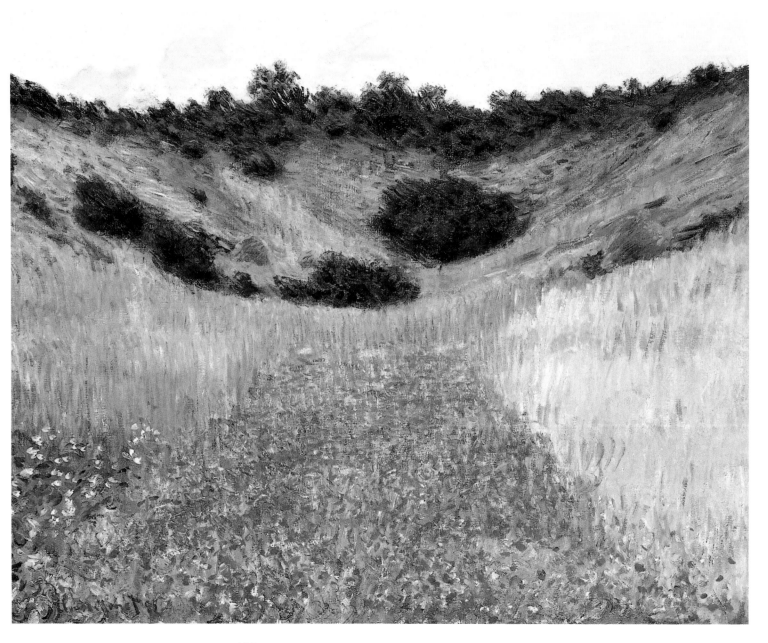

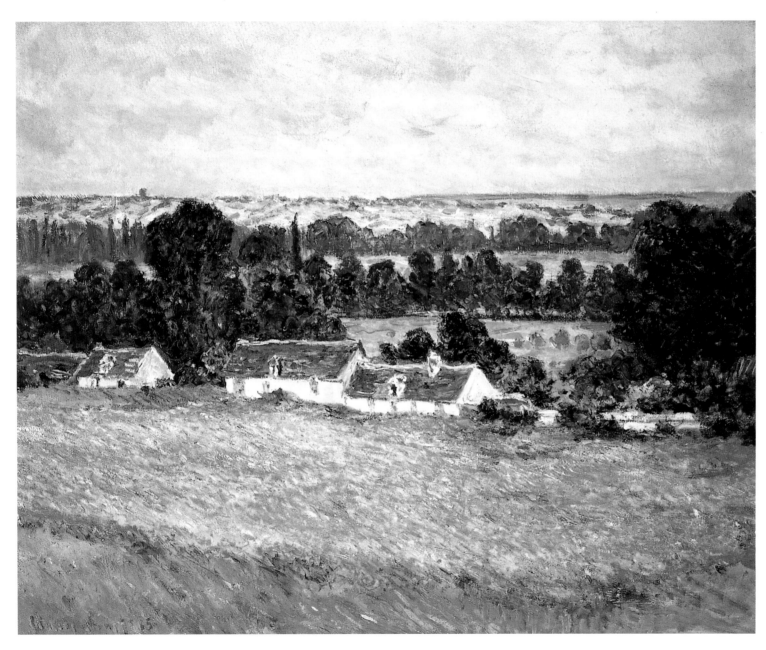

Field of Poppies, Giverny, 1885
Oil on canvas, 23⅝ x 28¾in
(60 x 73cm)
Virginia Museum of Fine Arts,
Richmond

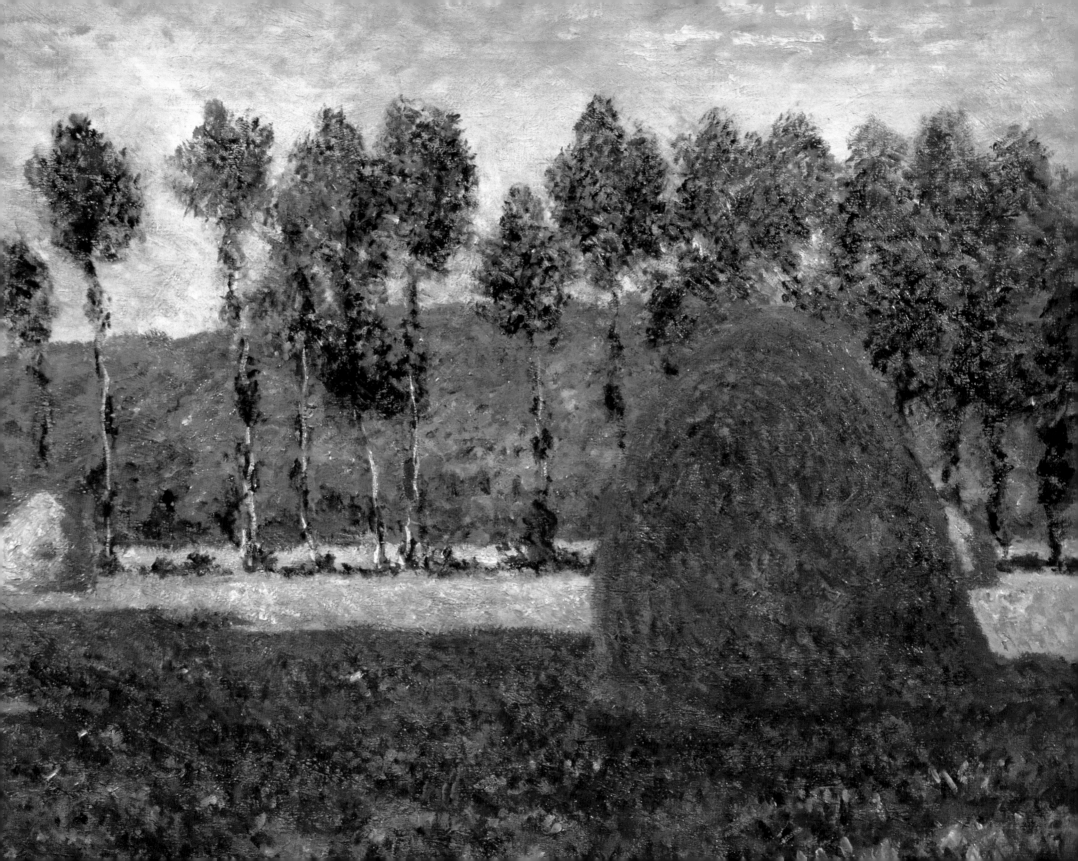

was also Monet's landlord at Fresselines, an 'unfriendly old moneybags' who had needed to be persuaded by the local priest to allow Monet to continue working in one of his fields.

Despite such difficulties, Monet found plenty of subjects nearer home. A particularly enticing one was a nearby orchard, in which his step-daughters Blanche and Suzanne Hoschedé sat reading under blossom-laden branches while Monet painted *Spring* (page 200). Or there was the wood in which Blanche would sometimes set up her own easel and paint, while her sister leaned against a tree and read a book. Monet called his 1887 painting of this scene *In the Woods at Giverny – Blanche Hoschedé-Monet at Her Easel with Suzanne Hoschedé Reading* (page 202). Both these paintings of the late 1880s are notable for the way in which Monet uses elaborate patterns of brushwork over the entire surface of the canvas and carefully harmonizes the colours to obtain an essentially undramatic, wonderfully serene effect. The paintings are clearly the work of a more practised and sophisticated painter than the man who painted the river scenes around Argenteuil in the early 1870s.

John Singer Sargent has left us a delightful study of Monet at this time, painting near Giverny. *Claude Monet Painting at the Edge of a Wood* (c.1885) shows the artist, wearing his familiar, low-crowned summer hat, sitting on

a folding stool in front of a large canvas – one that a strong enough gust of wind would be likely to blow over. One of the women of his family sits companionably nearby.

The American-born Sargent, who studied with Carolus-Duran in Paris but did most of his best work in England, came to know all the Impressionists, some of whom, notably Degas, dismissed his abilities as an artist. Monet, who also late in life denied that Sargent was an Impressionist but still greatly admired his work, developed a close friendship with him and saw much to admire in the younger artist's work. Sargent stayed at Giverny on numerous occasions in the 1880s and several of his paintings of the period, including *Claude Monet Painting at the Edge of a Wood* and *Claude Monet in his Bateau-Atelier* (1887) – an interesting companion-piece to Manet's painting of a decade before – indicate that Sargent had absorbed some of the teachings of the Impressionists, not least their *plein-air* techniques.

Monet, of course, spent many hours in his studio boat on the rivers near Giverny. The River Epte, in particular, was the setting of wonderfully atmospheric river scenes, like the breathtakingly lovely *A Bend in the River Epte, near Giverny* (1888), and of his family boating on it. An early problem he had to deal with at Giverny was where to house his boats. Paul Durand-Ruel, constantly asked to

OPPOSITE
Haystacks near Giverny, c.1884
Oil on canvas, 25³/₈ x 31⁷/₈in
(64.5 x 81cm)
Pushkin Museum, Moscow

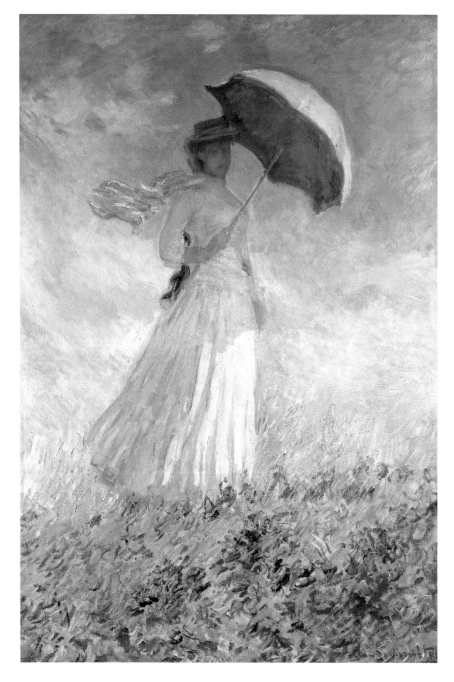 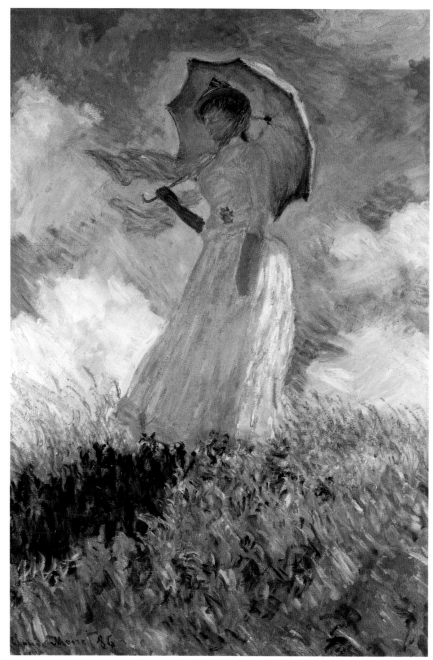

supply more money, needed to be quite understanding concerning an artist's essential requirements when he read notes like the one Monet sent to him on 5 June 1883. Monet thanked him for 200 francs, but asked for a larger sum 'tomorrow without fail', then went on to say that he had not been able to concentrate on painting in recent days because he was very put out with organizing his boats, which had involved having a secure shed built on the bank of the Seine to shelter them and to store his easels and canvases.

No doubt Durand-Ruel thought the money well spent when he eventually saw such paintings as *The River Epte at Giverny* (page 185), *The Boat* (page 203), *In the Rowing Boat* (page 204), *Girls in a Boat* (page 205), and *Boating on the Epte* (c.1890). Many of these paintings were done, or at least begun, on boating trips (including some devoted to fishing) that the family enjoyed taking up and down the rivers and streams near their home. A favourite trip was to a small island, the Ile aux Orties (Nettles Island), reached via a channel which led from Monet's property to the bank of the Seine where the island was situated. Later, when he was thoroughly involved with the business of buying land, Monet bought the island.

These paintings of his stepdaughters in boats were almost the last in which Monet included figures in

landscapes. He seems to have returned to figure painting in the mid-1880s at the suggestion of friends like John Singer Sargent, whom he met through the dealer Georges Petit, and Renoir, himself full of renewed interest in painting the nude after a gap of many years.

Five Figures in a Field (1888) is a particularly interesting example of Monet's experiments with figures in a landscape. The five figures, members of his family, merge with a landscape so brilliantly sunlit that the trees in the background almost disappear in a haze of light. Monet said that he was experimenting with figures treated like landscape, but he apparently did not think his efforts were very successful and stopped.

The problem was probably not that Alice Hoschedé, who appears to have been going through an emotional time through much of the decade, to judge from Monet's letters, had threatened to leave him if he employed professional models. It was more likely that Monet subconsciously recognized that his real genius lay elsewhere – in landscapes, for instance. In the year in which Monet painted *Five Figures in a Field*, Vincent van Gogh was in Arles, struggling with his own work, and with his own internal demons. In May, Van Gogh wrote to his brother Theo saying that he would go on working, believing that 'here and there among my work there will be things that will last, but who will be in

OPPOSITE LEFT and RIGHT
Woman with a Parasol Turned to the Right, 1886
Woman with a Parasol Turned to the Left, 1886
*Oil on canvas, 51^1/$_2$ x 34^5/$_8$in
131 x 88cm)
Musée d'Orsay, Paris (Details are the same in both paintings)*

This pair of pictures of Suzanne Hoschedé, set high against a summer sky, marks the high point of Monet's efforts to overcome the difficulties involved in painting figures in the open air in his unique, impressionistic style. In painting after painting in the mid-1880s, Monet attempted to enclose figures outdoors in the same 'envelope' of light and atmosphere that he aimed to create in his landscapes. He came near to achieving his object in these two pictures, in which light, air and the figure's pose merge to create that 'instantaneity of vision' that was the ultimate goal of Monet's painting.

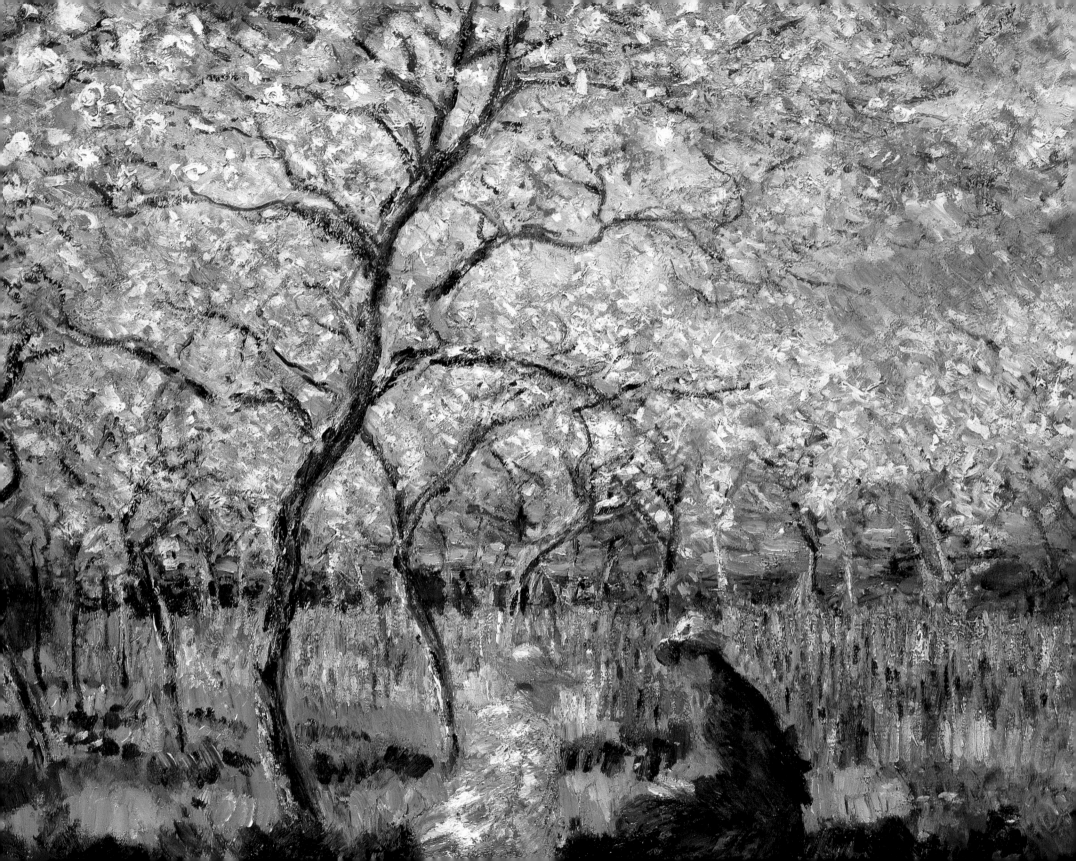

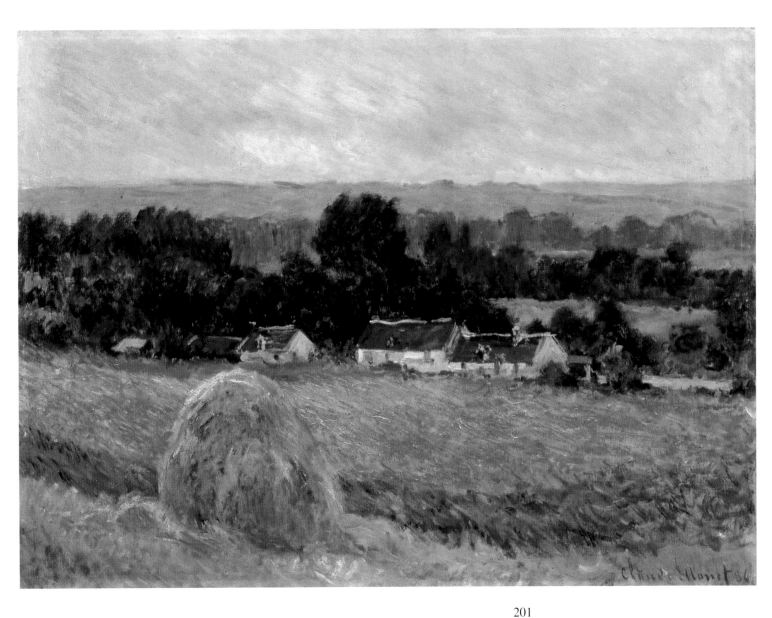

OPPOSITE
Spring, 1886
Oil on canvas, 25^1/$_2$ x 31^3/$_4$in
(64.8 x 80.6cm)
Fitzwilliam Museum, University of
Cambridge

LEFT
Haystack at Giverny, 1886
Oil on canvas, 24 x 31^7/$_8$in
(61 x 81cm)
Hermitage Museum, St. Petersburg

RIGHT

In the Woods at Giverny – Blanche Hoschedé Monet at Her Easel with Suzanne Hoschedé Reading, 1887

Oil on canvas, 36 x 38^1/$_2$in
(91.4 x 97.8cm)
County Museum of Art, Los Angeles

OPPOSITE LEFT

The Small Haystacks, 1887

Oil on canvas
Christie's, London

OPPOSITE RIGHT

The Boat, 1887

Oil on canvas, 57^1/$_2$ x 52^3/$_8$in
(146 x 133cm)
Musée Marmottan, Paris

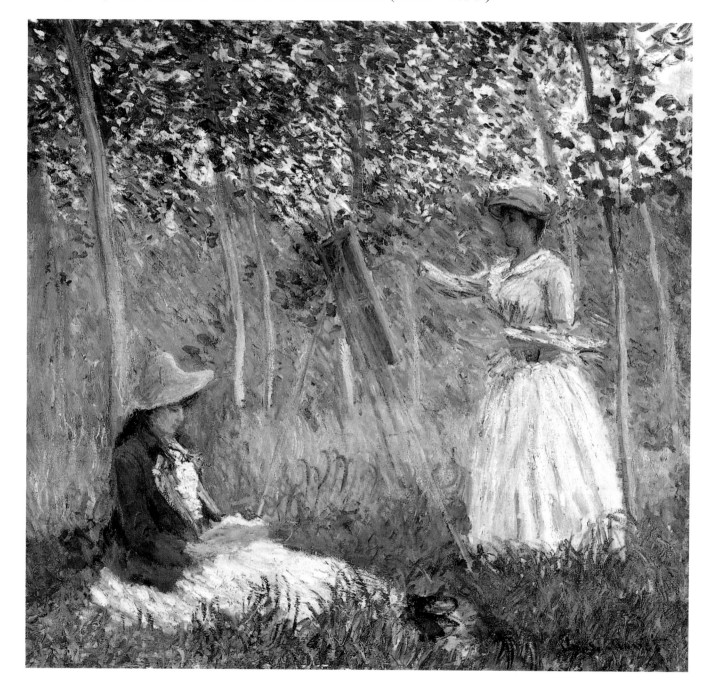

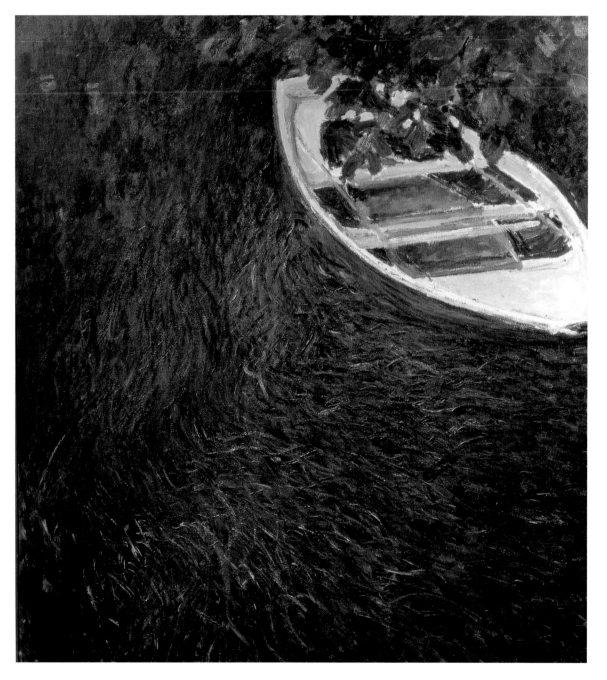

figure painting what Claude Monet is in landscape?'

After a few years at Giverny, Monet made a few changes to the land surrounding the house, such as tidying up and planning a new layout for the kitchen garden at his back door. But it was not until he was able to buy the house (helped by a large loan from Durand-Ruel), and had signed the papers giving him ownership on 19 November 1890, that he started to make the extensive changes that would, over the next 20 years or so, make Giverny into a sort of earthly paradise.

Fruit trees and bushes were grubbed up and vegetable patches were done away with. The west side of the orchard was turned into a lawn, in true English style, and

In the Rowing Boat, 1887
Oil on canvas, 38¹/2 x 51¹/2
(98 x 131)
Musée d'Orsay, Paris

Monet painted many pictures of his family boating on the rivers near Giverny in the mid-1880s in pursuit of his long-held dream of solving the problems involved in painting figures in outdoor settings. In the end, very dissatisfied with the results of his labours and brought to a point of near-illness by the stress, he abandoned his attempts. Idyllically atmospheric paintings like the ones here and on on the following pages, from all of which the sky is completely absent, remain to demonstrate how near Monet got to achieving his aims.

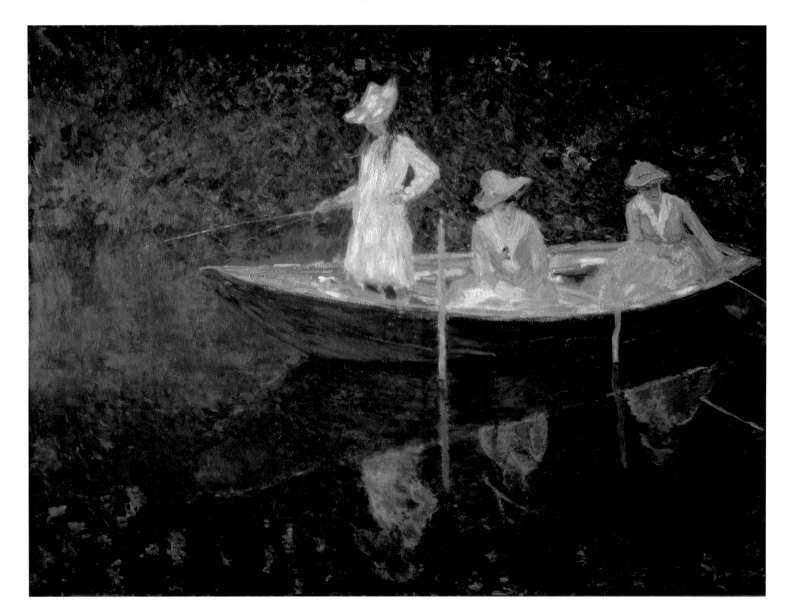

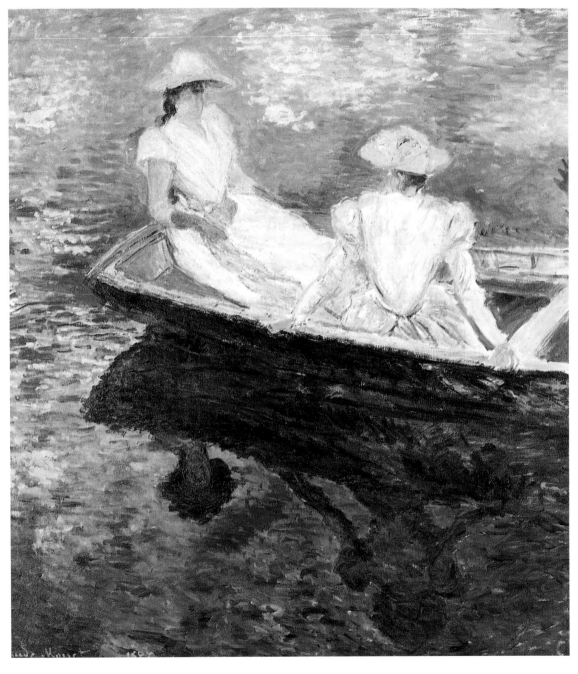

Girls in a Boat, 1887
Oil on canvas, 57^1/4 x 52^1/2in
(145.5 x 133.5cm)
National Museum of Western Art, Tokyo

Boating on the River Epte, 1887
Oil on canvas, 52³/8 x 57in
(133 x 145cm)
Museu de Arte de São Paulo

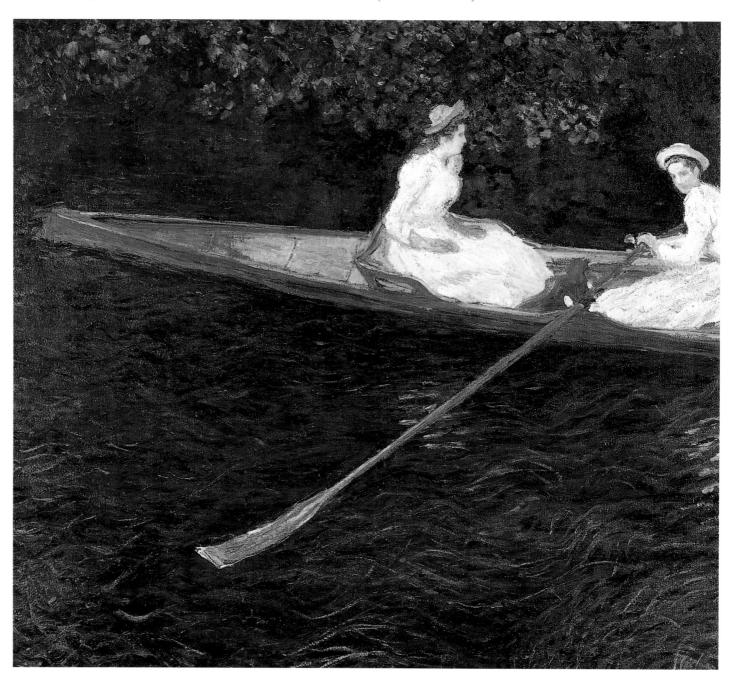

MONET

was kept in superb condition by constant watering and regular mowing. Thousands of plants, bulbs and seeds were ordered from catalogues, most of them from England. A greenhouse was built in which to germinate the seeds and preserve the many non-hardy plants, particularly Monet's precious waterlilies, in the winter months. A head gardener and half a dozen assistants were set the task of laying out and caring for the geometrically-planned beds, some of which were raised to make them easier to cultivate. Trellises and pergolas were built to allow plants to clamber over them.

None of the planting was haphazard. Monet planned everything in precise detail, from arranging his planting cycles so that one species was coming into flower as another faded, to the positioning of plants according to colour and size. He chose his plants for their colours and shapes, rather than from a botanical viewpoint. Nor did he stick to conventional plants: his taste for the exotic was apparent in many imports from foreign places, such as bamboos from China, peonies from Japan, and tuberoses from Mexico, many of which were quite unknown to the local people of Giverny. These grew among the more common dahlias, chrysanthemums, roses, irises, nasturtiums and antirrhinums.

If Monet thought he would be away at a crucial time in the gardening year, he would leave long, detailed notes for his gardeners. The note left before leaving for London in February 1900 covered everything from how many of which plant to put where and when, how to protect delicate plants from the cold, when to move things out of the greenhouse or put the sulphur sheets back over the greenhouse frames, when to trim the borders or put up wires for the clematis.

Even when abroad and concerned with his painting, Monet would still send reminders home, voicing his concerns at what was happening in the garden at Giverny in his absence. While he was in Norway in February 1895, ice and snow made him think of his pond, especially when Alice told him that the weather in France had been almost as cold. He wrote back reminding her that the ice on the pond must be watched carefully; it would be sad if everything planted there were to die.

Monet was, in fact, the lord of all he surveyed – except for the occasions, which were not infrequent, when Alice argued with him about garden matters. There was, for instance, the matter of the pine trees and cypresses already in the garden at Giverny when Monet first rented the property, and which Monet wanted chopped down because his beloved flowers would not grow in their shade.

According to Alice's son, Jean-Pierre, the battle was epic but eventually ended in compromise. The cypresses

Tulip Fields with the Rijnsburg Windmill, 1886
Oil on canvas, 25⁷/₈ x 32in
(65.6 x 81.5cm)
Musée d'Orsay, Paris

Monet was invited to Holland in 1886 by an admirer of his work who felt sure that the famous tulip fields would greatly inspire him. Monet spent several days among the bulb fields between Leiden and Haarlem, but was not totally happy with the paintings he did: the bulb fields were just too colourful. As he wrote to a friend, the enormous fields of flowers in full bloom were admirable, but were likely to drive poor artists mad, who did not have the colours in their paintboxes to do the flowers justice. Even so, Monet returned home with five canvases of the bulb fields, testament to the fascination which the tulip has exercised over people for centuries.

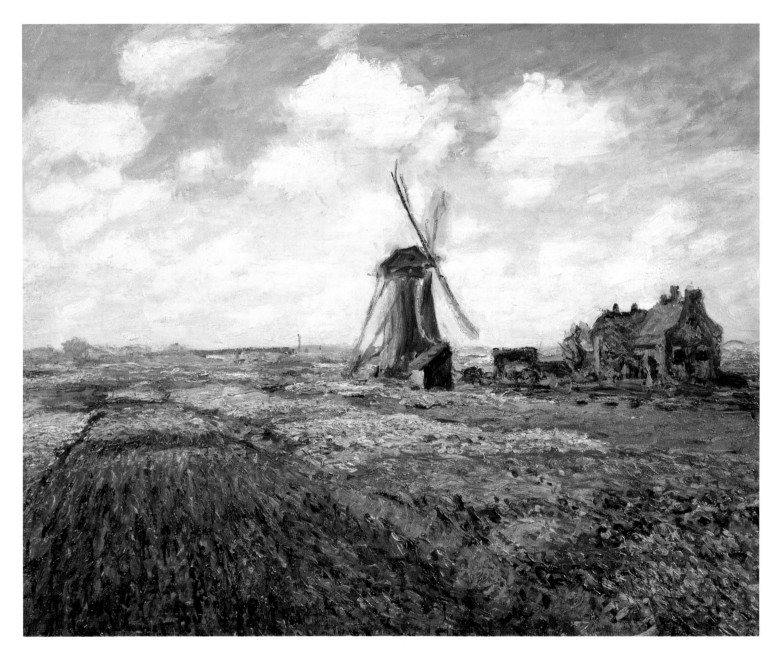

were uprooted and replaced by metal arches over which roses, still in existence in the 1960s, were soon climbing in profusion. As for the pine trees, Monet got his way by stealth. First of all, the trees' lower branches were removed, then the tops were cut off from half-way up the trunks. The unsightly, pillar-like remains also had roses grown up them, but, eventually, the trees rotted round their bases and had to be completely removed.

Despite these minor disturbances, the relationship between Monet and Alice was close. Ernest Hoschedé died in 1891, and they were at last able to legalize their union when they were married in July 1892. To their friends, this was simply a way of regularizing a relationship that had long been accepted. When Berthe Morisot, her husband, and the poet Stéphane Mallarmé visited Giverny in July 1891, spending an entire day and dining there in the evening, they felt exactly as they would visiting a married couple in their own home.

This was a particularly happy visit for Mallarmé. Monet suggested he select a painting. Mallarmé, after some hesitation, because he was loath to choose the beautiful picture he already had his eye on, a landscape of Giverny showing the smoke rising from a train, chose it at Berthe Morisot's insistence. That evening, Mallarmé was radiant as the three returned home. As he sat in the carriage, the painting on his knee, he remarked, 'One thing that makes me happy is to be living in the same age as Monet.'

The 1890s were a particularly relaxed and happy time at Giverny. By now, Monet had become such an important personage in the world of art than his house had become a magnet for visitors of all kinds. Politicians and diplomats, friends and relatives, artists and dealers, collectors from as far away as America and Japan, were often to be found at Giverny or meeting up at the local inn where many of them stayed. Grand dinners were comparatively rare at Giverny, Monet preferring to give his visitors lunch, so that he could retire early after a family meal in the evening. Mary Cassatt had her first meeting with Cézanne on such an occasion at the inn in 1894.

Cézanne, of course, was used to dining at Monet's house, where the artist liked to have his evening meal, consisting of the choicest ingredients, with his family in his yellow dining room, the walls of which were hung with a fine collection of Japanese woodcuts. Cézanne also knew that Monet 'did not much like being bothered', as he wrote to the young artist Charles Camoin in 1903. But, he knew, too, that meeting Monet would be good for the young man and suggested that when Camoin did visit Monet he should mention his name. Cézanne was too modest to say – or perhaps even to think – that Monet

OPPOSITE

Meadows in Giverny, 1888

*Oil on canvas, 36¹/4 x 31¹/2in
(92 x 80cm)
Hermitage, St. Petersburg*

For Five Figures in a Field, *painted in
the summer of 1888, Monet put five
members of his family in this
watermeadow near Giverny, in pursuit
of his dream of painting 'figures in the
open air as I understand them, treated
like landscape'. In this painting, he
forgets about the figures and simply
paints the watermeadow, with its trees
and vegetation, as a misty landscape.*

would give a warm welcome to anyone who came with
his recommendation, contenting himself with remarking
that 'in view of the sincerity [Monet] may relax a little'.

By the late 1880s a colony of ambitious young
American artists was established near Giverny. Their
constant visiting, seeking artistic enlightenment from the
Master, often made Monet, who refused to set himself up
as a teacher and found the young people's demands on
his time excessive, very bad-tempered. He would tell
them to use their eyes to study Nature, then retire to his
studio. However, one young American, Theodore Butler,
did manage to make himself welcome at Giverny,
and married Monet's stepdaughter Suzanne Hoschedé
in 1892.

In February 1893, Monet bought a second parcel of
land adjacent to the River Ru, a stream that ran into the
Epte, to make the pond he had been planning for some
time. The land was separated from his house by a country
road leading to the towns of Vernon and Gasny and by a
railway line which, though not very busy (only four
trains clattered along it every day except Sunday),
brought thoughts of modern life to the forefront of his
mind. Eventually, an underground passage took Monet
and his increasing number of visitors from the main
house and garden to the water's edge.

Monet's first water garden was a relatively modest

affair which he said he planted for pleasure, with no
thought of painting it. After all, he told a friend in 1890,
painting water with reeds floating below the surface
would be 'utter folly to attempt'. (This was a sure sign
that he had it in mind to do just that.)

It was necessary for Monet to apply to the local
prefect of the *département* for permission to build his
pond, which he explained was 'for the purpose of
growing aquatic plants' that would be agreeable to the
eye and provide him with subjects to paint. This was
approved and within two years a pretty Japanese bridge
had appeared, built over the narrow neck of the pond at
its northern end, and similar to those depicted in the
Japanese prints he owned. About this time, he suddenly
'had the revelation of the magic of my pond'.

Soon after its completion in 1895, the Japanese
bridge began to appear in Monet's paintings. There it
was, arching over what had been miraculously
transformed into a waterlily pond, surrounded by
graceful willows and other plants.

Public Acceptance At Last

While Monet may often have despaired of the progress or
lack of progress in his work as an artist, in fact he had
substantially less reason to worry during the 1880s. The
move to Giverny seemed to have marked more than one

turning point in his life. Not only had he found the place where he was to spend the rest of his life, but his financial affairs had also taken a turn for the better. Since 1881 he had been receiving appreciable amounts from Durand-Ruel, his main dealer, including 20,000 francs in 1881 and 35,000 in 1882. He had also begun to sell more paintings through his own efforts.

By this time, the Paris art world had seen considerable changes. The Salon, though still artistically important, immensely popular, and one of the highlights of the Paris social scene, had lost something of its old prestige. The Third Republic was not as concerned to play an active role in the arts as Napoleon III's empire had been and by 1880 had abandoned its role in the selection of Salon juries. The Salon itself had split into two bodies, one run by the Société des Artistes Français, the other by the Société Nationale des Beaux-Arts.

Artists no longer needed the Salon as desperately as they once did. There was still the network of friends and aquaintances in the Paris cafés, which Monet again approached with enthusiasm from the mid-1880s. A special favourite was the Café Riche in the boulevard des Italiens, where Monet was in the habit of dining once a week with Renoir, Pissarro, Caillebotte, Sisley and others, when he was back from his travels.

More importantly, the art world was now much more

commercial than it had been in mid-century and Paris had become a major centre for art-dealing in all its forms and for promoting it via a network of art-oriented publishing, whose journals and magazines were filled with the writings of influential critics

There were numerous well-found picture-dealing firms in Paris, many with their own galleries. These dealers made regular payments to the successful artists on their books, expecting in return to receive work of a nature and quality that would easily find buyers among the wealthy clients that they cultivated. Once an artist had made his name, these close relationships with dealers could bring their own problems. Monet, for instance, was not always happy that Durand-Ruel sometimes put his work into mixed exhibitions with other artists. Even if the dealer had bought works from Monet, and was not charging the public anything to visit the gallery where they hung, there was not much Monet could do about it – much to his irritation.

Paul Durand-Ruel was Claude Monet's main dealer, and the two had a close, though sometimes fraught, relationship which lasted for decades. Himself the son of a picture dealer, Durand-Ruel took charge of the family business in 1865 and soon extended it to London, where he rented a gallery in New Bond Street to show works from his Paris stock, interspersed with the work of a few English artists. Durand-Ruel's move across the Atlantic to New York in the 1880s gave the Impressionists a new and most enthusiastic market for their work. Until well into the 20th century, Durand-Ruel's firm, which his sons joined as soon as they were old enough, was a leading player in the world of international art.

There were rivals, however, notably Georges Petit, whose interests were rather wider than those of Durand-Ruel, who concentrated very much on the Impressionists and their friends. Georges Petit had a very grand gallery in a fashionable part of Paris where he specialized in showing rich and socially important Parisians the latest work by artists who, although traditional in the Salon manner, were also rather in advance of the times.

In 1882, in collaboration with one of his leading artists, Giuseppe de Nittis, a painter of stylish pictures of high society at play who had taken part in the first Impressionist exhibition, Petit started a series of Expositions Universelles – annual international exhibitions of painting – at his gallery. These were successful enough to attract Monet and Renoir in 1885, the two artists exhibiting their work only after some soul-searching as to whether they might be seen by their friends as abandoning the cause for which they had all been working. Both artists were happy enough with their success at the 1885 Exposition Universelle to become

OPPOSITE
General View of Rouen from St. Catherine's Bank, c.1892
Oil on canvas, 25¹/₂ x 32in
(65 x 81.5cm)
Private collection

Although Monet's celebrated paintings of Rouen Cathedral are dated 1894, they were actually painted, or at least begun, during two extended campaigns of work in 1892 and 1893. This general view of the city of Rouen shows that Monet did not spend all his time in front of the city's great cathedral. It is possible that he painted this picture, with its muted palette of violet-greys and reddish-browns, before the cathedral drove everything else out of his mind.

MONET, MASTER OF IMPRESSIONISM (1883–1899)

regular exhibitors to them, preferring the 1886 Exposition Universelle to the final Impressionist exhibition that year. (Monet's work at the latter was entered not by him but by Durand-Ruel's son, Charles.)

Another major player in the game was the firm of Boussod & Valadon, formed in the 1870s from the takeover of the old-established Goupil empire, which at one time had two galleries in Paris and branches in London, New York, Berlin and Brussels. Vincent van Gogh himself once worked at the London branch of Goupil, sent there by his uncle, also Vincent van Gogh, who ran a gallery in the Hague that became part of the Goupil group in the 1860s. Boussod & Valadon had a stylish gallery in the Place de l'Opéra, which concentrated on selling works by Salon artists, a branch in the boulevard Montmartre, and a printing works which continued with the original Goupil business of printing reproductions.

The importance of Boussod & Valadon's Montmartre branch in the history of French painting lies in the fact that from 1879 it was run by Theo van Gogh, Vincent's brother, and a man totally convinced of the worth and importance of the work of the Impressionists and other independent artists. Etienne Boussod was unhappy with the way in which Theo van Gogh had by the latter part of the 1880s turned his firm's branch in Montmartre into

one of the main buyers and sellers of Impressionist art in Paris. Boussod's main concern was that the branch was not as profitable as the main gallery, but he also did not like the 'appalling things by modern artists' that Theo van Gogh had in stock. While work by Monet, Sisley, Renoir and Pissarro formed the largest part of Theo's purchases, work by Gauguin and Degas were also prominent in his catalogues.

Even though he was so closely involved with Durand-Ruel, Monet began to look for other outlets for his work early in the 1880s. Mindful of the large family he had to support and also needing to fund painting trips to the far corners of France and beyond, Monet was not averse to pursuing several dealers at the same time, even, to judge from his correspondence, playing one off against the other. By now, although still regarded with deep suspicion by diehard traditionalists, Monet was considered an artist to watch by more and more people in the business and he knew his worth. His 1883 exhibition at Durand-Ruel's may not have been a financial success, but it was well-reviewed. Despite his travels, Monet was to show at increasingly successful exhibitions as the 1880s progressed.

As he had done at Argenteuil, Monet began to invite dealers and potential buyers to Giverny to see his work. There he could display and explain it to them in his own

Morning on the Seine at Giverny, 1893
Oil on canvas, 29 x 36¹/4in
(73.5 x 92cm)
Private collection

This lovely work, painted early in the morning when the rising sun was beginning to disperse the river mists, demonstrates why the major exhibition of work by Claude Monet at the Galerie George Petit in Paris in 1898, one of the themes of which was 'Mornings on the Seine', was such a resounding success.

RIGHT
The Church of Vernon in the Mist, 1893
Oil on canvas, 25³/4 x 36¹/4in
(65.5 x 92cm)
Private collection

OPPOSITE
The House of the Douanier, Pink Effect, 1897
Oil on canvas, 25¹/2 x 36¹/4in
(65 x 92cm)
Private collection

terms in his own studio, rather than having to carry examples of his latest work to them: Monet did not relish the role of supplicant, but as he became more successful the need for subservience disappeared. Nor did he now have to apologize for offering his guests such modest fare. He had the money to eat well and Alice, a superb housekeeper, catered admirably to his culinary needs. Monet, something of a gourmet and an avid collector of recipes, took a great interest in the food that was served at his table, often planning the menus and giving the cook her orders for the day himself.

A letter from Monet to Georges Petit in April 1887 shows how far the artist, rather that the dealer, was in control of the sale of his work by the end of the decade. Monet begins by saying how sorry he is that Petit had not managed to get down to Giverny before Theo van Gogh, who had been there the day before, because Petit had now missed out on taking several works for an exhibition of Monet's paintings he was in the middle of organizing. Monsieur van Gogh, having already sold one of Monet's *Belle-Ile* paintings, took six more, four of them for showing at Boussod & Valadon. Petit was not to worry, however: there were still some left for him, 'and good ones at that'. Monet ended his letter by arranging to be with Petit by the end of the month to draw up the catalogue for his exhibition, although he could not be

RIGHT

The Cliffs at Varengeville, 1897

Oil on canvas, 25^1/$_2$ x 36^1/$_4$in
(65 x 92cm)
Musée des Beaux-Arts Andre Malraux,
Le Havre.

OPPOSITE

The Cliffs at Pourville, 1896

Oil on canvas, 25^1/$_2$ x 39^3/$_8$in
(65 x 100cm)
Private collection

Morning on the Seine, 1897
Oil on canvas, 28¹/₃ x 35in
(72 x 89cm)
Private collection

Monet often rose at 3am in the morning to observe the light effects for the paintings he included in the 'Mornings on the Seine' section of his triumphant exhibition in Paris in 1898. He must have been on the river very early indeed to catch the light effects in this painting, because the dark shadows of night have not yet been completely expelled by the rising sun.

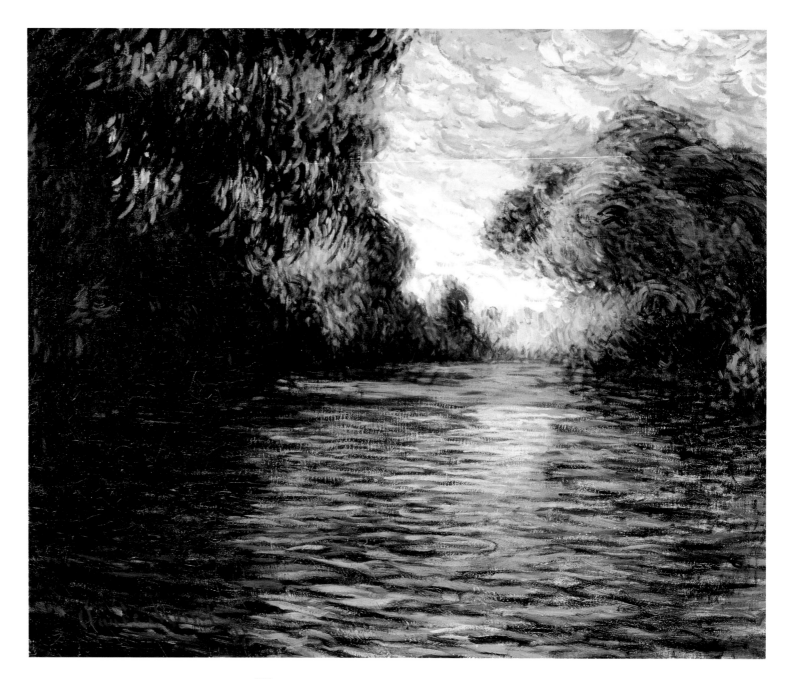

sure of its contents until the last moment. Meanwhile, he was counting on Petit to remind the picture framer to be ready on time: Monet never lost sight of the essential details in any matter in which he was involved.

In fact, Monet's relationship with Petit had flourished since his first showing with him in 1885 and the one-man show at Petit's gallery in May 1887 was a great success. Monet sold most of his paintings, a fact he took pleasure in telling Durand-Ruel, then in New York trying to get his second exhibition organized.

Monet had his doubts concerning the American venture when Durand-Ruel broached the subject in 1885, and was not at all happy when some of his best work disappeared across the Atlantic. In the event, the 1886 exhibition of Impressionist art which the American Art Association asked Durand-Ruel to organize in New York was only a moderate success, with rather less than 25 per cent of more than 280 pictures on show being sold. But press reaction was far from hostile, and American art lovers were by now familiar with the work of Degas, Manet, Monet, Pissarro, Renoir, Caillebotte and Sisley as well as their own Mary Cassatt. Of all these artists, Monet, 48 of whose paintings had been shown, was the most sought-after by American collectors and several exhibitions of his work were held in America before the end of the century. Soon, Americans were coming to

Europe to buy direct from the Paris dealers.

Because Monet was such a famous artist, it is possible to track the provenance of many of his paintings, from the time they left his studio to their location today. Knowing the history of a painting seen hanging in an art gallery or exhibition can give an extra dimension to the viewer's enjoyment of it. Take a painting like *Val de Falaise (Giverny), Winter*, for example. Monet painted it near Giverny in the winter of 1884–85. In May, 1885, Durand-Ruel bought it from Monet and sold it within months to Charles Leroux, having first exhibited it at Petit's Exposition Universelle that year.

Leroux kept the painting for two years or so, then put it up for sale at the Hôtel Drouot on 27 February 1888 as lot 54. It was bought by Boussod & Valadon. Did Theo van Gogh make the purchase himself? He probably did, and he would certainly have been responsible for including it in Boussod & Valadon's Monet exhibition of 1889. The painting crossed the Atlantic when it was bought by Eastman Chase of Boston in 1891, then by Desmond Fitzgerald, also of Boston, probably in 1892.

Val de Falaise, Winter was exhibited several times in America in the years that followed, and next appeared in a sale at the American Art Association in New York in April 1927, when it was bought by Mr. and Mrs. Edwin

The Valley of Falaise, 1883
Oil on canvas
Private collection

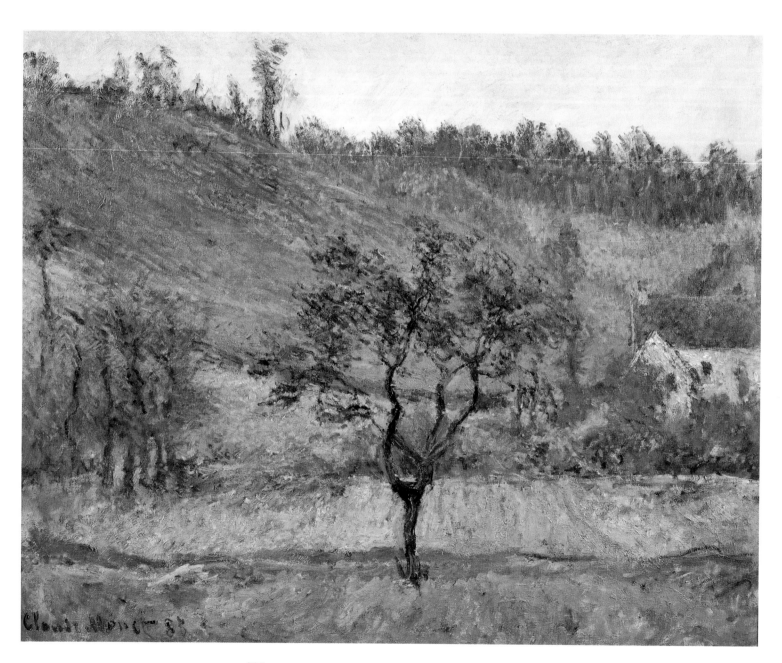

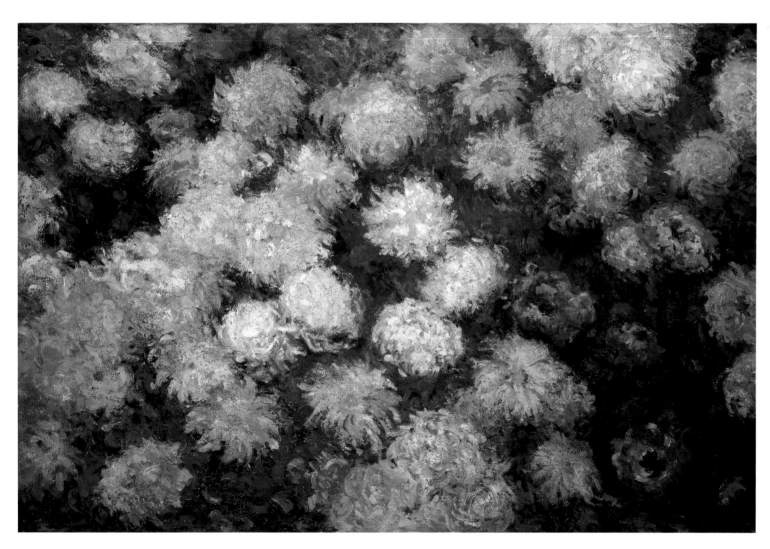

Chrysanthemums, 1897
Oil on canvas, 31⁵/₈ x 47¹/₄in
(80.3 x 120cm)
Private collection

S. Webster. Fifty years later, the painting was up for sale again, this time at Sotheby Parke Bernet, New York in May 1977. The purchasers were Gabrielle and Werner Merzbacher. Thus Monet's intense and atmospheric painting of Giverny in winter came back to Europe to find a place in the superb Merzbacher collection in Switzerland. It was one of the stars of the show in two recent exhibitions at the Royal Academy of Arts in London, most notably the appropriately named Masters of Colour exhibition in 2002.

Although Durand-Ruel's second New York exhibition was a disaster from a sales point of view (unresolved problems over the payment of customs duties meant that the pictures could be exhibited but not sold), he was confident enough of the American market to open a gallery in New York in 1888. From this time, many of Monet's paintings were, like *Val de Falaise*, to find homes in the United States.

Theo van Gogh arranged Monet's next successful one-man exhibition in Paris. In 1888 he organized a showing in Boussod & Valadon's boulevard Montmartre gallery of ten paintings of Antibes, in the south of France, that Monet had made that year. Included in this exhibition were the well-known *Antibes* (page 259), now in the Courtauld Galleries in London, and *The Umbrella Pines, Antibes*, a study of a line of umbrella pines on the

coast at Cap d'Antibes that seems so real that the viewer can almost feel the warm breeze blowing through the branches and smell the scent of the pines and the piles of dry needles laying on the ground beneath. That Monet had become a force to be reckoned with in French art by this time was demonstrated by the offer of a state honour, the Cross of the Légion of Honneur. Monet refused it.

Maybe the state should have postponed its offer until 1889, when Monet, intoxicated by unaccustomed success at two exhibitions, might had been induced to accept it. The great joint exhibition of the work of Monet and his exact contemporary, the sculptor Auguste Rodin, held in June that year in the Galerie Georges Petit, was an enormous success.

Among the many favourable critical reviews of Monet's work, which numbered 61 paintings, the novelist and critic Octave Mirbeau's was perhaps the most understanding of what Monet was trying to achieve. He wrote of Monet's paintings that 'Air floods through every object, fills it with mystery, envelops it with every possible shade, now muted, now bright'. Mirbeau recognized a different mood in the most recent works that Monet included in the exhibition: five of the paintings he had done at Fresselines in the wild Creuse valley in the winter of 1888–89. Mirbeau called these darkly painted works, full of blues, lilacs, browns and

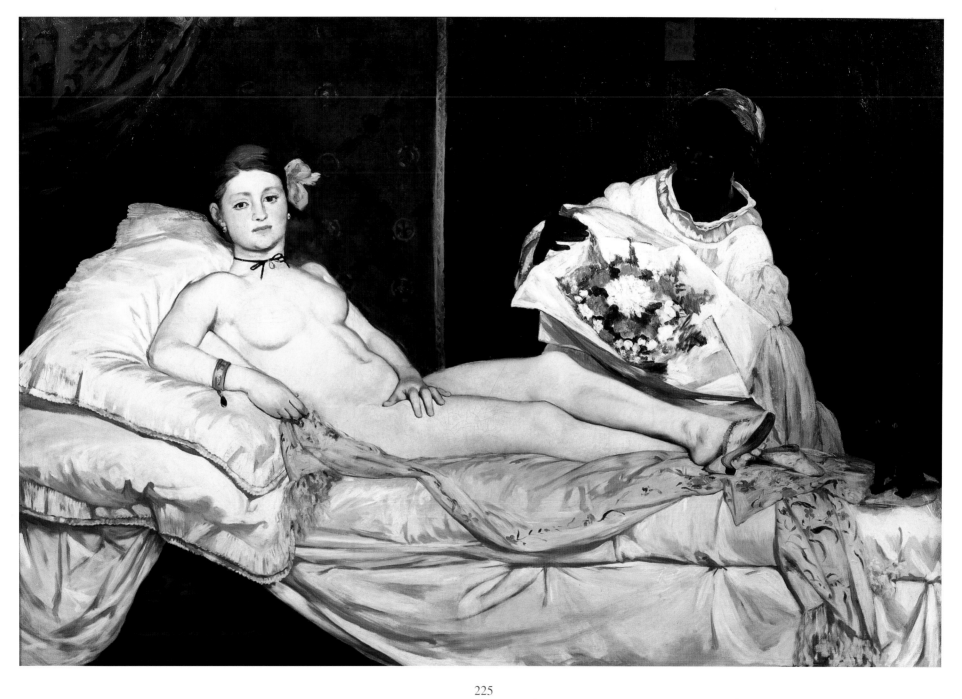

OPPOSITE
The Ice at Bennecourt, 1898
Private collection

violets, 'tragic landscapes' that expressed the 'almost biblical mystery' of the valley.

The success of the exhibition must have given special pleasure to the left-wing journalist, former member of the Conseil Municipal de Paris and budding national statesman Georges Clemenceau. Much the same age as Monet, Clemenceau was greatly interested in art and literature and by the 1880s his two favourite artists were Rodin and Monet, whom he visited many times at Giverny and with whom he enjoyed a lifelong friendship.

The other exhibition of 1889 that demonstrated Monet's increasingly prominent role in French art was Petit's annual Exposition Universelle. While Monet's work was prominently displayed among that of the 100 or so exhibiting artists, most attention was paid to a work by a dead artist. The artist was Edouard Manet and the work was his once-notorious *Olympia* (page 225).

When Manet's widow, in desperate financial straits, began negotiating with an American buyer for the sale of the painting, Monet spearheaded a campaign to buy it for the state. The display of the painting in 1889 was an early shot in that campaign which achieved success in February 1890, when Monet's diligence found enough subscribers to put up the 20,000 francs required. Monet's letter to the Minister of Public Instruction, offering to the state on behalf of a group of subscribers the *Olympia* by

Edouard Manet, made clear the art world's concern that so many works 'the joy and glory of France' were leaving for 'another continent'.

By the end of the 1880s, Monet had become an astute collector of the work of his colleagues, using his increasing affluence in a way that suited him far more than the purchase of grand houses and the life of a celebrity. He was one of Cézanne's more important collectors, and at one time owned 14 of his paintings, including the well-known *The Negro Scipion*, which hung in his bedroom at Giverny, and *Boy in a Red Waistcoat*, all of which he left to his son Michel. Monet eventually acquired so many of what he described as 'beautiful paintings by all his friends', that works by Renoir, Pissarro, Degas and Berthe Morisot, as well as Cézanne and others, hung cheek by jowl on his walls, like some Impressionist exhibition in miniature.

There was to be a string of increasingly successful exhibitions of the work of Claude Monet in the 1890s, now recognized as one of the most important artists of his time. Paul Durand-Ruel explored a new route for Monet's work in May 1891 when he put on a show centred round the unlikely subject of haystacks. There were 15 paintings from Monet's now-famous haystacks series, and they were all sold before the exhibition closed. The point about the haystacks pictures was that,

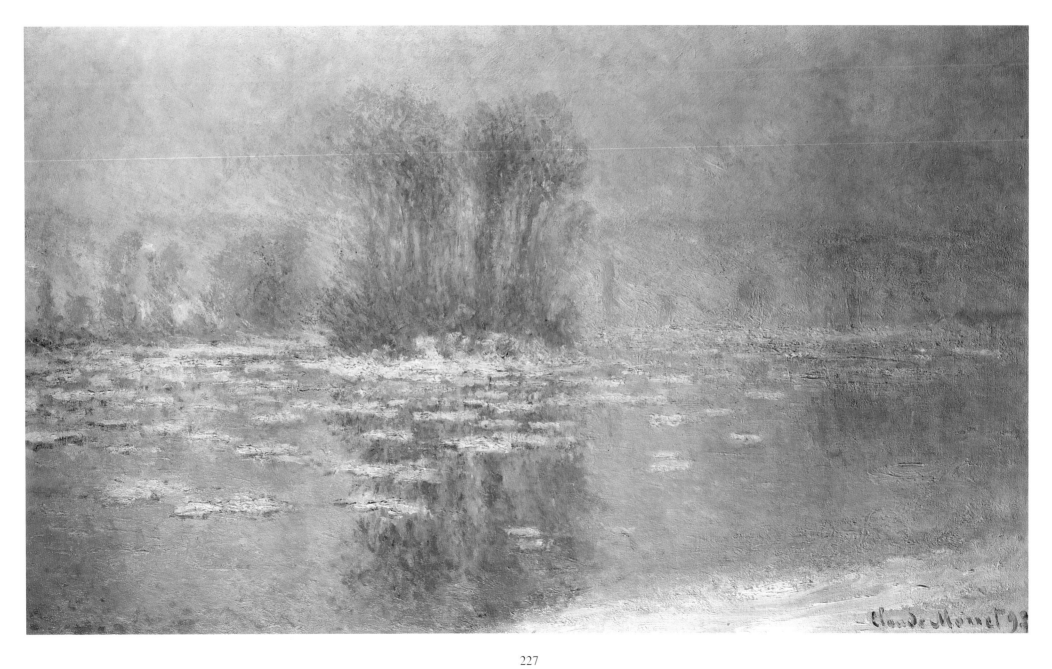

View of the River Creuse on a Cloudy Day, 1889

Oil on canvas

Heydt Museum, Wuppertal

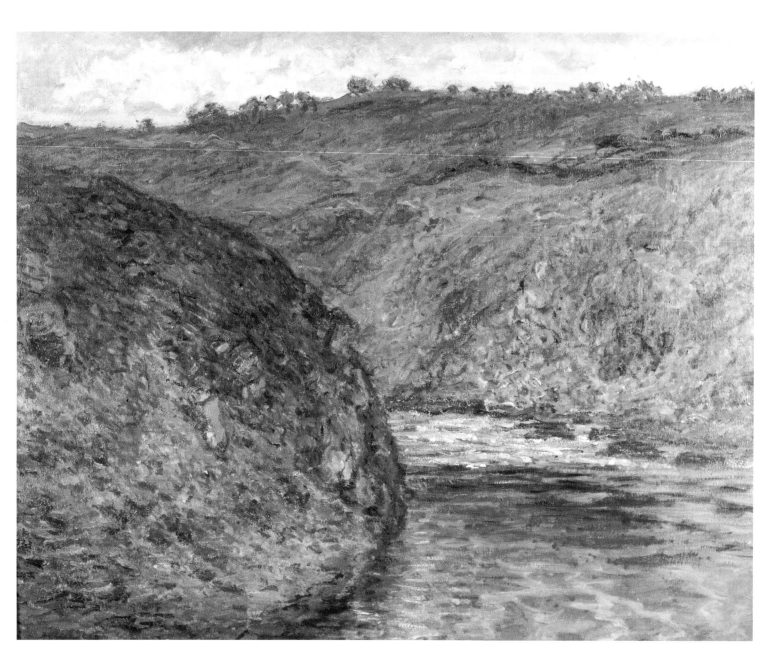

unlike the Antibes paintings exhibited at Boussod & Valadon's boulevard Montmartre gallery in 1888, they were conceived by Monet as a unity: one subject seen in different atmospheres and at different times of the day and season. Before 1891, the nearest thing to this had been the group of five of the paintings Monet had done at Fresselines, in the Creuse in 1888–89, which were included in the 1889 retrospective at Georges Petit's.

Two more highly significant and very successful series were shown in Durand-Ruel's gallery in the 1890s. First, in February, 1892, was an exhibition of 15 paintings of the poplars on the River Epte that Monet had been painting almost from the time of his arrival at Giverny. So concerned was Monet to keep his painting subjects intact and in existence, that he had to buy poplars more than once to save them from the axe.

Then, in May 1895 came the exhibition of the paintings of Rouen Cathedral that Monet had been working on since 1892 (page 302 et seq.). Durand-Ruel, recognizing the unique brilliance of the paintings from early on in their creation, was anxious to show them, but Monet, always reluctant to admit that he had done all he could do to a painting, kept putting back the date of the proposed exhibition. Eventually, Durand-Ruel managed to prise from Monet 20 of his more than 30 Rouen Cathedral paintings, and the exhibition was a huge

success. Georges Clemenceau tried, without success, to persuade the state to buy the whole series, but it was dispersed among a number of buyers in France and America.

By this time, Monet was growing very tired of the consequences of celebrity. Three months before the Rouen Cathedral exhibition opened, he went to Norway, where his stepson Jacques Hoschedé was working. Monet had hoped to do a little quiet painting, but found that his fame had preceded him. As he wrote to Alice, 'one small snag' was upsetting his great enjoyment at being in Norway and seeing Jacques: 'there is a little too much attention given to my person from newspapers, in restaurants and cafés'. Monet had to drop a hint to Jacques that he really did not want the banquet planned by local painters and writers, being used to a simple life on his own, and 'not very fond of such things'.

Three years after the Rouen Cathedral exhibition – and a year after Monet exhibited 20 of his paintings at the second Venice Biennale – came a major exhibition of his work at the Galerie Georges Petit in June 1898. For this, he returned to two favourite motifs, subjects seen across water and the cliffs of the Normandy coast.

One section of the exhibition was called 'Mornings on the Seine' and included paintings that had all been executed mostly in the open air but with some final

workings in the studio, during the summers of 1896 and 1897. Another section, 'Falaises' ('Cliffs'), included 24 paintings chosen from among the 50 Monet made during trips to the Normandy coast between February 1896 and April 1897. Among them was a final study of the *House of the Customs Officer, Varengeville* (see versions on pages 177 and 239) which, the inscription on it tells us, Monet gave to a friend, the designer and lithographer Jules Chéret.

The newspaper, *Le Gaulois*, issued a special supplement devoted to the exhibition, justifying its publication in its opening paragraph by asserting that an exhibition of the work of Claude Monet was too important an event in the world of art for the newspaper to ignore. It was sure, too, that its readers would be pleased to have a souvenir of such an important occasion, especially when it included a new photographic portrait of the celebrated artist, reproductions of several of his works, and appreciations of his 'magnificent talent' by some of the most authoritative writers of contemporary criticism. These appreciations were reprints of reviews of past exhibitions, including the giant retrospective with Rodin that had been mounted by the Galerie Georges Petit ten years earlier.

The photograph shows Monet older, certainly, and with a beard now turning grey, but otherwise not much altered from the Monet of 20 or 30 years before. The low-crowned, broad-brimmed bowler hat set at an angle on his head is the same as the one he wears in Renoir's portrait of him in the garden in Argenteuil, the clothes are dapper, and his right hand rests on a cane much like the one he flourished at the directors of the Western railway line at the Gare Saint-Lazare. The far-sighted, rather imperious look on his face would have been familiar to all his friends from their earliest days in Paris.

The June 1898 exhibition was Monet's last solo show of the decade, and therefore of the 19th century. With Pissarro, Renoir and Sisley, he participated in a show at Durand-Ruel's gallery in December 1899, which included paintings from the early 1880s as well as examples of his most recent work, which drew great praise from Raymond Bouyer, an art critic who up till then had had reservations about the real greatness of Monet's work. Not any more. 'Monet's work above all expresses France, at once subtle and ungainly, nuanced and flashy,' he wrote. '[He] is one of our greatest national painters; … he has expressed everything that forms the soul of our race … for me [Monet] is the most significant painter of the century.'

The exhibition of 12 of Monet's lily pond paintings and other paintings of his garden held at the end of 1900 was devoted to paintings of his water garden at Giverny after the Japanese bridge was installed in 1895 and mention of it makes a fitting conclusion to any account of Monet's

connections with what was, for him, the increasingly lucrative business of painting in the 19th century. Monet's earnings in 1898 have been calculated at around 170,000 francs, and as 224,000 francs in 1899.

Given such vast sums, it is rather surprising that, in these last years of the century, Monet painted so little – or, at least, little that has survived and that can be dated to these years. It is possible that he was going through a period of reassessment of his art and of the direction he was planning for the 20th century. In so doing, he would have been no different from many of his contemporaries. Impressionism, which had set artists so many challenges, was now itself being challenged.

Since the late 1880s, many artists, Cézanne among them, had changed direction, so that experience, rather than appearance, became a major concern. Cézanne became interested in the structure of his pictures, Gauguin rejected naturalism in favour of line and colour, Seurat sought a rational system for expressing the colours that the Impressionists used almost by instinct, and Van Gogh explored an intensely personal and emotional response to art. These artists and others, who would be given the label Post-Impressionists in the next century, were all demonstrating that modern art could develop in many different ways, and that it should develop. Standing still was not an option.

Chapter Five
Monet's Travels:
Seeking Extremes of Light

Chemin de la Cavée, Pourville, 1882
Oil on canvas
Private collection

Monet painted this path along the cliffs at Pourville several times. The general shape and content of the pictures were very similar, because Monet set up his easel at much the same point on the path for each. But different weather conditions radically changed the atmosphere of each picture.

In France, as elsewhere, travel for everyone became cheap and easy in the second half of the 19th century due to the explosion in railway building. The railway had allowed Monet and his friends to live cheaply out of Paris while still within easy reach of the artistic life of the capital. Now, in the 1880s, it took Monet quickly and easily from north to south of his own country and into Italy and Holland as well, and in the 1890s extended his travels by sea to England and Norway. Because Monet always had to have a paintbrush in his hand, he did many paintings at Giverny, but the bulk of his work in the 1880s was done during the long series of trips he made away from home, most of which kept him from Giverny for weeks and even months at a time. Paintings done or started on these trips would subsequently need many weeks of finishing before Monet was happy to see them leave his studio.

It was in the 1880s that Monet switched roles from river to marine artist, his work in this category being among Western art's greatest achievements in marine painting. The sea, after all, was Monet's first love as a painter, and it is not surprising that his earliest trips of the decade were back to the old and familiar haunts on the Normandy coast, with its attractive resorts like Etretat and Fécamp and coastal villages like Pourville and Varengeville around Dieppe.

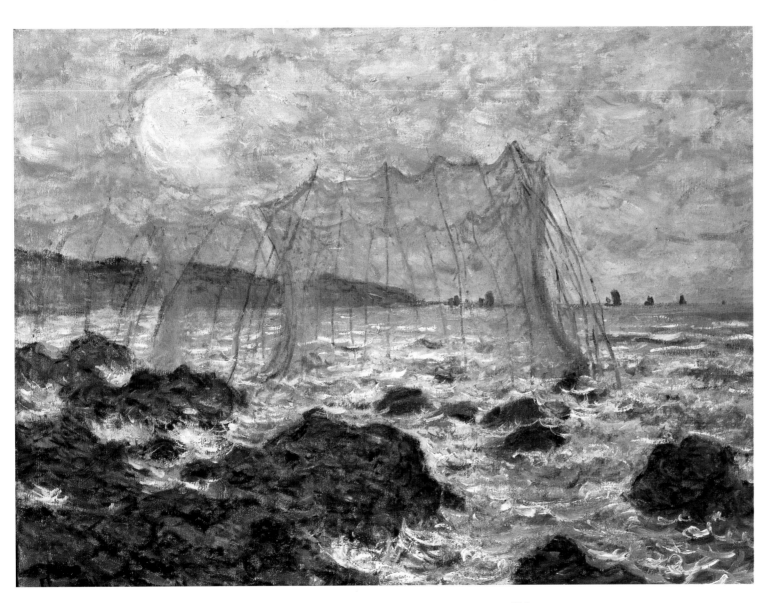

The Nets, 1882
*Oil on canvas, 23⁵/₈ x 31⁷/₈in
(60 x 81cm)
Haags Gemeentemuseum, The
Netherlands*

*Monet's paintings of the Normandy
coast included numerous pictures of
objects connected with the lives of the
fishermen, including their boats, the
fish they caught and the nets they
caught them in.*

Red Houses at Bjoernegaard, 1895
Oil on canvas, 25^1/$_2$ x 31^7/$_8$in
(65 x 81cm)
Musée Marmottan, Paris

At last, some colour! Monet, who complained bitterly about the snow covering everything in Norway when he first arrived there, must have been delighted to come across these red houses set against a blue sky.

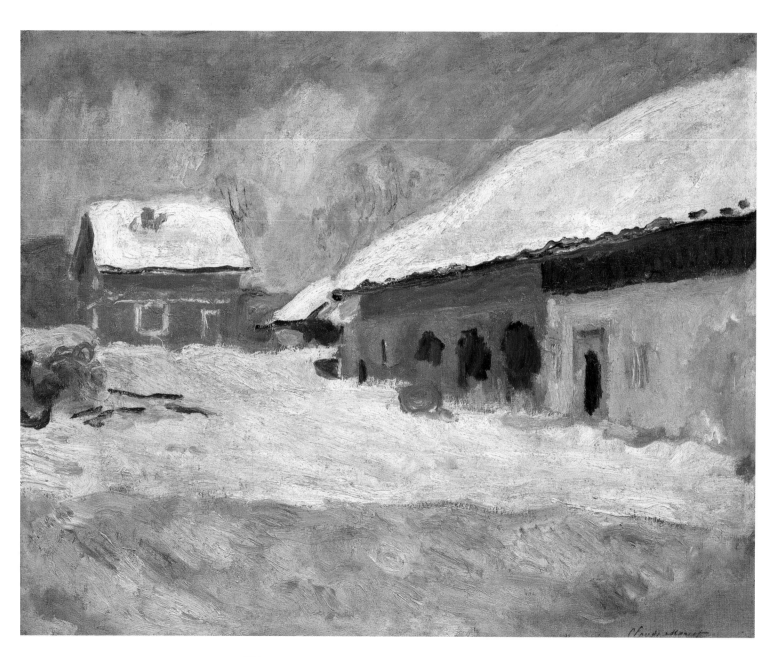

Later, he visited the Mediterranean, unseen since his days as a soldier on his way to Algiers on a cargo boat, and made long stays on the French and Italian Rivieras. Coming between these trips was a time spent on Belle Ile, a large island off Brittany's Atlantic coast, visits to the valleys of the Creuse in the Massif Central, and trips to other old favourite places, Holland and London.

Monet's search for purer, more vivid colour, took him back to Holland, a country he had visited several times before, in the late spring of 1886, when the tulips were in full bloom. Surely, here, more than anywhere else in Europe, he would find subjects unequalled for the brilliance of their colours. In the event, the tulips proved unsatisfactory, perhaps because the fields in which the Dutch habitually planted them were too geometric and static. This could account for the 'crude execution … in which the impasto is so thick that an unnatural light is added to the canvas' that the painter Bracquemond noted in some of the paintings that Monet chose to exhibit from his trip.

While the number of long trips made in France away from Giverny declined in the 1890s, Monet took two serious painting trips further afield, once to Norway and once to London. Monet exhibited in London, often at the suggestion of John Singer Sargent, in the 1880s and 1890s, and made at least one painting trip to England

Mount Kolsaas, Pink Reflections, 1895
Oil on canvas, 25^1/$_2$ x 39^3/$_8$in
(65 x 100cm)
Musée d'Orsay, Paris

The effect of the setting sun on Mount Kolsaas has allowed Monet to introduce a touch of warm colour into an otherwise quite bleak scene.

early in the 1890s, but did not go there for an extended painting session until the late 1890s. His summer trip to London in 1888 coincided with an exhibition of work by Impressionist painters that drew very unpleasant criticism from the old guard of the English art establishment but still managed to sell more paintings than ever before. The magnificent series of paintings Monet did of the Thames during three trips at the end of the century is described in the next chapter.

The two-month–long expedition to Norway in February and March 1895 yielded far fewer paintings than Monet had hoped. Monet went there to visit his stepson Jacques and although he was very happy to be with him,

discovered that there was far too much snow. 'The place must be infinitely more beautiful without snow, or at least with less that this,' he complained to Alice (who had remained at home in Giverny), a few days after his arrival. The main problem was that he could see no water, nor sea: snow even covered the ice on the water.

What really delighted Monet about life in Norway in the winter – sleigh rides in the snow, with everyone wrapped in furs, people wearing delightful costumes, or heading up mountains lit up with torches in the dark – were the sorts of things that he no longer painted. And even when he did see a possible motif, getting things set up for his way of painting took too long to be practical, especially in such low temperatures.

By the end of his stay, Monet was admitting that, in the beginning, he had been blind to the wonders of Norway. He had had to limit his time getting a motif on canvas to one or two sessions only because he knew it could quickly change out of all recognition. Thus the winter landscapes he brought home from Norway, such as his several paintings of Mount Kolsaas, were painted in a broad style that recalled his work of the 1870s.

Monet's primary focus during his trips around the coasts of France was on the effects of light and weather on his chosen motif. In paint on canvas, he attempted to capture all the nuances of weather, from the great Atlantic storms pounding the granite rocks of Belle Ile to the wonderfully luminous winter light that played on the exotic trees and plants of the Riviera. He was also very concerned to bring out what he saw as the special, unique characteristics of each place, not only the physical landscape and the flora that grew on it, but also its intrinsic mood.

Over the years, Monet extended his painting technique into areas previously unexplored in his struggle to capture and master the forces of nature. Storms and breaking waves were set on the canvas in an answering storm of flecks and hooked dashes of dramatically dark-hued paint, and the calm serenity of end-of-day sunlight on the foliage of trees on the Mediterranean was mirrored in a delicate merging of tender hues of pink, blue and gold.

Monet's many letters of the time show that he was often depressed by the difficulty of the task he had chosen to undertake and often feared that he would never produce work to match the exacting standards he had set himself. He scraped off, painted over and even destroyed much of what he did. Once, the weather did the destroying for him, snatching up his easel and canvas and hurling them into the sea. Much more often, the weather was so bad that he could not paint at all and when he did return to a canvas, the conditions of weather, flora and landscape that he had been painting had changed so radically that he had to

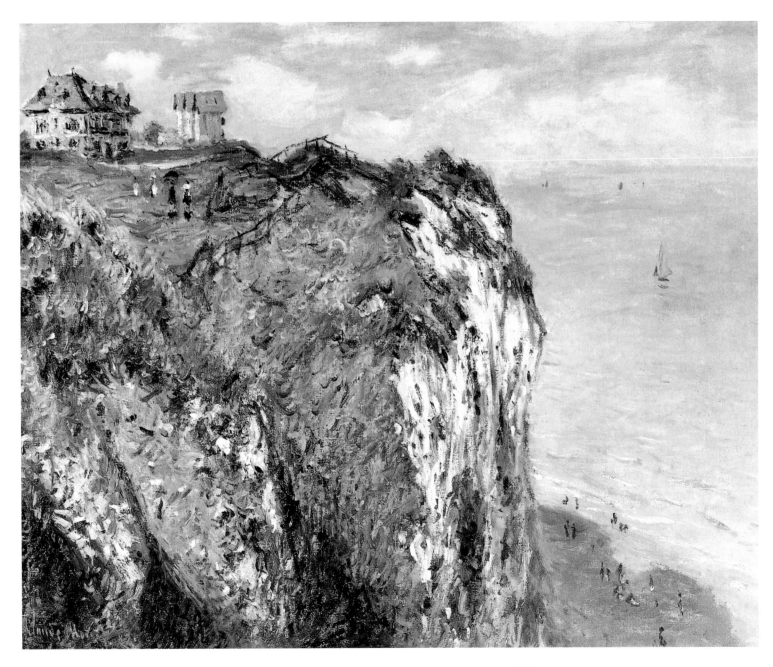

The Cliffs at Dieppe, 1882
Oil on canvas, 25$^{1}/_{2}$ x 31$^{7}/_{8}$in
(65 x 81cm)
Kunsthaus, Zürich

The sheer cliffs of the Normandy coast, dropping dramatically into the sea, not only offered Monet many interesting lines of vision, but also provided dramatic shapes for his paintings.

Sea Coast at Trouville, 1881
Oil on canvas, 23¹/₂ x 35⁷/₈in
(59.7 x 91cm)
Museum of Fine Arts, Boston

This solitary tree, bent over by the prevailing wind, appeared in several of the paintings Monet did at Trouville.

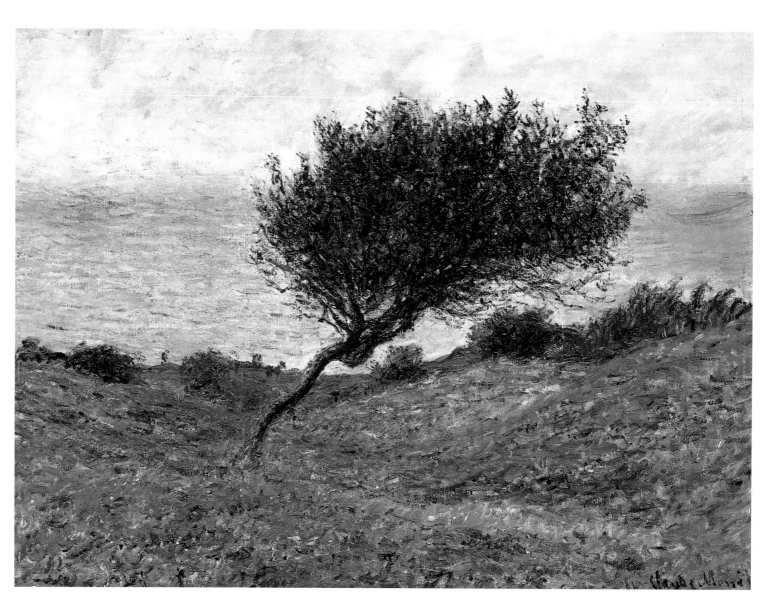

declare it 'done for' and start again. But he never thought to give up and mastered the difficulties in the end. In fact, he probably relaxed his intensive travelling once he knew, consciously or subconsciously, that he had accomplished his goal.

On the Normandy Coast

Monet's first trips to France's sea coasts early in the decade were really a kind of homecoming, for Monet spent many weeks on the Normandy coast in 1880 and

LEFT
The Coastguard's Cottage at Varengeville, 1882
Oil on canvas, 23⅞ x 32in
(60.5 x 81.5cm)
Museum of Modern Art, Boston

BELOW LEFT
The Church at Varangeville, Sunset, 1882
Oil on canvas, 25½ x 31⅞in
(65 x 81 cm)
Private collection

The village of Varengeville-sur-Mer, west of Dieppe, lies in a beautiful seaside setting that has long attracted artists. The village provided Monet with two cliff-top subjects, a cottage variously described as a customs officer's post or a coastguard's cottage, and a small church. Monet painted both at different times of day and in all weathers.

then again every year up to 1886, sometimes making more than one trip in a year. The northern coasts of France offered painters a very different set of subjects and motifs from the Seine valley, with its predominantly horizontal lines. The sheer cliffs of the coast, clad in a wonderful array of flowers and grasses, and folding into many dramatic shapes and outlines, produced some excitingly different lines of vision. Then there was the splendid effects of light and shadow, created by sun, wind and clouds scudding across the sky.

In the early years of the 1880s Monet tended to stay for several weeks at a time in one place, often choosing a

The Cliff Walk, Pourville, 1882
Oil on canvas, 26¼ x 32⅜in
(66.5 x 82.3cm)
The Art Institute of Chicago

The figures Monet has included in this wonderful study of light and shade on sea and land allow him to indicate that a fresh breeze is blowing along the clifftops.

Etretat, Rough Sea, 1883
*Oil on canvas, 31⁷⁄₈ x 39³⁄₈in
(81 x 100cm)
Musée des Beaux-Arts, Lyon*

*The striking rock formations in the sea
at Etretat had attracted artists long
before Monet made them world-famous
by including them in many of the
paintings he did at Etretat.*

RIGHT

The Cliffs at Etretat, 1885

Oil on canvas, 26 x 32^1/$_2$in
(65.8 x 82.4cm)
Sterling and Francine Clark Institute,
Williamstown

OPPOSITE

The Manneport, Etretat, 1886

Oil on canvas, 25^3/$_8$ x 32in
(64.5 x 81.3cm)
Metropolitan Museum of Art, New York

Two great arches of rock, known as the
Porte d'Aval (in the picture, right, with
the free-standing rock known as
l'Aiguille, or The Needle, behind it) and
the Manneport (opposite), dominate the
cliffs at Etretat. Monet included both in
his paintings, depicting the more
broadly massive Manneport in close-up
in all weathers.

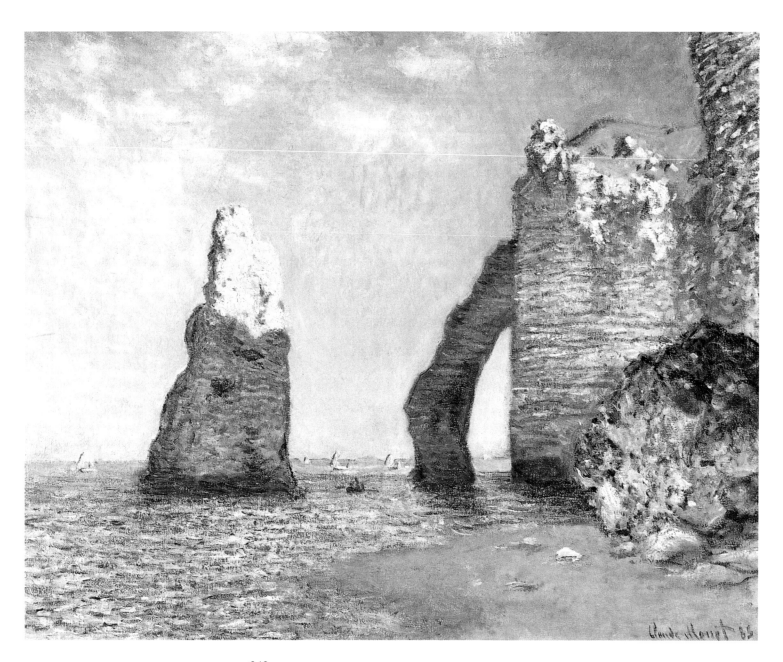

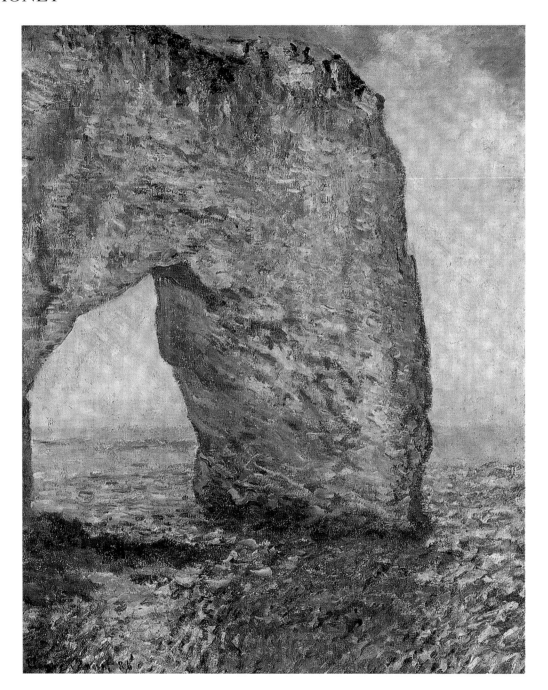

small town he had known since childhood, most of them along the stretch of Channel-facing coast between the mouth of the Seine at Le Havre and Dieppe. Thus, he was in Fécamp in March 1881, Dieppe in February 1882, Pourville with his family for much of the summer of 1882, and Etretat in February 1883 and again in the summers of 1885 and 1886. From his base camps in these towns he would make sorties to many other sites that he had noticed on his painting expeditions.

The site could be something as apparently insignificant as the lone, wind-bent tree by a cliff-path at Trouville which dominates *Sea Coast at Trouville* (page 238), a painting with a strong hint of a Japanese landscape print in its layout. It could be any one of the spectacular rock formations at Etretat, which were so famous that they had been given names, such as Porte d'Aval, the Needle, or the Manneporte. Or it could be a church or the small, unassuming customs officer's cottage on the cliffs at Varengeville, near Dieppe, which Monet painted 18 times from different angles and in different light and weather conditions in 1882.

For one aspect of *The House of the Customs Officer, Varengeville* (page 239), Monet planted his easel above his subject and to the south-east. This allowed him to paint a delightfully sun-lit scene, looking beyond the cottage to the open sea with the white sails of boats

dancing on the water behind and the horizon beyond disappearing into a summery haze. He also painted it from the south-west in darker, more stormy conditions. This time (see page 177), the cottage and the vegetation surrounding it takes on a much darker hue; the sea is rough, the flecks of white paint now indicate, not attractive sails, but the crests of breaking waves, while the distant horizon, painted near to the top of the canvas, is dominated by the cliffs of Dieppe.

The church, perched on a clifftop and overlooking the sea at Varengeville, gave Monet yet another motif with dramatic possibilities, of which he took full advantage in *The Church at Varengeville* (page 239). In this painting Monet was concerned with capturing the vividly theatrical, lavishly-coloured effect that the setting sun throws onto the landscape. The church rests in a golden haze against a backdrop in which gold-orange sky and blue-yellow sea merge; in the foreground, two dark pine trees and the vegetation surrounding them, all set off-centre on the canvas, are touched by bold accents of gold, crimson, yellow and pink, applied to the canvas in short, firmly-flicked brushstrokes. *The Church at Varengeville* shows Monet already coming to grips with the major problem of his Mediterranean pictures: how to capture the brightness and luminosity of sunlight in colour.

The cliffs and coast paths at Pourville, just outside

Dieppe, provided Monet with more subjects that allowed him to explore the way in which light and shadow dramatizes shapes and colours. In *The Meadow Road to Pourville* (1882) the sandy-yellow road – really little more than a path – leads the eye into a picture in which horizontal bands of sea, cliffs and sky fill the top half of the canvas. The *Cliff Walk, Pourville* (page 240), a joyous evocation of the special pleasure of walking on sea-girt, wind-swept cliffs in summer, is one of very few pictures of the period to contain figures. They are there, not so much to provide human interest as to allow Monet to indicate, by their skirts and parasol, that an invigorating sea breeze is blowing along the flower- and grass-strewn cliffs.

Although Monet preferred to paint out in the open air, surrounded by his subject, atrocious weather would sometimes send him indoors – 'making use of my various windows', as he told Alice in a letter from a wet and stormy Etretat in October 1885. Monet's preference for painting *sur le motif* in all weathers, even if it meant tethering his easel to a rock and donning waterproof clothes, thick socks and fishermen's boots, was very nearly his undoing at Etretat just a month after he wrote to Alice about his 'windows'.

He had taken advantage of a lull in the rain to go out to one of his favourite motifs, the great rock arch called

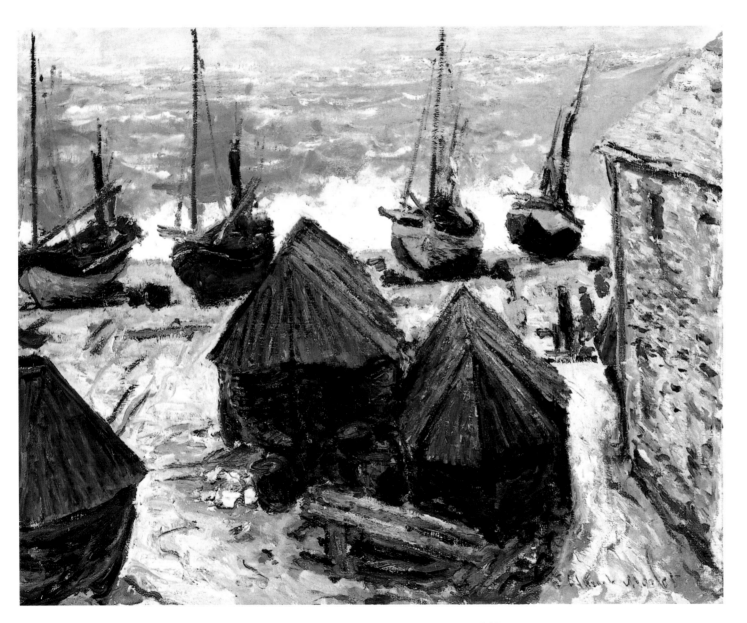

Boats in Winter Quarters, Etretat, 1885
Oil on canvas, 25³/4 x 32in
(65.5 x 81.3cm)
Art Institute of Chicago

Vincent van Gogh greatly admired this picture of fishing boats drawn up out of the water when he saw it in an exhibition in Paris.

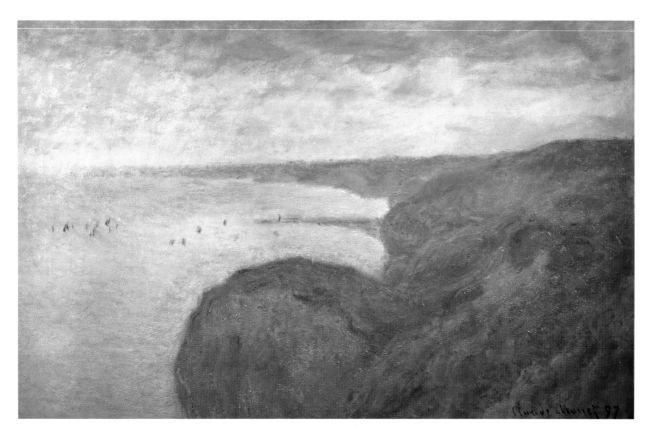

Steep Cliffs near Dieppe, 1897
Oil on canvas, 26³/₈ x 39³/₈in
(64.5 x 100cm)
Hermitage, St. Petersburg

thought he was done for, but managed to drag himself out of the water on all fours. His clothes were soaked through and his beard was covered in splodges of paints from his palette, which he had kept a grip on but which had been flung by the sea into his face. His painting, his bag of paints and brushes and his easel, were all broken up and torn to pieces.

Although annoyed by the loss of his painting equipment, which he replaced by means of a telegram to his suppliers, his greatest fury was reserved for the loss of the painting, which he had been counting on as a good one. Still, it could have been worse. 'To think I might never have seen you again,' he ended his letter to Alice that evening.

In the end, of course, Monet completed to his satisfaction many pictures of the Manneporte at Etretat in the 1880s. He had included the spectacular arch in earlier paintings (it is in the background in *Rough Sea at Etretat* (page 61), for instance, but now the rock became a main motif of his work, observed in fine detail in many different fluctuations of light and weather. In *Etretat, Rough Sea* (page 241) the great arched cliff is shown in warm, cloudy weather; the sun casts a bright light on the underside of the arch but the sea still pounds angrily against the rocks. *The Cliffs at Etretat* (page 242) and *The Manneporte, Etretat* (243) are much quieter scenes: now

the Manneporte, thinking that the high winds and rough seas would make for fruitful painting. He was so absorbed in his work that he did not see a huge wave hurtling down on him, which threw him against the cliff and dragged him and all his painting materials down into its wake. He

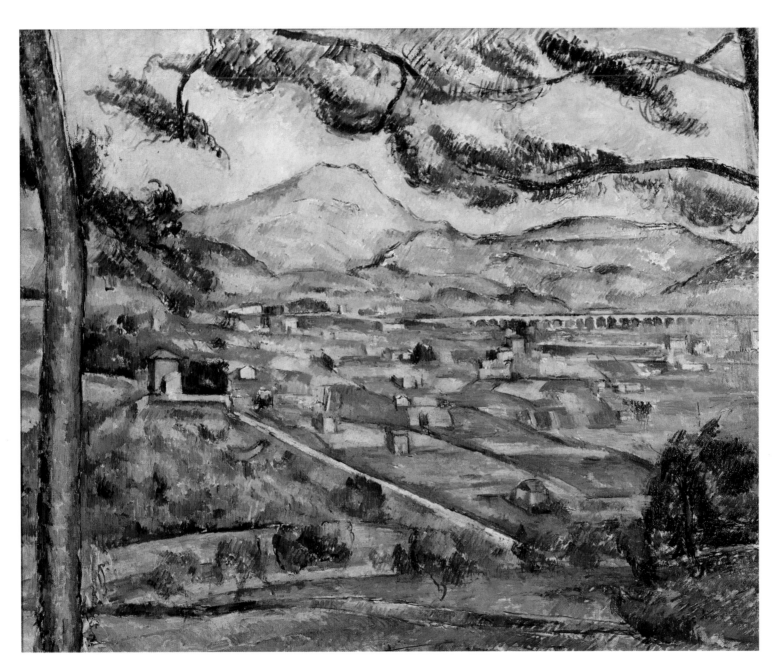

Paul Cézanne
**Mont Sainte-Victoire with Pine,
1886–87**
Oil on canvas, 22³/4 x 28¹/2in
(57.7 x 72.5)
Phillips's Collection

Although Paul Cézanne took a very
different path from Monet on the hard
road to achieving success as a painter,
as this painting of one of his favourite
motifs demonstrates, he still considered
Monet to be one of the greatest artists
of their age.

OPPOSITE
Villas at Bordighera, 1884

Oil on canvas, 45¹/4 x 51¹/4in
(115 x 130cm)
Musée d'Orsay, Paris

Monet's stay at the attractive Italian town of Bordighera in 1884 gave him his first opportunity to grapple seriously with the many difficulties involved in depicting the light of the Mediterranean, which was very different from that of northern France.

the sea is gentle, merely lapping against the rocks, and the sun has moved away from under the arch to light up the tops of the cliff, the nearby rocks and the sea beyond.

Etretat, a busy and attractive fishing village on the coast about 16 miles (26km) north-east of Le Havre, famed for its spectacular rock formations, had been popular with writers and painters since the 18th century. Among the celebrated Parisians who had holiday villas there in Monet's time were the composer Offenbach, the writer Guy de Maupassant, and Monet's friend and patron, the singer Jean-Baptiste Faure. In 1885 Faure lent his villa to Monet, who took Alice and their children with him for a stay lasting several months in the late summer and autumn, although they had returned home some time before the near-disaster at the Manneporte. They had actually been with Monet to the painting site from which the sea had so dramatically swept him, so they would have had a very clear picture of the incident in their minds as Alice read out Monet's vivid description.

Another vivid account of Monet at work at Etretat appeared in an article written by Guy de Maupassant for the journal *Gil Blas*. In 1885 Maupassant spent much time watching Monet going about the village 'more like a hunter than a painter. He stalked on ahead, followed by his children and Madame Hoschedé, who carried his canvases, sometimes as many as five or six, representing

the subject at different times of day and with different effects … Face to face with his subject, the painter lay in wait for the sun and shadows, capturing in a few brushstrokes the ray that fell or the cloud that passed …'.

Maupassant's description of Monet painting became almost histrionic. 'I have seen him seize a glittering shower of light on the white cliff and fix it in a flood of yellow tone which strangely rendered the surprising and fugitive effect of the elusive and dazzling brilliance. On another occasion he took a downpour beating down on the sea into his hands and dashed it on the canvas – and succeeded in really painting the rain as it seemed to the eye.' The painting whose creation Maupassant describes so dramatically could be *Etretat: Rainy Weather* (1885).

Not all of Monet's paintings at Etretat needed great expanses of sea or lashing rain to make them effective. A painting which made a great impression on Vincent van Gogh when he saw it at Boussod & Valadon's gallery was *Boats in Winter Quarters, Etretat* (page 245). This intense painting has an enclosed, boxed-in feel, allowing it to concentrate on the four strongly-coloured fishing boats pulled up at the water's edge, forming a line across the painting and on the huts in the foreground. The paint is densely applied, on the huts and hulls of the boats in thick strokes of dark browns, blues and violet, and in lighter tones on the sea and the building on the

right-hand edge that holds the eye to the painting.

Late in the 1890s Monet returned to some of his favourite haunts in Normandy with a plan in mind to recapitulate his entire artistic career by doing a few canvases of his favourite motifs. He was in Pourville, Dieppe, Fécamp and Varengeville in 1896 and 1897 and in Vétheuil in 1900 and 1901. While some fine paintings resulted from the visit, 24 of which were exhibited as 'Falaises' in 1898, the plan, if such it was, was never completed, partly because Monet's 60th birthday in 1900 did not mark the end of his career or any kind of retirement.

The Mediterranean

In December 1883, having seen his family safely settled at Giverny, Monet went with Renoir to the south of France. They explored the painting possibilities along a stretch of the Mediterranean coast from Marseille to Genoa, in Italy. At L'Estaque, a small fishing village near Marseille, they stopped to visit their friend and long-standing comrade-in-arms, Paul Cézanne.

Nearly two years before, Renoir had stayed with Cézanne at L'Estaque, and the two artists had spent many happy days working together. But Renoir fell ill with pneumonia and was nursed devotedly by Cézanne and his mother until he was restored to health. All three artists

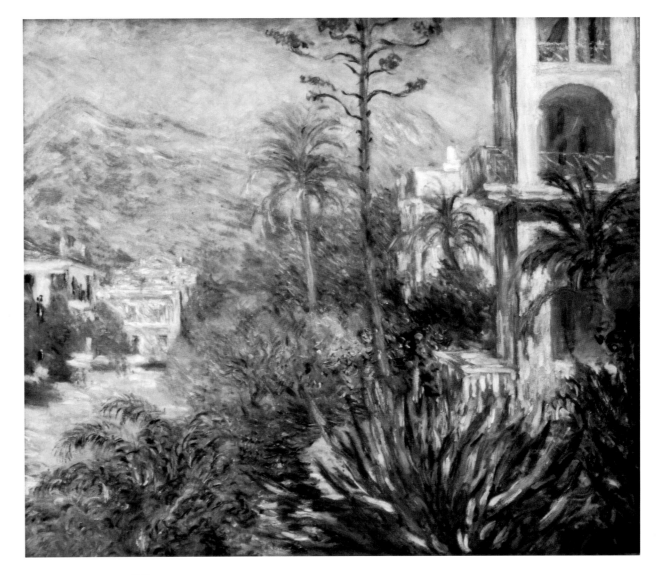

OPPOSITE
Bordighera, 1884
Oil on canvas, 25¹/₂ x 31⁷/₈in
(65 x 81cm)
Art Institute of Chicago

Monet wrote to Alice when he first arrived in Bordighera, 'So much blue in the sea and the sky – it is impossible!' Paintings like this one show that one way in which Monet dealt with the problem was to reduce the amount of sea in many of his pictures to a minimum.

thought this 1883 meeting significant enough to tell others about it, Monet recounting the incident in a letter to his friend and patron Georges de Bellio on 16 December. When, 20 years later, Cézanne remarked in a letter to his friend, the Provençal poet Joachim Gasquet, 'I despise all living painters, except Monet and Renoir', it was also likely that he was thinking of this particular moment in a lifetime of knowing and working with the two artists.

Although Monet regarded himself as a tourist rather than a painter when he visited the Mediterranean in 1883, he nevertheless loaded himself up with canvases, an easel and the rest of his painting paraphernalia. He also took on the train a large suitcase full of warm clothes. At least this time, unlike their first rail trips together 20 years before, he and Renoir could afford porters, first-class travel and good food, but in the end, Monet saw the trip as a reconnaissance exercise. He found that he could no longer concentrate on painting when there were others, even an old friend like Renoir, around him.

The small resort town of Bordighera, just across the French border from Menton on Italy's Ligurian coast and famous for its palm trees, had particularly impressed Monet, and within weeks of his return to Giverny he was already determined to return. Informing Paul Durand-Ruel of his plans, Monet asked him not to tell Renoir or, indeed, anyone (underlining the word in his letter), not

because he wanted to make a big secret of his visit, but because he insisted on going alone: 'I have always worked better alone and from my own impressions.'

By mid-January 1884, Monet was in Bordighera, installed in an English pension, where the food was good enough for him to dine well, he told Alice in the course of one of the letters he wrote to her each evening before climbing into bed. He spent most of the daylight hours either painting or walking 'here, there and everywhere', on the lookout for a new motif for his paintings. As always, he would see a possible motif – groups of orange or lemon trees, the fronds atop immensely tall palm trees tossed about by a breeze, or perhaps some particularly splendid and gnarled olive trees – then work out in his mind just how he was going to paint them. The difficulty was to find his motif in exactly the setting he wanted: he had to see it in its 'envelope' rather than imagine it. He found his palm trees, for example, in the walled garden of a private house; they pose elegantly in *Villas at Bordighera* (page 249), their fronds and trunks touched with the mandarin-orange colour, along with shades of ultramarine and turquoise, that Monet had begun to use in his Bordighera paintings.

He would arrive back at the pension at dusk, dog-tired and ready for a meal, then some reading and letter-writing, and, of course, some contemplation of what he

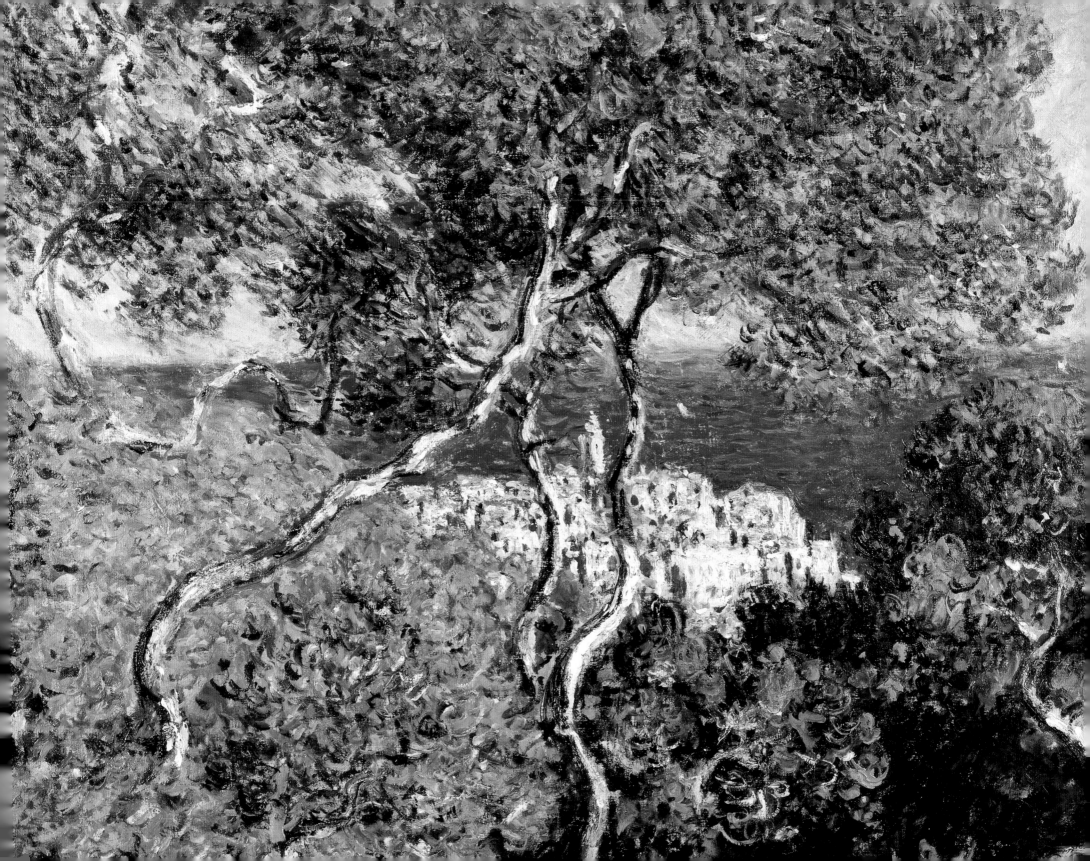

Cap Martin, Near Menton, 1884
Oil on canvas, 24³/₈ x 32¹/₈in
(62 x 81.6cm)
Museum of Fine Arts Boston

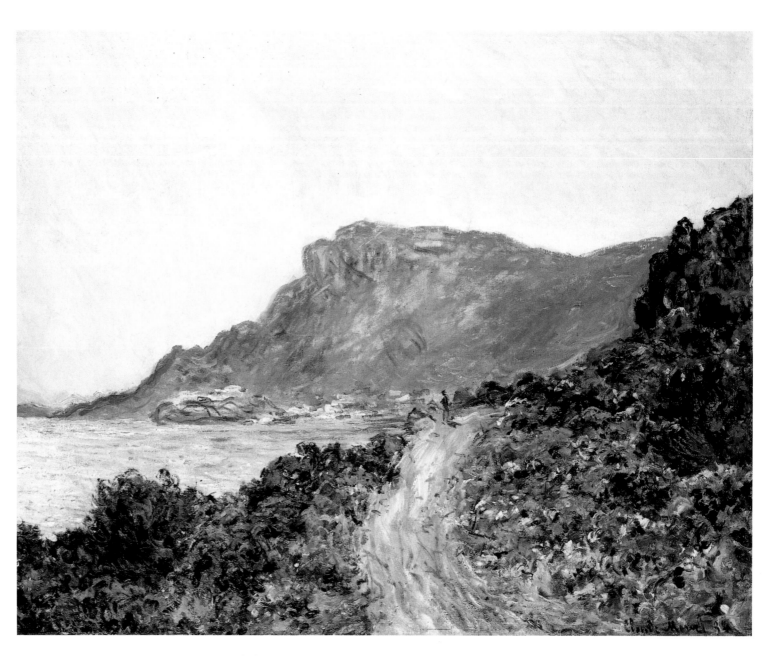

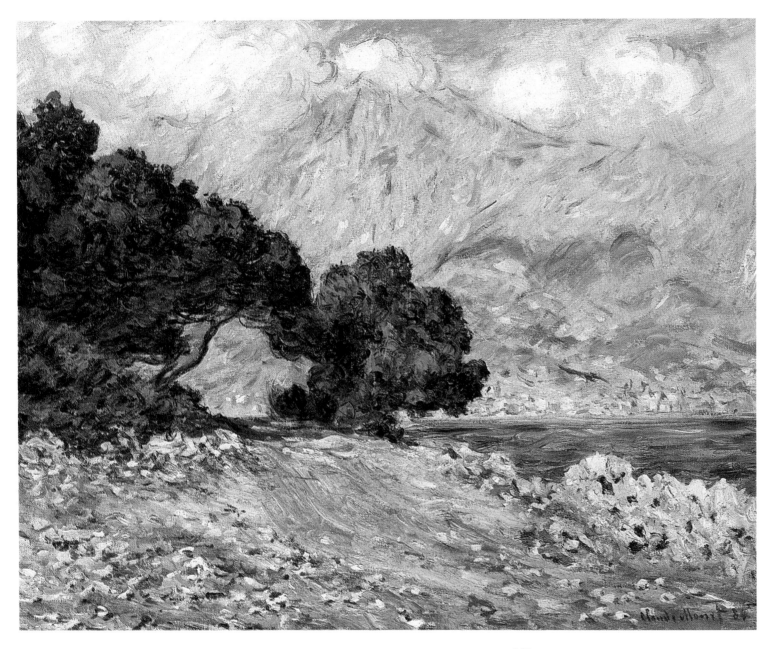

*View of Menton from Cap Martin
(La Corniche de Monaco), 1884*
Oil on canvas, 29^{1}/8 x 36^{1}/4in
(74 x 92cm)
*Collection Stedelijk Museum,
Amsterdam*

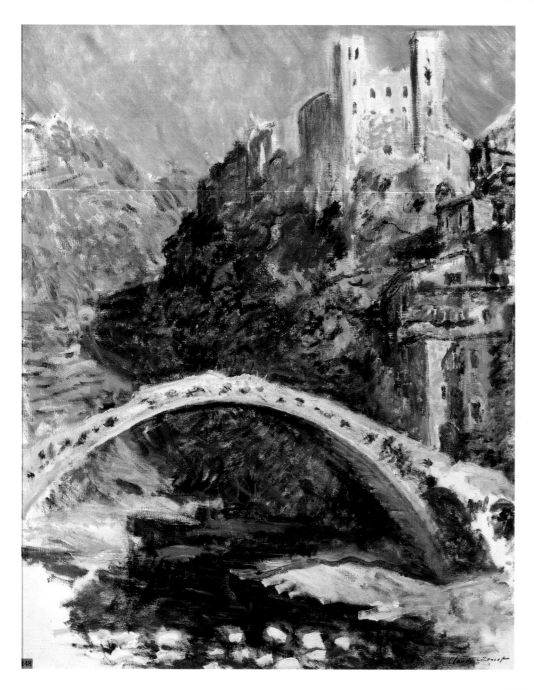

had painted during the day and what he would paint the next, then bed and sleep.

He kept this up day after day, usually with half a dozen canvases on the go at a time. Everything was so different from what he had experienced before – the air, the light, the sky, the colours of the landscape, the exotic plants: 'palm trees make me curse and swear', he told Alice early in his stay – that he found it difficult to capture the motifs he found and to put them down on canvas. Because, at first, he found the extraordinary intensity of the light 'simply terrifying', afraid that he was choosing all the wrong colours; confronted with that Mediterranean clarity and, as he thought, consciously understating the colours, he suspected that he might actually be getting it all wrong.

He refused to be depressed, however; on the contrary, he regarded it as a challenge, looked forward to doing better the next day. His time was not always spent in Bordighera. One day he ventured up the Nervia river, finding a medieval bridge and ruined castle at Dolceacqua which he recorded on canvas in a flamboyantly romantic style.

Another day he hired a carriage and was driven back across the French border into Menton. Deciding instantly that the small town, with its splendid setting among hills with its feet in the sea, was a wonderful subject for

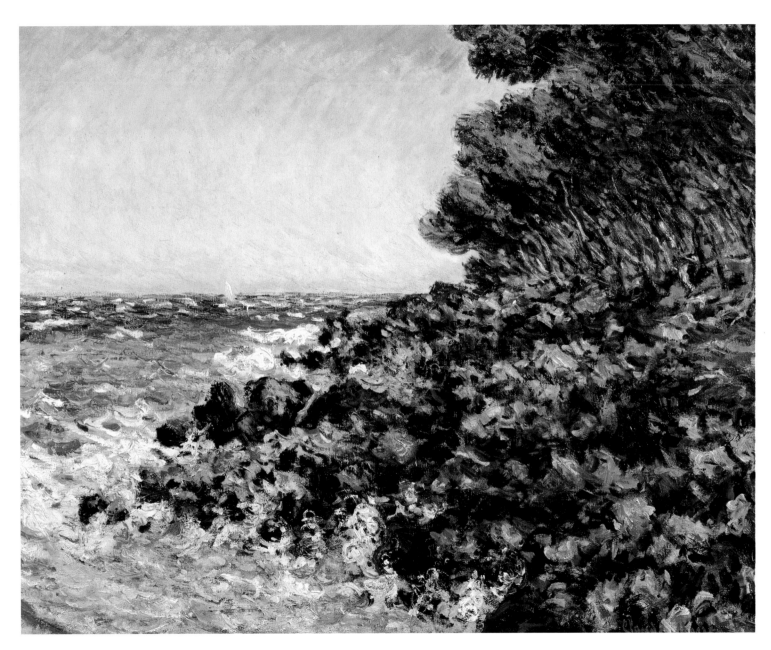

OPPOSITE
The Castle of Dolceaqua, 1884
Oil on canvas, $36^1/4$ x $28^3/4$in
(92 x 73cm)
Musée Marmottan, Paris

LEFT
Cap Martin, 1884
Musée des Beaux-Arts, Tournai

painting, he eventually spent several days there in April at the end of his stay. Presumably humping his painting gear, he walked to Cap Martin, a point midway between Menton and Monte Carlo from where he had a superb view, mostly of hills and trees with only a glimpse of sea, back to Menton. *View of Menton from Cap Martin* (also called *The Corniche of Monaco*) and *Cap Martin, Near Menton* (pages 252 and 253) are among the paintings that resulted from Monet's time in Menton. Both paintings concentrate on the landscape – misty blue hills, deep green pine trees and a vivid orange-tan road – with just patches of blue-green sea in a small area of each canvas. As Monet told Alice, the sea played no big part in his studies on this trip to the Mediterranean.

The more he painted, the more confident Monet felt that he could rise to a challenge. By early February he was able to tell Alice that his latest work was much improved over his early, poor paintings. He radically changed his palette, using many much bolder colours than were possible in the cooler, northern light of Giverny. Because he was beginning to feel the landscape he knew he could be much braver with his colours – 'every tone of pink and blue – it's enchanting, it's delicious'.

Enchanting, delicious – these are the right words to apply to the 50 paintings that Monet brought back from Bordighera and the Riviera at the end of March. There is,

indeed, a great range of blues and pinks in many of his Bordighera paintings, often rich and bright in the foreground, where the colours emphasize the plants, which are painted in exquisite detail, fading to more delicate hues on the hills, sea or buildings in the background.

The spectacular colours and bravura rhythms of many of Monet's Bordighera paintings seem, from a modern point of view, to forecast much that was to come in art. Pictures like *Olive Trees, Bordighera*, in which the quiet olive grove becomes a mass of enclosing curves, suggest the emotionally-charged work of Vincent van Gogh and the sinuous curves of Art Nouveau, while the brilliance of the colours in many of the Bordighera paintings look toward the colourist work of Matisse and the Fauves early in the 20th century.

Virtually none of the Bordighera paintings had been completed to the artist's satisfaction when he brought them home. He was still not happy with them at the end of April, when he took just a few to Paris to whet Durand-Ruel's appetite for what he might expect to receive some time soon. Durand-Ruel was probably not surprised: he had often listened to Monet's worries concerning the need for revisions and finishing touches, done with care in the right, quiet conditions. In the event, many of Monet's Bordighera paintings were sent in Durand-Ruel's

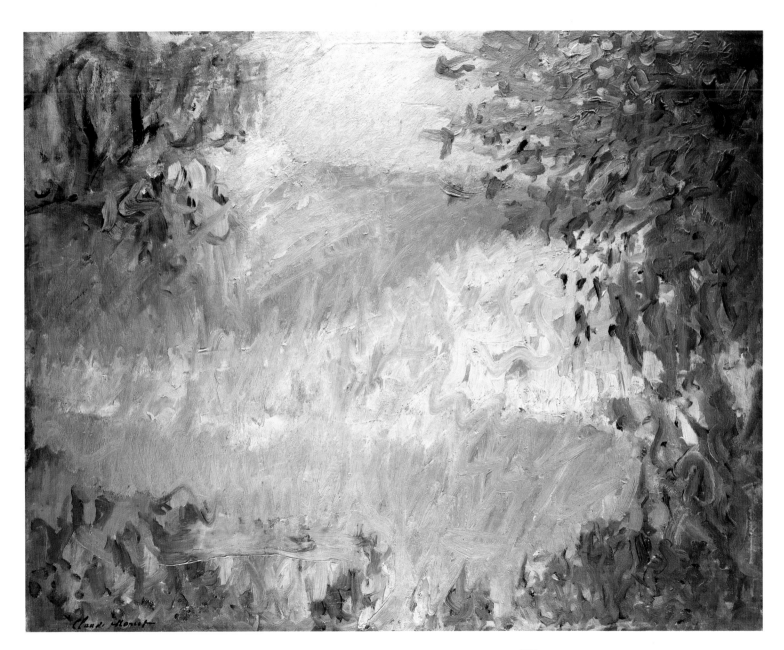

Monte Carlo: *View of Roquebrune*,
1884
Oil on canvas, 25¹/₂ x 31¹/₂in
(64.7 x 80cm)
Private collection

During his first stay on the
Mediterranean, Monet made several
day trips from Bordighera back into
France. Here, he found so many
attractive viewpoints, such as this one
of Roquebrune seen from Monte Carlo,
that he eventually stayed on the French
Riviera for two weeks before returning
home.

packing cases across the Atlantic to America.

Four years were to pass before Monet returned to the Mediterranean in 1888. This time he based himself at Antibes on the Côte d'Azur, right at the heart of the French Riviera. He stayed four months, from January to April, lodging in a house romantically named the Château de la Pinède, which was outside Antibes on the road to Juan-les-Pins. Monet had chosen an area notable for the paintable splendour of its surroundings. Antibes itself was an attractive old town with relics of an interesting past, including a fort, a château once owned by the Grimaldi family (and which today houses a museum devoted to the work of Pablo Picasso) and a fine church with Romanesque origins. South of the town, the land rises to the attractive peninsula known as Cap d'Antibes, on the south side of which lies the elegant resort town of Juan-les-Pins. Encompassing all this are the blue-green Mediterranean and, away to the south, the mountains of the Esterel Massif pointing skywards.

While winter was the fashionable time to visit the Mediterranean coast in the late 19th century, it was also the best time of the year for an artist, when the often ferocious mistral miraculously cleared the air; then, all the colours seemed purer and sharper, with no heat haze to subdue the light. Snow often added a white coating to the Esterel mountains, also adding to their value as a backdrop for many of Monet's paintings – provided, of course, that there was snow on the mountains to begin with. Snow appearing as a motif that Monet had been working on for some time turned into something entirely different, forcing him to start all over again.

On this trip, Monet proceeded as he had on his first visit to the Mediterranean, beginning slowly because he had no wish to start too many paintings at once, which would have detained him there for too long – or so he told Alice. It is possible that he concealed his true intentions when he left Giverny because Alice was restive and unhappy when left in sole charge of home and family for months at a stretch.

The overall effect of the paintings Monet produced at Antibes and Juan-les-Pins was rather more subtle than that of the Bordighera paintings. It was as if Monet was deliberately restraining himself – what he deplored in a letter to Berthe Morisot as his tendency to be 'given to brutality' – in favour of a rather more delicate elegance of style. Not that the 1888 paintings lacked the brilliant colours of the earlier works; this time Monet was intent on capturing what he described as the 'so tender and so delicate' air of the Côte d'Azur in winter.

On this trip Monet discovered several motifs that he painted many times, and which formed miniature series in the process. The 16th-century Fort Carré at Antibes, relic

Antibes, 1888
Oil on canvas, 28⁷/8 x 36¹/4in
(73.3 x 92cm)
Museum of Art, Toledo

Antibes, Seen from the Salis Gardens, 1888
Oil on canvas, 25^1/$_2$ x 36^1/$_4$in (65 x 92cm)
Private collection

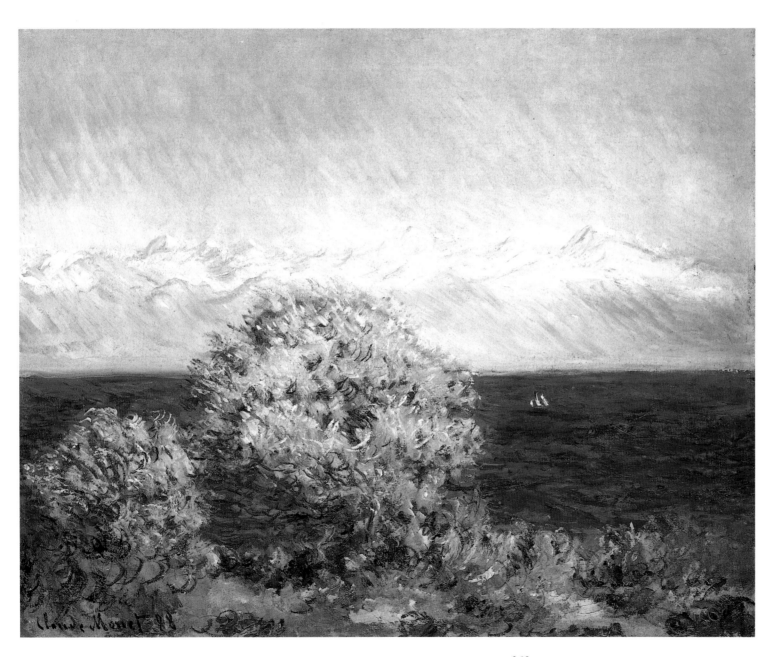

OPPOSITE
***Antibes, View of the Cap, with the
Mistral Blowing, 1888***
*Oil on canvas, 25$^1/_2$ x 32in
(65 x 81.2cm)
Private collection*

LEFT
Cap d'Antibes, Mistral, 1888
*Oil on canvas, 26 x 32in
(66 x 81.3cm)
Museum of Fine Arts, Boston*

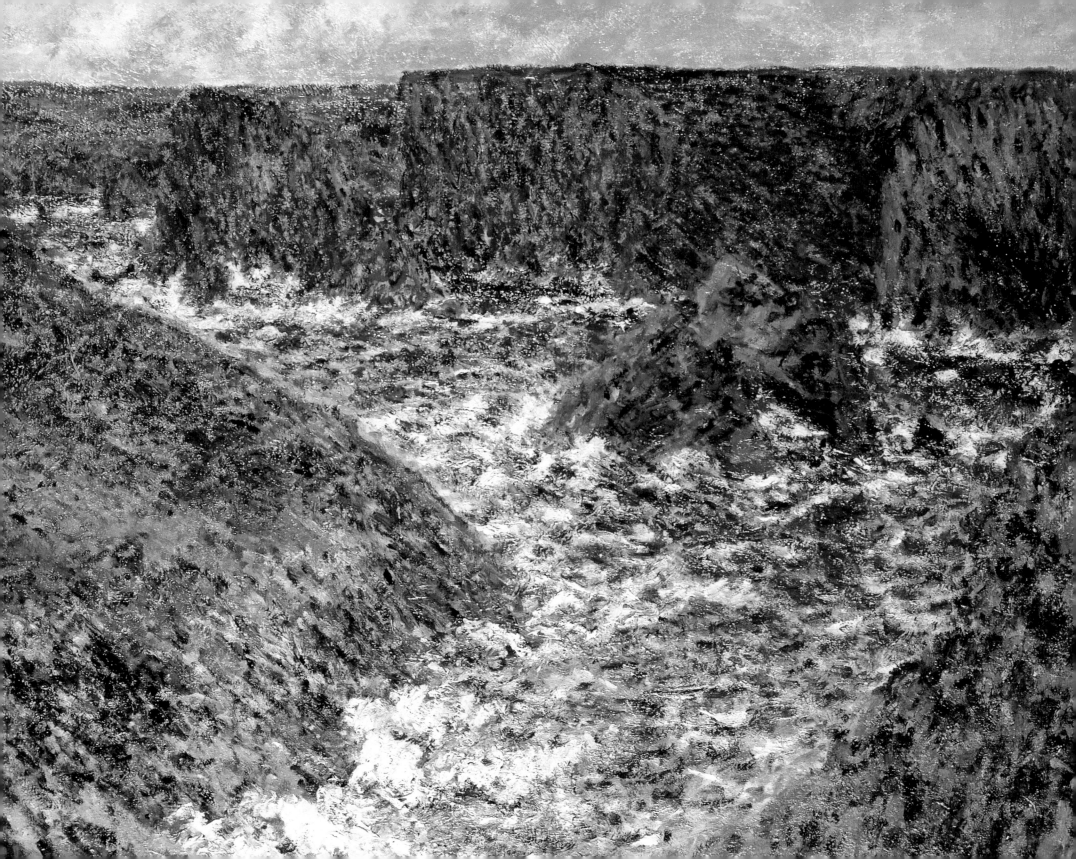

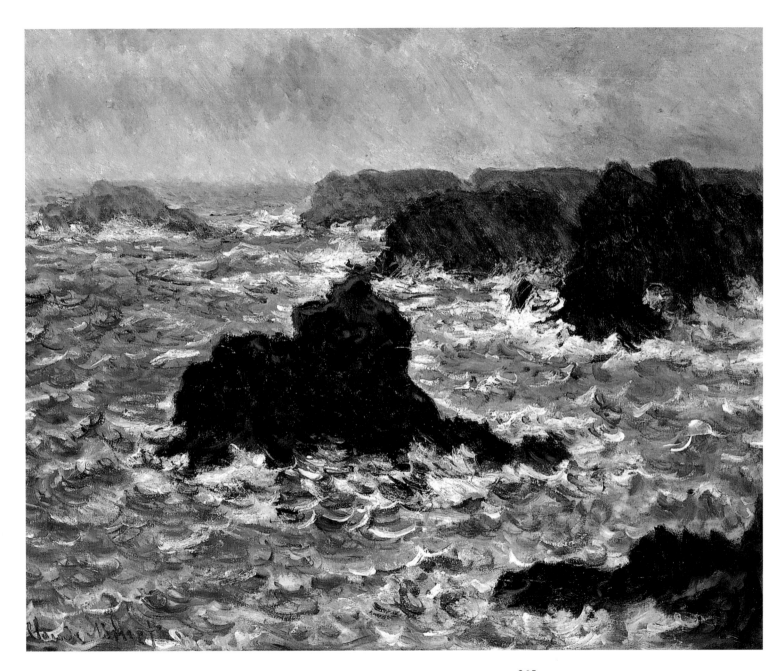

OPPOSITE
Port Domois at Belle-Ile, 1886
Oil on canvas, 25$\frac{1}{2}$ x 31$\frac{7}{8}$in
(65 x 81cm)
Galerie Daniel Malingue, Paris

LEFT
Belle-Ile, Rain Effect, 1886
Oil on canvas, 23$\frac{5}{8}$ x 28$\frac{3}{4}$in
(60 x 73cm)
Bridgestone Museum of Art, Tokyo

of the days when the town was a frontier post between France and Savoy, was one of these. Monet produced six paintings which featured the old fort on the seafront at Antibes. The paintings do not form a series as we have come to understand the term when considering Monet's work; rather, they are the same subject seen from different viewpoints.

Juan-les-Pins was another motif, appearing in some seven canvases. Again, viewpoints were different although the basic subject was the same. In *The Beach at Juan-les-Pins*, for instance, which Monet painted from a viewpoint near his lodgings, the Château de la Pinède, the houses and other buildings of Juan-les-Pins do not feature at all. The greater part of the canvas is taken up by a magnificent clump of pine trees, their green mass set against a series of horizontal bands – sky, mountain, water's edge and sea – in which different shades of blue, flecked with white and grey, merge in a harmony of light and colour.

The town of Antibes itself was the subject of a great many of Monet's paintings. As with the fort and Juan-les-Pins, Monet painted the town from various viewpoints, but he could also produce markedly different paintings from the same spot. The viewpoint – from between groups of trees on the Cap d'Antibes – from which *Antibes* (page 260) and *Antibes, Seen from the Salis Gardens* (page 261)

were painted is the same; the different light and time of day, and therefore the very different colours used, make the two pictures strikingly different.

Monet was also fascinated by the effect of the mistral. There is a sharp clarity in the air combined with great movement in the trees in a painting like *Cap d'Antibes, Mistral* (page 263) that is quite different from the limpid serenity of paintings done during quiet days on the Baie des Anges.

Although Monet was overjoyed to be back in the warm south of France, enthusing in a letter to Gustave Geffroy in February about being 'afloat in blue air ... it is awe-inspiring!', he was less than satisfied with his response to the brilliance before him. He wrote despairingly to Alice and others that he was unable to capture the true atmosphere of the Mediterranean.

At the end of three months, Monet returned to the north with many pictures that even he thought might 'turn out well', once he had worked on them and applied some finishing touches. Nagging away at the back of his mind was the thought that back in Paris his dealers were waiting for more work from him. Even on his way home after his painting marathon in Antibes, he saw his dealers before his family. He caught an overnight train from the south to Paris, arriving at 9 in the morning. This gave him time to see three dealers, Durand-Ruel, Petit and Van Gogh,

before catching the 1pm train home to Vernon, Giverny and his family.

Theo van Gogh exhibited the Antibes paintings at the Boussod & Valadon gallery he managed in the summer of 1888. The exhibition was a tremendous success, the poet Stéphane Mallarmé telling Monet, 'This is your finest hour'. Berthe Morisot said much the same thing in her letter congratulating him on the exhibition. 'You have conquered this recalcitrant public. At [the exhibition] one meets only people who have the highest admiration for you … The picture I like best is the one with the little red-brown tree in the foreground; my husband and I stood in ecstasy before it for an hour.' Far away south in Provence, Vincent van Gogh wrote to his brother, mourning his inability to get to Paris to see this landmark exhibition.

From a more practical viewpoint, the exhibition marked the point in Monet's life when he finally achieved true financial and artistic security.

The Rocks of Belle-Ile

Belle-Ile, the largest of the many islands skirting the western coast of Brittany, sits out in the Atlantic south of the Quiberon peninsula. It is famed for its sandy beaches and the extraordinary granite rock formations of its coast, the most splendid stretch of which, the aptly-named Côte Sauvage, confronts the stormy Atlantic Ocean on the western side of the island. Mid-way down the Côte Sauvage and on the edge of a promontory on which stands one of Europe's most powerfully-equipped lighthouses, a series of sharp rocks called the Aiguilles ('Needles') de Port-Coton rise from the sea. Every summer, a small local population of fishermen and smallholders is trebled when the tourists, holidaymakers and French celebrities seeking a discreet refuge arrive. The guidebooks, however, have only three famous visitors to offer holidaymakers with a taste for history: the great actress Sarah Bernhardt, the composer Albert Roussel, and the painter Claude Monet.

It was a guidebook, in which he read vivid descriptions of the extraordinary rock formations of Belle-Ile, that persuaded Monet to visit the island. Having made a short trip to Holland in the spring to paint the bulb fields and spent the summer painting on the Normandy coast, Monet moved to Belle-Ile in the late summer of 1886, intending to stay just a week or two but in the end remaining there until early winter.

He found himself a room in a house belonging to a local fisherman who also owned the small inn in a remote hamlet called Kervilahouen near the Aiguilles de Port-Coton on the Côte Sauvage. Père Poly, the fisherman-innkeeper, agreed to cook for him, and Monet assumed that he would be living on fish, mostly lobster, because the butcher and baker called only once a week. The Café

Port Donnant, Belle-Ile, 1886
Oil on canvas, 25⁷/₈ x 32in
(65.6 x 81.3cm)
Yale University Art Gallery, New Haven

Painted early on his stay on Belle-Ile, this and the painting on page 276 are the calmest and sunniest paintings that Monet produced during his long stay on the Breton island.

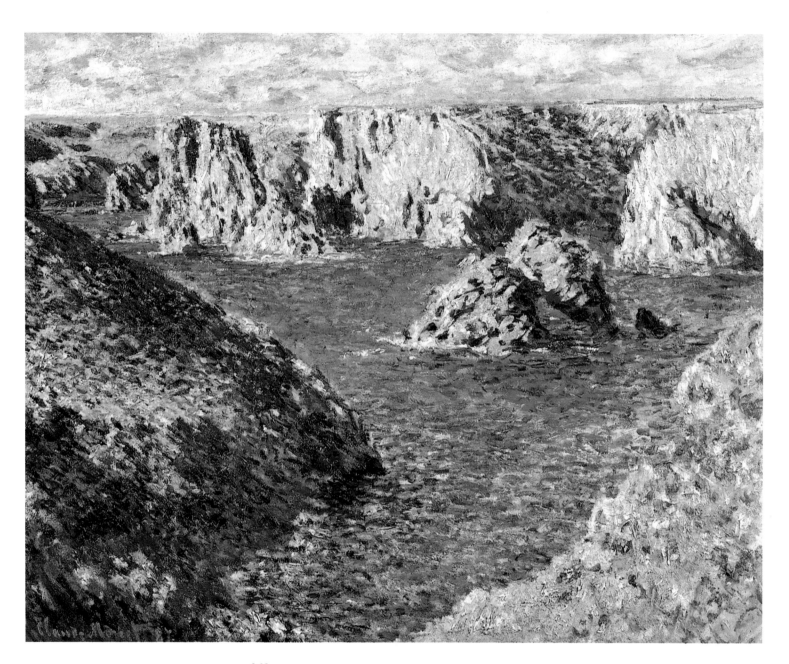

Riche it was not, but as Monet was being charged only 4 francs a day all in, he was not complaining – except once, in a letter to Alice, about the rats in the roof over his head and the smelly pig in a room beneath his own.

From the beginning, he was enthusiastic about this Atlantic island, whose scenery he found very different from the Channel coast. He realized, though, that it would take time to attune his eye and mind to this new landscape, dominated by extraordinary rock formations, grottos, needles and rocks that had been pounded into fantastic shapes by the sea that crashed, foamed and hissed around them.

When winter came and the sunny days and calm seas were replaced by dark, stormy seas and Atlantic gales, he was in his element – provided the rain held off in long enough stretches for him to paint and give full reign to what he called his 'tendency to brutality'. Sometimes, he braved the weather and continued to work in lashing gales: 'wet rocks look that much darker, but perhaps it adds to the beauty of it,' he wrote hopefully to Alice. In *The Wild Sea* Monet drags rain in diagonal slashes of paint across the canvas, whipping up the waves and turning the rocks in the foreground to shiny masses of dark brown and red paint.

In fact, Monet had to overcome his natural tendency to put light colours on his palette, still seen in paintings such as *Port Donnant, Belle-Ile* (opposite) which he did in the early days of his stay, and struggled with the dark colours needed to express what he saw as the sinister and tragic quality of the place. Thus the famous tall, needle-shaped rocks at Port-Coton, such as those included in *The 'Pyramides' at Port-Coton* (page 270), were painted, despite the cloudy blue sky and relatively gentle seas, in densely applied strokes of dark blues, greens and even sombre reddish-browns.

Monet came to refer to the sea, with its bluish-green depths and terrifying fluctuations of mood as an 'old hag' and would spend hours every day for several days just looking at the sea in one particular place, the better to understand its ways. He would subsequently spend just as long working on each painting.

Not that spending a long time on a painting was any guarantee of success. At the end of one particularly foul-weathered day in November, Monet wrote to Alice that he had lost a painting beyond repair. He had been working on it indoors and had been happy with it, having spent about 20 sessions working on it outside in front of the subject, but in the end felt impelled to scrape it all away.

Another effect of the bleak November weather was that Monet, desperate for something to do, asked his landlord to pose for him. One of Monet's last portraits, *Portrait of Poly* (page 271), is a lively study that makes

The 'Pyramides' at Port-Coton, 1886
Oil on canvas, 23³/8 x 28³/4in
(59.5 x 73cm)
Ny Carlsberg Glyptothek, Copenhagen

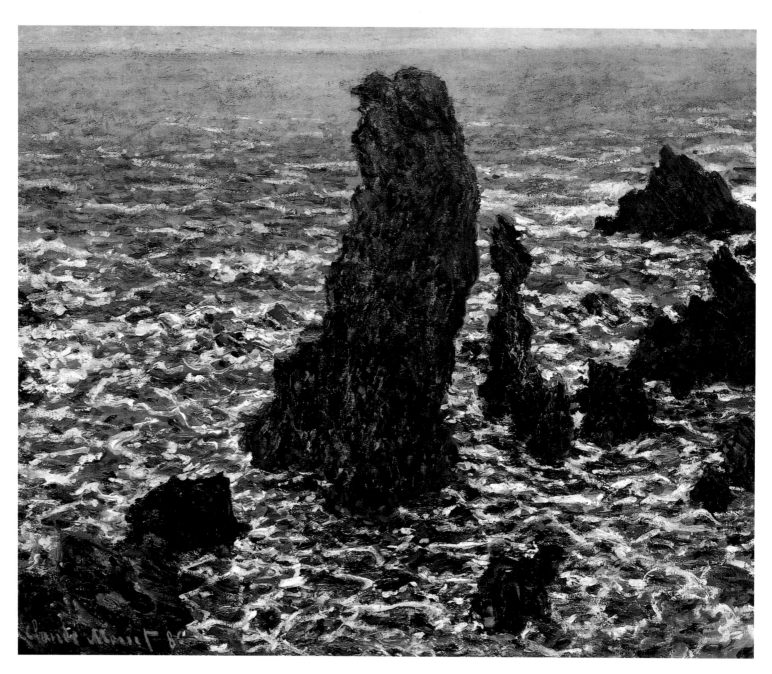

good use of the dark blue-greens typical of the Belle-Ile paintings and, according to Monet, was an extremely good likeness of his jolly host. The whole village turned up to see the portrait and to congratulate Monsieur Poly on his good fortune. Embarrassingly for Monet, they all thought that the painting was a gift, and Monet did not know how to get out of the embarrassing situation. He must have talked his way out of difficulty somehow, for today Monsieur Poly looks out from his portrait, a twinkle in his eye, on visitors to the Musée Marmottan in Paris.

By the time he had been at Kervilahouen a month, Monet had painted 38 canvases. Most of them were not finished, of course, and a few Monet dismissed either as just sketches or 'pretty poor', but on the whole, he thought he was making progress.

This view was shared by the critic Gustave Geffroy, who had turned up at Monet's remote hamlet with friends for an 'away from it all' break at the beginning of October. Monet had already corresponded with this leading critic, but his first meeting with the man who was to become first a close friend and confidant and later Monet's first biographer now took place at the inn where Monet usually ate in the evening. Geffroy and his friends had inadvertently seated themselves at the table habitually occupied by Monet and in resolving the confusion the two men quickly found that they had much in common.

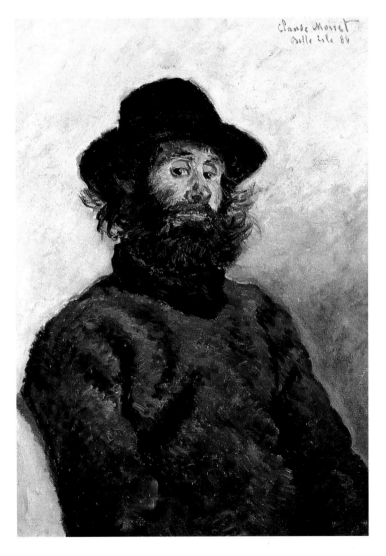

Portrait of Poly, 1886
Oil on canvas, 29^{1}/$_{8}$ x 20^{7}/$_{8}$in (74 x 53cm)
Musée Marmottan, Paris

Bright-eyed Père Poly was Monet's landlord at Kervilahouen on Belle-Ile's Côte Sauvage. Père Poly was a man of many parts, being an innkeeper, cook and fisherman, and Monet's portrait of him catches his many-sided character very well indeed.

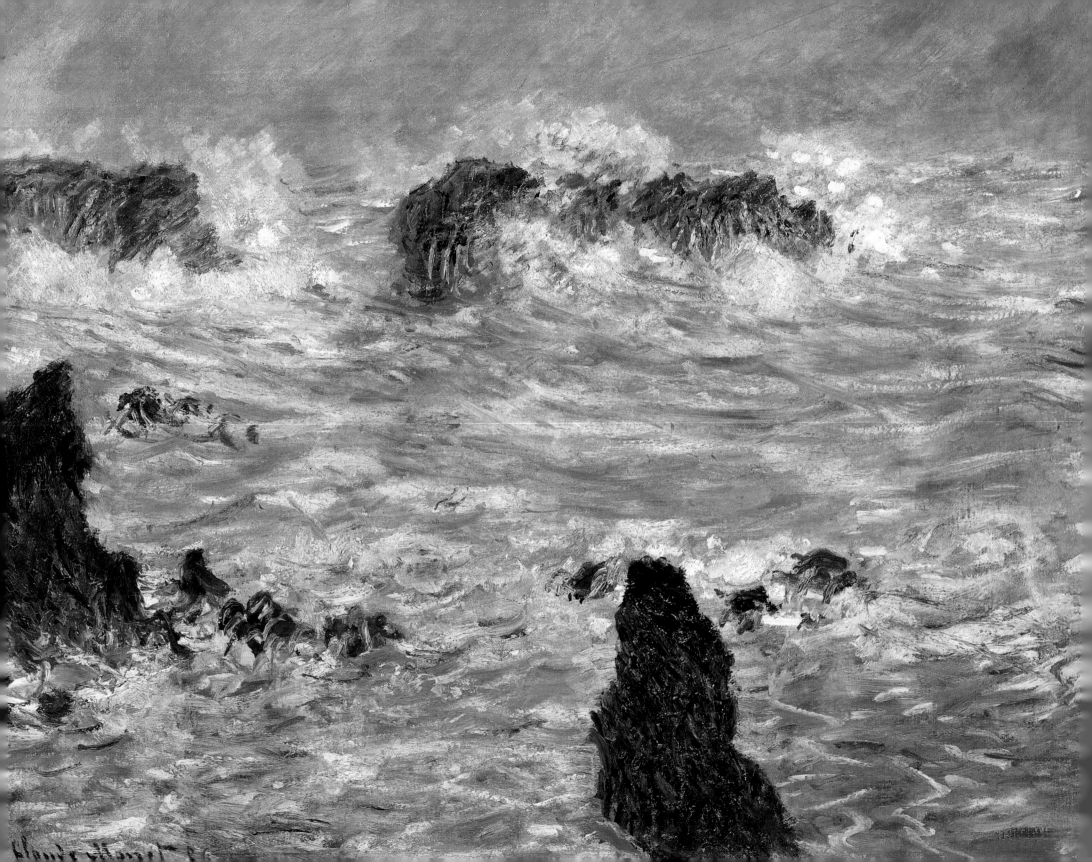

MONET

Gustave Geffroy has left us a fine word portrait of Monet as he entered the inn at Kervilahouen. 'Soon the painter made his entry ... a rough man, tanned, bearded, wearing heavy boots, dressed in coarse material, a sailor's beret on his head, a wooden pipe projecting from his thick beard, and in the centre of all that, a fine profile and an intelligent eye.' They ate together that evening, enjoying a meal that began with soup and went on to two meat courses (Monet was tiring of the lobster that turned up at every meal), washed down by Breton cider and wine. By the end of the meal, painter and critic had started on what was to be a lifelong friendship.

Naturally, Geffroy and his friends, an engraver and his wife, asked to see Monet's work. Monet spread it out before the newcomers and took their 'considerable approval' with a pinch of salt, such admirers being much easier to please than himself. Geffroy was even allowed to follow Monet about when he was painting, a rare privilege granted to few outside his family and close circle of fellow-painters. Perhaps Geffroy offered to help Monet carry his canvases and painting equipment: Monet had complained to Alice soon after his arrival that he had been unable to find a porter and was having to hump everything about himself.

In fact, there was a great deal to approve of in Monet's Belle-Ile paintings, even in their unfinished state. Once completed and signed, they very soon came to be seen as among the best, most atmospheric and dramatic marine paintings in Western art.

Many remained as sketches, Monet realizing that such rapidly and enthusiastically painted canvases as *Belle-Ile (Storm)* and *Storm off the Coast of Belle-Ile* (opposite), essentially half a dozen needle-shaped rocks poking up through a raging, white-crested sea, would lose their immediacy if painted over. But Monet worked long and hard on most of his Belle-Ile paintings; on their highly-finished surfaces he hoped to convey the constantly changing moods of sea and sky and the ever-shifting patterns of light.

When Monet had been working on Belle-Ile for a couple of months he received a letter from Paul Durand-Ruel, who asked if Monet could send him some work. Monet replied in his usual terms: nothing finished, everything must be worked on at home, a short break needed before finishing touches attempted, etc. When Durand-Ruel did see Monet's Belle-Ile paintings he was at first doubtful, not to say alarmed: Monet had made his name as a painter of sunlight and colour and the intensely dark, dramatic and even sombre Belle-Ile paintings might well prove difficult to sell.

Theo van Gogh's response to seeing the paintings was to take two initially, one of which sold quickly enough for him to return to Giverny in April 1887 for another four. Other paintings from Belle-Ile also did well at the

OPPOSITE
Storm off the Coast of Belle-Ile, 1886
*Oil on canvas, 25¹/₂ x 32in
(65 x 81.5cm)
Musée d'Orsay, Paris*

Monet's Belle-Ile storm paintings were executed in a series of sweeping brushstrokes rapidly sketched on the canvas that were quite different from the short flicks and dashes of his typically late Impressionist landscapes and, indeed, from his more worked-on Belle-Ile paintings.

RIGHT
Rocks at Port-Coton with the Lion Rock, 1886
Oil on canvas, 25^1/$_2$ x 31^7/$_8$in (65 x 81cm)
Fitzwilliam Museum, University of Cambridge

OPPOSITE
The Rocks at Belle-Ile, La Côte Sauvage, 1886
Oil on canvas, 25^1/$_2$ x 32in (65 x 81.5cm)
Musée d'Orsay, Paris

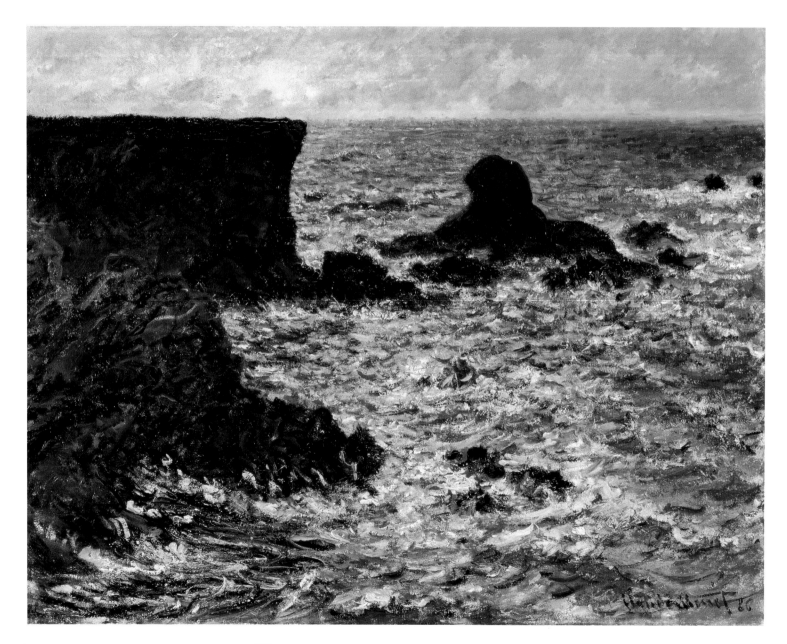

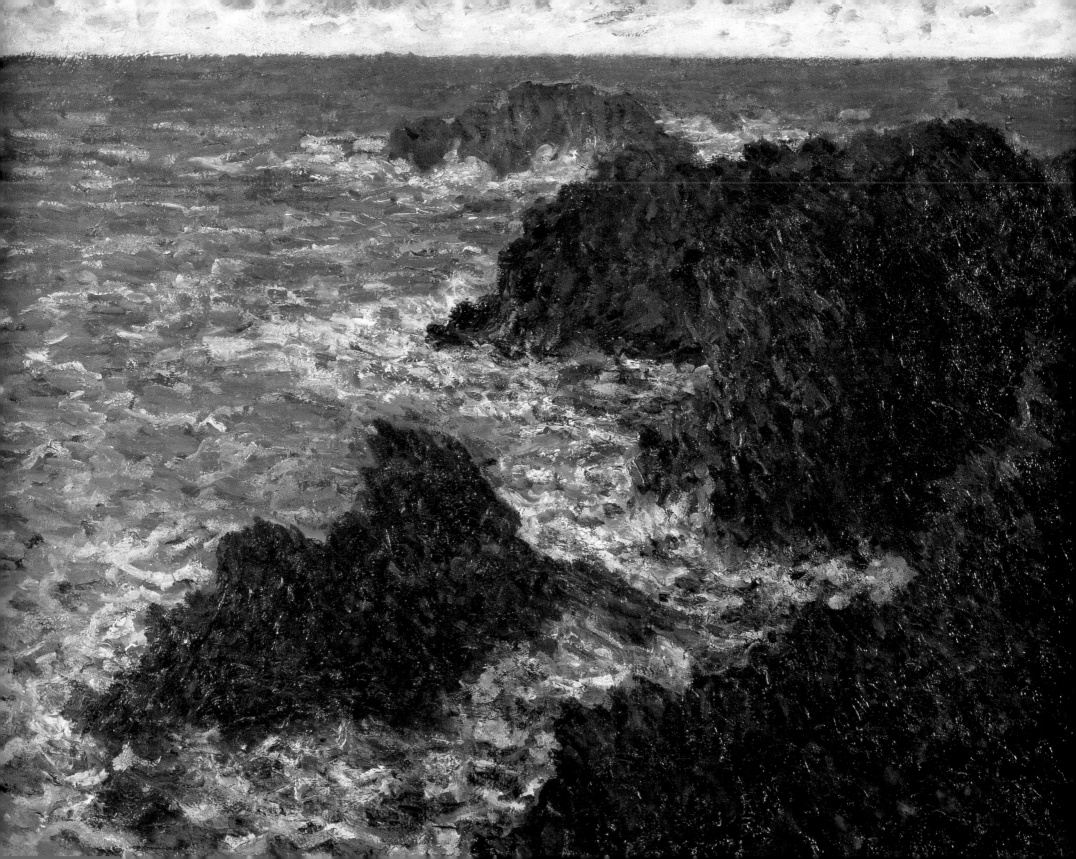

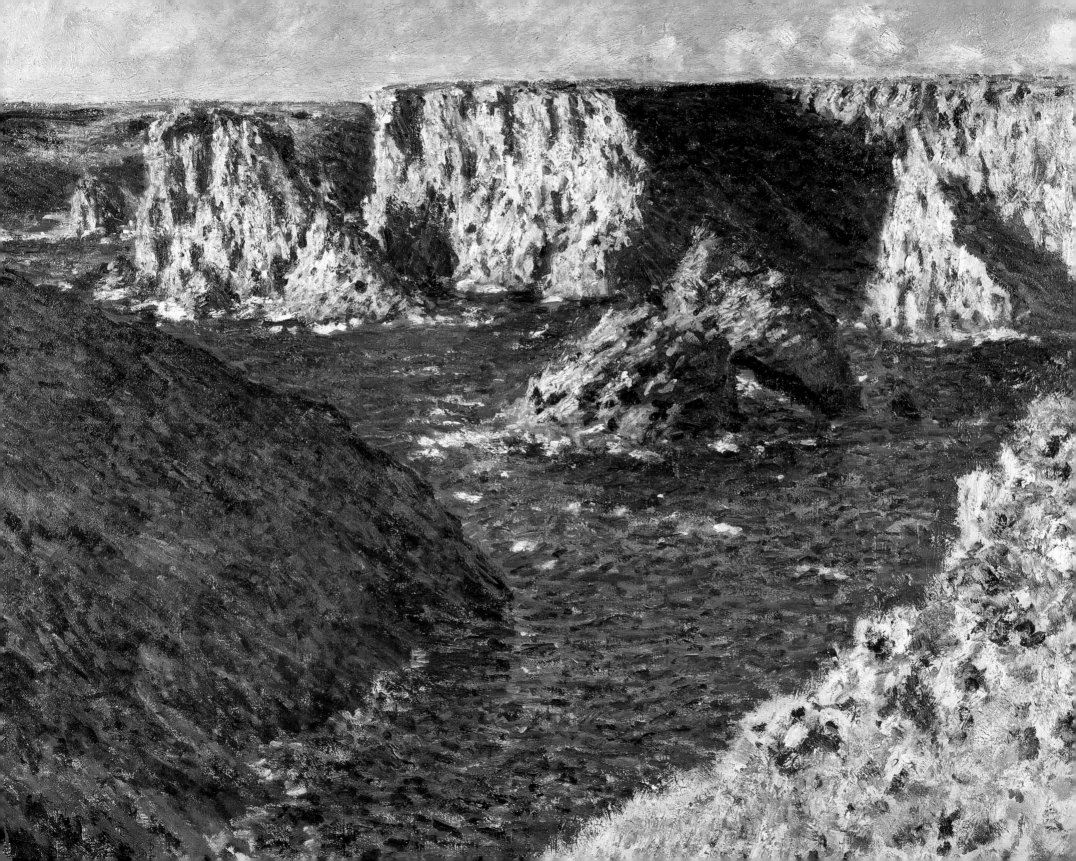

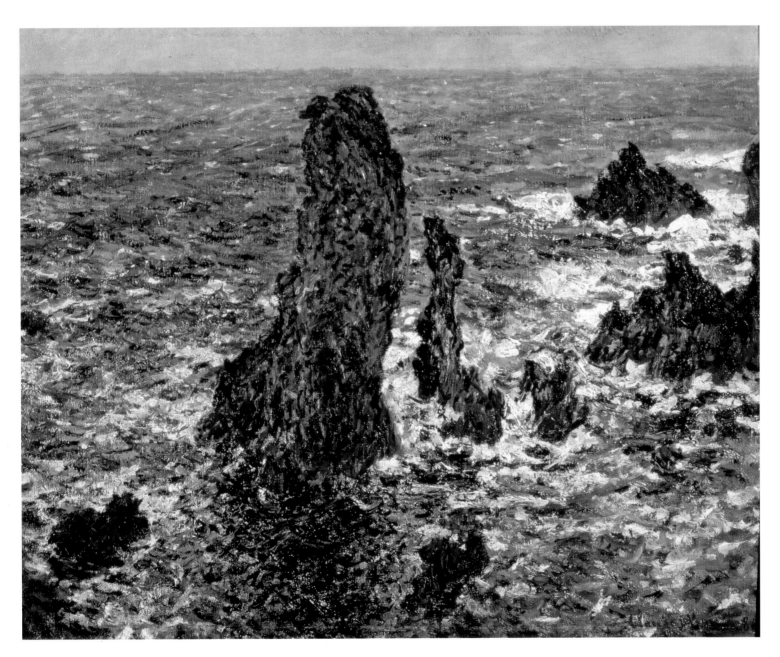

OPPOSITE
The Rocks at Belle-Ile, 1886
Oil on canvas,
Musée Saint-Denis, Reims

LEFT
The Rocks at Belle-Ile, 1886
Oil on canvas,
Pushkin Museum, Moscow

Rapids on the Creuse at Fresselines, 1889
Oil on canvas, 25³/8 x 36¹/8in
(64.5 x 91.8 cm)
Metropolitan Museum of Art, New York

For this painting, Monet closes in on his subject like a photographer doing a close-up. There is no sky and no horizon, just water, flecked with white foam and rocks, touched by a wintry daylight.

big exhibition at Georges Petit's gallery that year. Durand-Ruel took a number of the Belle-Ile paintings to New York with him in 1888 for showing in his new gallery, where they sold very well indeed; in fact, the works of Claude Monet, whatever their subject, would be among Durand-Ruel's best-selling paintings in America.

In the Valley of the Creuse

The Creuse river cuts its way through rocky ravines in a valley in the Massif Central at the heart of France. Monet made his final expedition away from home in the 1880s to a wild valley of the Creuse, where he visited the nature poet Maurice Rollinat at the village of Fresselines. He went there first in January 1889, accompanied by Gustave Geffroy and other friends, and returned in the late spring of 1889. His time was spent much as always on these long periods away from home. The days were spent painting, there was some talking and smoking by the poet's fire in the evening after dinner, then off to bed. Painting was made difficult this time by the fact that a minor accident had aggravated a rheumatic condition in Monet's hand and he had to wear a special glove in which to paint.

The Creuse valley in winter was a deliberate choice. Monet wanted to paint works that would be in as great a contrast as possible to the Mediterranean paintings of

1888, even reminiscent of the Belle-Ile paintings of 1886. 'Nature' in the Mediterranean tended to be 'delicious' and 'enchanting'. In the Creuse it was wild and rugged and also, in Monet's eyes, 'staggeringly beautiful'. Here he discovered a mood of melancholy loneliness in the wintry landscapes that he expressed in dark, sombre browns and greens.

As always, there were many periods of doubt and despair, most of them caused by changes in the weather at times critical to the continuance of Monet's paintings. Snow, accompanied by icy winds and cold, not only made painting outdoors torture at the end of March, but so altered the landscape and the quality of the light that he was not able to complete two studies done in rainy weather that were coming along well and for which he had high hopes. By the middle of April drought was causing the Creuse to shrink visibly and its colours to change so radically that the motif for many of the paintings ceased to exist. Then there was the well-known problem of the oak tree, coming into bud and leaf at absolutely the wrong time. At least this could be remedied – it only required a couple of men to carry long ladders into the ravine, set them against the offending tree, climb up, and remove all the leaves from it.

In the Creuse Monet concentrated on just a few motifs, painting them several times over in very similar versions.

Ravine of the Petite Creuse, 1889
Oil on canvas, 25⁷/8 x 32in
(65.6 x 81.3cm)
Museum of Fine Arts, Boston

Monet's paintings done near Fresselines in the Creuse valley fell into several 'true' series: that is, Monet chose a subject and painted it several times, always from virtually the same position. The differences in the pictures, as with these two of the famous oak tree in the ravine (right and opposite), grew out of the fact that Monet painted them at different times of day and in different conditions of light and atmosphere.

Torrent, Creuse, 1889
Oil on canvass, 26 x 36⅝in
(65.9 x 93.1cm)
Art Institute of Chicago

OPPOSITE

Ravines of the Creuse at the End of the Day, 1889

Oil on canvas, 25¹/₂ x 31⁷/₈in (65 x 81cm)
Musée Saint-Denis, Reims

The confluence of the Petite and Grande Creuse rivers provided Monet with the major motif of his paintings done in the valley of the Creuse. He painted the subject nine times, exhibiting five of the paintings in his major retrospective exhibition at the Galerie Georges Petit in 1889.

He did nine paintings of the confluence of the Petite and Grande Creuse rivers near Fresselines, five of which were included in the major retrospective exhibition at the Galerie Georges Petit in the summer of 1889. *Valley of the Creuse at Fresselines* (1889), depicting the waters of the joined rivers flowing away from their confluence, is one of the brightest and most sunlit of the paintings.

There were also several versions of a clump of trees in the valley of the Petite Creuse. The first in the series, *Ravine of the Petite Creuse* (page 280) shows the valley lit by bright sunshine that turns the winter foliage on the trees a vivid gold and gives a violet-blue haze to the hills. *The Petite Creuse* (1889) was painted, perhaps on the same day, in a dramatically different light that throws cold, wintery shadows among the rocks above the river.

There were also paintings of the Pont de Vervit, the tiny village of Rocheblonde clinging to the side of a ravine, a close-up of rapids on the Petite Creuse, and – one of the most extraordinary paintings Monet ever did – an almost telescopic close-up of a rock face called *Study of Rocks (Le Bloc)*. This simple yet monumental study of rock in rich brown-violet, green and gold hues, was for many years in the collection of Georges Clemenceau, who was given it by Monet. It is now in the Royal Collection in Britain, having been bought by the late Queen Elizabeth, the Queen Mother.

To understand why Monet gave Clemenceau *Study of*

Rocks one has to be aware of the Dreyfus Scandal that tore French society apart in the 1890s. Dreyfus was a Jewish officer in the French army, wrongly accused and found guilty of treason. Dreyfus's Jewishness brought to the surface a strong streak of anti-Semitism that ran through much of French society and had profound effects in the artistic community. Pissarro, for instance, was Jewish and a staunch Dreyfusard; Renoir and Degas were not and did not disguise their belief in Dreyfus's guilt or their near-contempt for Pissarro and his art.

Monet was a Dreyfusard. He wrote many letters of support and encouragement to Emile Zola, whose writings concerning the grave injustice of Dreyfus's sentence, including the famous 'J'Accuse' article, landed him in prison. Georges Clemenceau, by now a leading politician, who would be prime minister early in the new century, took up Dreyfus's case and mounted a vigorous campaign in support of Dreyfus and Zola, both of whom were eventually released from prison. Dreyfus was pardoned, but it was generations before the French state apologized for what it had done.

Monet sent Clemenceau his painting of the massive rock, reaching skywards with forceful purpose, as a token of his esteem for Clemenceau and, as he told Gustave Geffroy, in admiration for his old friend's 'beautiful campaign for justice and truth'.

Chapter Six
The Series Paintings

The pattern of Monet's life changed in the early 1890s. He stopped travelling to the almost obsessive extent that had marked his life in the 1880s, and spent most of his time at home in Giverny. Now, the search for a way to record precisely and systematically the changing effects of light on a motif became an obsession, resulting in the great series of paintings – haystacks, poplar trees and Rouen Cathedral – which set him on a plateau of his own among French artists in the late nineteenth century. Late in the decade came two more series. One of them, the first lily pond paintings, was done in his own garden, and the other, the River Thames series, was begun on his last major trips of the century abroad.

Some critics and art historians see in Monet's work of the decade a falling away from the great peaks of his achievements as an Impressionist, as a time when his art lost its spontaneity of expression, buried under his concentrated desire to repeat the same motif again and again. This is to deny an artist the right to progress through experimentation, to expect him to go on producing the same thing, however innovative and rule-breaking in its day, for the rest of his life. This was not Claude Monet's way.

Monet was not simply repeating the same motif in painting after painting. He had always been an artist who needed to return to a subject to note how it looked as changes in time, season and weather radically altered the light that fell upon it. Thus, he had returned time and again to the poppy fields near his house in Argenteuil, or to the town's bridges over the Seine. And in pursuit of his vision he had set up his easel in the same spot across the river from Vétheuil in the hazy warmth of summer and in the fog and frost of winter to record how the light and air seemed to change the very shape and substance of the town and its lovely little Romanesque church.

Now, this need to make cyclical records of a subject or motif changed in intensity from pinpointing the intrinsic qualities of the subject, which could be painted satisfactorily on just one canvas, to concentrating on the light in which it was fixed, something that required continuing effort over several or even many canvases. The timescale of each picture in the series could be reduced from something as large as the season of the year to something as small as the hours in the day, and even the minutes in the hour.

The technique involved in painting such pictures became very intense. Monet's eye, flicking from subject to palette to canvas, directed his brush to pick up paint in a darting rhythm of smaller and smaller brushstrokes, painting and overpainting until he had achieved the effect he was seeking. Critics often commented on the impasto

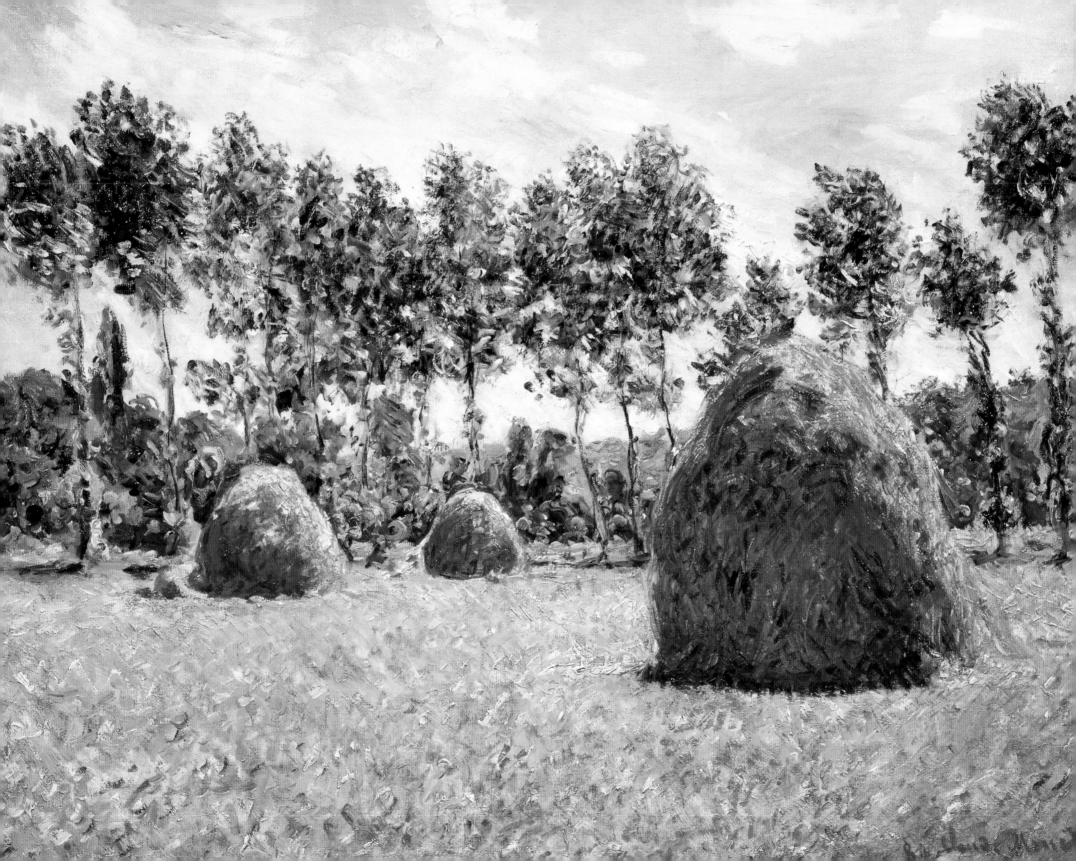

Haystacks at Giverny, 1893
Oil on canvas
Private collection

In this painting, done after the majority of his haystacks series paintings were completed, Monet concentrates on placing his haystacks in a recognizable landscape again. But the main subject of the painting is not the landscape, but the light that falls on it, softening and transforming it.

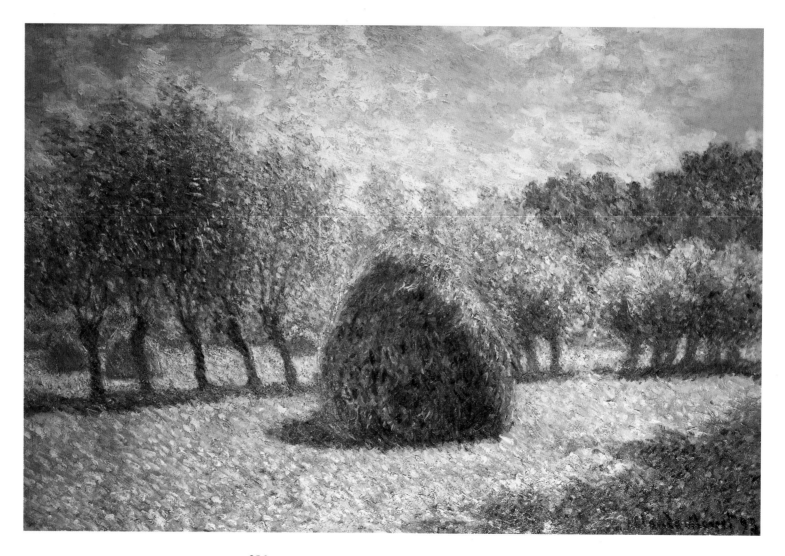

286

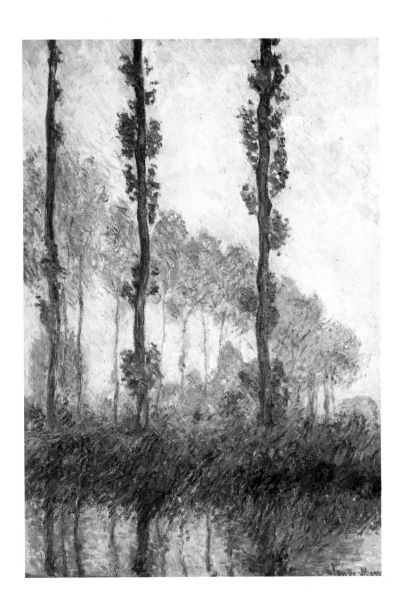

on Monet's series canvases – thickly-applied opaque paint in which the brushmarks or the marks of other painting instruments can be clearly seen. This way of painting was exhausting. Time and time again, he wrote to family and friends during the creation of the great series, that he had all but exhausted his mental and physical energies in his great task.

One important thing that distinguished Monet's series of paintings of the 1890s from those of earlier decades, such as the Gare Saint-Lazare mini-series of 1877, or the paintings of the 'Pyramides' at Port-Coton done during his stay on Belle-Ile and the views of Antibes in the late 1880s, was the artist's own attitude to them. Monet did not see these earlier groups of single-subject paintings as something distinct from the rest of his work. He tended to emphasize the variety of his paintings of one motif rather than their unity. He was concerned that they should be shown as just one element in the whole range of his work, diverse as it was in subject matter and treatment.

With his first series exhibition, the haystacks show in 1891, all that changed. Now Monet was concerned that his paintings should be seen as a unity. As he told one visitor to the exhibition, the individual paintings there only acquired their value 'by the comparison and succession of the entire series'. In seeing unity as an essential element in his work, Monet was giving voice to

The Three Trees, Autumn, 1891
Oil on canvas, 36^1/3 x 28^3/4in
(92.3 x 73cm)
Private collection

This group of three poplars appeared many times in Monet's poplar series of paintings.

RIGHT

Haystack in the Snow, Morning, 1890

Oil on canvas, 25³/4 x 36¹/3in
(65.4 x 92.3cm)
Museum of Fine Arts, Boston

OPPOSITE

Haystacks: Snow Effect, 1891

Oil on canvas, 25¹/2 x 36¹/4in
(65 x 92cm)
National Gallery of Scotland,
Edinburgh

something that had been occupying his thoughts, and that of many of his artist friends, for some years. It was no longer enough for an artist to express on individual canvases his sensations on beholding a motif; each painting had to fit an idea of unity that extended over the whole corpus of the artist's work.

The Haystacks Series

The changing circumstances of life at Giverny was a major factor in Monet's creation of the three great series of paintings in the early 1890s. Monet's purchase of the house at Giverny in 1890 and his marriage to Alice Hoschedé in July 1892, meant that extended painting holidays away from home lost much of their attraction. Everything that was important in his life, not least his family, was to be found in or near his own home.

Nearness to home was essential for the series paintings because of the number of canvases Monet worked on in the course of a day's painting. He might do only seven or eight minutes' work on one painting before changes in the light made him turn to another. Monet's family, in fact, provided him with his essential helpers; as the decade wore on there would even be grandchildren growing big enough to help carry his canvases. In the early days of the haystacks series, it was Blanche Hoschedé, who was soon to marry Monet's eldest son Jean, who did the running

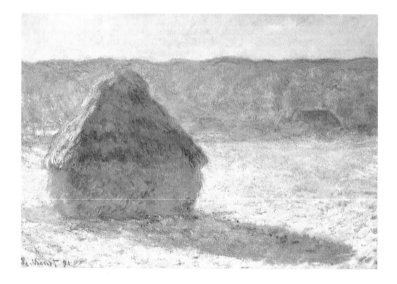

back and forth to the house, bringing more canvases out to the artist as he worked out in the field.

Monet had often included haystacks in his paintings and made them the title subject of paintings before he tackled them as the series he began work on in the late summer of 1890 and finished in 1891. After all, haystacks are regular sights on farmland after harvest. They are not always stacks of hay, of course, a point made by the few writers/critics who call Monet's series 'grainstacks'. But the French word *meule* that Monet used in his titles for the haystacks series can translate into English as a stack or rick of hay, corn or other grain. 'Haystack' is commonly

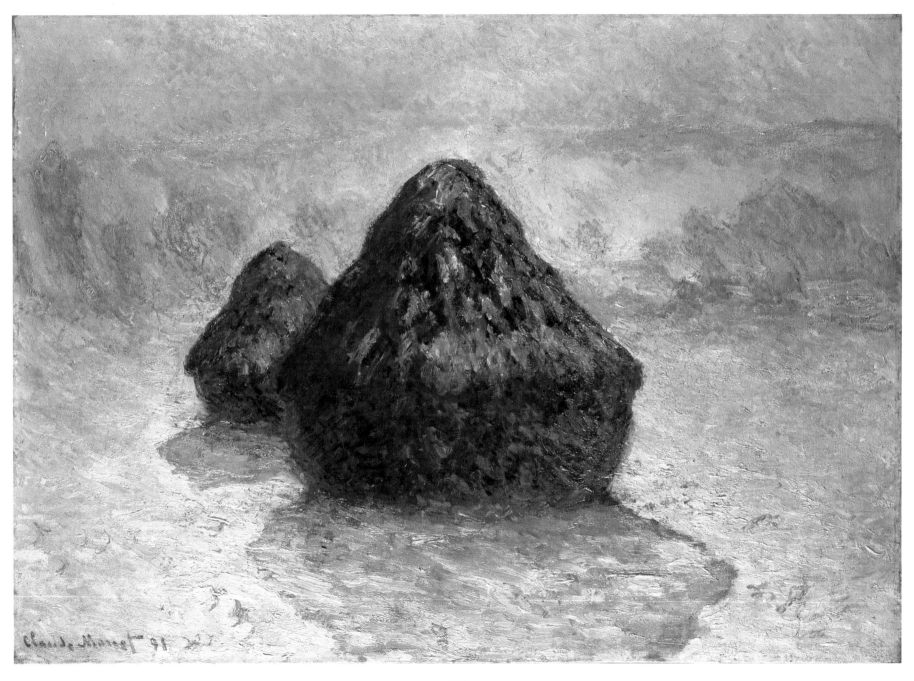

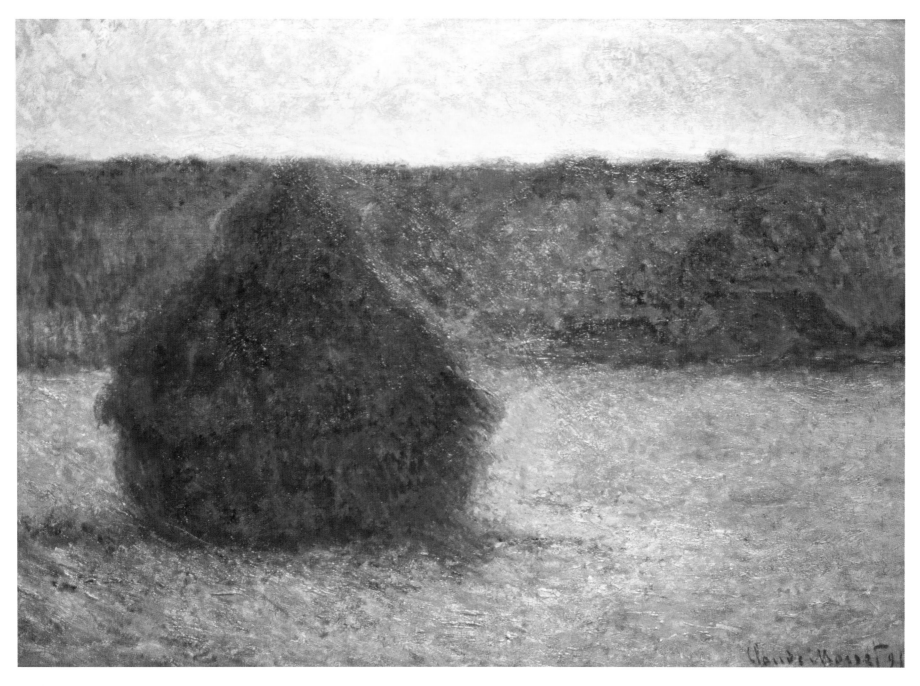

MONET

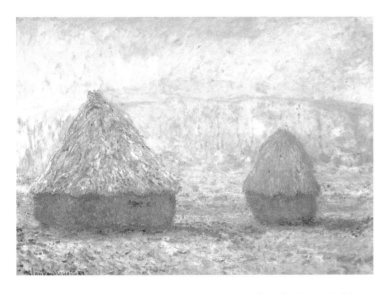

used in English to apply to any stack of grain in a field, so it has been decided to stay with that term.

Monet started out on his haystacks series in the way that he always had. He was walking with his stepdaughter in a field on the slopes above his house one day, when they noticed that one of the haystacks in it glowed almost white from the effect of the bright sun shining on it. He went back inside, brought out a couple of canvases and started work on his picture, even though the effect of the light had already changed. 'When I began … I believed that two canvases, one for grey and one for sunny weather, would be enough,' he recalled later.

Soon, he was sending Blanche back to the house for a fresh canvas, then another, and another. Over the days and weeks ahead, he would take all his canvases of a subject to the field and work on each one only when the particular effect he had been recording returned, 'so as to get a true impression of a certain aspect of nature and not a composite picture'.

This change of approach can be clearly seen when a haystacks series picture is compared with one from an earlier period. The small, casually piled-up haystacks in *Haystacks Near Giverny* (page 196) is in the same part of the countryside, a field near Monet's house at Giverny, as the much more carefully, even architecturally constructed haystacks that feature in the series. But the approach is very different.

The 1884 painting is a landscape. This is the lovely Giverny countryside that Monet had already painted several times before, in high summer, painted in breezy, sunlit detail. Within a few years of painting the picture, Monet was taking a rather different view of landscape painting, commenting in 1891, 'For me, a landscape does not exist in its own right; since its appearance changes at every moment; … the surrounding atmosphere brings it to life – the air and the light … vary continually.'

In the haystacks series, the detailed depiction of landscape and topography has gone. The line of cottages

OPPOSITE
Haystacks at Sunset, Frosty Weather, 1891
Private collection

LEFT
Haystack in a Thaw at Sunset, 1891
Oil on canvas, 25$^{1/2}$ x 36$^{1/4}$in (65 x 92cm)
Private collection

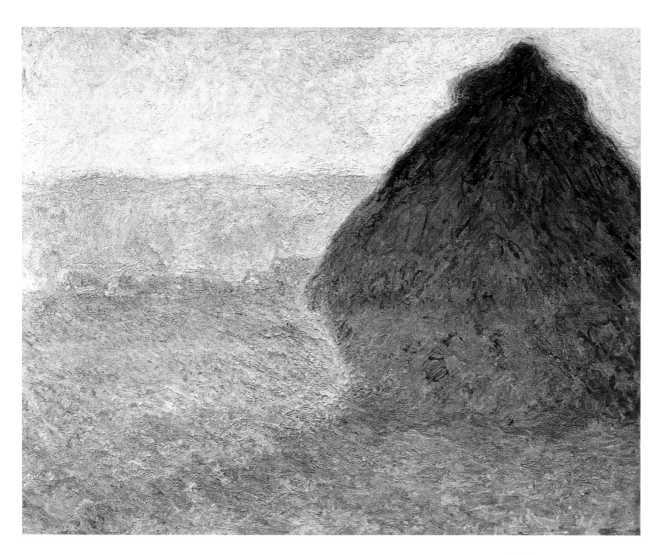

across the horizon, if present at all, has been reduced to blurred rooflines and gable ends – just enough to indicate the presence of people and the farming community. Even the haystacks are not in themselves the most important things in the paintings; they are not painted as beautiful or even particularly attractive objects. It is the effect on them of different light, at different times of day and in different seasons, so that their shapes and the shadows around them are transformed by colour into objects of beauty that the artist wishes us to contemplate.

Two paintings of haystacks in snow indicate the importance of colour in creating atmosphere and emphasizing time differences. *Haystack in the Snow, Morning* (page 288) is a study in cold blues, the first pale rays of winter sun adding a little gilding to the dense orange-brown of the haystack but doing nothing to add warmth to an intensely cold winter scene. The two haystacks in *Haystacks in a Thaw at Sunset* (page 291) have tops like strawberry ice creams, an effect of the vivid pinks of the sunset reflected on the snow that covers the two stacks. Even the shadows on the snow and the ghostly branches of the bare trees are pink. But there are dashes of cream and yellow among the pinks, and much of the sky is painted in the same ice cream colours – vanilla, cream, and pale strawberry – with dashes of blue.

Monet gave many of the paintings in the haystacks

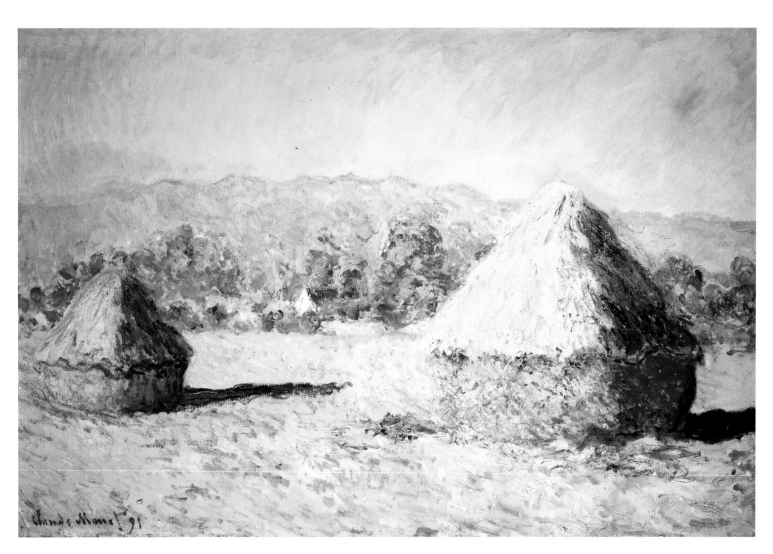

OPPOSITE
Haystack at Sunset, 1891
*Oil on canvas, 28⁷/₈ x 36¹/₂in
(73.3 x 92.6cm)
Museum of Fine Arts, Boston*

LEFT
Haystacks, End of Summer, Morning Effect, 1891
*Oil on canvas, 23⁵/₈in x 39³/₈in
(60 x 100cm
Musée d'Orsay, Paris*

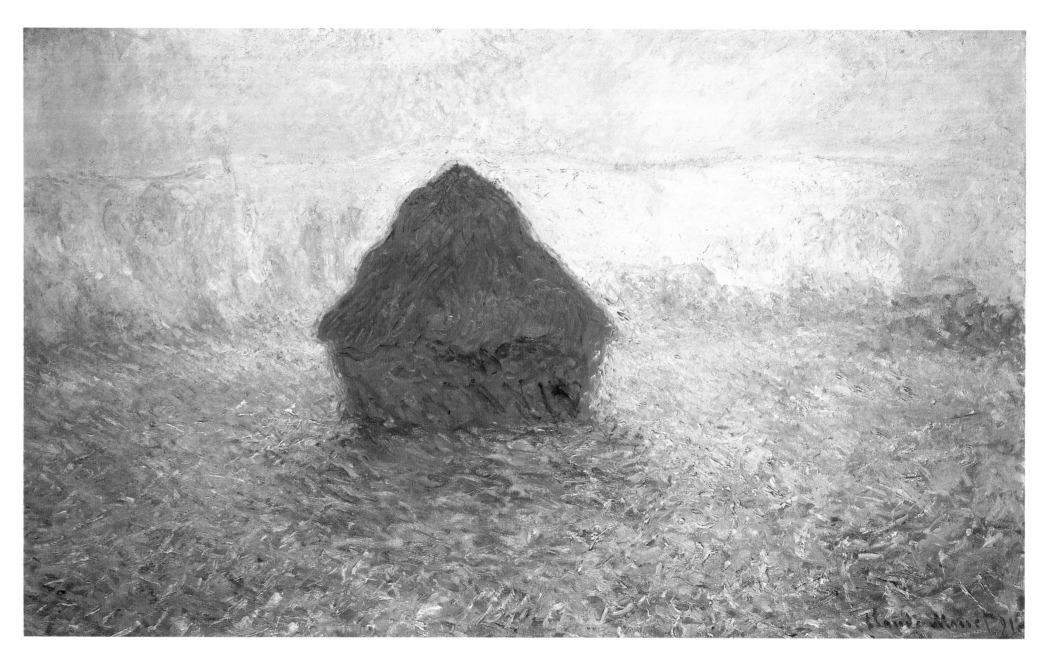

could not keep up with its effects on his work. There was also a far greater problem, as he told Gustave Geffroy. 'I'm becoming so slow in my work that it makes me despair, but the further I get, the better I see that it takes a great deal of work in rendering what I'm looking for: "instantaneity", above all the "envelope" – the same light spread over everything.'

The main reason for Monet's slowness was the amount of overpainting he was now adding to his canvases. He would start off with broad brushstrokes, covering the canvas quite quickly. But on top of these he would add layer after layer of much shorter, smaller strokes and dashes of paint chosen from a wide and subtly varied range of colours.

This all meant that a painting capturing a moment, or a few minutes, of time could take many months of working on to be finished, or to reach a satisfying enough state for Monet to put his signature on it. Thus, *Haystacks* or, *The End of Summer, Giverny* (page 296), which was clearly begun in the hazy, golden days of late summer, 1890, is dated 1891.

Monet's haystacks paintings formed the centrepiece of an exhibition mounted by the Durand-Ruel gallery in May 1891. The exhibition was a resounding success in commercial terms because all of the 15 canvases Monet had chosen from among his much larger number of

series 'timed' titles – *Haystack at Sunset*, *Haystacks in the Snow, Morning* and *Haystacks at Noon* were others – in order to fix the importance of the time of the painting firmly in the viewer's mind.

The haystacks series was the result of very hard labour on the painter's part. Although it had been many years since Monet's best work was the result of entirely *plein-air* painting, all done in a few hours in the warm sun or the cold frosts of winter, the haystacks series took Monet's working practice to very intense levels. The time Monet spent in the studio reworking his paintings greatly exceeded the many hours he spent on them *sur le motif*.

It was not only that the sun set too quickly so that he

OPPOSITE
Haystack, Hazy Sunshine, 1891
Oil on canvas, 23⁵/8 x 39¹/2in
(60 x 100.5cm)
Agnew & Sons, London

LEFT
Haystacks at Noon, 1890
Oil on canvas, 25³/4 x 39¹/2in
(65.4 x 100.3cm)
Australian National Gallery, Canberra

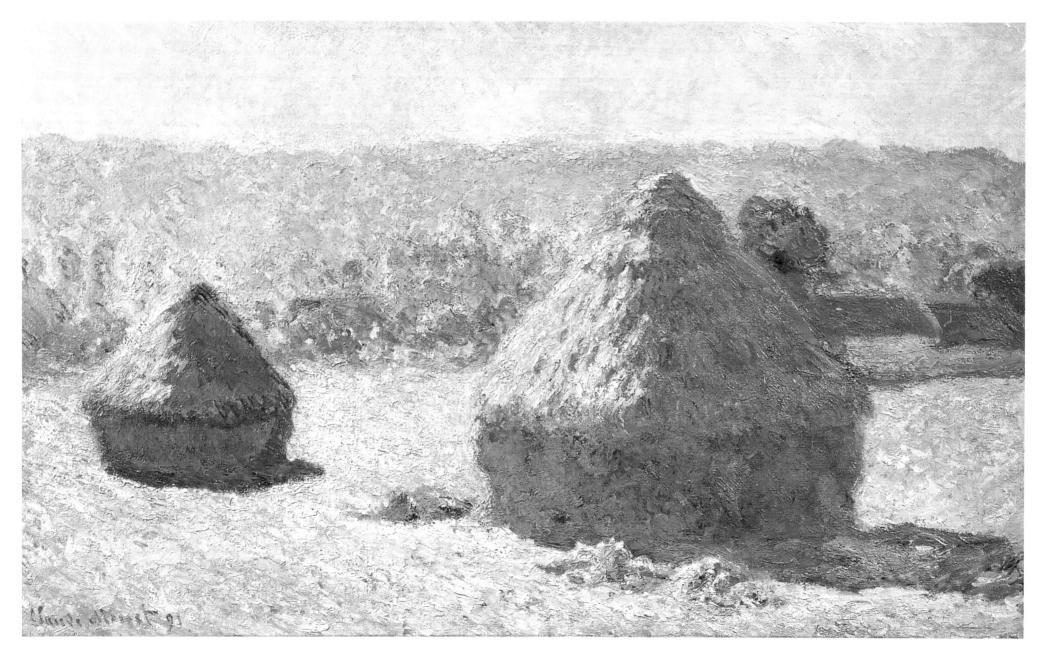

haystack pictures were sold before the exhibition closed for very high prices, ranging between 3,000 and 4,000 francs. Artistically, the success was muted for Monet and his admirers by the fact that the paintings found many different buyers: the unity of the concept was lost.

If Monet's haystacks paintings were less than successful in promoting that concept of unity, they had a profound effect in another direction. Monet's haystacks, almost lost in extraordinarily complex pools of harmonizing colours, strongly influenced artists early in the 20th century. They showed a way of painting in colour rather than line that led to the work of the colourists, of whom the Fauves were the most dramatic, and that of the abstract artists later in the century.

The story of Wassily Kandinsky's encounter with a Monet haystack painting at an exhibition in Moscow in the mid-1890s has often been told. When Kandinsky first stood in front of the painting he thought it was without subject – something abstract. Then, out of the amazing swirl of colours on the canvas emerged the haystack. He later wrote that the painting opened up for him 'the unsuspected power, previously hidden from me, of the palette, which surpassed all my dreams …Unconsciously, the object was discredited as an indispensable element of a painting'. Shortly after, Kandinsky abandoned his promising career as a law teacher at university and went to Munich to study painting, becoming a master of colour painting and an abstract artist of great power and distinction.

The haystacks exhibition set Monet's own public career in a new direction. For the rest of the decade his working life and, therefore, his exhibitions, were centred round the creation of series of paintings, all of subjects either close to hand at Giverny or not too far away.

Poplars on the Banks of the Epte
The tall, graceful, silvery-green poplar tree is widely planted throughout northern and central France. Long lines of poplars shade roadways and mark field boundaries; plantations of them, intended to provide dowries for farmers' daughters, grow in fields and beside farm gates; they grow in abundance along streams and rivers.

Poplars featured often in Monet's paintings, providing his compositions with verticals. This was their main role in one of his pre-haystack series pictures, *Haystacks at Giverny* (page 285), a painting that combines two motifs, haystacks and poplars, that Monet also studied individually. Now, at much the same time as he was studying haystacks on their own, he began to do the same with poplars.

He may not have started the poplars series while still working on some of the haystacks paintings but for the fact

OPPOSITE
Haystacks or, The End of the Summer at Giverny, 1891
Oil on canvas
Musée d'Orsay, France

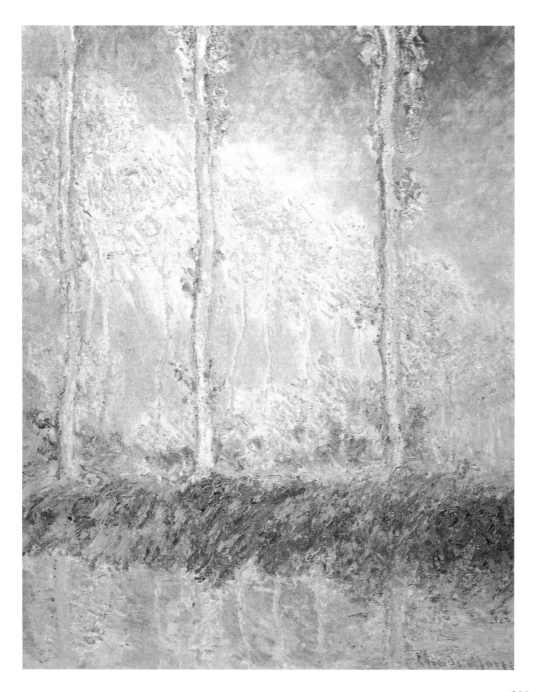

that a magnificent stand of the trees stretching along a bank of the River Epte that he had painted before was to be sold at auction. Monet unsuccessfully tried to persuade the mayor to postpone the sale. He then made inquiries about the auction and, discovering the likeliest highest bidder, offered to reimburse him for any money he had to pay over his planned maximum bid, on condition that he left the trees standing until Monet had finished his paintings. Unusual – but very characteristic of Monet in pursuit of his own artistic ends.

As with the haystacks series, Monet took his canvases and painting equipment to the trees at various times of day and at different seasons, starting work in the summer of 1891 and working on into the autumn. And, again as with the haystacks series, he gave many of his poplar pictures carefully timed titles: *Poplars, Three Pink Trees in Autumn* (left), for instance, and *Three Poplars in Summer (page 300)*.

With others paintings in the series, Monet was much less careful to point up the time differences. Two paintings of the same line of seven trees are both titled *Poplars on the Banks of the River Epte*. One is painted in dark blues and dark greens that give the picture the feel of a cold autumn day (page 300). The other (right) is all bright, shimmering, summer sunlight, with the foliage on the trees turned light gold against a pale-blue sky.

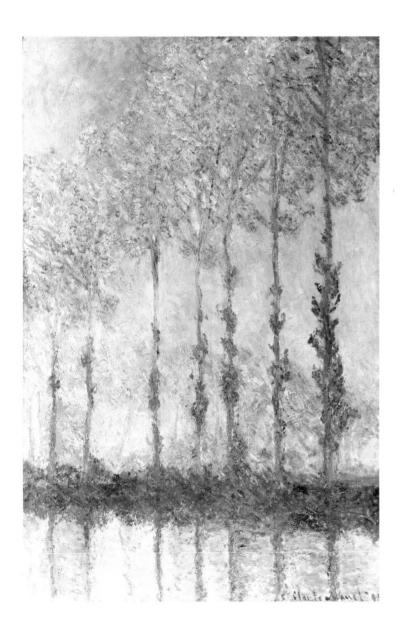

From close to, the colours on these, and the other poplar canvases, form a mosaic of little touches of complementary and adjacent colours. Except that he is not using primary colours, Monet seems to have employed techniques similar to those used by pointillist painters such as Seurat.

Monet's poplar paintings are based on carefully composed grids of verticals, consisting of the trees, both against the sky and reflected in the waters of the river so that the verticals run from top to bottom of the canvas, and of horizontals: the river bank and river and a usually low horizon, marked by more trees. Over this basic grid, Monet superimposes the conditions of light, air and foliage, translated into beautiful harmonies of colour that give the pictures their atmosphere.

There are no figures and no sign of a human presence in the poplar paintings. Nothing distracts from Monet's main concern, which is to study the range of light effects, created by time and weather, on the trees, sky and water. The subject itself has no particular significance. It is not the trees that Monet is painting; what he is seeking to set down on the canvas, rather, are the air and the atmosphere that lie between them and himself. This is not to say that the trees lose their organic quality as trees; their trunks may provide the paintings with their verticals, but they remain living tree trunks, the work of

OPPOSITE
Poplars: Three Pink Trees in Autumn, 1891
Oil on canvas, 36⅝ x 29¼in
(93 x 74.1cm)
Philadelphia Museum of Art

LEFT
Poplars on the Banks of the Epte, 1891
Oil on canvas, 39⅜ x 25½in
(100 x 65cm)
Private collection

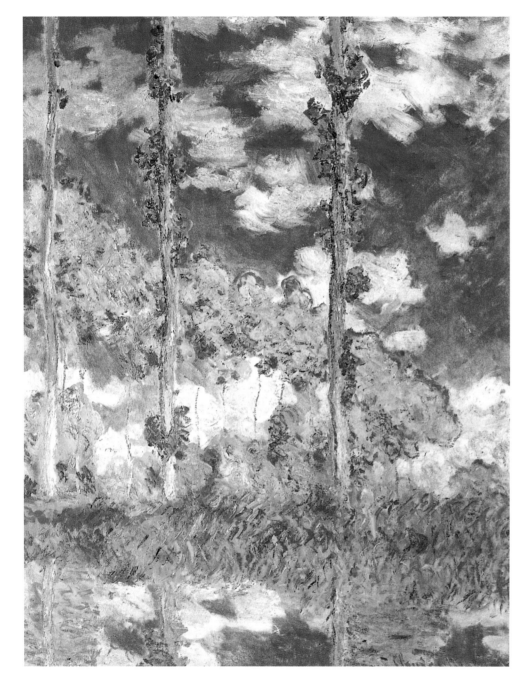

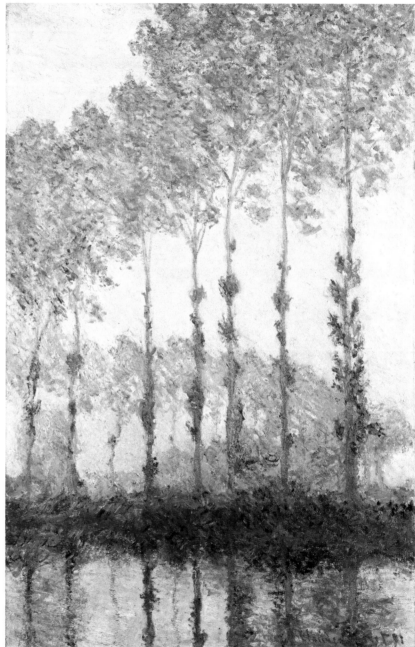

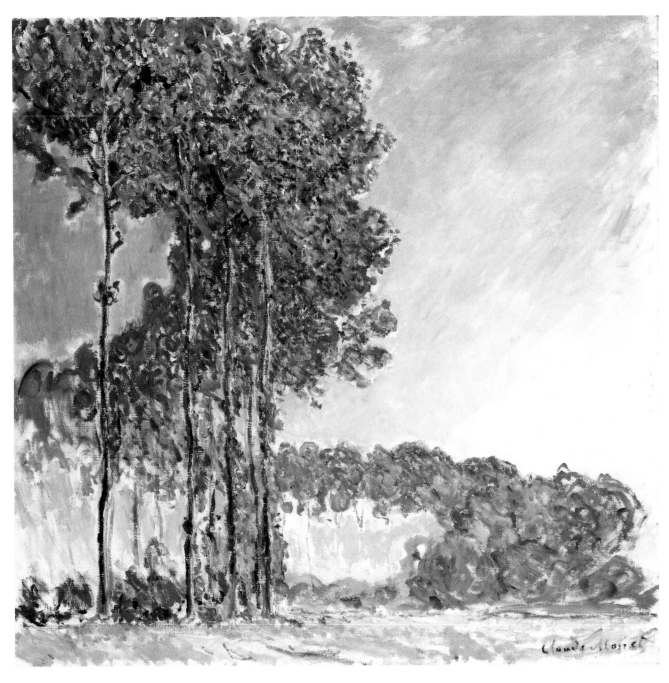

OPPOSITE LEFT
Three Poplars in Summer, 1891
Oil on canvas, 36¹/4 x 28³/4in
(92 x 73cm)
National Museum of Western Art, Tokyo

OPPOSITE RIGHT
Poplars on the Epte, Autumn, 1891
Oil on canvas, 39³/4 x 26in
(101 x 66cm)
Private collection

LEFT
Poplars, c.1891
Oil on canvas, 35 x 36¹/4in
(89 x 92cm)
Fitzwilliam Museum, University of
Cambridge

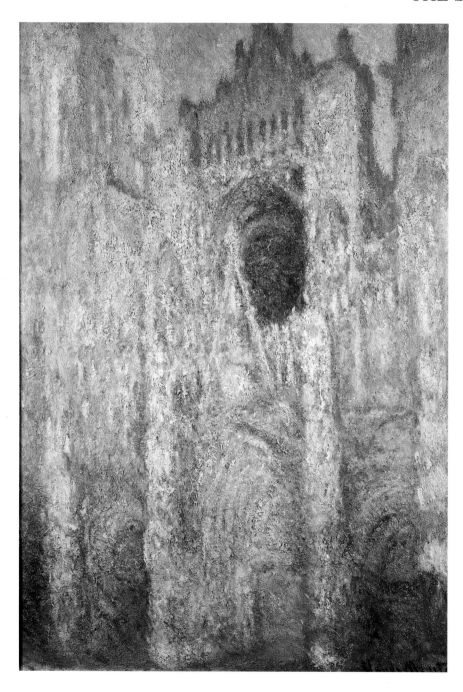

a master painter totally in accord with nature.

Monet exhibited 15 of his poplar paintings, which numbered more than 20 in total, at the Durand-Ruel gallery in February, 1892. It was a small exhibition with no other paintings by Monet on show, but was large enough to confirm to friends and art critics alike that his work was continuing to show the increasing complexity and subtlety in composition and technique that the haystacks series had achieved so triumphantly.

Painting a National Icon: the Rouen Cathedral Series
The great church of Notre-Dame in Rouen is one of the greatest Gothic cathedrals in France. Begun in the early thirteenth century, it took more than 300 years to complete, allowing plenty of time for Europe's master craftsmen to decorate it with an exuberantly carved network of bristling pinnacles, pediments, gargoyles and stone-fretted windows.

Monet's interest in Rouen began because of his interest in gardens. He liked to paint in the Botanic Garden in the city and even obtained some plants for his Giverny garden there. But once he had spent some time looking at the cathedral's west façade and at the way in which the changing light seemed to make the intricate stone carvings, the arched and colonnaded doorways and statue-decorated niches change shape and substance, he knew that he had found his greatest challenge. The virtually colourless stone

MONET

cathedral would give him no guide to the colours he should use; it would be for his eye and his mind to see and represent the colours that changing light conditions, weather and time of day, gave to the subject.

Monet laid the foundations for his Rouen Cathedral series in two extended periods of work during the early months of 1892 and of 1893, when he would stay in Rouen for several days or even weeks at a time, especially when it looked as if the weather was going to stay settled and sunny.

The titles of Monet's Rouen Cathedral series indicate the nature of his approach to this magnificent subject: *Rouen Cathedral: The Façade at Sunset*; *Rouen Cathedral: The Portal, Harmony in Brown*; *Rouen Cathedral: The Portal and the Saint-Romain Tower; Morning Sun, Harmony in Blue*; *Rouen Cathedral: the Portal and the Saint-Romain Tower on a Dull Day, Harmony in Grey*.

His working method was the same as for the haystacks and poplars series, in that he had as many as a dozen or more different canvases in progress at the same time. He chose which one to work on depending on the time of day, the weather, and the amount of sunlight, if any, playing on the façade of the cathedral. The main difference was that he worked inside, at a second-floor window in an empty apartment above a souvenir shop called *Au Caprice* in the rue Grand Pont, opposite the west front of the cathedral.

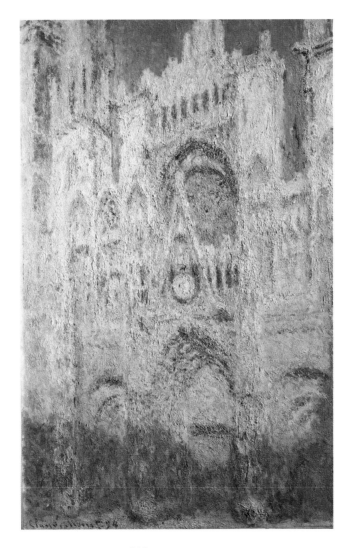

OPPOSITE
Rouen Cathedral, 1891
Oil on canvas
Christie's Images, London

LEFT
Rouen Cathedral: The Façade at Sunset, 1894
Oil on canvas, 39³/₈ x 25¹/₂in (100 x 65cm)
Pushkin Museum, Moscow

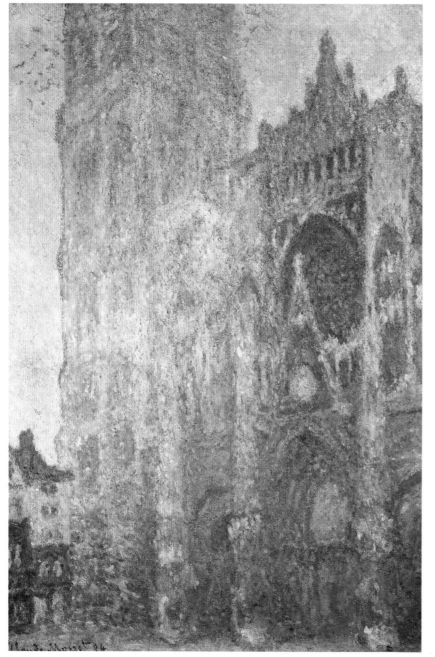
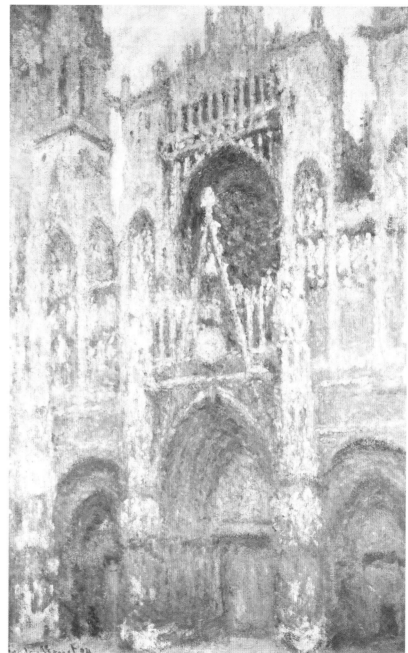

He would get up before 6 to start work early in the morning, when the west façade was wreathed in misty, blue-grey shadows, and stay standing at the easel until the end of the day, when the setting sun (provided it wasn't raining or snowing) disappeared behind Rouen's buildings around 6.30 in the evening, turning the façade a vivid orange.

Monet's work sessions in Rouen were fraught with difficulties and frustrations, which is not surprising given that it was wintertime in northern France. To start with, Monet did not like living in towns; then, he had become something of a celebrity and people kept dropping in with invitations to dinners that he did not know how to refuse. It was not that Monet was unsociable; he enjoyed his food very much and liked stimulating conversations round the dinner table. The problem was that he always felt that it would be impolite to leave his host's table early so that he could get a good night's sleep before his early start the next day. Sometimes the invitation was a way of concealing the visitor's real intention, which was to get his name near the top of the list of would-be purchasers of the Rouen Cathedral pictures.

In April 1892, when spring brought visitors back to Rouen, there was a problem with his landlord who asked him not to work in the afternoons because it put off passing customers. A desperate Monet ended up giving

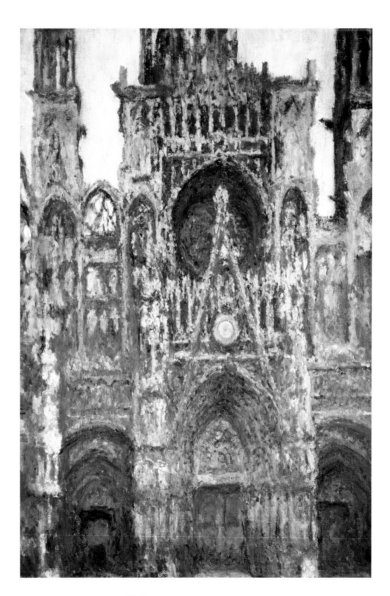

OPPOSITE LEFT
Rouen Cathedral: The Portal and the Saint-Romain Tower, Morning Sun, Harmony in Blue, 1894
Oil on canvas, 35⁷/₈ x 24⁷/₈in
(91 x 63cm)
Musée d'Orsay, Paris

OPPOSITE RIGHT
Rouen Cathedral: The Portal and the Saint-Romain Tower on a Dull Day, Harmony in Grey, 1894
Oil on canvas, 39³/₈ x 25¹/₂in
(100 x 65cm)
Musée d'Orsay, Paris

LEFT
Rouen Cathedral: The Portal, Harmony in Brown, 1894
Oil on canvas, 41¹/₈ x 28³/₄in
(107 x 73cm)
Musée d'Orsay, Paris

RIGHT
Rouen Cathedral, Midday, 1894
Oil on canvas, 39³/4 x 25¹/2in
(101 x 65cm)
Pushkin Museum, Moscow

OPPOSITE
Rouen Cathedral in Full Sunlight:
Harmony in Blue and Gold, 1894
Oil on canvas, 42¹/8 x 28³/4in
(107 x 73cm)
Musée d'Orsay, Paris

the man 2,000 francs to allow him to stay for a few days more.

The weather was, of course, the greatest cause of Monet's frustrations. In a letter to Alice, he described some particularly difficult March days as an unreliable chain of wonderful sunshine on the first day, fog in the morning, and afternoon sun that disappeared just when he needed it on the second day, and a prediction of dark grey and rain for the following day. After weeks of this sort of thing, Monet would become very nervous, bad-tempered and easily irritated. He would also become depressed, seeing no good in anything he had done and convinced that he was in pursuit of something that lay beyond his powers.

Sometimes, seeing the barometer falling and a period of sunny days about to come to an end, he would work too hard at his paintings, desperately trying to make the most use of the sun. On at least one occasion, he stood back from his paintings, took a long, hard look at them, then 'transformed, demolished all [the] paintings with sunshine … If the fine weather continues, I may come through unscathed, but if there is another break in the weather, then I'm done for'.

The truth was that Monet was, at least at first, seldom happy with his work. Towards the end of his second period in Rouen, in March 1893, Monet compared his

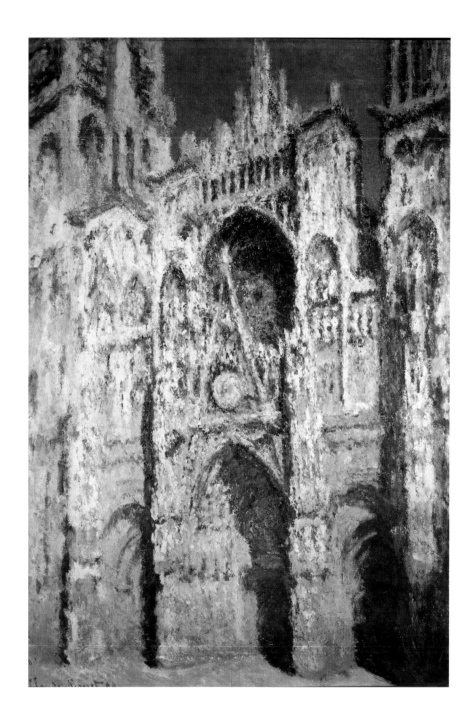

recent work with that from the year before, something he preferred not to do in case he fell into old errors. He decided that he had been right to be unhappy with the early work. 'It's ghastly and what I'm doing now is quite as bad, bad in a different way,' he moaned to Alice. His paintings had to be left to mature, as it were, in his studio for weeks or even months before he could decide whether or not he had something worth taking to a finished state.

The long painting sessions in Rouen were followed by months of work in his studio at Giverny, building up on the canvases thick layers of impasto that seemed, to some, to be an attempt to copy the very stones of the cathedral. When he saw them, the artist Paul Signac described the Cathedral paintings as 'marvellously executed walls' and the Irish writer George Moore remarked that the paint surface looked to him like 'that of stone and mortar'.

The viewpoint scarcely altered over the whole series, which by 1895 numbered more than 30 completed canvases. Monet's attempts to record his personal responses to a subject reached new levels of intensity in the Rouen Cathedral paintings. As with the haystacks series, there is virtually no topographical interest; we are shown nothing of what must have been in front of the façade, neither footpath, gateway nor road. Nor can we explore over the 30 paintings the marvellously intricate carvings in the stone of the cathedral, for Monet does not

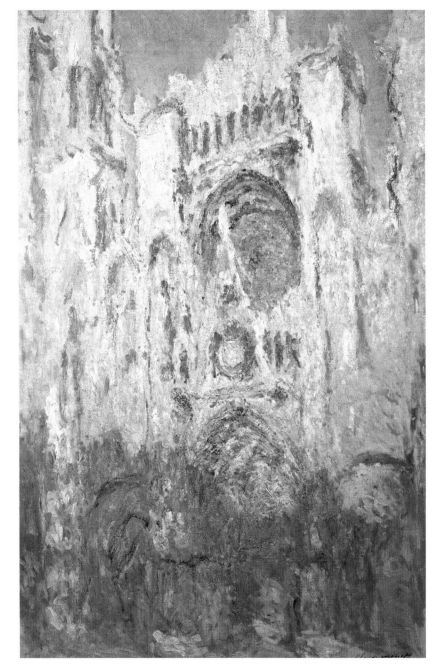
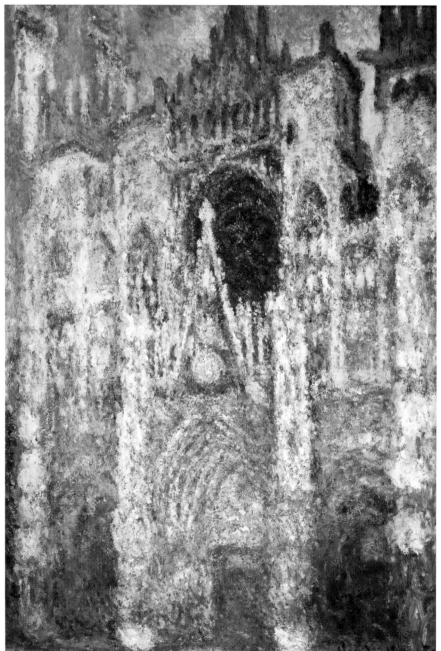

paint them in any detail. It is all a rendering of shapes and forms according to the transient effects of the light that plays on them.

Monet included 20 of the Rouen Cathedral series in an exhibition of 50 of his paintings at Durand-Ruel's gallery in May 1895, with the cathedral's west façade the subject of 18 of them. The remaining two were of the Saint-Romain tower, the cathedral's oldest, standing alone. The Rouen Cathedral paintings came in for some strong criticism, but much more in the way of praise.

The most succinct criticism of Monet's Cathedral paintings was expressed by Kenneth Clark half a century later. In *Landscape Into Art*, Clark wrote that Monet made a disastrous mistake by choosing the grey-stoned cathedral for his motif because it lacked the sparkle essential to make it an effective vehicle for light. In the Rouen Cathedral pictures, Impressionism had totally 'departed from the natural vision from which it sprang', and the arbitrary colour of the cathedral paintings was 'much less beautiful than the truly perceived colour of [Monet's] Argenteuil paintings'.

In 1895, however, praise for the paintings greatly exceeded the criticism. Georges Clemenceau led the chorus of approval in an article in the journal *La Justice*. 'The painter has given us the feeling that he could have made …fifty, one hundred, one thousand, as many as the

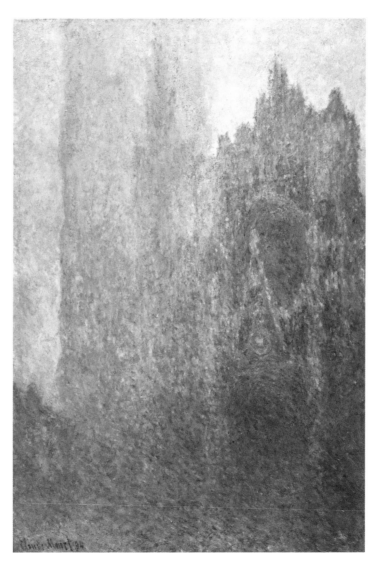

OPPOSITE LEFT
Rouen Cathedral, Effects of Sunlight, Sunset, 1894
*Oil on canvas, 39³/₈ x 25¹/₂in
(100 x 65cm)
Musée Marmottan, Paris*

OPPOSITE RIGHT
Rouen Cathedral: Morning Sunlight, 1894
*Oil on canvas, 35⁷/₈ x 24⁷/₈in
(91 x 63cm)
Musée d'Orsay, Paris*

LEFT
Rouen Cathedral, Foggy Weather, 1894
*Oil on canvas, 41³/₄ x 28¹/₂in
(106 x 72.5cm)
Private collection*

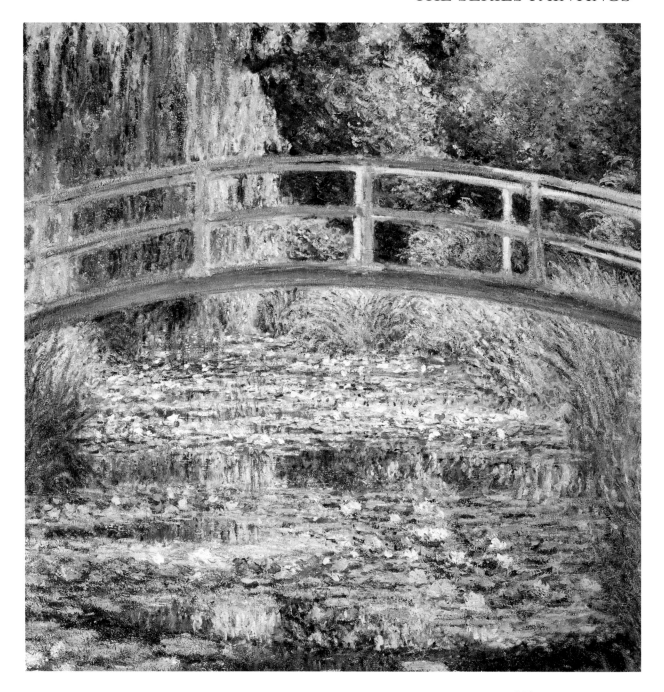

seconds in his life,' he wrote. In a volume of essays called *Pan* that was published in 1896, Clemenceau wrote how art, from primitive cave drawings right up to Monet's cathedrals, 'allows us to appreciate in an encapsulated form those phases of visual understanding through which our race has passed ...In front of Monet's views of [Rouen Cathedral] one begins to realize that art, in setting out to express nature with ever-growing accuracy, teaches us to look, to perceive, to feel.'

Clemenceau tried very hard to persuade the state to buy the whole series. The paintings had been conceived, painted and exhibited by the artist as a set, and should remain so, he argued. Unfortunately, officialdom was not yet ready to forget that Monet had once been a great rebel and refused to put up the considerable sum needed. So the Rouen Cathedral paintings were dispersed, finding homes in many different countries. The Musée d'Orsay in Paris has five of the series, the largest group in one place.

The First Lily Pond Series

In the last summer of the 1890s, Monet began a series of scintillating, lively and colourful paintings of his water garden, in most of which featured the Japanese bridge he had had built in 1895. The titles of the pictures in this series, such as *White Waterlilies*, *The Waterlily Pond with the Japanese Bridge*, all of which were painted in 1899,

OPPOSITE
The Waterlily Pond, 1899
Oil on canvas, 34³/4 x 36⁵/8in
(88.3 x 93.1cm)
National Gallery, London

LEFT
White Waterlilies, 1899
Oil on canvas, 35 x 36⁵/8in
(89 x 93cm)
Pushkin Museum, Moscow

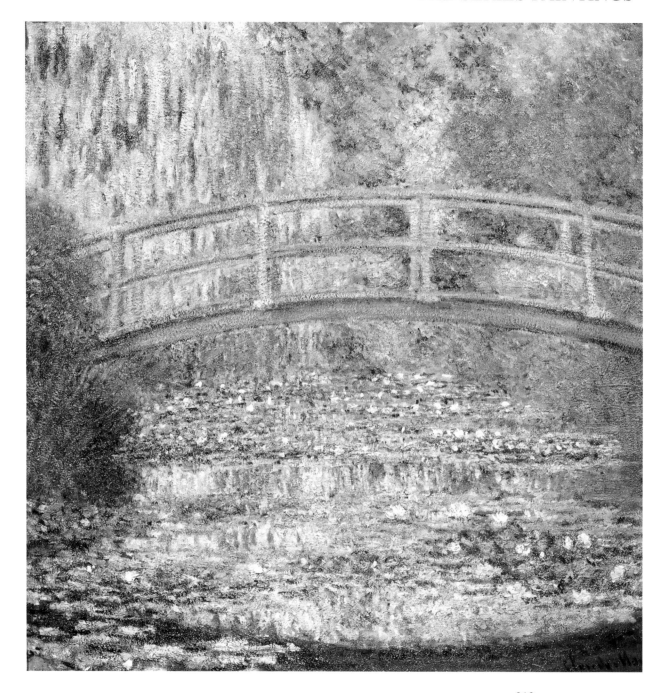

indicate that Monet was much more relaxed in his approach this time. Even so, the first lily pond series was nearer in the manner of its execution to the great series of the early 1890s than it was to the series called 'Mornings on the Seine' which also occupied Monet later in the decade.

The lily pond paintings, which Monet chose to execute on square canvases to better control the composition, were very closely related to each other, both in colour and in the organization of the subject on the canvas. As their subject they all had the same northern section of Monet's water garden. This was made up of trees, including willows and water plants on the banks of the pond, the bridge, which at this time was a simple wooden structure, with curved rails but without the wisteria-hung trellis that features in later paintings, and the waterlilies floating on the surface of the pond. Few of the paintings have even so much as a glimpse of the sky, for Monet has concentrated all his attention on the close confines of the one section of the pond and its lush, close-packed, light-dappled foliage.

Even though he was closer to the motif of his series than he had ever been before, Monet still put much work into the paintings in his studio. If the composition required it, he would alter the placing of plants and trees, the waterlilies in the pond, and even the bridge itself.

As with the great series of the early 1890s, it was the play of light across the surfaces of the various elements of

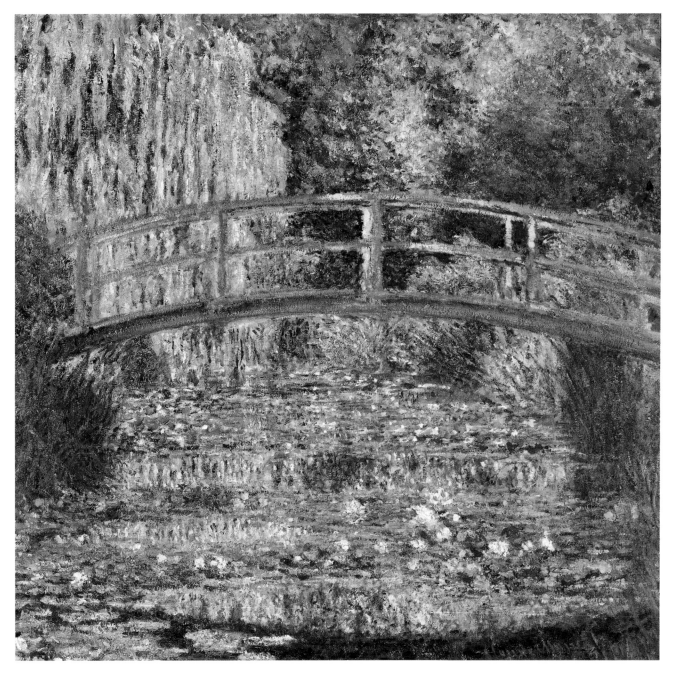

OPPOSITE
The Waterlily Pond with the Japanese Bridge, 1899
*Oil on canvas, 35¹/4 x 36in
(89.5 x 91.5cm)
Private collection*

LEFT
The Waterlily Pond: Green Harmony, 1899
*Oil on canvas, 35 x 36⁷/8in
(89 x 93.5cm)
Musée d'Orsay, Paris*

White Nenuphars, 1899
Oil on canvas, 35 x 36⅝in
(89 x 93cm)
Pushkin Museum, Moscow

the paintings, especially the water, that concerned Monet most and gave the paintings what differences they had. But Monet's efforts were not nearly so concentrated on enclosing his subject in an 'envelope' of atmosphere and the series, essentially 'gardenscapes', became his first serious recording of the glories of his garden at Giverny.

Twelve of the first lily pond series were exhibited by Paul Durand-Ruel in Paris in November–December 1900, along with other paintings of Monet's garden at Giverny and a few from the Creuse valley. The dealer visited Monet at Giverny to choose the pictures and to decide the prices he would pay for them, which, by now, was a matter in which Monet, rather than the dealer, had the final say. The prices – 6,000–6,500 francs – were high when one considers that in 1900 a Parisian manual worker had an annual salary of about 1,000 francs, but they were the kind of prices that Monet's work had been fetching for several years now and which were rapidly making him a wealthy man.

The exhibition was a venture into uncharted waters for Monet on two counts. It was the first time he had shown his lily pond and Japanese bridge to the general public, and it was the first time he allowed the public to have a glimpse of life behind the walls of his garden and home. One of the more unwelcome results of this was that Monet and Giverny became tourist attractions.

Painting London's Bridges Again
Monet began and ended the 1890s with painting trips to London. A trip in 1891, made to take part in an exhibition at the New English Art Club, served to remind Monet of how exciting a subject he had found misty,

foggy London and its river 20 years before.

But it was not until the end of the decade that he was able to get across the Channel again for longer than the relatively fleeting visits he had been making to attend exhibitions, see artists such as Sargent and Whistler and, in 1898, visit his son Michel, who was studying English in London and who had fallen sick. He made one six-week visit to London in the autumn of 1899, when he was accompanied by his wife and stepdaughter, Germaine Hoschedé, on what was supposed to be a holiday, although he included canvases and painting equipment in his luggage. Then he went back alone in the winters of 1900 and 1901, staying three months each time.

He preferred London in winter because 'without the fog, it would not be a beautiful city,' he told the dealer René Gimpel many years later. 'It is the fog which gives it its marvellous breadth. Its regular, massive blocks become grandiose in that mysterious mantle.' He did not understand how English painters in the nineteenth century could have painted the houses brick by brick: 'Those people painted bricks that they did not see, that they could not see!'

Monet's London Thames series was the largest group of paintings he ever did, numbering almost 100 by the end of his third trip. Within the series was three 'mini'

series covering Charing Cross railway bridge, a subject that gave him the additional effects of smoke from the trains to add to the other mists, smoke and fog of London, Waterloo Bridge and the Houses of Parliament. A much smaller group consisted of three sketches of Leicester

Waterloo Bridge, c.1899
Pastel on paper, 11¹/₂ x 18¹/₄in
(29.2 x 46.4cm)
Christie's Images, London

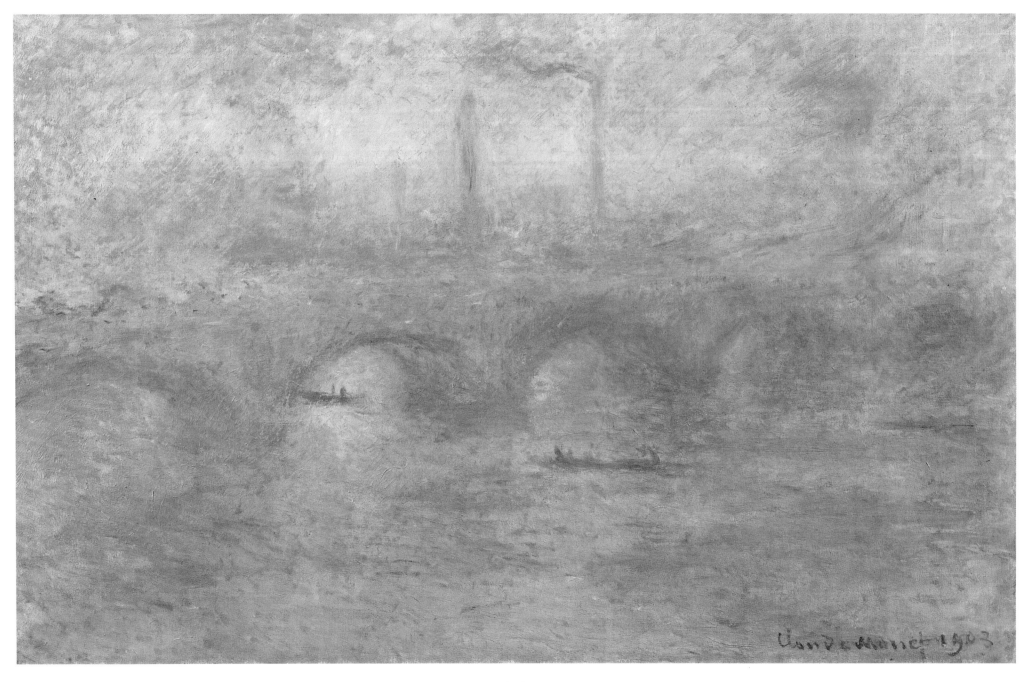

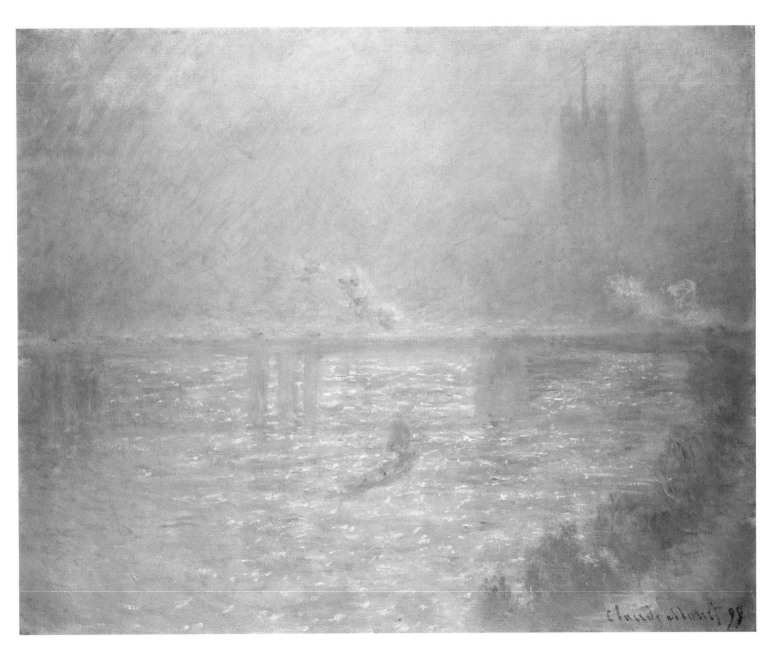

OPPOSITE
Waterloo Bridge in Fog, 1899–1901
Oil on canvas, 25^1/$_2$ x 39^3/$_8$in
(65 x 100cm)
Museum of Fine Arts, Moscow

LEFT
Charing Cross Bridge, 1899
Oil on canvas
Christie's Images, London

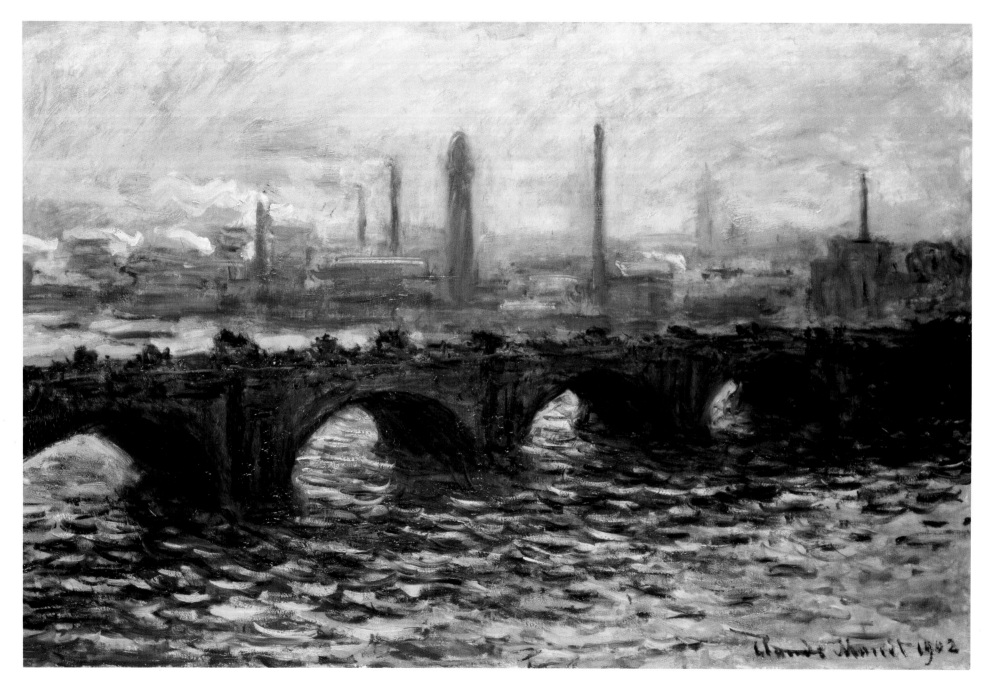

Square, done from the balcony of a private club. Then there were 26 pastels done in 1901 while Monet was waiting for his canvases to be rescued from customs. In its conception, composition and concentration on colour harmonies the series is every bit as impressive as the haystacks, poplars and Rouen Cathedral series.

Monet chose two vantage points for his River Thames paintings. In the grand Savoy Hotel, on the Embankment, he took a sixth-floor suite of rooms with a balcony overlooking the river. From here he painted most of his views upstream to Charing Cross Railway Bridge and the Houses of Parliament and, downstream, across Waterloo Bridge to London's South Bank.

His second vantage point was in St. Thomas's Hospital, where he made arrangements to go every day at the same time in later afternoon. From the hospital he had an excellent view of the Houses of Parliament across the river and he was made welcome in proper English style. The hospital treasurer, showing a proper concern for his welfare, invited him downstairs for tea on his first day. When Monet thanked him but said in a mixture of poor English and sign language that he could not leave his painting, the 'good man' came back ten minutes later bearing a cup of tea, sandwiches and cakes, for which Monet was most grateful.

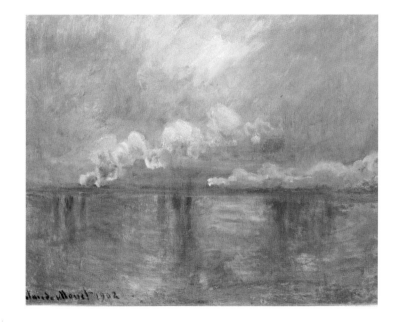

Monet's view of the Thames as a suitable subject for painting had been very much formed by his encounters with the work of James McNeill Whistler, whom Monet met in 1885 and with whom he quickly developed a close and lasting friendship. Whistler's famous series of Thames Nocturnes greatly impressed Monet, as they did many other artists, so that when Monet began painting the misty Thames in London in the 1890s he was not, in fact, doing anything that was artistically particularly revolutionary.

OPPOSITE
Waterloo Bridge in Fog, 1902
Oil on canvas, 25^1/$_2$ x 39^3/$_8$in
(65 x 100cm)
Hamburg Kunstalle

LEFT
Charing Cross Bridge, Smoke and Fog, 1902
Oil on canvas,
Musée Marmottan, Paris

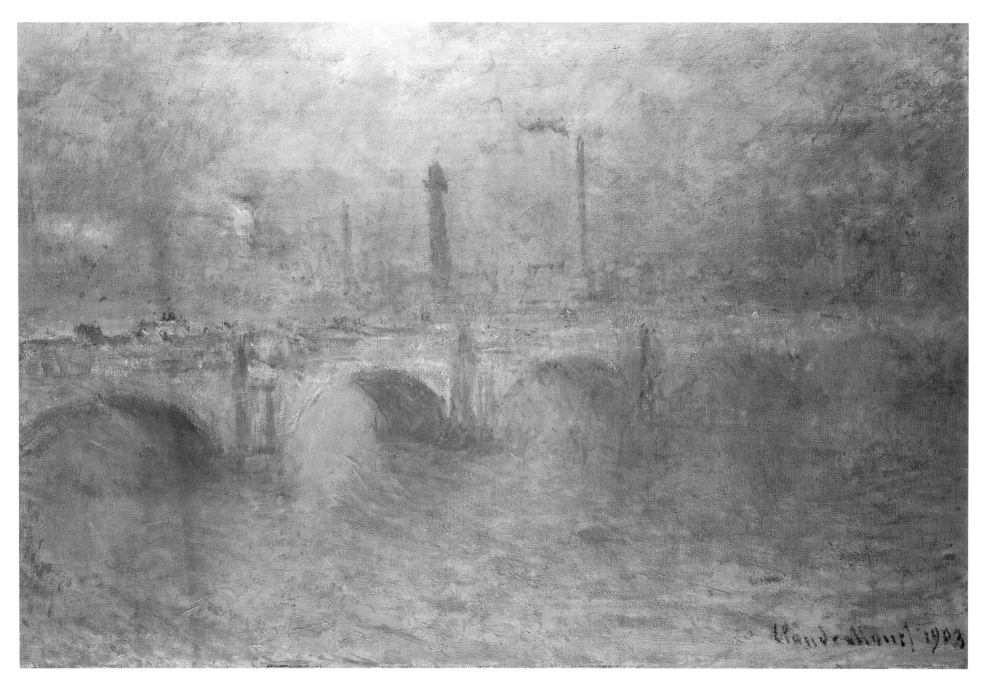

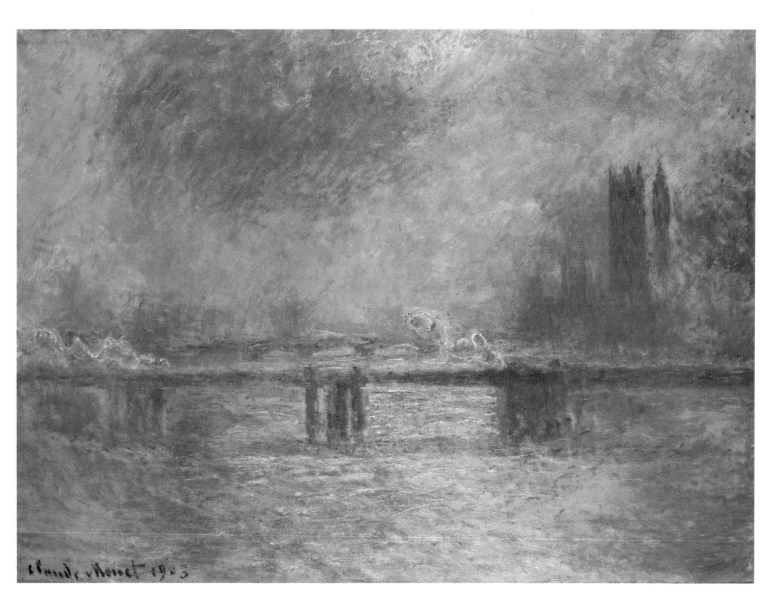

OPPOSITE
The Thames at Waterloo Bridge, 1903
Oil on canvas
Private collection

LEFT
The Thames at Charing Cross, 1903
Oil on canvas
Musée des Beaux-Arts, Lyon

The Thames at Waterloo Bridge at
Dusk, 1903
Oil on canvas,
Private collection

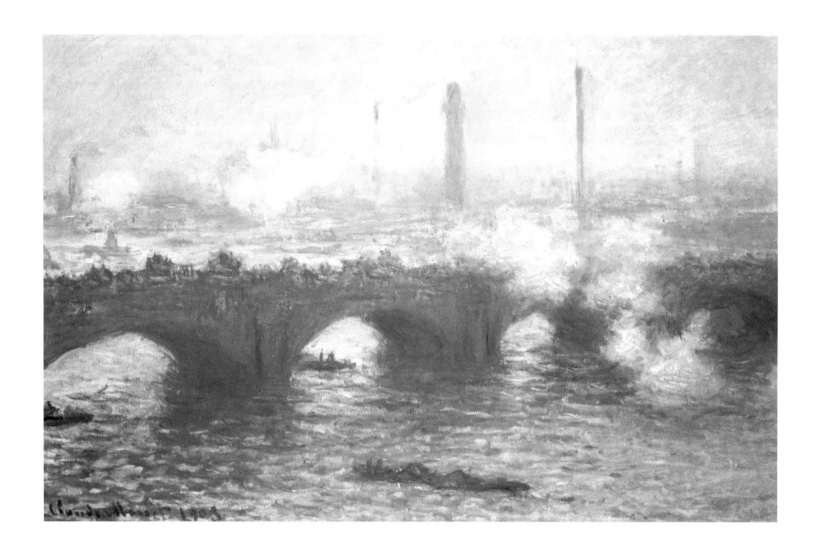

Where Monet's work differed from Whistler's paintings, which were all about evoking a mood, was in his concentration on depicting the effect of light on the Thames and its bridges and the surrounding buildings. Monet's painting technique, which suffused the river mists and the moisture-laden air of London with endlessly varied harmonies of bright but delicate colours, was in great contrast to the work of Whistler and his followers, who generally used a subdued and greyish range of tones in their paintings of London's river. Monet's achieved volume and depth in his paintings, not from the linear depiction of solid objects, but from the great many touches of pigment that he applied in a wide range of tones.

Monet was not painting Thames views or recording the scene before him. He did not hesitate to alter the size, shape and perspective of the historic buildings in his paintings. The Gothic towers, spires, and windows of the Houses of Parliament, hovering in the mists across the water, are not only simplified as a mass in the paintings, they are also heightened and narrowed. The same is true of the towers and factory chimneys that rise up behind Waterloo Bridge.

After Monet, the Thames had to wait only a year or two to be painted again in such bright colours, and by a Frenchman rather than an Englishman. André Derain was

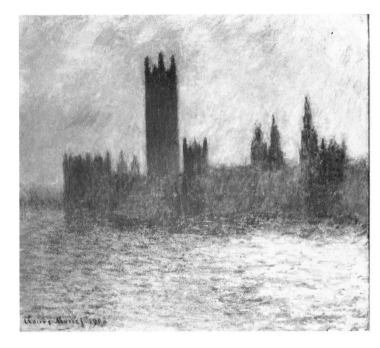

The Houses of Parliament, 1903
Oil on canvas
Brooklyn Museum of Art, New York

sent to London by the dealer Ambroise Vollard, who had seen Monet's paintings exhibited in Paris, to paint some pictures 'in the modern style'. Derain's paintings of the Thames, vividly, even garishly coloured, and flatly painted, are often reproduced in books and exhibition catalogues in proximity to Monet's to provide thought-provoking comparisons of style.

Monet's pursuit of the momentary changes of light on his subject became feverish in London, where the light

***The Houses of Parliament, Stormy
Sky, 1904***
*Oil on canvas, 32 x 36$\frac{1}{4}$in
(81.5 x 92cm)
Musée des Beaux-Arts, Lille*

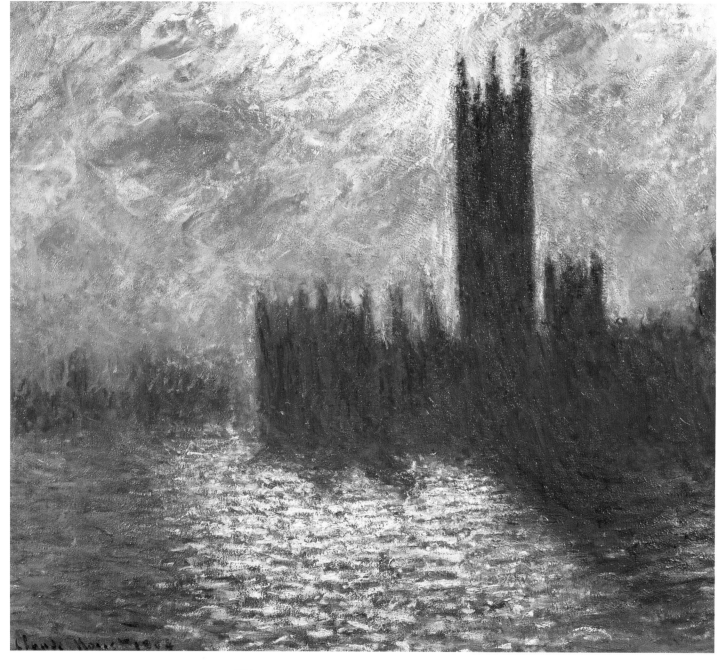

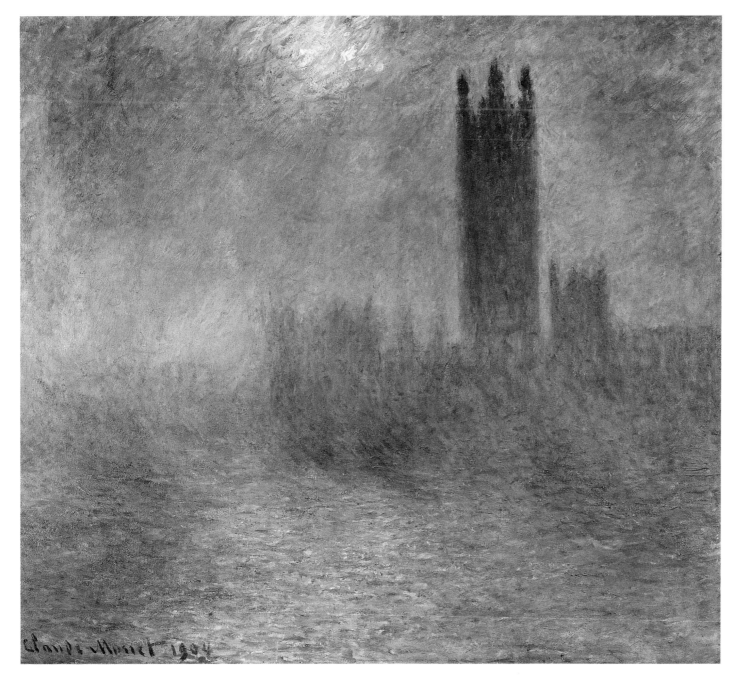

The Houses of Parliament, with the Sun Breaking through the Fog, 1904
*Oil on canvas, 31⁷/₈ x 36¹/₄in
(81 x 92cm)
Musée d'Orsay, Paris*

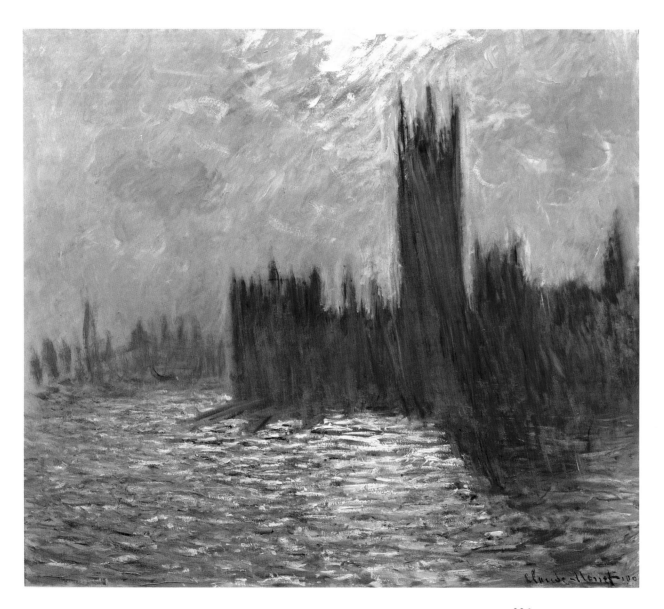

and atmosphere could change very quickly many times in the course of a day. His room in the Savoy Hotel was stacked with as many as 90 unfinished canvases, which he would have to shuffle through at speed to find the one that most approximated the light conditions outside. Often, he had to leave for the day what he was painting at the Savoy because the time had come for him to switch to the hospital. Working in two places on the same day was not a good idea. Nor was it a good idea to work outside so much in winter. The reason his Leicester Square pictures never got beyond three in 1901 was because he was struck down with pleurisy and had to give up painting for two weeks.

Over the course of his visits to London Monet built up a huge collection of canvases, all of which were crated back to Giverny for many months of additional work in the studio. A year after his return from London, Monet was still insisting that he was not ready for an exhibition. 'It is indispensable to have [the pictures] all before me, and to tell the truth not one is definitely finished. I develop them all together,' he wrote.

The problem was, as Monet explained to Gustave Geffroy in April 1903, that he should have left his paintings alone and not worried about people having to look at incomplete sketches. Where he had gone wrong was in insisting on adding finishing touches to them: 'a

good impression is lost so quickly'. If he had left them, people could have done what they liked with them after his death. Now, having added touches to one, he had to work on them all.

It was not until 1904 that Monet felt he had 37 pictures good enough to exhibit, and he was still working on the rest in 1905. The writer Octave Mirbeau wrote the introduction in the catalogue for the exhibition, which opened at Durand-Ruel's gallery in May 1904. Mirbeau's pen produced prose more colourful and flamboyant than the paintings themselves. He wrote about 'the multiple drama, infinitely changing and shaded, sombre or magical, anguishing, charming, florid, terrible, of the reflections on the waters of the Thames; of nightmare, of the dream, of mystery, of fire, of the furnace, of chaos, of floating gardens, of the invisible, of the unreal ...' and so on.

Perhaps it would be better to leave the description of London and the Thames to Monet after a good day's painting. He wrote to Alice on Sunday, 3 February 1901 (the day after Queen Victoria's funeral, which he also recounted to Alice in vivid detail), describing his day, which had begun at 6am, so that by 9 o'clock he had worked on four paintings.

'As always on Sunday, there was not a wisp of fog; it was appallingly clear in fact. Then the sun rose and was so dazzling I found it impossible to see. The Thames was all gold. God, it was beautiful, so fine that I began work in a frenzy, following the sun and its reflections on the water ... I can't begin to describe a day as wonderful as this. One marvel after another, each lasting less than five minutes, it was enough to drive one mad. No country could be more extraordinary for a painter.'

Chapter Seven
Monet in the 20th Century

Claude Monet, photographed on 25 August 1905

Musée Marmottan, Paris

Monet was 64 when this photograph was taken. Wearing the same-shaped bowler hat that first appeared in paintings and photographs of him in the 1860s, Monet, cigarette between his fingers, gazes out over the garden that will inspire most of his work for the next 20 years.

In 1900 Claude Monet's reputation was at a peak. He was one of the stars of the great state-sponsored exhibition of fine arts held in Paris as part of the 1900 World's Fair, in which the Impressionists were given a room devoted exclusively to their work – an acknowledgement of their great influence on art in the nineteenth century. With fourteen works on show, Monet had a bigger representation than any other Impressionist and bigger, too, than such important French artists as Millet or Troyon. Roger Marx, one of the curators of the exhibition, said of Monet's work: 'Never were pictorial faculties put to the service of such a refined and sensitive eye. Apart from Turner and Corot, modern landscape cannot count a master of more noble ability.'

Such comments, and the great success of the exhibition of the first series of the lily pond paintings at the end of 1900, were all very satisfactory, but it was also daunting for Monet to know that he had this great reputation as a leading artist of France to maintain. Monet, as is clear from his letters and from the comments of people who had visited him at Giverny, did have ambitious ideas in mind for more work. But, when he turned sixty in November 1900, he may well have wondered if he would be granted time to explore them. He could not have guessed that more than a third of his working life still lay ahead of him or that he would

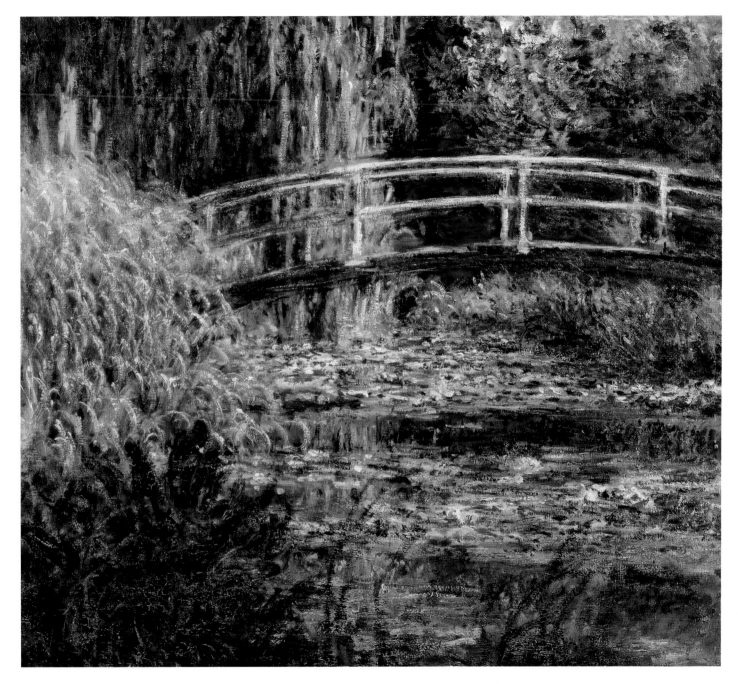

***The Waterlily Pond: Pink Harmony,
1900***
*Oil on canvas, 35$\frac{1}{4}$ x 39$\frac{3}{8}$in
(89.5 x 100cm)
Musée d' Orsay, Paris*

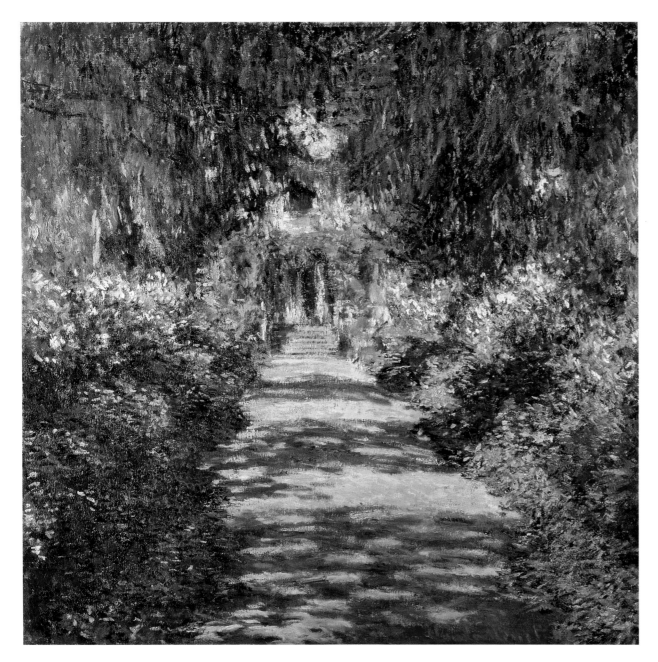

complete nearly four hundred and fifty more paintings, many of them on a very large scale indeed, before his death.

Monet would also have noted the great changes of direction to be seen in modern art at the turn of the century. Following on from the work of the Post-Impressionists – Roger Fry's convenient label, devised in 1910 for the many artists whose art had been moving away from what might be called 'classic' Impressionism – other artists following new styles and new theories were causing great ferment in the world of art in France and beyond. Wassily Kandinsky, working mainly in Germany, was moving away from pictures that combined the techniques of Art Nouveau with the traditions of Russian folk art to explore theories on the dissolution of natural form. There were young men like Henri Matisse, Raoul Dufy and André Derain who were laying colour on their canvases in a manner so wild that the name *fauves* ('wild animals') would become attached to them. There were others, like Georges Braque and the immensely talented young Spaniard, Pablo Picasso, who had experimented with Fauvism, Futurism and other styles before progressing to Cubism.

Monet, taking all this in, may well have wondered if there was any more that he could give to art. He knew that he was less vigorous than he once had been and he had

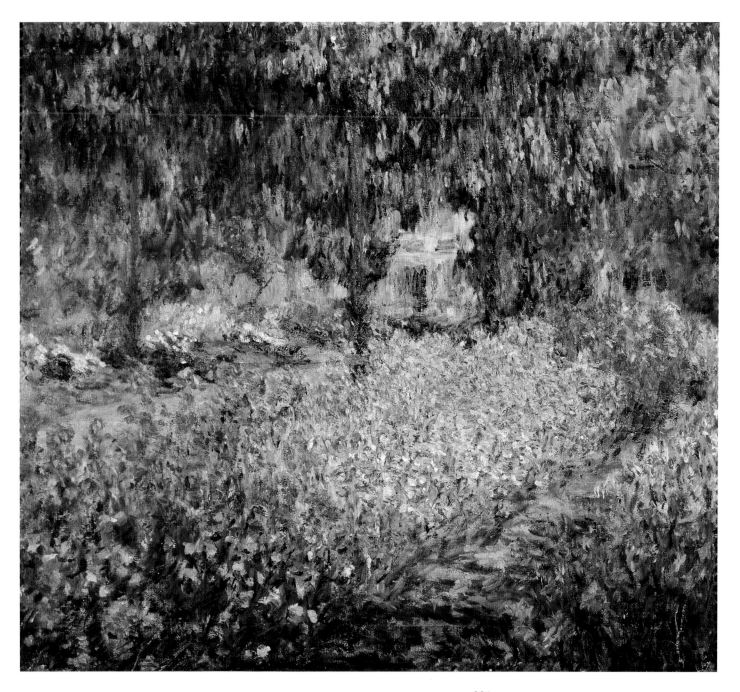

OPPOSITE
The Main Path through the Garden at Giverny, 1902
Oil on canvas, 35 x 36¹/₄in
(89 x 92cm)
Kunsthistorisches Museum, Vienna

LEFT
The Artist's Garden at Giverny, 1900
Oil on canvas, 31⁷/₈ x 36¹/₄in
(81 x 92cm)
Musée d'Orsay, Paris

Monet transformed the garden around the house at Giverny from an ordinary cottage garden, complete with vegetable patches and compost heaps, into a place of such beauty and style that it became famous even in his own lifetime. He planned the layout of paths and plots, and chose the trees, plants and flowers that would grow there.

Monet in his studio at Giverny, 1920s
Private collection

The studio in this photograph, taken early in the 1920s, was the third one Monet built at Giverny and was completed in 1916. It was made very large so that Monet could set up the canvases for his great waterlily décorations: *the one here is* Morning.

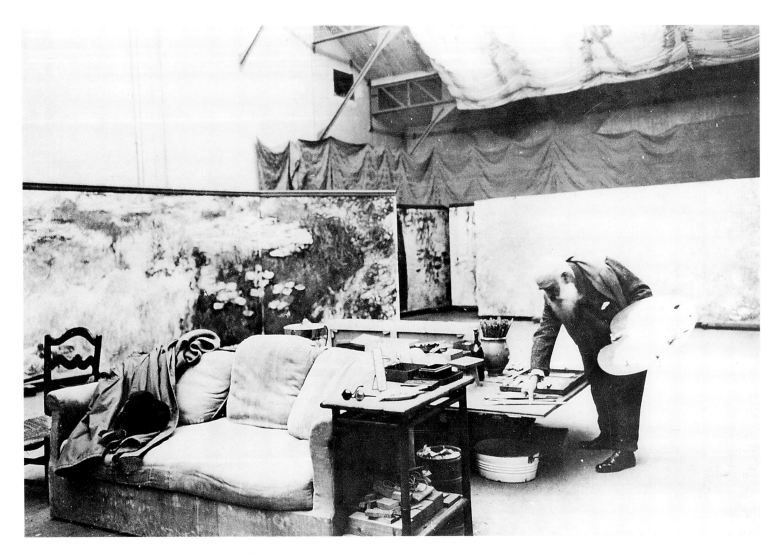

also mourned the deaths of several of his close friends and fellow artists in recent years, most notably Berthe Morisot in 1895, Eugène Boudin in 1898 and Alfred Sisley in January 1899. Perhaps his time would not be far off.

Such thoughts were to be given even greater weight by the deaths of Pissarro in 1903 and Cézanne in 1906, the year in which Monet first noticed that his eyesight was failing. Now only he, Degas and Renoir were left of that enthusiastic, confident band of artists who had set out on their great journey in the 1860s.

Sisley's death, from throat cancer, came just four months after the death of his wife and ended a life that had known little other than poverty since the early 1870s. Monet was active in arranging Sisley's funeral and sorting out his affairs so that his now orphaned children would have something to live on after their father's death.

Monet and Alice had attended Sisley's funeral and Alice returned to Giverny from it with such acute bronchitis that she had to take to her bed. While she lay ill, her daughter, Suzanne Hoschedé-Butler, who had modelled for some of Monet's loveliest paintings in the 1880s and was now a mother herself, died early in February 1899 at the age of only 30. Several weeks later, Monet, in a letter to Paul Durand-Ruel about an exhibition of Sisley's work he was arranging, said that although Alice had now recovered from her bronchitis it would be

Monet with a visitor on the Japanese bridge over the lily pond
Private collection

Vétheuil, 1901
Oil on canvas, 35^1/$_2$ x 36^1/$_4$in
(90 x 92cm)
Pushkin Museum, Moscow

Monet revisited Vétheuil, as he did
several other places he had worked
happily at 20 years before, at the turn
of the century. He painted several
canvases there in a rapid, sketchy style,
concentrating on depicting the light and
atmosphere at different times of the day.

Vétheuil, Sunset, 1901
*Oil on canvas, 35$^{1}/_{2}$ x 36$^{1}/_{4}$in
(90 x 92cm)
Musée d'Orsay, Paris*

MONET IN THE 20TH CENTURY

a long time before she would get over the tragedy of Suzanne's death. Monet himself, deeply affected, was hardly able to lift a paintbrush until he went to London in the autumn of that year.

By the turn of the century, the house at Giverny was constantly ringing to the sound of children's voices. Several of Monet's eight children and stepchildren lived at home, while others had married and had had children of their own. Some of these also lived in the big house at Giverny, while his son Jean, married to Blanche Hoschedé, lived nearby in a house Monet had bought for them.

Given Monet's continuing fabulous income – 231,000 francs in 1900, 217,000 francs in 1904 and 272,000 francs in 1909 – he no longer had to worry about how he was going to support this lively household in the coming years. Indeed, he was very generous with his money, buying expensive cars for his son Michel and stepson Jean-Pierre Hoschedé and two, including a Rolls-Royce, for himself.

The chauffeur-driven Rolls-Royce took Monet, Alice and Michel to Spain in October 1905 on a visit to Madrid and Toledo so that Monet could study the work of the great Spanish masters, especially Velázquez. It was an indication, if one was needed, that Monet had put aside any thoughts of mortality that might have troubled him a few years earlier.

Renoir, many years before, and Picasso more recently,

were both very much influenced by the work of Velázquez, the greatest artist of the Spanish school. Now Monet, who once had no enthusiasm for trailing round art galleries looking at classical painters, came to see for himself. He might be approaching his mid-sixties and be regarded as a master of his art, but he knew there was still much to discover about painting and the way it could be used to express profound thoughts about life and death.

Like other great painters, such as Titian and indeed Velázquez, in the later parts of their careers, Monet felt a need to find a way to make his painting express his response to the deeper rhythms of life. It was no longer satisfying enough to paint what he saw; he had to paint what he felt about what was beneath the surface. In the paintings of Velázquez he would have found much to admire and much to inspire him. He would have noticed the confidence with which Velázquez laid on his warm and generally quite muted colours in loose, fluid brushstrokes. And he would have seen the way that Velázquez brought light and atmosphere into his pictures in a way that added to the great sense of life that pervaded everything he painted. Most of all, Monet would have seen how in his many brilliant portraits, Velázquez saw beyond the external trappings of fine clothes and accoutrements to the real character beneath, which he portrayed with a warm humanity.

Transforming Giverny

One of the consequences of living in an increasingly crowded house was that Monet had to move out of the large room, that had served him as a studio since he had first rented the Giverny house, into a big upper room in the gardeners' storage and workplace he had constructed in the north-west corner of his garden in 1897. This was his main studio until he built the much larger one in which he began painting his monumental waterlily 'decorations' during the First World War.

While all this cost Monet a good deal, the expense was nothing compared with the amounts he invested in expanding and rebuilding his garden to make it the major subject of his painting and motifs in the twentieth century.

In 1901, Monet's garden was already famous for its beauty and style, which was the sort of garden beloved by the English, complete with lawns, herbaceous borders and flower beds, rather than the more formal continental layout. In his large greenhouse he cultivated orchids, exotic ferns and other flamboyant plants, including a large and splendid climbing begonia, given to Monet by the curator of the botanical gardens at Rouen and which had to be pruned regularly to prevent it from breaking the glass of the greenhouse. The greenhouse was also where Monet overwintered many of his less hardy plants, including the waterlilies that graced his pond.

Outside the greenhouse and surrounding the house was a beautiful flower garden laid out in beds separated by paths, some of which were surmounted by trellises supporting climbing roses. Monet chose his flower plantings so carefully that the garden appeared to change its appearance almost from week to week as the seasons unfolded.

The extension of Monet's pond and the garden surrounding it brought great changes to the water garden at Giverny. He began the project in 1901 by purchasing for a modest sum – about a sixth of what he might expect to get from the sale of one of his series paintings – a parcel of land on the far side of the River Ru, the stream that fed his existing pond. There was much planning to do and many permissions to obtain from the town council of Giverny, the prefect of the *département* and others before Monet could begin work.

By the time the workmen left early in 1902, Monet's water garden had been transformed: the whole garden now covered an area of 700,000sq ft (65000sq m). Small, flat footbridges allowed walkers to cross the Ru to a new gravel path alongside the stream's new bed. The size of the lily pond had been tripled and there was a tiny island at its eastern end. On the pond's surface soon floated red, yellow, pink and white waterlilies and around its edges grew irises, callas and other water-loving plants.

In 1905 Monet decided that the Japanese bridge should take an even more prominent role in his paintings by building a trellis over it to support beautiful mauve and white wisteria, an idea he almost certainly borrowed from his Japanese prints, in which it often featured, falling in graceful curves from bridges and trellises. Near the bridge, a semi-circular stone seat, protected from winds by a great clump of bamboo, offered a convenient resting place from which to view the glories of the lily pond.

In 1910, after severe floods had submerged both the gardens at Giverny, Monet changed the pond's shape so that it became more subtly curved, enhancing the banks with grassy verges planted with peonies which produced large, heavily-drooping pink, white and wine-red flowers in early summer. On both sides of the path that bordered the pond grew the willows and poplars that had already been on the land when Monet bought it and which had since been augmented by a glorious array of rhododendrons, azaleas and hydrangeas, backed by hedges of shrubby roses.

By this time, the water garden had reached its final shape. Monet had carefully designed it so that it could be seen from many viewpoints, and would appear larger than it actually was – although, at roughly 10,000sq ft (1000sq m), the lily pond was not exactly a typical garden pond. Thus, parts of the pond curved away behind trees so

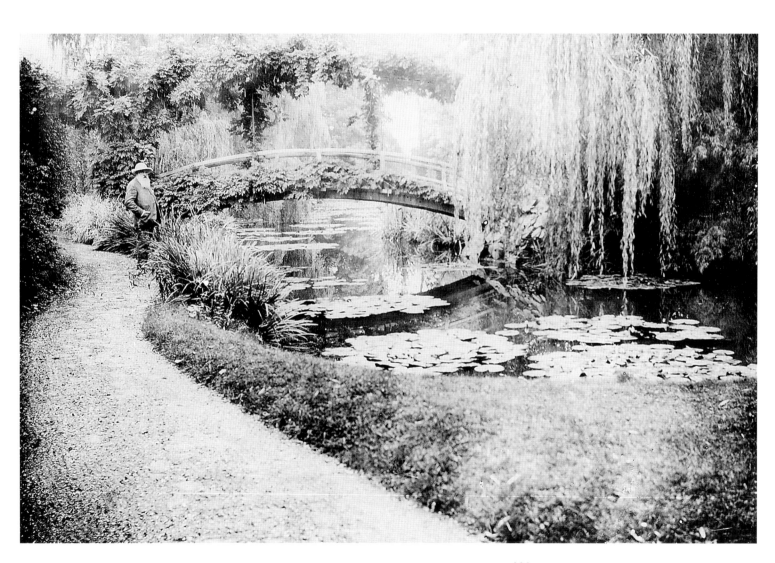

Monet in his water garden at Giverny
Private collection

Monet surveys his lily pond from the gravel path round it. The woodwork of the Japanese bridge behind him has almost disappeared behind the foliage of the plants that Monet has grown over it.

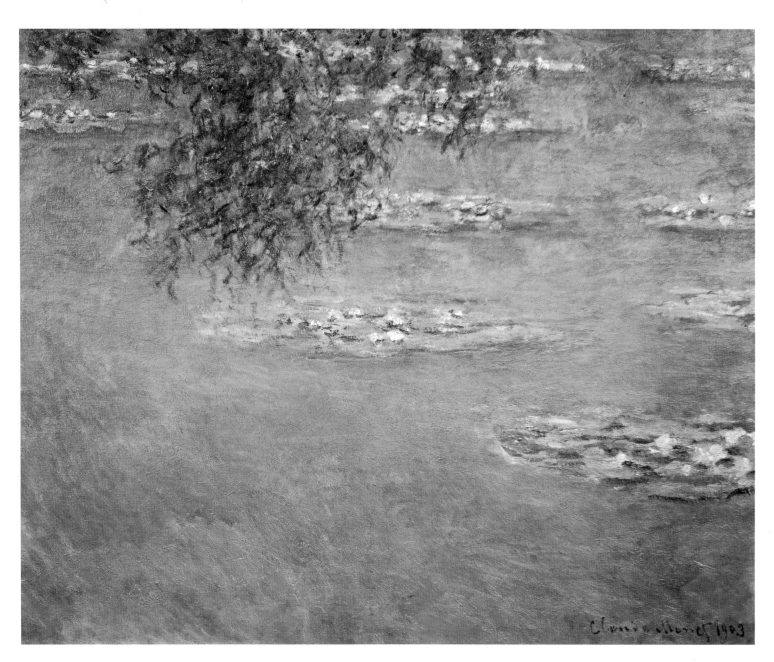

RIGHT
Waterlilies, 1903
Bridgestone Museum of Art, Tokyo

OPPOSITE
Waterlilies, 1903
Oil on canvas, 35 x 39³/₈in
(89 x 100cm)
Musée Marmottan, Paris

that its actual size and extent were hidden from view.

When he extended his garden at Giverny early in the 20th century, Monet was not succombing to a whim, to a casual thought that it would be nice to have a lovely garden to stroll about in and where his children could play. It is clear, from the reports of visitors, that he had been planning the extended lily pond from at least the mid-1890s, because he had already carefully chosen the subjects that he wished to paint in the years ahead. As Gustave Geffroy wrote in his review of Monet's great 1898 exhibition at Georges Petit's gallery, 'One of the numerous fantasies born of the …appellation "impressionism" is that [the Impressionist artists] did not actually choose their subjects. On the contrary, choice was always their lively and important concern.'

An indication that Monet had already decided in his mind the subjects of his early twentieth-century paintings years before he began to paint them came from a Paris journalist. In the late summer of 1897, Maurice Guillemot was sent by the journal *Revue Illustrée* to visit Monet at Giverny, where he spent time talking to the artist and observing his working practices. Since Monet seldom encouraged such intimacy from anyone who was not a friend, it is probable that the visit was a deliberate arrangement, planned so that Guillemot would produce an article to coincide with the opening of the 1898 exhibition.

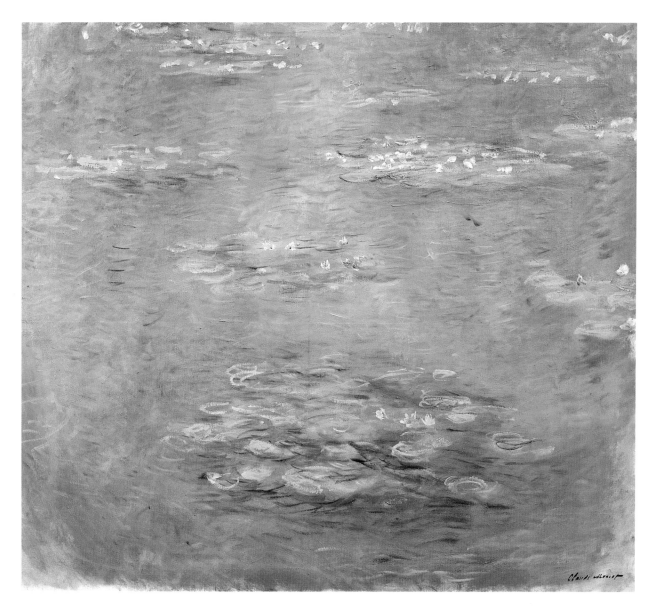

Pond with Waterlilies, 1904
Oil on canvas, 35¹/₂ x 36¹/₄in
(90 x 92cm)
Musée des Beaux-Arts, Caen.

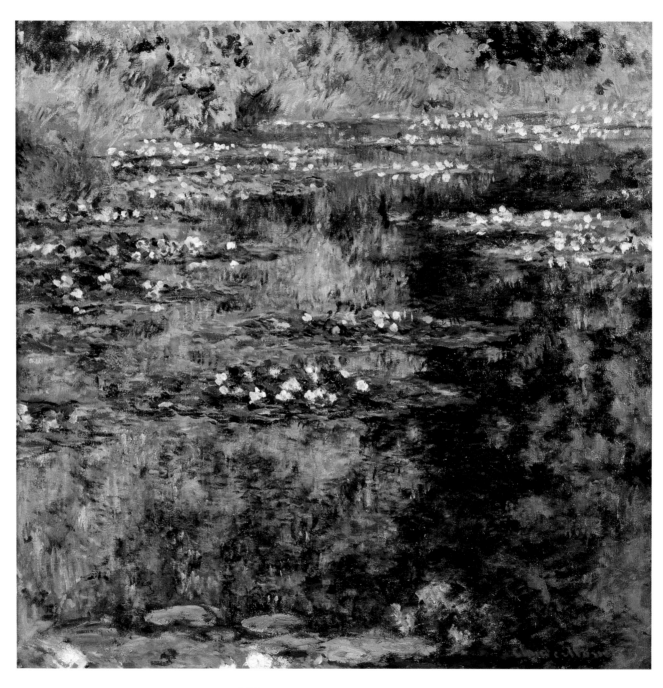

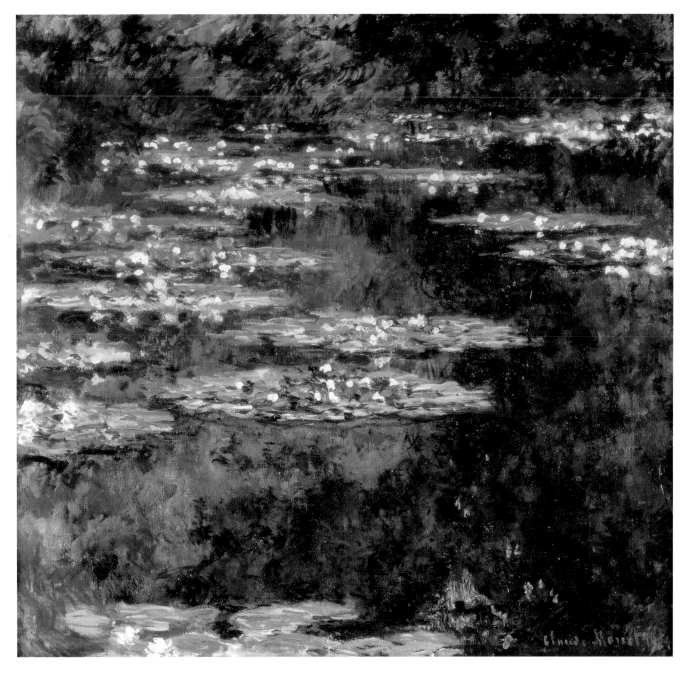

Waterlilies 1904
Oil on canvas
Musée des Beaux-Arts André Malraux,
Le Havre

RIGHT
Waterlilies with Weeping Willows, 1907
Oil on canvas, 39¹/₂ x 28⁷/₈in
(100.5 x 73.4cm)
Bridgestone Museum of Art, Tokyo

OPPOSITE
Waterlilies, 1907
Private collection

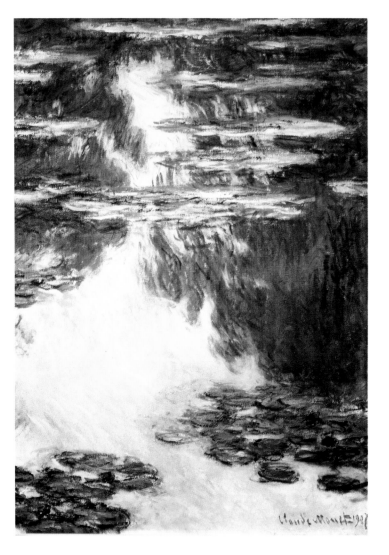

This was the period when Monet was painting the works that were included in the 'Mornings on the Seine' part of the exhibition, and Guillemot had to be out and about very early indeed to keep up with his interviewee: Monet left the house at 3.30 in the morning in order to set up his easel in what Guillemot called his true workshop – nature – in time to catch the dawn light.

Back in Monet's indoor workshop at Giverny, Guillemot claimed to have been shown studies, or large panels, for a 'decoration' modelled on the lily pond, which Guillemot described as an 'immobile mirror [on whose surface] float waterlilies, aquatic plants, unique species with broad-spreading leaves and disquieting flowers of a strange exoticism'. Guillemot went on to suggest that a suitable place for such paintings would be 'a circular room in which the dado beneath the moulding is covered with [paintings of] water, dotted with these plants to the very horizon … The tones are vague, deliciously nuanced, with a dreamlike delicacy'.

Did the journalist imagine all this himself, or did Monet himself describe what he had in mind – nearly 20 years before he actually began to paint his 'decorations'? It is not impossible. After all, Monet was aware of how much his series paintings gained in impact when they were shown together as a complete concept. And he was also aware that many other artists, including his friend

Whistler, had for some time been exploring the same idea of works of art intended to be shown as an ensemble.

Little, if anything, has survived of the 'decorations' that Guillemot claimed to have seen. Monet did not mention them in his letters, nor did he show them to anyone else. It is possible, of course, that Monet destroyed them because they were simply ideas or experiments that, this time, did not quite come off. Monet is known to have made big bonfires of paintings that did not come up to scratch in the summer of 1898. In contrast with his wonderfully lively and light-filled series of paintings of the whole pond, including the Japanese bridge, that was exhibited in 1900, the few 'close-up' waterlily studies that survive from the late 1890s seem curiously lifeless and airless. Much better water lily paintings were to come in the twentieth century.

The Second Waterlily Series

It was not until 1909 that Monet was ready to reveal the water garden paintings that he had been working on, at intervals, for much of the decade. At the end of 1906, he had decided to show his waterlily paintings in 1907, and exchanged several letters with Durand-Ruel on the subject. But when the time grew near, he pulled back, much to Durand-Ruel's annoyance. Monet was apologetic but firm: his paintings were not ready, and much more

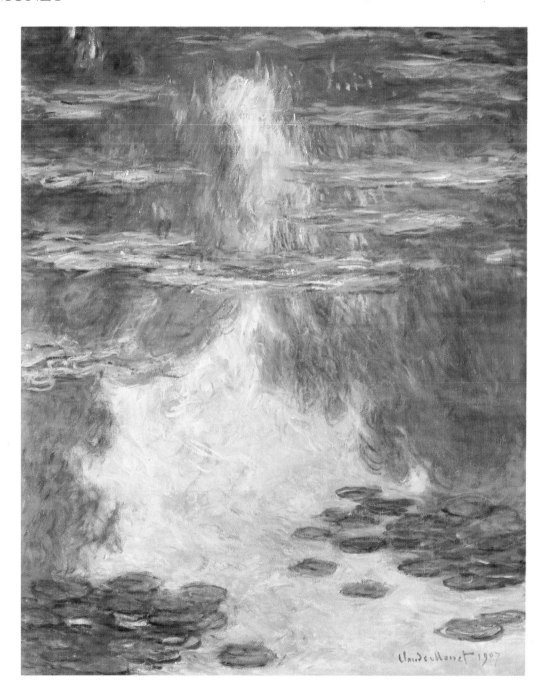

would have to be done to them 'in front of nature'. He would not show work that to his hypercritical eyes was mediocre.

The next date arranged for the second waterlily show was 1908. This time, it was Durand-Ruel, not happy with what he had been shown at Giverny in September 1907, who engineered a postponement. The paintings Monet had been working on for months were very different from the paintings of the 1900 exhibition.

First of all, they were not manageable squares or horizontals that could be hung in drawing rooms or over mantelpieces. These paintings were vertical, and quite large. They were also painted in intense colours, with a vigorously executed impasto. Many of the compositions were dramatic, with tumbling foliage reflected as dark shadows on the water of the pond and occupying a large part of the canvas. Durand-Ruel knew that he was looking at what painters, rather than buyers of paintings, would appreciate, and was doubtful that he could sell these restless pictures, with their powerful juxtapositions of dark and light colours, shapes and forms.

Seen today, with the benefits of hindsight, the paintings seem as though they may have been, in part, Monet's reaction to the work of the Fauves. The dramatically and flatly coloured paintings that several of the Fauves, including Matisse and Derain, exhibited in the

1905 Salon d'Automne had stunned Paris and had led many critics to suggest that Impressionism was, if not dead, then on the way out as the main yardstick by which artists measured their own work.

Monet visited the 1905 Salon d'Automne, a new annual show begun in 1903 as an alternative to the official Salon, still going strong, and the Salon des Indépendants, because both Blanche Hoschedé-Monet and Theodore Butler, his son-in-law, had paintings on show. Monet encountered the Fauves again in 1906 when the young André Derain exhibited a vibrant and strikingly coloured, if crudely painted work called *Waterloo Bridge* at the 1906 Salon d'Automne which Monet could well have taken as both a tribute to his own art, especially his London series, and a warning. His mid-decade lily pond paintings could be seen as his vigorous, tension-filled response.

Monet was perhaps encouraged in his belief that he was moving in the right direction and that Durand-Ruel was wrong by the fact that in October 1907, the French State, in the guise of the French National Museums, decided to honour him by buying one of his paintings. The decision was undoubtedly promoted, if not engineered, by Georges Clemenceau, then in the middle of his first period as prime minister of France. In response, Monet sold to the state one of the most difficult

and uncompromising, because it was the most austere, of his Rouen Cathedral series.

Monet did reconsider his waterlily paintings, however, and worked on them throughout the summer of 1908. In the autumn, when his garden was past its best, he and Alice went to Venice for the first time, and it was not until 1909 that Monet was able to return to the waterlilies. In February, he allowed Durand-Ruel to announce that the show of his waterlily paintings would take place in May 1909. He was confident that he would be ready and that the intervening trip to Venice would enable him to judge the quality of his pictures more clearly.

Forty-eight paintings of Monet's water garden, many of them now very different from the ones that Monet had shown Durand-Ruel in 1907, were included in the 1909 exhibition, which, at Monet's direction, was called, not Reflections, which had been Durand-Ruel's suggestion, but Waterlilies, Series of Waterscapes.

The overall effect of the show was one of peace and contemplation, a feeling achieved partly by the overall view of the lily pond in most of the paintings, which was closer to the water and the waterlilies and the tangle of foliage above them than it had been in the series exhibited in 1900. Now, neither the Japanese bridge nor the borders of the pond appeared in many of the paintings. Instead, the most tangible objects were the light-filtering foliage above

the water and the groups of lily pads, some with constellations of flowers among them, some with just one or two. They seemed to float above the reflections of sky, trees and plants on the surface of the water, but at the same time suggested the depths beneath. This was because Monet had been concentrating on the relationship between what lay on the surface of the water and what lay below, what was visible and what was unseen. The compositions had no clearly defined edges; as a result, the viewer's eye and imagination were free to wander in any direction they chose.

In these paintings the harmonies were much more muted and were applied with greater restraint than in the earlier paintings. The strong, almost uncomfortable contrasts of light and dark of what had gone before had now been replaced by a much gentler light. In some of the paintings the pictorial content – the waterlilies and the overhanging foliage – almost disappear into delicate, near-abstract arrangements of forms and colours. The contrast with what Fauve artists, such as Matisse and Derain, and the young Pablo Picasso were doing at this time was immense.

Monet had been living quietly out of the public eye for so long that the exhibition was keenly anticipated. Advance publicity included a long article published in *Le Gaulois* on 4 May, the day before the opening. It was the

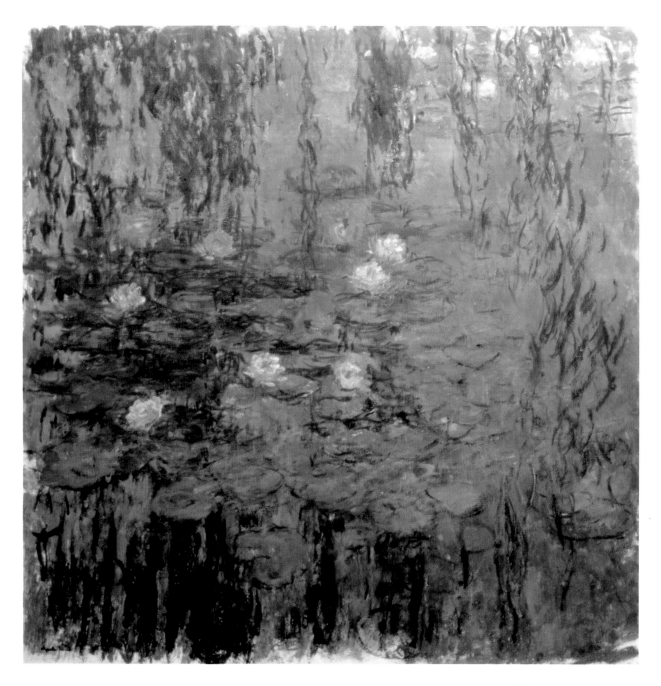

work of a young writer, Jean Morgan, who as a prelude to the exhibition had been allowed to see the paintings and talk to Monet at Giverny. In his article, Morgan noted how Monet's vision had become more simplified in his recent work, 'limiting itself to the minimum of tangible realities in order to amplify, to magnify … the impression of the imponderable … The water invades the entire canvas, becoming the fluid field upon which the … waterlilies open out'.

The public response to the exhibition was overwhelming, and many of the paintings were sold within days of the opening. But buyers would have needed several of the paintings in order to hang them in the way, according to critic Roger Marx, that Monet intended. In his review of the exhibition, Marx reported a conversation with Monet, during which he revealed that he had been tempted to employ the waterlily theme in the decoration of a salon, 'carried along its walls, its unity, enfolding all the panels, would have given the illusion of an endless whole, of water without horizon or bank … [such a room] would have offered the refuge of a peaceable meditation in the centre of a flowering aquarium'.

Within a few years, Monet had built a third enormous studio at Giverny so that he could make just such wall-sized 'decorations', based on the peaceful contemplation of his water garden.

OPPOSITE
Blue Nympheas, 1907
Oil on canvas, 78³/4 x 78³/4in
(200 x 200cm)
Musée d' Orsay

LEFT
The waterlily pond and Japanese bridge in Monet's garden at Giverny, photographed in the 1920s
Musée Marmottan, Paris

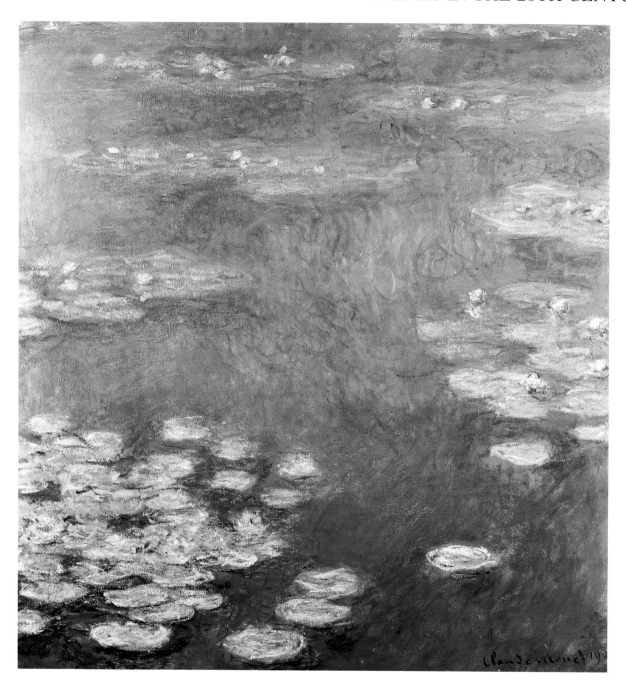

Nearly two years after the exhibition, when Durand-Ruel asked for more waterlilies to sell, Monet agreed to hold them at their exhibition prices, which meant that eight pictures cost the dealer 113,000 francs. This was 'a very fair gesture on my part', according to the businessman Monet in his accompanying note, though the artist Monet intervened at the end to ask Durand-Ruel to kindly warn Prosper that he would have to be careful when unpacking the canvases, as two had been freshly retouched.

One of the eight waterlily paintings Durand-Ruel bought in 1910 was sold by the firm to a private buyer in 1925 and remained in his family until early in the twenty-first century. Its appearance in a sale at the London auction house, Sotheby's, in 2002 caused a furore in the international art market, especially when the experts found how spectacularly beautiful it looked after having been left, unvarnished and unretouched, for so long. It was sold for £13.48 million, less than the £18 million that a larger painting of the lily pond and its bordering path had made in 1998, but still a sum that both Monet and Durand-Ruel would have found almost impossible to believe.

Monet in Venice

Monet had not been greatly impressed by his early exposure to the art of Venice. Renoir had occasionally dragged him into the Louvre when they were students and

MONET

once stopped him in front of a Canaletto. Monet's response to the wonderfully lively and romantic picture in front of him was that Canaletto was incompetent – 'he hasn't even put in the reflections of the boats'.

On the other hand, he was quite aware that Venice was one of the greatest art cities in the world. Many of his closest friends, including Renoir, Manet and Sargent, had found great inspiration in the beauty of the city and its unique light. Moreover, Monet had been so impressed by a watercolour of Venice's Grand Canal in 1908 by Paul Signac that he bought it for his own collection. Even so, Alice had a hard time persuading him to leave his garden and visit Venice, for the first time, at the end of 1908, where they stayed from September to December, first of all at the luxurious Palazzo Barbaro on the Grand Canal, which was owned by a wealthy American friend of John Singer Sargent and, later, when they had decided to stay much longer than originally intended, at the Grand Hotel Britannia.

While Venice had long enjoyed its reputation as an artist's paradise, it was also very much of a challenge. Many great artists – Bellini, Giorgione, Titian, Tintoretto and Canaletto – had been born in Venice and many more from all the countries of Europe had been inspired to produce some of their best work there, including J.M.W. Turner in the nineteenth century, who made his last visit

OPPOSITE
Nympheas at Giverny, 1908
Oil on canvas, 36^{1}/4 x 35in
(92 x 89cm)
Private collection

LEFT
Claude and Alice Monet in St. Mark's Square, Venice, in October 1908
Musée Marmottan, Paris

RIGHT
The Grand Canal, Venice, 1908
Oil on canvas, 29 1/8 x 35 7/8 in
(74 x 91cm)
Fine Arts Museums of San Francisco

OPPOSITE
Gondalas in Venice, 1908
Oil on canvas, 31 7/8 x 21 5/8 in
(81 x 55cm)
Musée des Beaux-Arts, Nantes

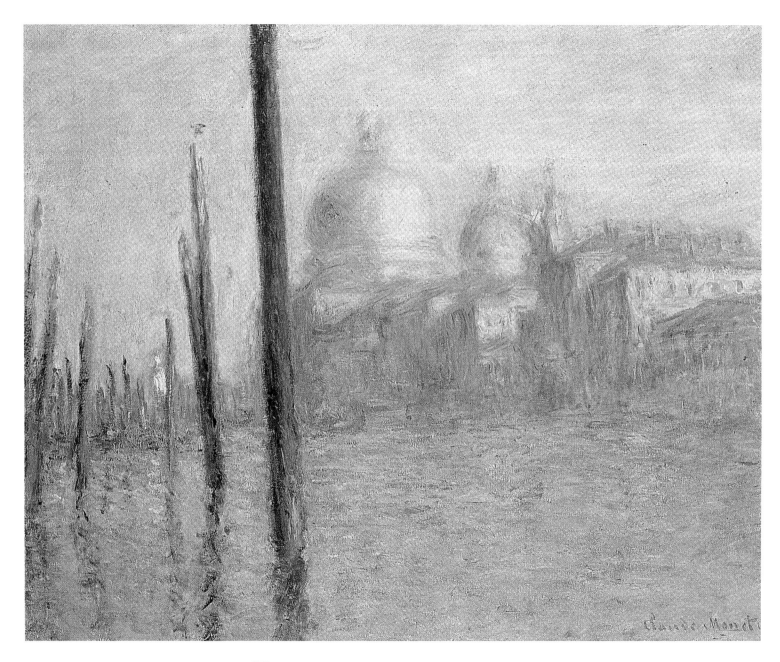

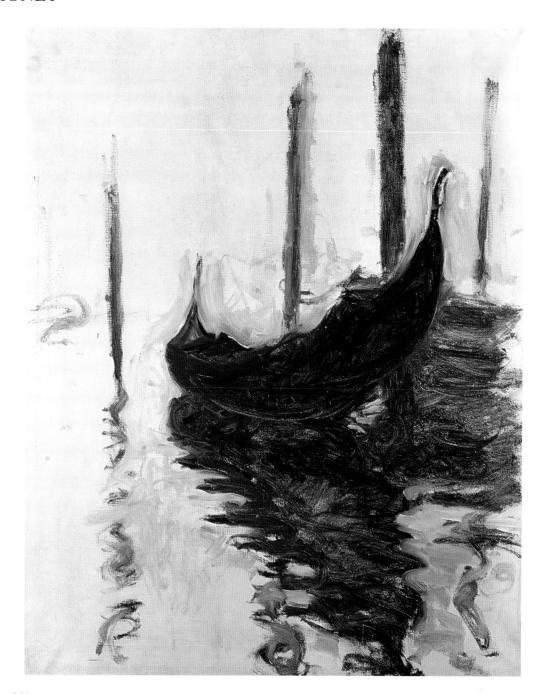

to Italy in the year of Monet's birth, and, of Monet's generation, Manet, Boudin, Renoir, Whistler, Sargent and Signac.

Monet was not in Venice with the intention of doing any serious work, although he did take his painting equipment with him and had crates of canvases sent to him from Paris. He may have persuaded himself that he was only going because his work had been included in three of the international *biennales* that Venice had been holding since 1895, and he wanted to see where they had been hung. Sargent's friend had invited them to stay and Alice insisted that they go, thinking that her husband needed a break from his work.

At first, Monet and Alice were typical tourists, visiting the art galleries and the churches, where they marvelled at the glories of Giorgione, Tintoretto and Titian, went on gondola rides, and fed the pigeons in St. Mark's Square. There is a delightful photograph (page 351) of the plump and elderly couple, he with a pigeon perched on his flat cap and another on his wrist, and she, wearing an exuberantly horned hat, supporting a bird on each hand.

Monet's canvases eventually arrived and, inspired by the beauty of the city's architecture and the uniqueness of the light, he was soon hard at work. In mid-October, he wrote to Durand-Ruel, hinting that the dealer must not expect too much of the visit: he and Alice were not

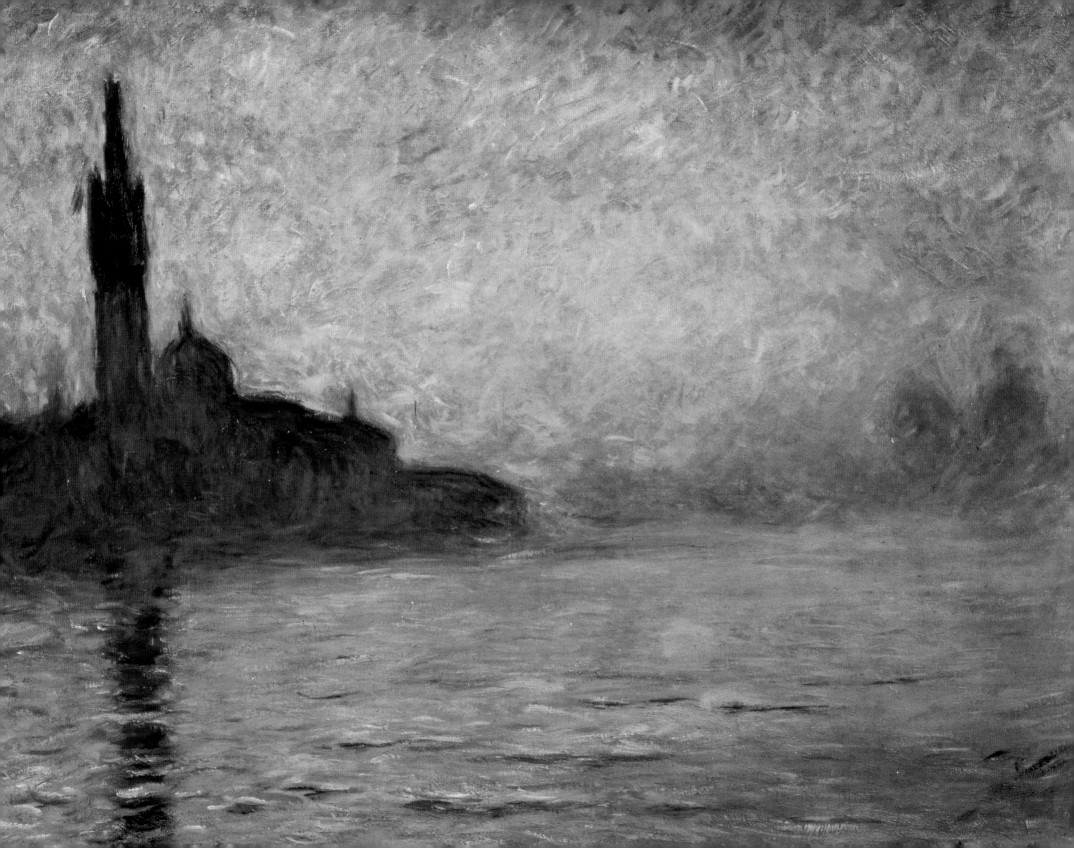

staying long enough for him to do any serious work. However, 'I am doing a few paintings in any case, to have a record of the place.'

At this stage Monet had some three dozen paintings in progress and Durand-Ruel knew his man well enough to know that Venice would inspire something saleable and which could be exhibited. Monet hoped to make another visit to Venice in 1909, but circumstances were against him and the canvases he took home with him from this first trip to La Serenissima were all that he did.
It would be three-and-a-half years before he was satisfied enough with the paintings to allow them to be exhibited.

From the outset, Monet referred to his Venice paintings in very modest terms; they were 'records', 'some studies' and 'some beginnings'. He was also telling his friends that it was a shame he had not come to Venice when he was younger, and still full of daring. Now he was an old man and he was afraid that the daring and the strength might have gone.

Such thoughts did not prevent him from working in his usual way. His painting schedule saw him at work before 8 in the morning and he did not stop until mid-

or late afternoon. He even hired a gondola to paint pictures from a viewpoint in the middle of the Canale de San Marco.

However, he no longer followed the same, almost

manic, multi-canvas system that had made Sargent smile when he observed his old friend frantically flicking through his 90 canvases in the Savoy Hotel in London. This was logistically impossible in Venice, when Monet often had his easel set up at the end of a boat landing stage or even on a gondola. Nor was he intent on depicting every minute fluctuation of light hitting his chosen subjects. Alice worried that he was working too hard for a man of his age, though there was one compensation. She told her daughter Germaine that she was happy that Monet was painting something other than 'the eternal waterlilies'.

Monet's paintings of Venice included both panoramas – views up the Grand Canal, and of San Giorgio Maggiore seen down the waters of the Grand Canal from the landing stage of the Grand Hotel Britannia, for instance – and close-up views of individual *palazzi* on the Grand Canal, many of which were painted from the steps in front of the Palazzo Barbaro. Monet's painting, *Venice, Palazzo da Mula,* was so close-up that he left the upper floors of the Grand Canal *palazzo* and the adjoining buildings right out of the picture. The buildings' façade is shown absolutely front-on and seemingly suspended above the waters of the canal along which they are built. The *palazzo* fills the top half of the canvas as a pattern of horizontals and verticals, floating in a shimmering haze and pink and blue light.

OPPOSITE
View of San Giorgio Maggiore by Twilight, 1908
Oil on canvas, 29$^{1/8}$ x 36$^{5/8}$in (74 x 93cm)
Bridgestone Museum of Art, Tokyo

OPPOSITE
The Doge's Palace, Venice, 1908
Oil on canvas, 28³/4 x 32¹/2in
(73 x 82.4cm)
Galerie Daniel Malingue, Paris

When he saw the Doge's Palace, Monet's comment was that it was 'Impressionistic' architecture, not Gothic, adding that the man who had conceived the great building was the first Impressionist. He painted the palace from a gondola in the Venetian lagoon – a rather perilous viewpoint, given the amount of water traffic at that point – and from the square in front of San Giorgio Maggiore.

Monet went home from Venice after ten weeks in the city with some thirty-seven canvases, which fell roughly into ten groups. There were six paintings of the Grand Canal, six looking across the lagoon towards San Giorgio Maggiore, and another six looking from San Giorgio Maggiore towards the Doge's Palace, three of the palace itself, and eight of three of the grand *palazzi* on the Grand Canal. The smaller Rio de la Salute and the upper section of the Grand Canal were the subjects of other canvases.

Because Monet had to finish all but two from memory, he was never entirely satisfied with them, partly because he did not feel he had got the light right. It is true that, because he was not finishing his pictures in front of the subject, the same generalized light appears in all the pictures.

What worried Monet more than anything else was that his Venice paintings would look too conventionally beautiful and, because they did not form series, as in his recent exhibitions, they would be just another hotch-potch collection of popular views of Venice done as a money-making venture. There was certainly no shortage of that kind of artist at work in Venice; Alice had counted six artists at work on their own Canaletto lookalikes in the Campo San Giorgio when Monet was there one morning working on his paintings of the Doge's Palace across the water.

It was not until March 1912 that Monet came to an agreement concerning the sale of the bulk of his Venice paintings. Twenty-nine of them were bought jointly by Paul Durand-Ruel and the Bernheim-Jeune Gallery. In mid-April 1912, when Monet had already sent some Venice paintings to the gallery which was going to exhibit them all, he sent the Bernheim-Jeune brothers a letter in which he refused to supply them with any more pictures, because those that were left in his studio were too poor for exhibition. They were so 'utterly bad' that their creator could not believe that 'people of taste, if they have any knowledge at all, could see any value' in them.

The Bernheim-Jeunes refused to return the Venice paintings that were already in their hands. Making great use of the diplomatic skills of Paul Durand-Ruel, developed over many years of working with Monet, they even managed to prise more out of his studio so that when the exhibition opened on 28 May 1912 it contained all the twenty-nine works they had agreed to buy.

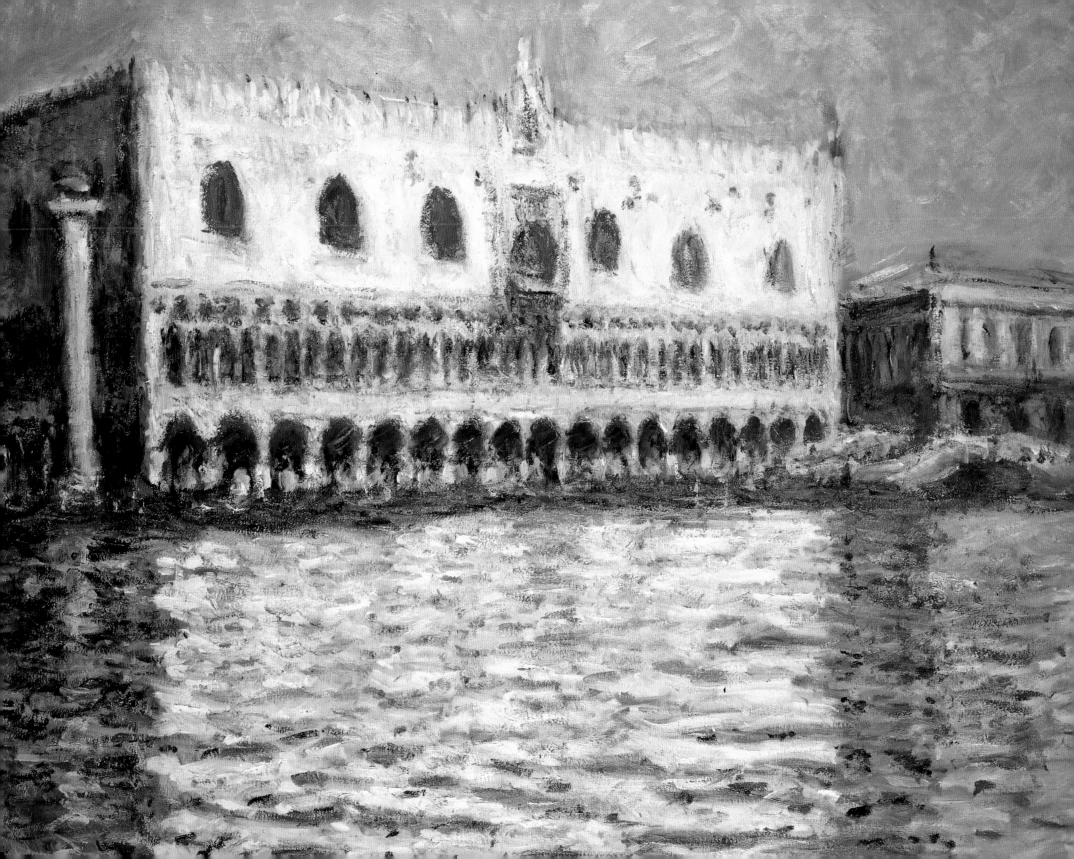

Waterlilies, Harmony in Blue, c.1914
Oil on canvas, 78³/4 x 79¹/8in
(200 x 201cm)
Musée Marmottan, Paris

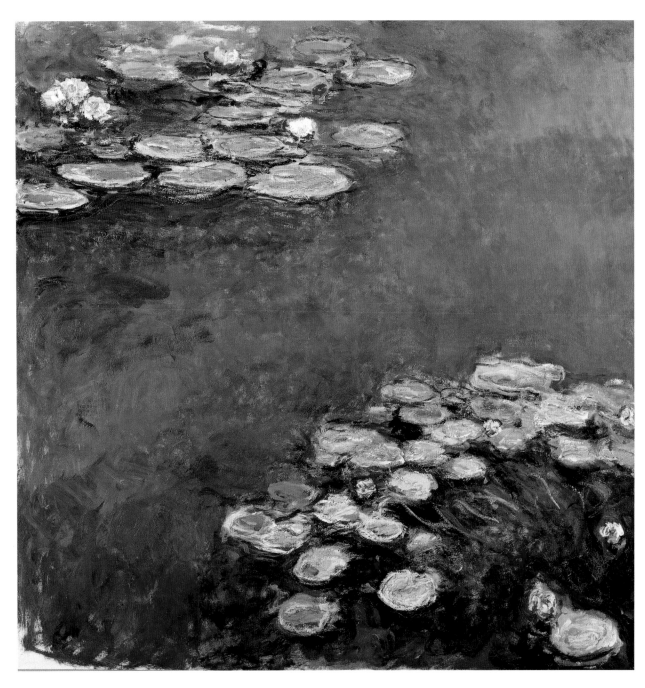

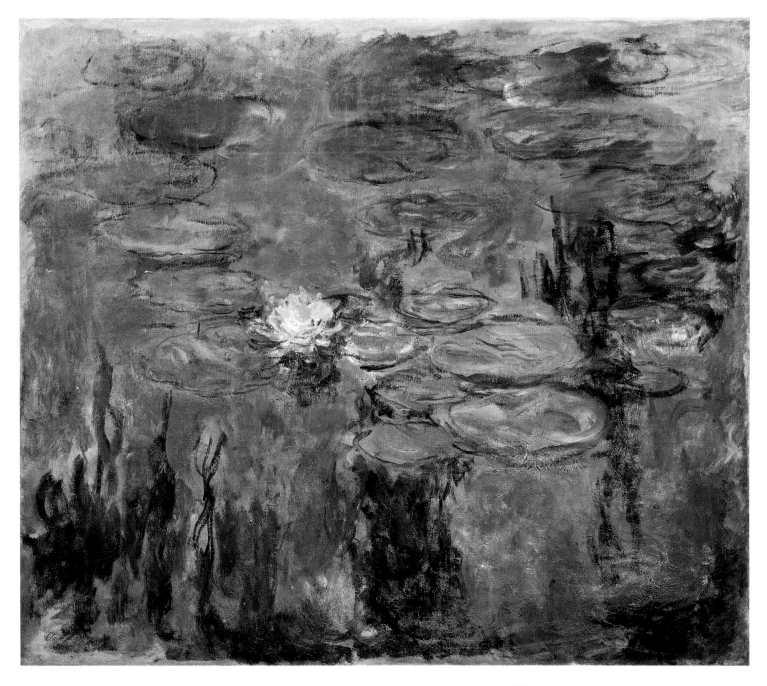

Waterlilies, 1915
Oil on canvas, 51^{1}/4 x 60^{1}/4in
(130 x 153cm)
Musée Marmottan, Paris

Waterlilies, Evening, c.1915
Oil on canvas, 35 x 36^1/4in
(89 x 92cm)
Musée Marmottan, Paris

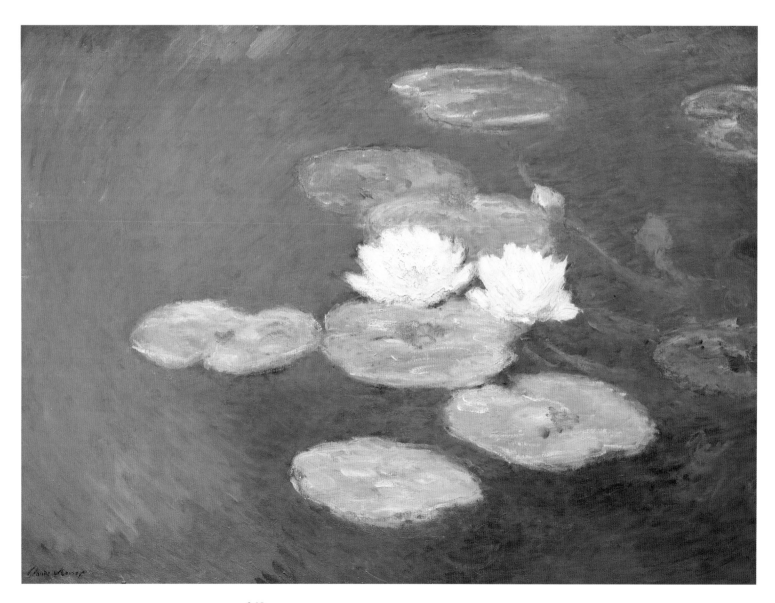

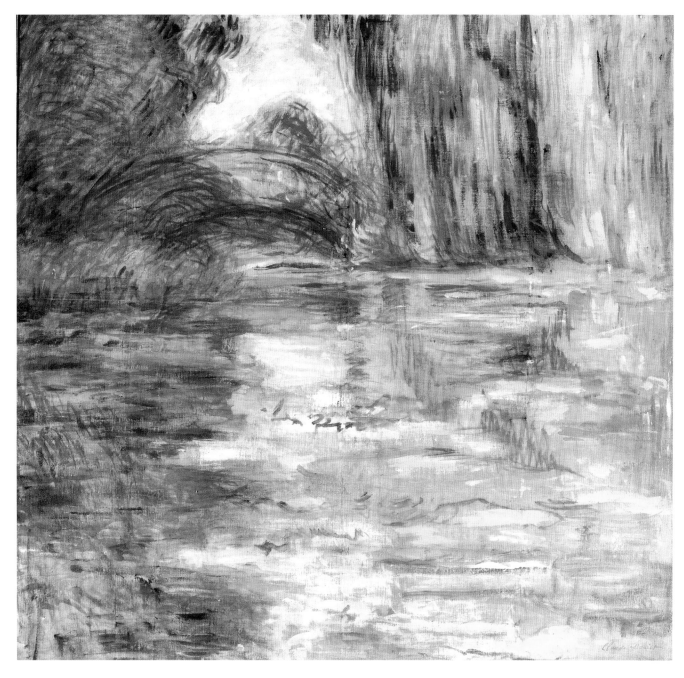

The Waterlily Pond: The Bridge, c.1915
Oil on canvas
Private collection

OPPOSITE
Waterlilies, 1914–19
Oil on canvas, 59 x 78³/₄in
(150 x 200cm)
Musée Marmottan, Paris

BELOW
Monet retouching **The Rose-Covered Pergola,** *Giverny, 1920*

Everyone, critics and public alike, disagreed with Monet's assessment of his paintings, their haunting beauty and sumptuous colouring and light ensuring them a near-rapturous reception. Monet's paintings of Venice were not postcard views. His treatment of the subject, turning the famous Venetian buildings into mirages floating on shimmering, always moving water – set, in fact, in an 'envelope' of atmosphere – was the work of an artist in his late maturity meditating on time, history and human experience.

Paul Signac, writing as a fellow-artist and addressing Monet as 'dear Master', said that he admired the paintings as the highest possible expression of Monet's art. 'Always a Monet has moved me profoundly. Always I have found something to learn from, and in my days of doubt and discouragement a Monet has always been for me a friend and guide.'

Years of Despair

The first decade of the twentieth century was far from being the happiest or most fruitful of Monet's life. His interest in his work seemed to have diminished and there were weeks at a time when he avoided his studio, except to show its contents to visitors. His attitude to his Venice paintings clearly grew out of a general depression and a feeling of dissatisfaction with everything he had done.

When Paul Durand-Ruel wrote to him when trying to persuade him to go back on his decision not to hand over any more paintings for the Venice exhibition, Monet replied that now, more than ever, 'I realize just how illusory my undeserved success has been. I still hold out some hope of doing better, but age and unhappiness have sapped my strength.'

He knew from mid-decade that he was not seeing as well as before, and when the problem was eventually diagnosed as a cataract in 1912, he was cast into despair. He knew that cataracts would make his eyesight increasingly poor until they had become sufficiently developed to be removed. And what then? Cataract operations were not always successful.

In the event, Monet underwent two operations in 1923 which, after several months of pain and difficulty, restored his sight; but the gradual deterioration in the preceding ten years or so had certainly affected his painting, though to what extent has long been a matter of conjecture among art critics.

For about ten years, from about 1908 to 1917, Monet finished very few pictures, to the point that he could sign and date them, of the garden round the house or of the water garden beyond. Just two paintings of the house, as seen from a corner of the flower garden, and three of the rose-covered pergola in the water garden were painted in

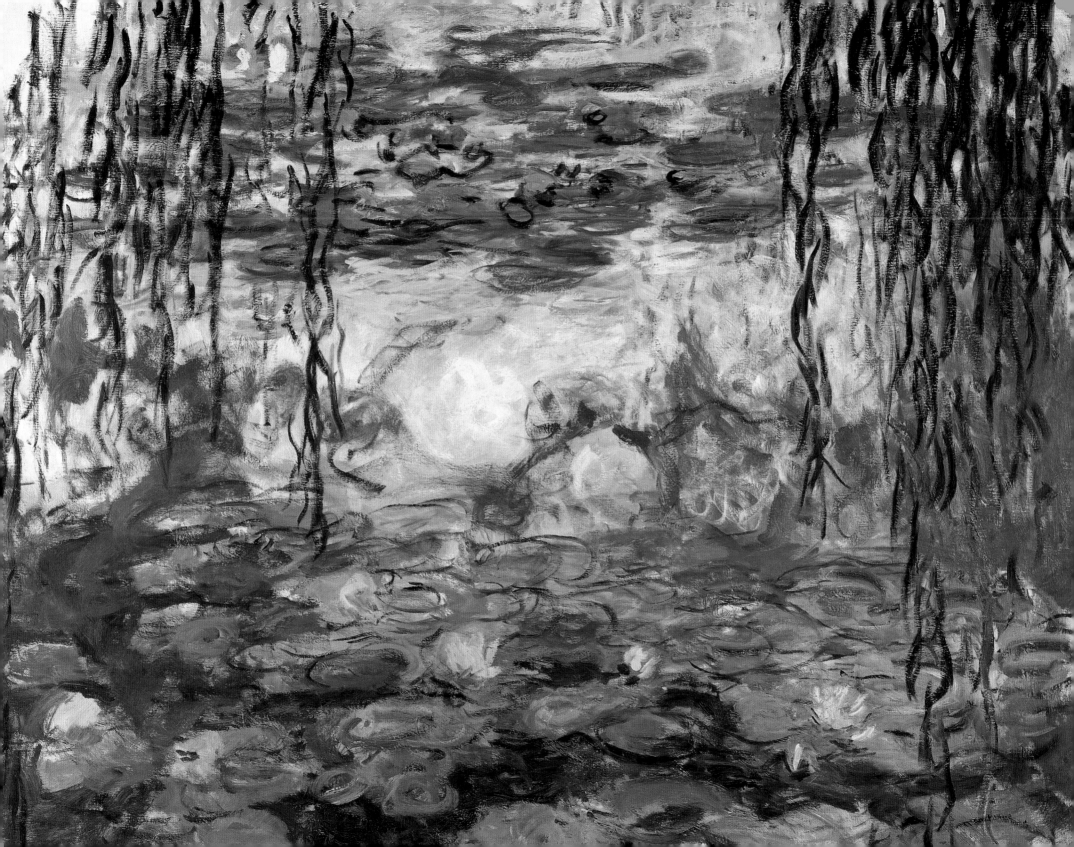

Waterlilies, 1916–19

Oil on canvas, $78^3/4$ x $70^7/8$in

(200 x 180cm)

Musée Marmottan, Paris

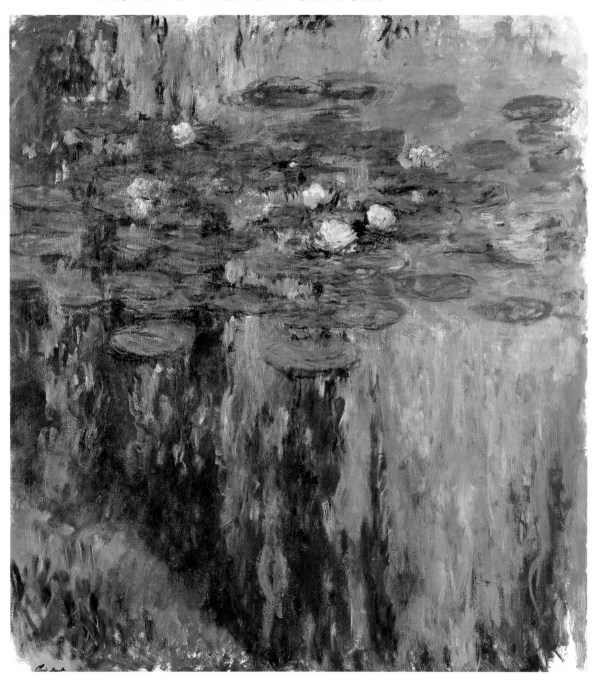

the years immediately before the outbreak of the First World War. The most striking thing about these paintings is that they show no sign that their creator was struggling with poor sight. Monet's choice of colour is as beautifully balanced as ever, the light and atmosphere that pervade the pictures is pure Monet, and the composition is clear and precise.

A photograph of Monet putting the finishing touches to *The Rose-Covered Pergola, Giverny* (page 362) was one of several taken during a photo session for an interview Monet gave to the weekly journal, *Je Sais Tout*. It was as if this was to be a last public glimpse of the white-haired, white-bearded Grand Old Man of French art before he retired.

Certainly Monet seemed to prefer just sitting and resting in his gardens, rather than painting them – though, clearly, he was also thinking about what he might do, such as that scheme for painting waterlily 'decorations', given reasonable sight and good health. For several years, his working life was dominated by the need to finish his second waterlily series, exhibited in 1909, and his Venice paintings, finally shown in 1912.

A minor tragedy in 1910, the inundation of both the gardens at Giverny during the great floods that wrought havoc in the Seine valley in February, had no long-term bad result, although a great deal of manpower and

considerable sums of money were needed to restore the flower garden. The flooding provided the impetus for Monet to reshape the lily pond. He was careful in his choice of a painting to donate to the flood relief scheme, to which he also gave a sum of money.

In 1911 came a major tragedy, the worst of Monet's life. In May, Alice died. She had been diagnosed with a form of leukemia in February 1910 and radiotherapy had brought only a temporary remission. Monet was at her bedside when she died in the early hours of 19 May. She had been his lifeline, his comfort and support and his bulwark against the annoyances of everyday life for so many years that her death left him utterly bereft; it was many months before he could even think about painting again. Even when he did start again, on the Venice paintings, he was unable to shake off a feeling that everything was a waste of time and that his own work was worthless.

Just when Monet had begun to feel his way back to life again, he was struck by another tragedy. His elder son, Jean, became very ill in 1912, grew increasingly weaker throughout 1913 and finally died in February 1914. The only good thing to emerge from Jean's death, in terms of Monet's future happiness, was that it brought Jean's widow, Blanche, back to the big house at Giverny. Always Monet's favourite daughter, who had painted at his side since her girlhood and had accompanied and helped him on

Nympheas, 1916–19
Oil on canvas, 78³/4 x 70⁷/8in
(200 x 180cm)
Musée Marmottan, Paris

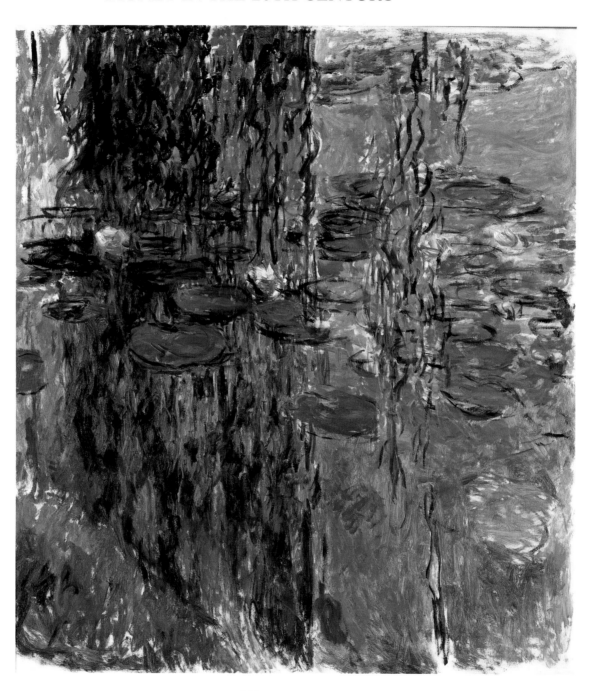

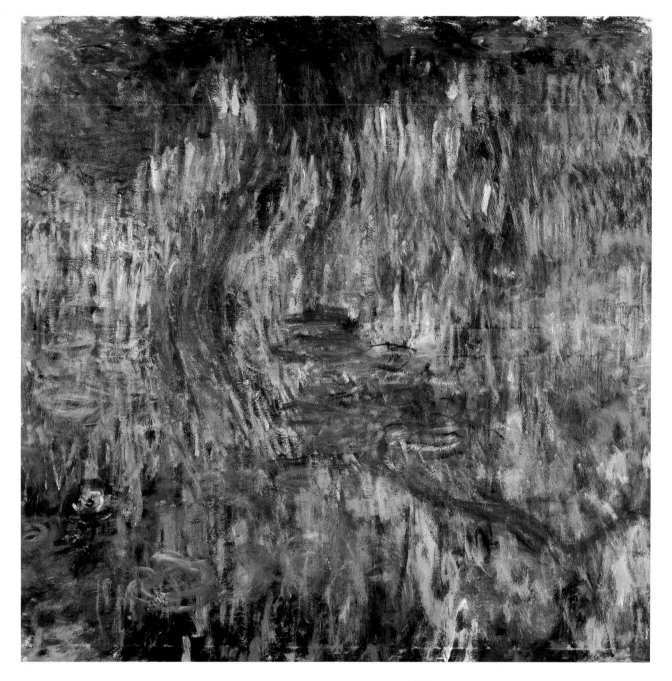

*Waterlilies and Reflections of a Willow
Tree, 1916–19*
Oil on canvas, 78³/4 x 78³/4in
(200 x 200cm)
Musée Marmottan, Paris

Boats in the Port of Honfleur, 1917
Oil on canvas, 19⅝ x 24in
(50 x 61cm)
Musée Marmottan, Paris

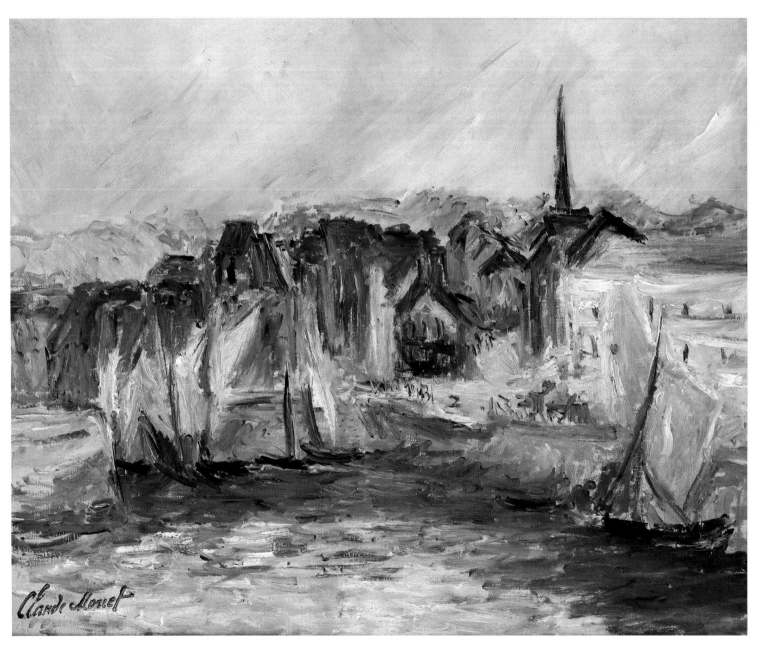

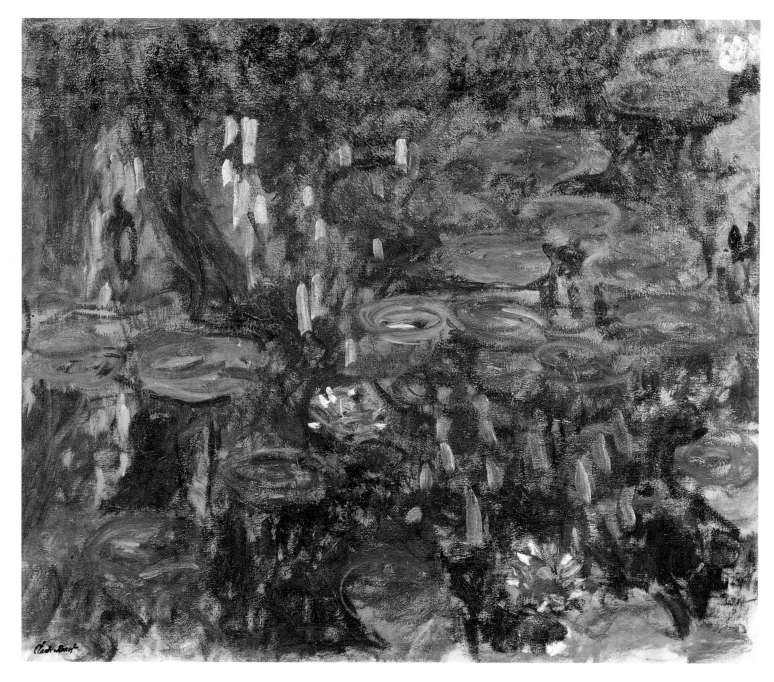

Waterlilies with Reflections of a Willow Tree, 1916–19
Oil on canvas, 51$^{1}/_{2}$ x 61 in
(131 x 155cm)
Musée Marmottan, Paris

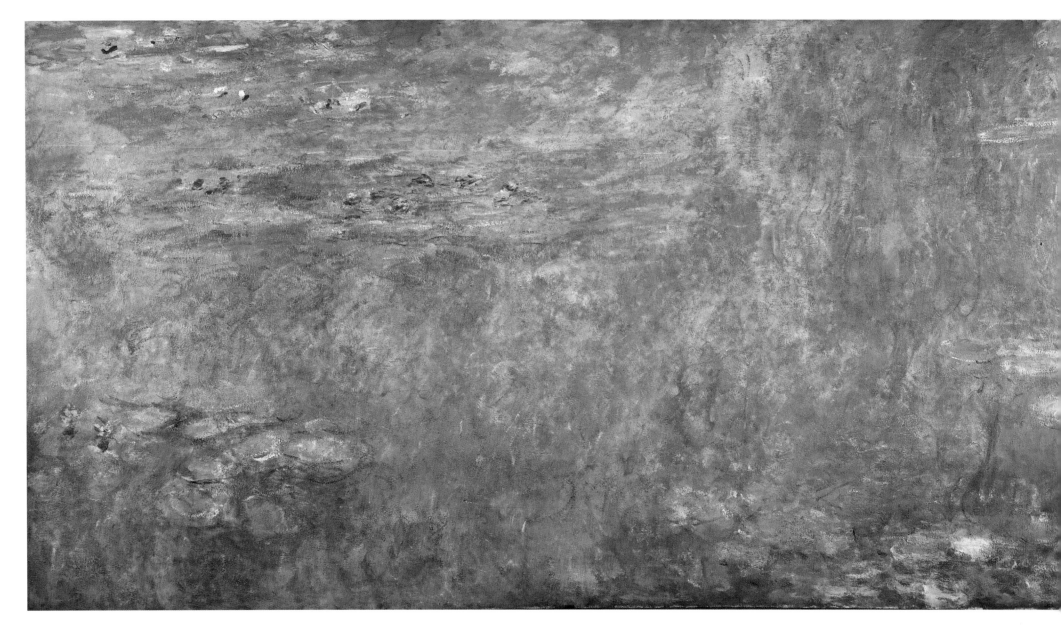

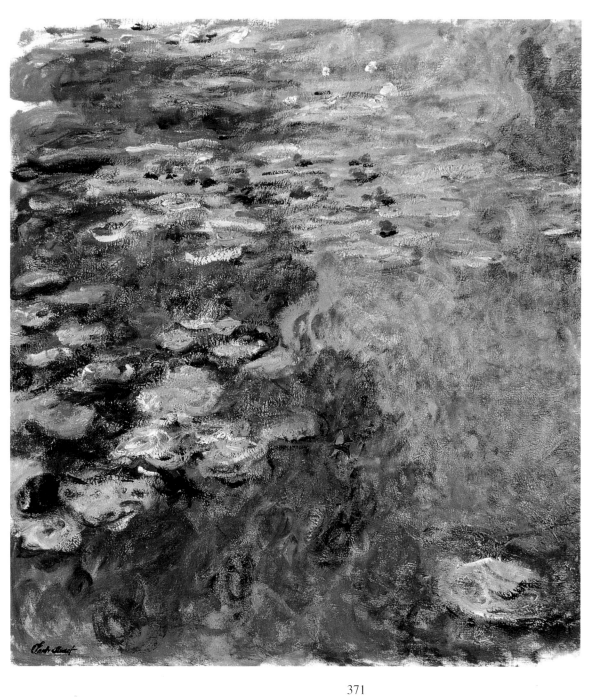

OPPOSITE
Waterlilies, c.1916
Oil on canvas, 79 x 18³⁄₈in
(200.7 x 46.7cm)
National Gallery, London

LEFT
The Waterlily Pond, 1917–19
Oil on canvas, 51¹⁄₄ x 47¹⁄₄in
(130 x 120cm)
Musée Marmottan, Paris

RIGHT
The Lily Pond, c.1917
Oil on canvas, 38$\frac{1}{2}$ x 51$\frac{3}{8}$in
(98 x 130.5cm)
Private collection

OPPOSITE
Waterlilies at Giverny, 1917
Oil on canvas, 39$\frac{3}{8}$ x 78$\frac{3}{4}$in
(100 x 200cm)
Musée des Beaux-Arts, Nantes

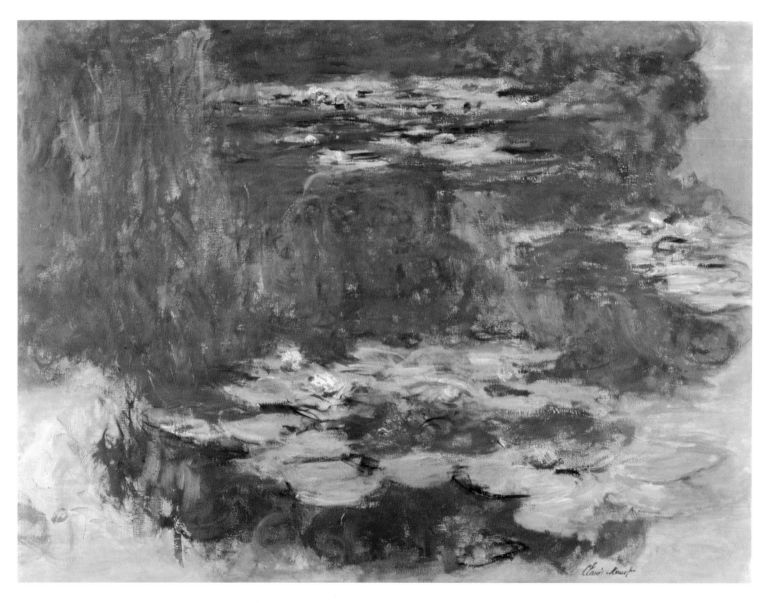

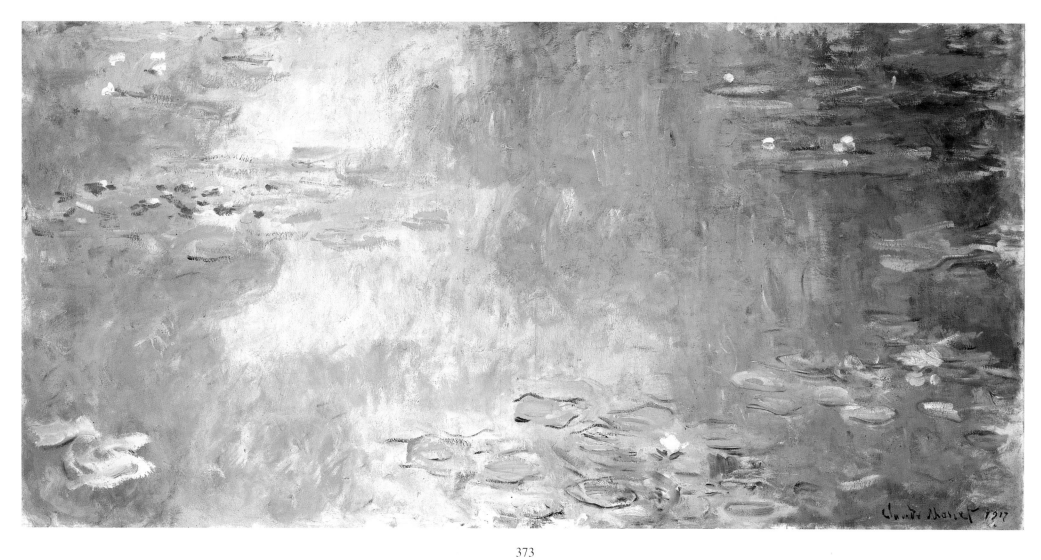

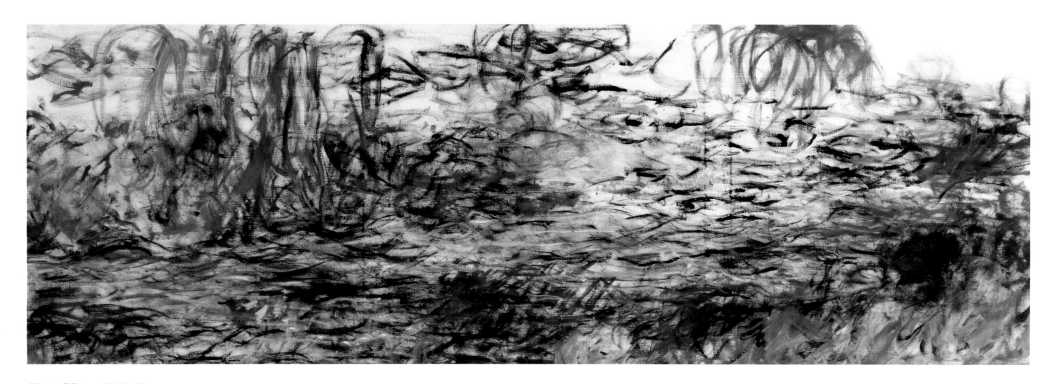

Waterlilies, 1917–19
Oil on canvas, 39³/8 x 118¹/8in
(100 x 300cm)
Musée Marmottan, Paris

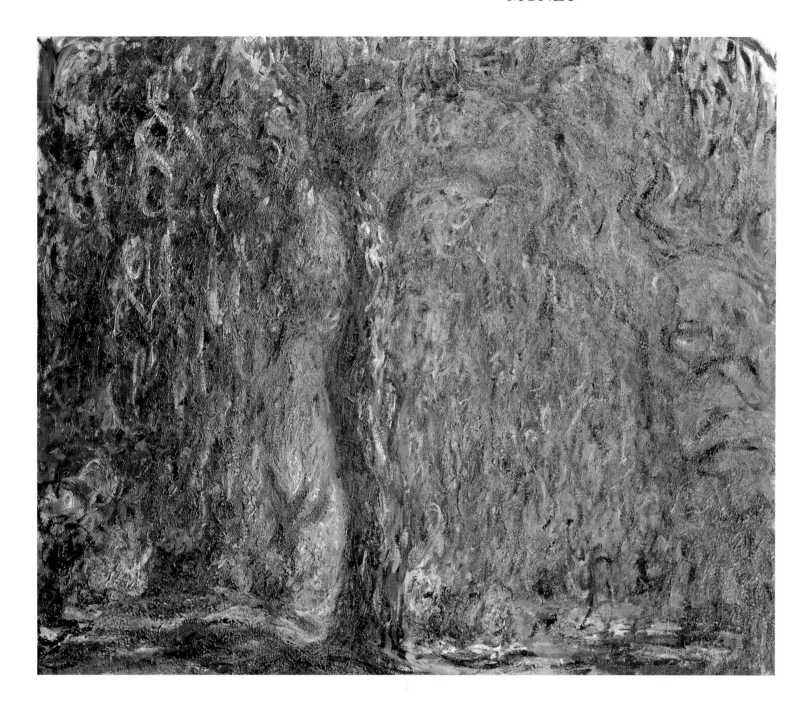

Weeping Willow, 1919
Oil on canvas, 39³/8 x 47¹/4in
(100 x 120cm)
Musée Marmottan, Paris

Waterlilies, 1916–19
Oil on canvas, 51^{1}/4 x 59^{7}/8in
(130 x 152cm)
Musée Marmottan, Paris

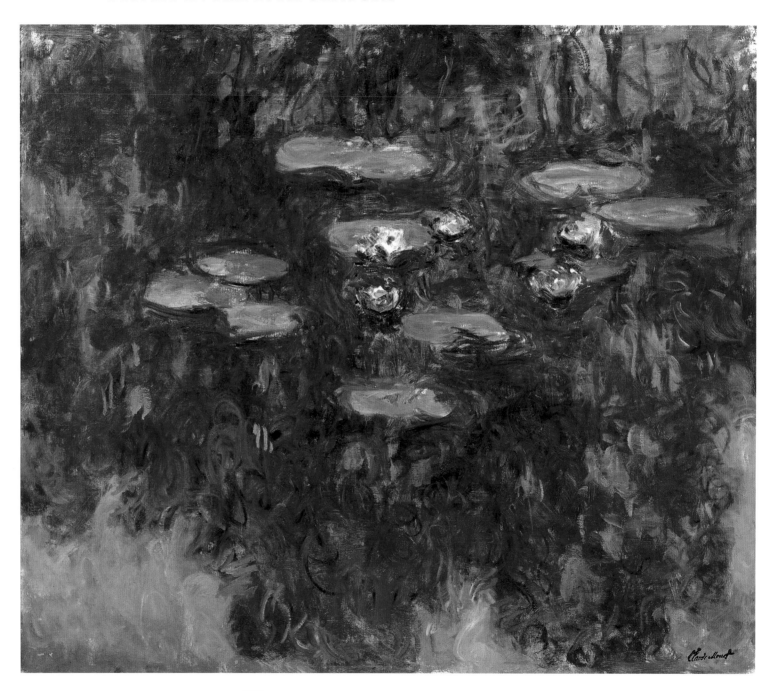

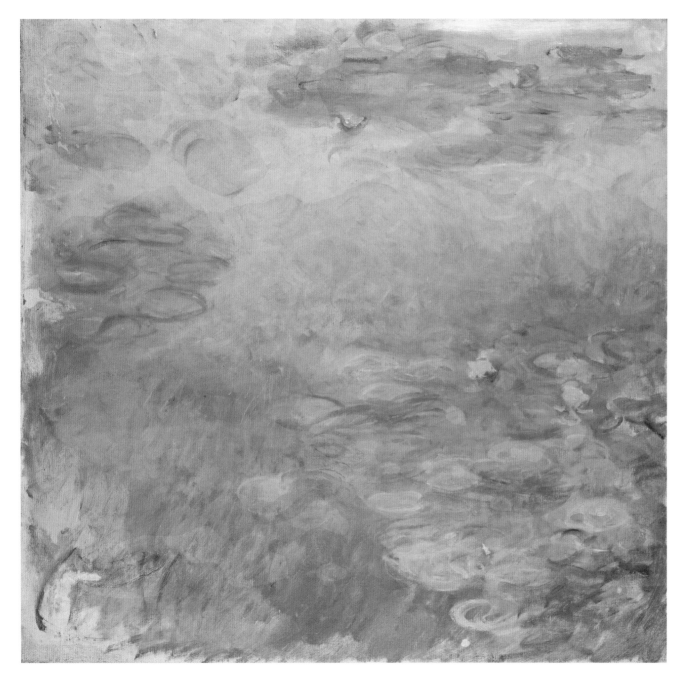

Light-Coloured Waterlilies, 1917–25
Oil on canvas, 34 x 35^{1}/$_{2}$in
(86.5 x 90cm)
Private collection

Nympheas at Giverny, 1918
Oil on canvas
Private collection

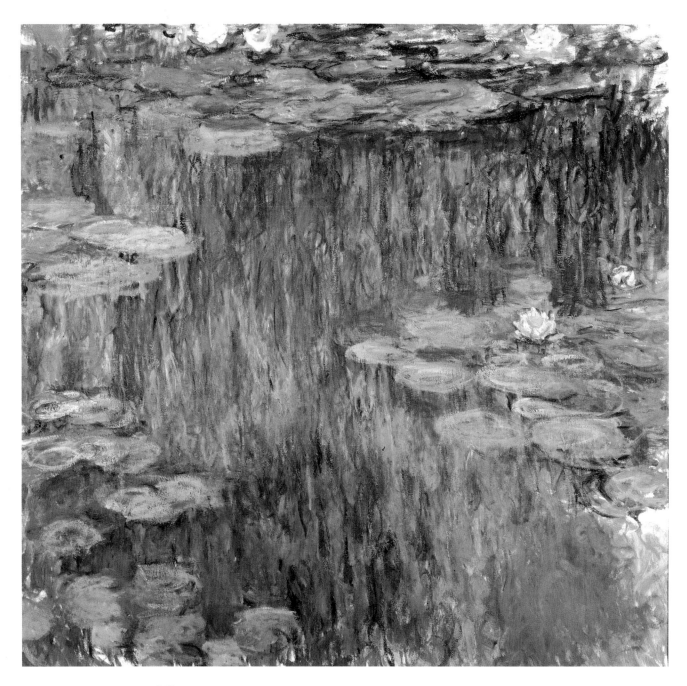

many of his expeditions, Blanche now took over the running of the household.

By April 1914, Monet was able to report to Gustave Geffroy that he was now in fine fettle and fired with a desire to paint. He had even been looking over some of his old paintings and had showed them to Clemenceau, who had been 'amazed' by them.

By summer, he was working hard in his water garden, producing large-format, close-up views of the different elements in the lily pond, especially the groups of waterlily pads. These very large paintings, four times the size of those exhibited in 1909, would be carried out to the lily pond where Monet would work on them, shaded by a large white umbrella.

If Monet had any particular purpose for working on such a large scale, he did not reveal what it was. Only one of the paintings was sold, to his friend Prince Kojiro Matzukata of Japan, and the rest remained in his studio. The fact that Monet was annoyed when Prince Matsukata's painting appeared in an exhibition in 1924 has been attributed to the fact, not that he was unhappy with it, but that he did not want any of his big waterlily paintings to be seen until he was ready to show them all.

Work on this large scale could also be explained as experimental: Monet was still visualizing a room decorated with great murals. Georges Clemenceau had

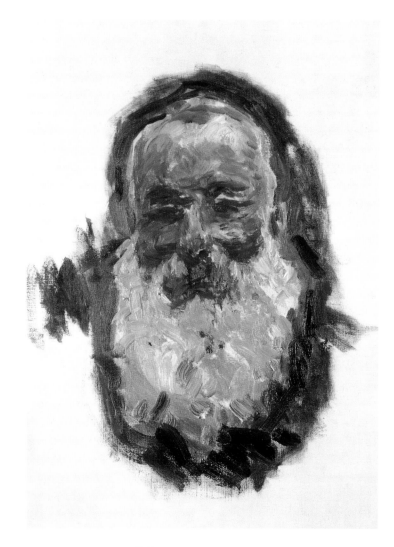

Self Portrait, 1917
Oil on canvas, 27^1/$_2$ x 21^5/$_8$in
(70 x 55cm)
Musée d'Orsay, Paris

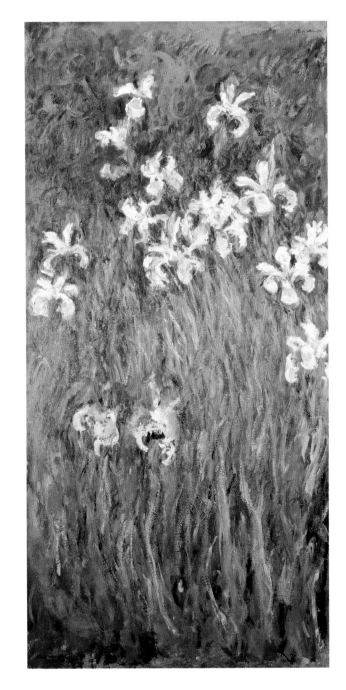

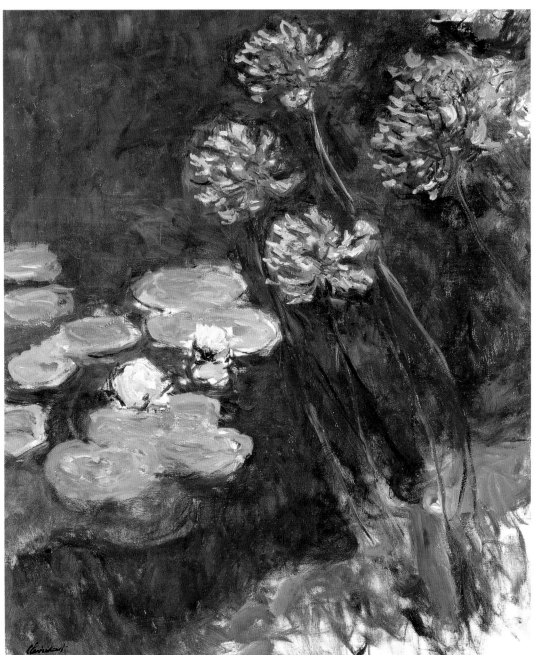

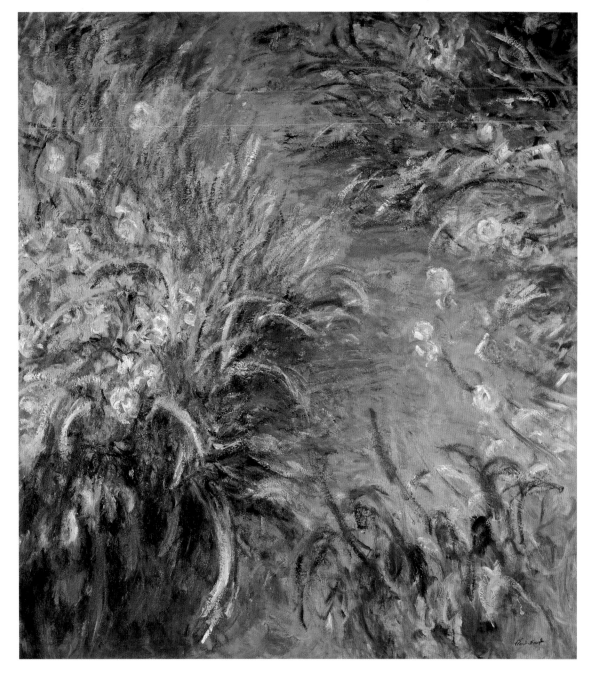

OPPOSITE LEFT
The Yellow Irises, c.1918
Oil on canvas, 78³/4 x 39³/4in
(200 x 101cm)
Private collection

OPPOSITE RIGHT
Waterlilies and Agapanthus, 1914–17
Oil on canvas, 55¹/8 x 47¹/4in
(140 x 120cm)
Musée Marmottan, Paris

LEFT
Irises, c.1915
Oil on canvas
Private collection

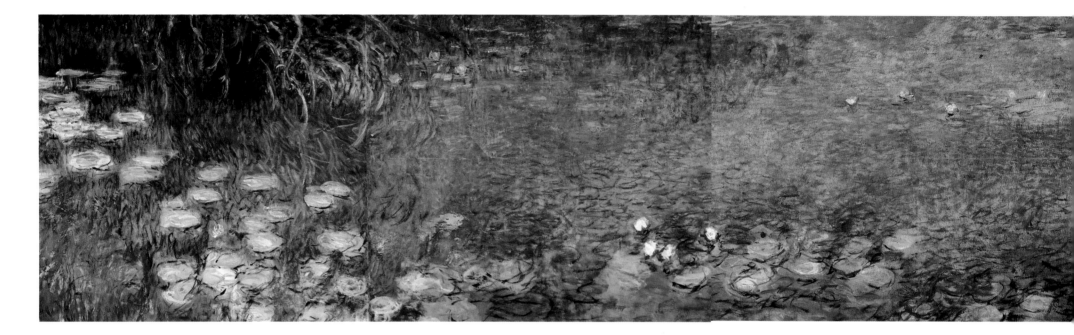

been one of Monet's most frequent and most welcome visitors in all the past years of his depressions and despair. Now, as the old artist and the elder statesman walked the paths round the lily pond, Monet talked again of his long-held ambition to paint a series of large waterlily 'decorations' to be hung round the walls of an oval salon, and of how he feared he did not have the strength to finish such a project. It was largely at Clemenceau's insistence that Monet began to think very seriously about how he should tackle it.

The Great Decorations

When Monet first thought of decorating a room with paintings, mural-style, he had had something relatively modest in mind, such as a dining room furnished only with a table in the centre. The paintings in such a room would be 'up to half a man's height'. Over the years, the concept had grown considerably in Monet's mind and now he conceived of his decorations as horizontal paintings $6^{1}/_{2}$-ft (2-m) high and correspondingly wide. Monet was no longer in the business of digging trenches to

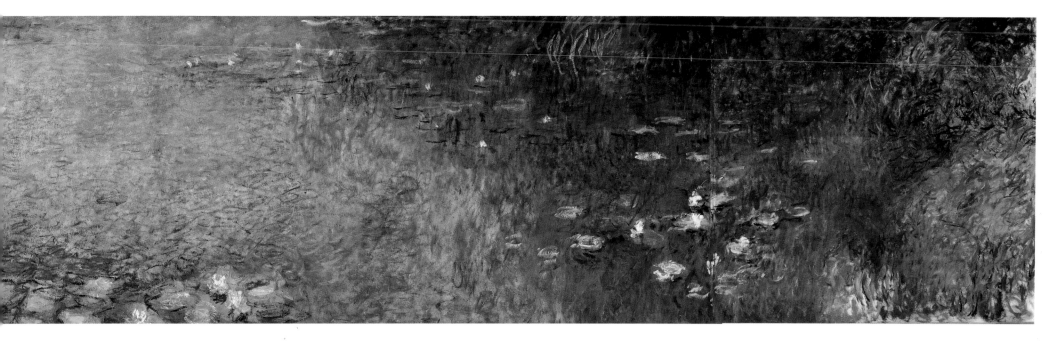

accommodate his paintings in his garden, and it was clear that he could not paint works of such a size by his lily pond. He would need a larger studio.

Even though the First World War was now in progress and Monet at Giverny, in the valley of the Seine, might well have found himself perilously close to the fighting, he decided to stay put. '... if these savages must kill me, it will be in the midst of my canvases, in front of all my life's work,' he wrote to Geffroy.

As if to underline his steadfastness, and even though building materials were in short supply, Monet began to plan his work space for the Great Decorations. Work would be a refuge from the horrors of war, which by 1915 included the worry of how his son, Michel, was faring at the front.

Soon, a vast and hugely expensive new studio, with large skylights in the roof, 50ft (15m) above the tiled floor, was taking shape at Giverny and was completed in 1916. In this airy, light-filled space, Monet spent much of the last decade of his life working, mainly from memory

Waterlilies, Morning, 1914–18
Oil on canvas
Musée de l'Orangerie, Paris

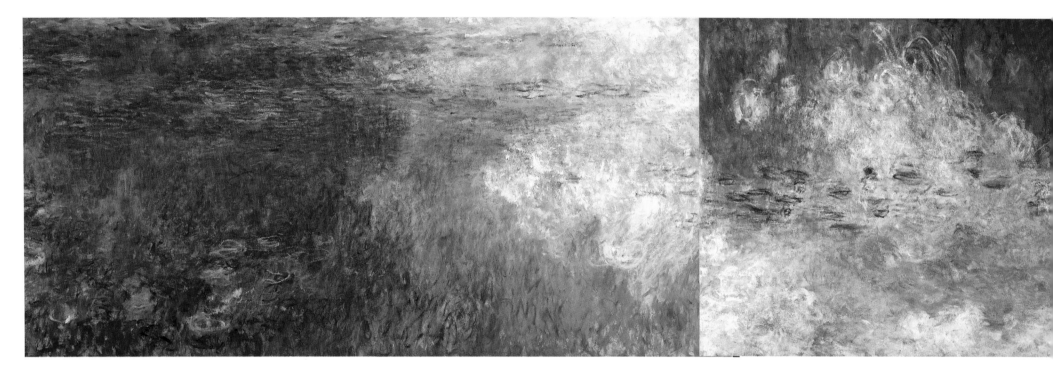

Waterlilies, The Clouds, 1916–26
Oil on canvas
Musée de l'Orangerie, Paris

on his *Grandes Décorations,* but aided by sketches he had made by the lily pond.

Georges Clemenceau left an intriguing word picture of Monet in his studio. The search for ways to depict light now took a form far removed from quick changes from one canvas to another that had marked Monet's method at the height of his powers. Now, Clemenceau observed, 'The moment the brush paused, the artist hurried to his flowers or sank into his armchair to think about his work. Eyes closed, his arms hanging casually, he would go in immobile quest of the light that had evaded him.'

Although Monet had completed many of his great panels within a year or so, he would not allow any of them out of his studio until after the war was over. It was only with great reluctance that he agreed to let Paul Durand-Ruel and his sons, desperate to have something to

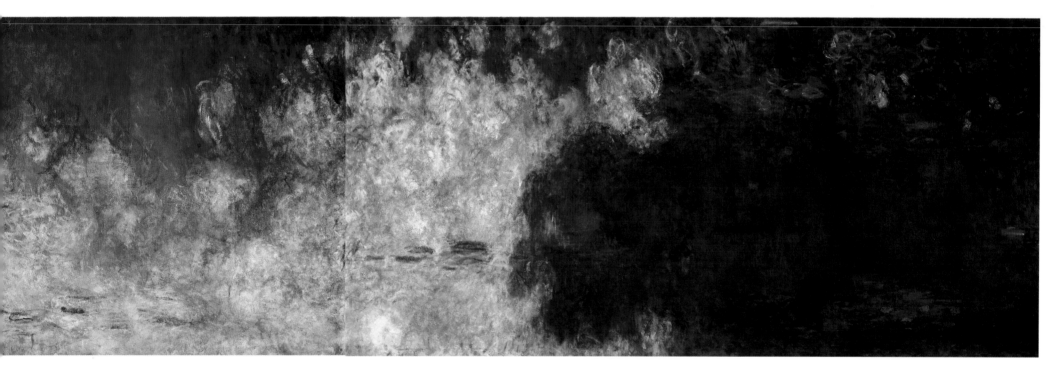

use in their catalogues, photograph them in November 1917. They were treated to an impressive sight: twelve $6^1/_2$-ft-high (2-m) panels, some of them with temporary moulded wooden frames, set on easels with castors so that they could be moved easily about the studio. Among the panels was a group of four showing the pond with two of the willow trees that grew beside it. There was a diptych of the glorious blue agapanthus flowers that grew along the edge of the pond and a panel of irises was propped against a wall.

Monet himself sold or gave away a dozen or so of the waterlily paintings between 1918 and 1923, and 22 panels eventually went to the Musée de l'Orangerie in Paris in 1927. The rest, numbering more than 100, were kept in his studio. After his death, they remained there, virtually forgotten, until the early 1950s, when Monet's

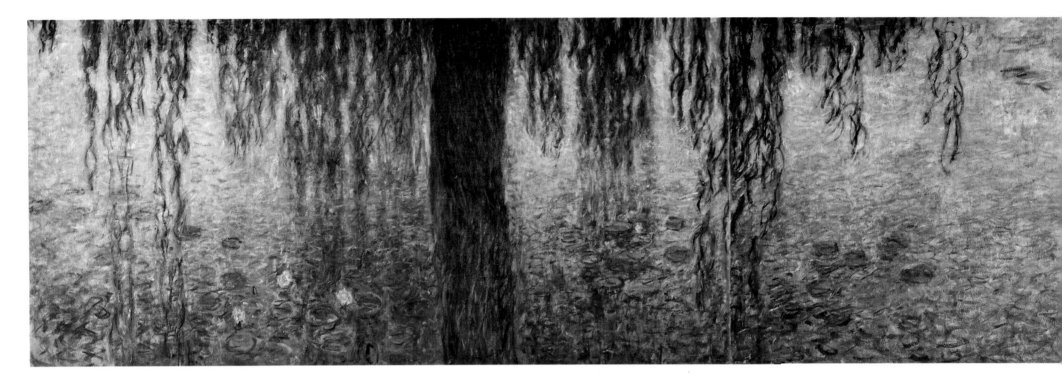

Waterlilies: Morning with Weeping Willows, 1915–26

Oil on canvas
Musée de l'Orangerie, Paris

son Michel began exhibiting and selling them to museums and galleries all over the world, eager, even desperate, to have one of the final works of the great Impressionist. Some of them were not seen in public until a major exhibition, Monet in the 20th Century, was mounted in Boston in 1998 and in London in 1999.

The main reason for Monet's reluctance to let go of his paintings was bound up with his obsession with protecting his reputation. He had seen the scramble for everything and anything left in Manet's studio after his death and could not bear the thought of his own work receiving similar treatment. He did not consider the waterlilies and other paintings in his studio to be finished and, until he had finished them to his own impossibly high standards, he would not let them go.

The Great Decorations, begun when France was once

386

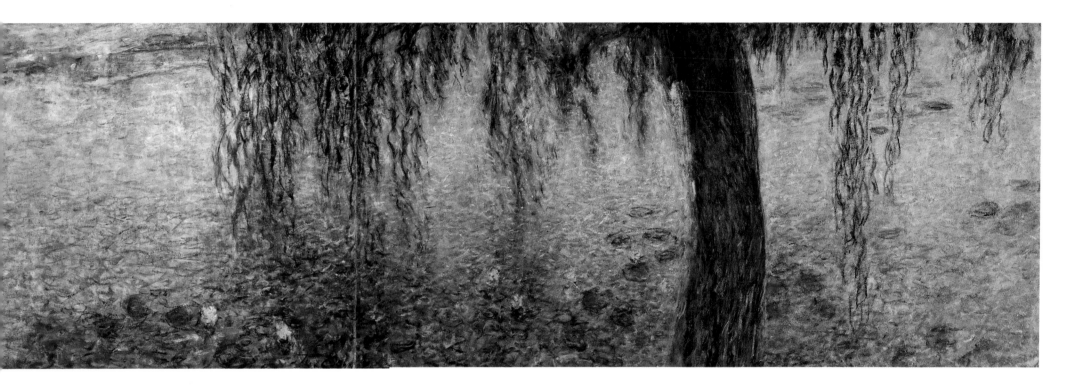

again at war with Germany, were the climax of Monet's art, his legacy to the country of his birth. They were meditations on the meaning of life through the depiction of nature. The decorations have no horizons, no margins, no obvious points of focus. Their limits are the limits of the imagination. Monet is looking into the depths of his lily pond as if he were delving into the deepest meaning of nature and of life itself.

Many of the large panels were conceived as part of diptychs, triptychs and even quadriptychs. On them Monet painted his lily pond and its waterlilies with a freedom and on a scale he had never attempted before. The subject, too, was something very different, because much more ephemeral, than that which he had tackled before. Late in life, he explained to an interviewer just what he was attempting. 'The essence of the motif is the mirror of

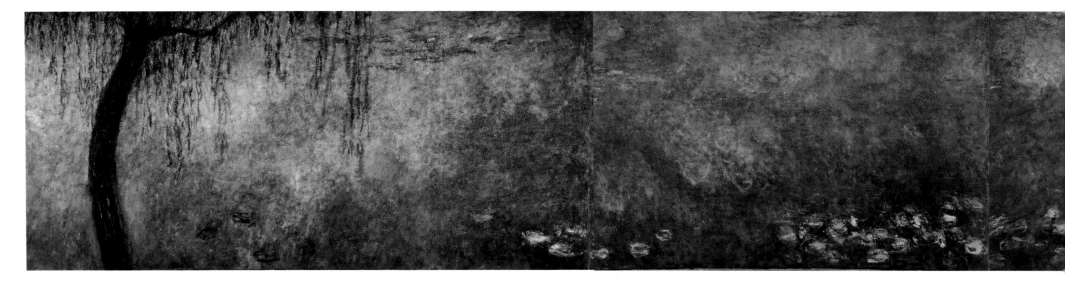

Waterlilies, Two Weeping Willows,
1914–18
Oil on canvas
Musée de l'Orangerie, Paris

water, whose appearance alters every moment, thanks to the patches of sky that are reflected in it.' The waterlilies, the willows, and the rest were not the whole scene; rather, they were just the accompaniments.

Monet held fast to the continuity of each vast canvas by using a very controlled, narrow range of colours. Each panel, or series of panels, was painted in variations of just a few tones – greens and blues, for instance – as in the triptych called *Waterlilies: Green Reflections (page 389)*, or yellows and mauves or pinks, as in *Waterlilies*, in the Tate Modern in London.

Almost from the time that Monet had begun painting his last watelily series, Georges Clemenceau and others had been urging him to give a group of them to the nation. When the war ended in 1918, Monet proposed giving the nation two paintings to mark the Armistice. Clemenceau, now in the middle of his second term as prime minister, joined with Gustave Geffroy in persuading Monet that the time was now right to think about a gift on a far larger scale – such as the waterlilies – in a room specially designed for them. They were undoubtedly intent on keeping Monet's paintings out of the clutches of museums and galleries from as far away as Japan and the United States, whose directors had begun to send envoys to Giverny in the hope of buying up as much as possible.

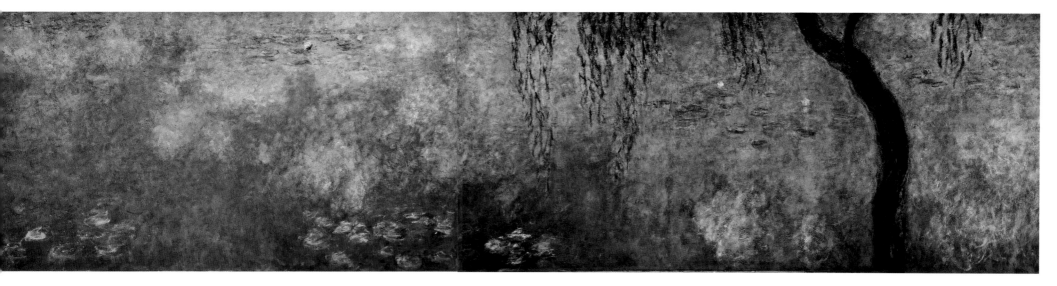

Monet agreed to Clemenceau's proposal, provided that the hanging space was built for the purpose and designed to his own specifications. The first plan was for a pavilion in the grounds of the Hôtel Biron, where a museum devoted to the sculptor Rodin had recently been opened. The Department of Public Buildings rejected this idea on the grounds that a purpose-built pavilion was too great an honour for one artist and suggested instead one room in the Jeu de Paume. Monet, annoyed, flatly refused and threatened to withdraw his offer. But Clemenceau was not nicknamed 'Tiger' for nothing, and eventually convinced Monet that the Musée de l'Orangerie, on the other side of the Tuileries Gardens from the Jeu de Paume, would be a perfect place for the waterlilies.

Monet chose the paintings that would go in the Orangerie and also spent a great deal of time planning how he wanted them hung. He sent Clemenceau a rough plan of the rooms, with places indicated for all the panels. His four panels set called *Three Willows* was to be the the focal point at the end of the second room.

Although Monet signed the deed of gift for the project in 1922, it was not until 1927, the year following his death, that two oval rooms on the ground floor of the Orangerie were filled with Monet's paintings. There they hung until the 1950s, largely forgotten during decades dominated by social depression and followed by another

PAGES 390–391
Waterlilies: Green Reflections, 1914–18
Oil on canvas
Musée de l'Orangerie

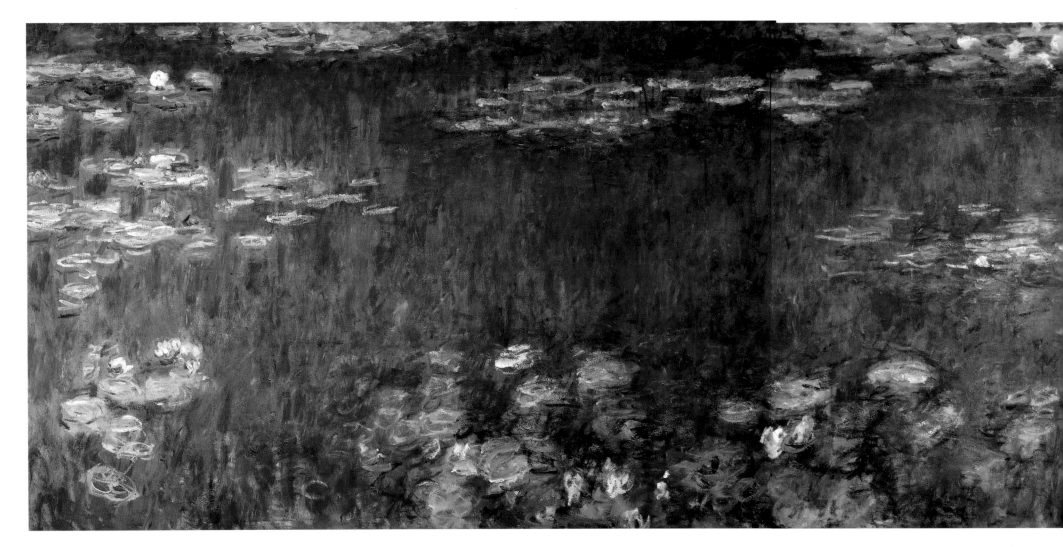

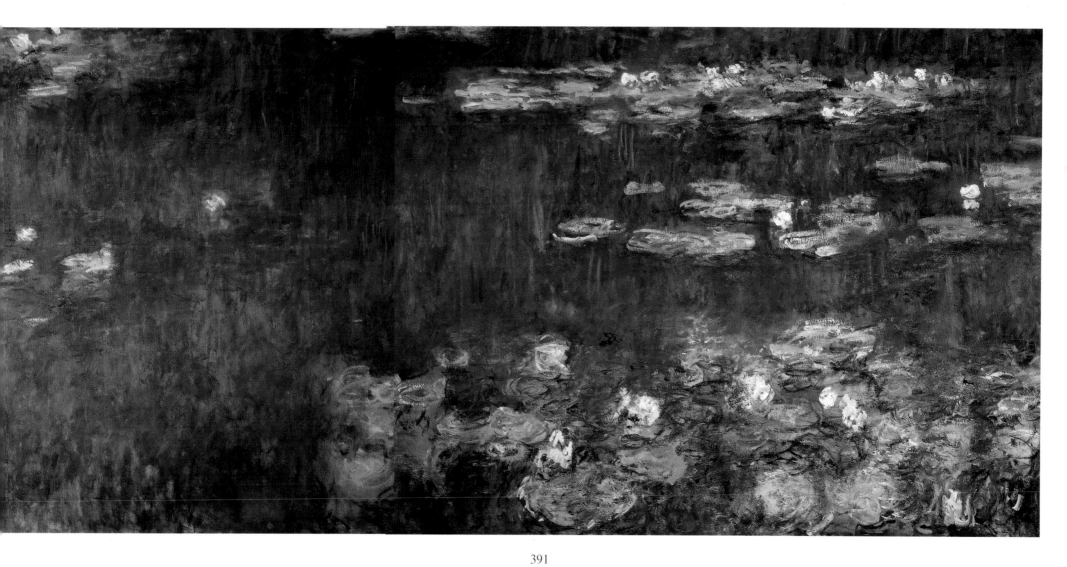

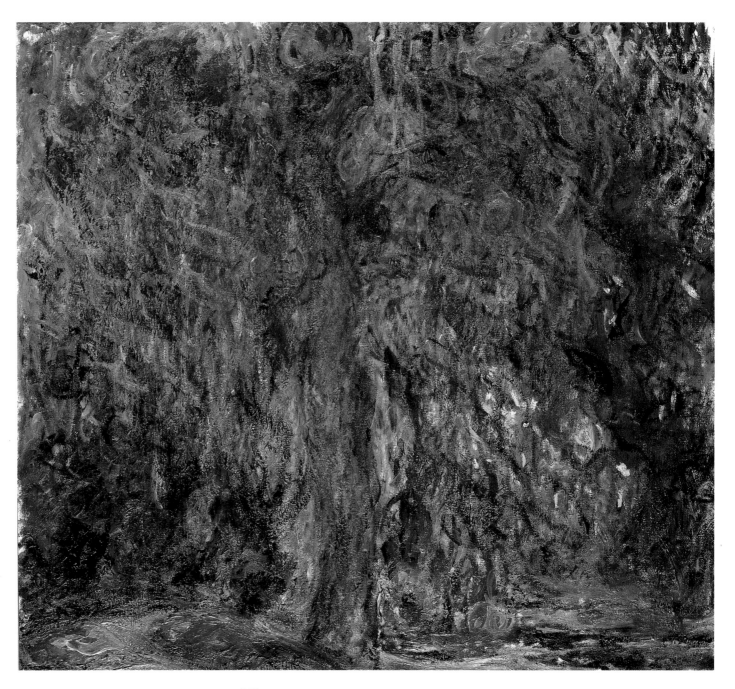

Weeping Willow, 1918–19
Oil on canvas, 39³/8 x 43¹/3in
(100 x 110cm)
Musée Marmottan, Paris

Monet painted ten dramatic and highly
coloured pictures of this magnificent
weeping willow tree, one of the glories
of his garden at Giverny, in 1918–19.

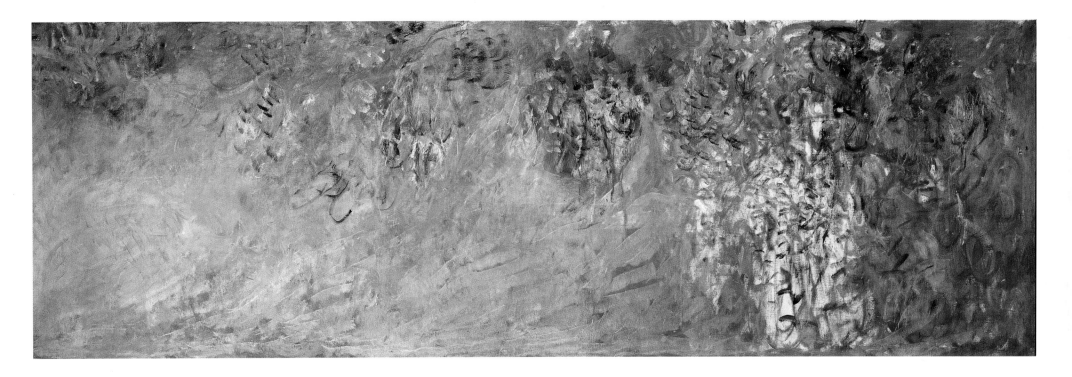

great war. Then the world, its mind and eye educated by the work of abstract expressionist artists in Europe and America, woke up to the true meaning and value of Monet's late paintings. Today, visitors come in their thousands to the two rooms in the Musée de l'Orangerie, described by the painter André Masson in 1952 as the 'Sistine Chapel of Impressionism'.

The Last Years

Life was very quiet at Giverny in the early years of the First World War. Fear of German invasion meant that Monet's grandchildren were evacuated to parts of France well away from the Front, so that Monet and Blanche were often the only two members of the family in the house. His garden became a haven of peace and beauty

Wisteria, 1919–20

Oil on canvas

Musée Marmottan, Paris

The Japanese Bridge, 1918
Oil on canvas, 39³/8 x 78³/4in
(100 x 200cm)
Musée Marmottan, Paris

for Monet, to which he often retreated when needing a break from his long, concentrated sessions on the big waterlily paintings.

There were more deaths among his friends and artist colleagues to distress him. Edgar Degas died in 1917 and Paul Durand-Ruel in 1922. Worst of all was the death of his old friend and companion-in-adversity, Pierre-Auguste Renoir. Renoir's death at the end of 1919 was a painful loss for Monet. As he wrote to a friend, 'With him goes a part of my own life', and he spent some days after hearing the news going back over their early years of struggle and hope. He now felt his own advancing years more than ever, and was sure that he would not last much longer himself. Even if he did, his despair over his failing sight caused him to think that his last years would not be spent in fulfilling his 'long-cherished hopes to do better'.

From about 1916, Monet returned to painting motifs, including the main garden path, the house and, in the water garden, the Japanese bridge and the willow trees, which he had last painted at the turn of the century.

He did ten paintings of a willow tree in his garden, all called *Weeping Willow*, in 1918–19. Most of them are heavily painted in thick swirls of colour, in which dark greens and yellows predominate. At first glance, these paintings seem to have nothing of the delicate beauty of the willow tree about them. But as one looks at them, the

atmosphere of airy coolness that Monet has injected into the rich foliage draws the onlooker into the shady cool of the artist's garden in summer.

OPPOSITE
Waterlilies, c.1919
Oil on canvas, 52 x 79^{1}/$_{8}$in
(132 x 201cm)
Private collection

LEFT
The Yellow Irises, c.1918–25
Oil on canvas, 39^{1}/$_{4}$ x 34^{1}/$_{2}$in
(99.5 x 87.5cm)
Christie's Images, London

The Japanese Bridge at Giverny, 1918–24
Oil on canvas, 35 x 45⁵⁄₈in
(89 x 116cm)
Musée Marmottan, Paris

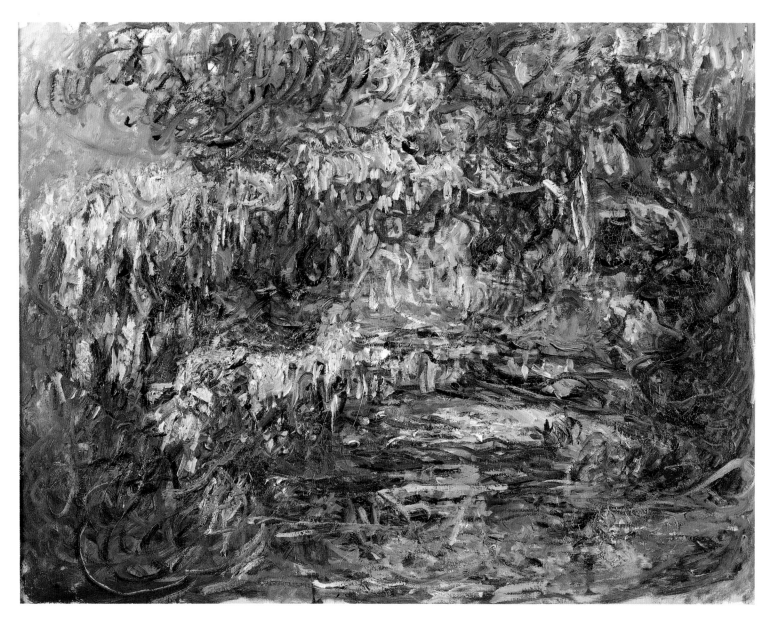

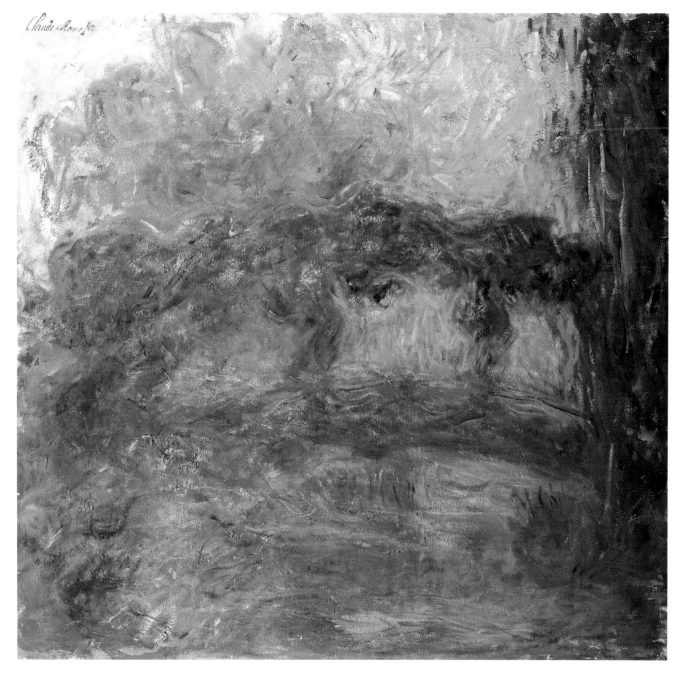

The Japanese Bridge, 1918–24
Oil on canvas, 35 x 36³/₈in
(89 x 92.5cm)
Galerie Daniel Malingue, Paris

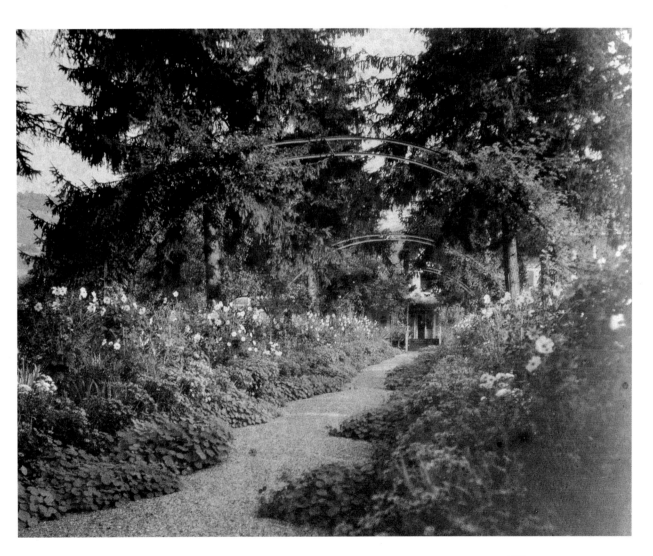

Monet seems to have stopped painting outdoors some time around 1920, when his failing sight made the light too bright for his eyes to endure, but ventured out again after his cataract operations in 1923. In all, he did sixty-nine paintings based around the garden motifs, with the Japanese bridge accounting for twent-four of them. Sixty-two of the sixty-nine remained in his studio and were never exhibited in his lifetime. Of the remaining seven, six were sold jointly to Durand-Ruel and Bernheim-Jeune and were exhibited.

Many of them, such as *The House at Giverny Seen from the Rose Garden* (page 412), *The House Viewed from the Rose Garden* (c.1922–24), and several called *The Japanese Bridge* (c.1919–24), were painted in what, for Monet, were exaggerated tones of strident colours, particularly reds, oranges and yellows. They may well have been experiments in handling techn:ques and the use of colour, but they also display an energy and power remarkable in an artist in his mid-eighties.

It is clear that the cataracts, which were removed during two operations in 1923, were having an effect on the way Monet was able to see his work. Before the operations, anything he could not view close-up outdoors was enveloped in a fog because the light was too bright. After the operations, his sight was very distorted for months. He himself commented in a letter written four months after one

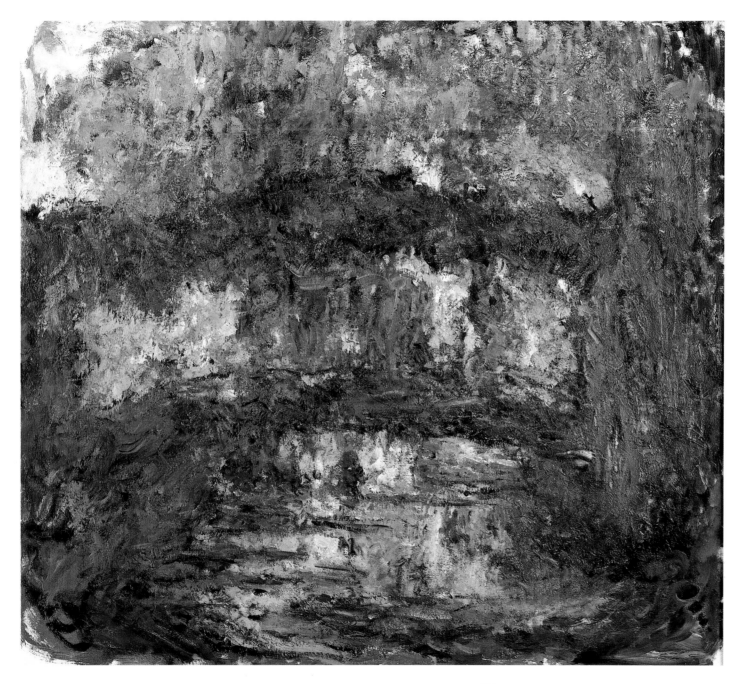

OPPOSITE
Path in Monet's garden at Giverny, photographed in the early 1920s
Musée Marmottan, Paris

LEFT
The Japanese Bridge at Giverny, 1918–24
Oil on canvas, 35 x 39³/₈in (89 x 100cm)
Musée Marmottan, Paris

The Garden at Giverny, c.1918
Oil on canvas
Christie's Images, London

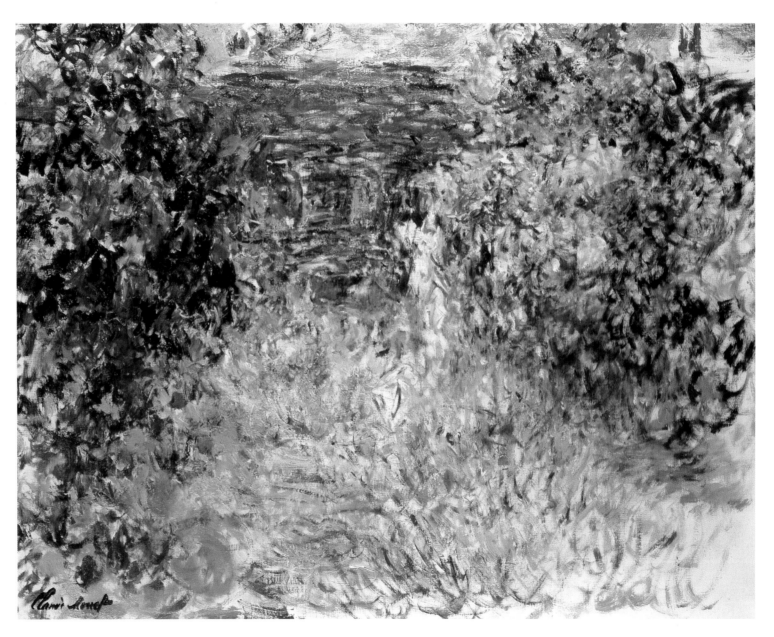

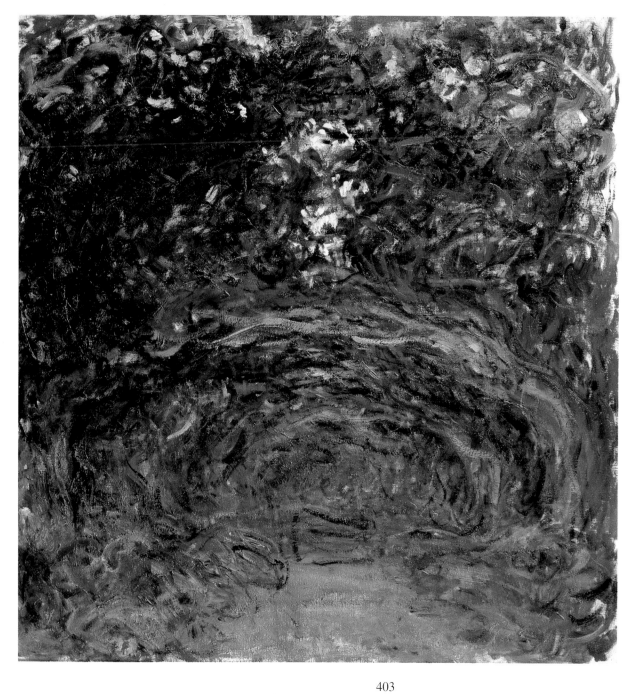

The Rose Path at Giverny, 1920–22
Oil on canvas, 36$^{1}/_{4}$ x 35in
(92 x 89cm)
Musée Marmottan, Paris

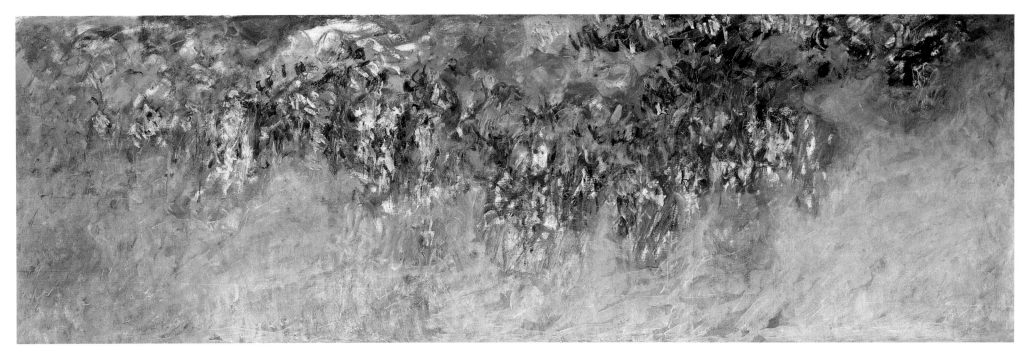

Wisteria, 1919–20

Oil on canvas

Musée Marmottan, Paris

of the operations that although he could now read more easily, which was restoring his confidence, going outside definitely was not, because the distortion and exaggerated colours he was seeing were quite terrifying. It was not until nearly seven months after his main operation that Monet was able to tell Joseph Durand-Ruel, who had photographed the Decorations in 1917, that he was immersed in his work again and working hard, and it was

not until the middle of 1925 that Monet was able to consider his sight 'truly recovered'.

One of the pleasures of Monet's last years was helping Gustave Geffroy write his biography. Over many conversations and in several long letters, in response to endless queries from the indefatigable writer, he recalled his long life and the influences on his art, from his earliest days in Le Havre, when, as a teenager, he sold his caricatures,

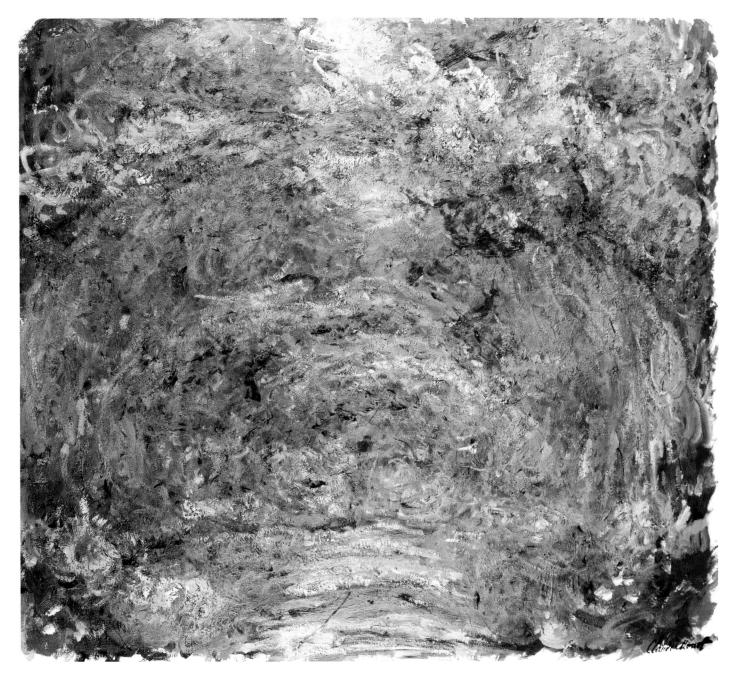

Shaded Path, c.1920
Oil on canvas, 35 x 39³/₈in
(89 x 100cm)
Private collection

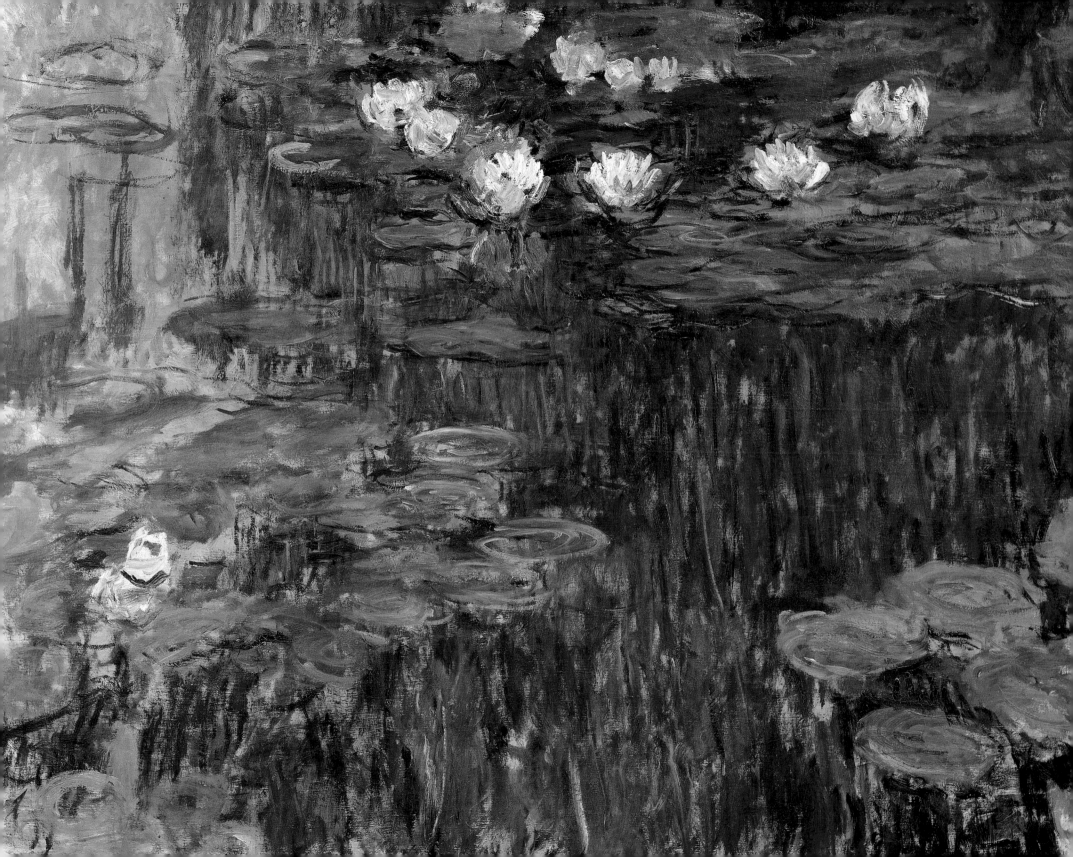

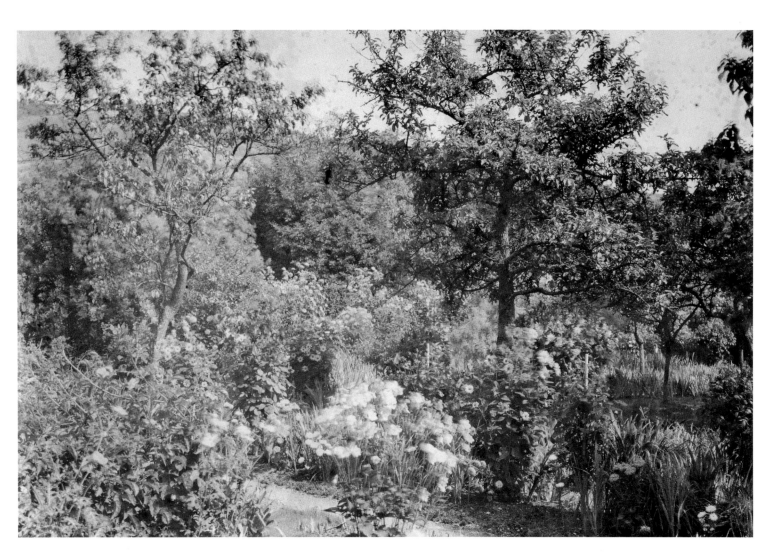

OPPOSITE
Waterlilies, 1914–17
Oil on canvas, 59 x 78³/₄in
(150 x 200cm)
Musée d'Orsay, Paris

LEFT
View of Giverny: Monet's garden in the early 20s
Musée Marmottan, Paris

RIGHT
The House at Giverny, 1922
Oil on canvas
Musée Marmottan, Paris

OPPOSITE LEFT
George Clemenceau, Monet and Alice Butler on the Japanese bridge in 1921
Musée Marmottan, Paris

OPPOSITE RIGHT
Yellow and Purple Irises, 1924–25
Oil on canvas, 41³/4 x 61in
(106 x 155cm)
Musée Marmottan, Paris

RIGHT
The Agapanthus, c.1920
Oil on canvas, 35 x 45⅝in
(89 x 116cm)
Minneapolis Institute of Arts

OPPOSITE RIGHT
Waterlilies: The Japanese Bridge, or
Japanese Bridge at Giverny, c.1923
Oil on canvas, 47¾ x 61in
(106 x 155cm)
Musée Marmottan, Paris

which he signed 'Oscar', for 10 or 20 francs, to the present, when his Decorations occupied his thoughts during most of his waking hours. Geffroy's biography, *Claude Monet, His Life, His Times, His Work*, was published in 1924 and still offers a valuable insight into the artist's life and thought, although it has, of course, been succeeded by hundreds, if not thousands, of books about Monet and his work.

Monet remained mentally vigorous right up to the end of his life and his body began to fail only in the last two or three months. In the last of the thousands of his letters to have survived, dated September 1926, Monet told Clemenceau that, although he had been unwell and in some pain, he had not given up hope of painting again and was thinking of preparing his palette and brushes to resume work.

Monet died at home at Giverny on 6 December 1926. He had practised no religion during his lifetime, and his funeral, two days after his death, was conducted without prayers or ceremonial. Georges Clemenceau, who led the large crowd of mourners, broke down and wept at his graveside in the churchyard at Giverny. Today, Monet's tomb occupies a place of honour in the churchyard, and his house and garden, declared a national monument by the French Government, are visited every year by thousands of people from all over the world.

RIGHT
**The House at Giverny Viewed from the
Rose Garden, 1922–24**
Oil on canvas, 35 x 39³/₈in
(89 x 100cm)
Musée Marmottan, Paris

OPPOSITE LEFT
The Garden of Giverny, 1923
Oil on canvas
Musée de Grenoble

OPPOSITE RIGHT
**The House at Giverny under the
Roses, 1925**
Oil on canvas, 36³/₈ x 29in
(92.5 x 73.5cm)
Galerie Daniel Malingue, Paris

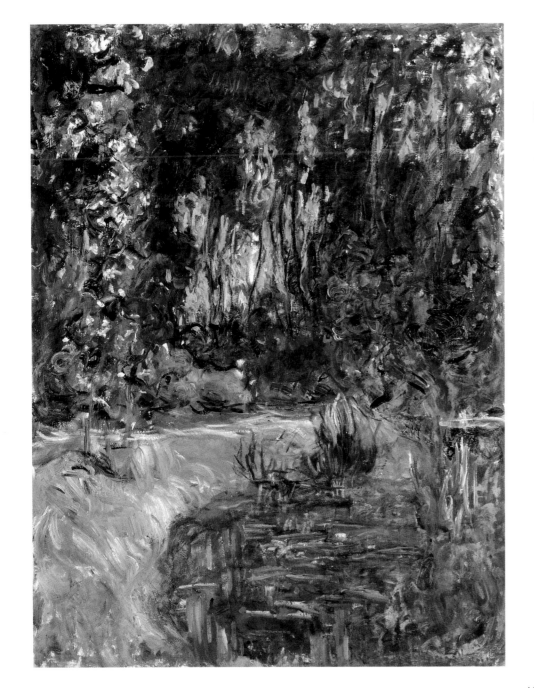

Chronology

1840 Claude Oscar Monet born in Paris on 14 November.

c.1845 Monet's father takes his family to Le Havre, where he joins the business run by his brother-in-law, Jacques Lecadre.

c.1855 Begins selling caricatures of his school fellows, teachers and Le Havre citizens.

c.1857 Meets Eugène Boudin, who introduces him to painting *en plein-air*.

1858 Exhibits a landscape painting at a contemporary art exhibition in Le Havre.

1859 Goes to Paris to study art. Visits the Salon and joins the Académie Suisse, where he meets Camille Pissarro.

1861 Called up and does military service in Algeria.

1862 At home in Normandy, works on the Channel Coast and meets Johan Barthold Jongkind. Returns to Paris in the autumn and joins Charles Gleyre's atelier, where he meets Pierre-Auguste Renoir, Alfred Sisley and Frédéric Bazille.

1863 Paints in the Forest of Fontainebleau with his new friends.

1864 Gleyre's atelier closes, and Monet's formal art training ends.

1865 Exhibits at the Salon for the first time, showing two large marine paintings.

1866 Camille Doncieux, now Monet's companion, poses for *Woman in a Green Dress*, which is exhibited at the Salon and is much praised. Meets Edouard Manet about this time.

1867 Paints on the Normandy coast in the summer, his Salon paintings having been rejected, along with those of Bazille, Pissarro, Sisley and Renoir. Camille gives birth to their first son, Jean, in Paris. Back in Paris at the end of the year, where he shares Bazille's studio.

1868 Has another painting accepted by the Salon. Works in Etretat and Fécamp.

1870 Rejected by the Salon, as is Boudin. Marries Camille Doncieux. Moves to London at outbreak of Franco-

Prussian War. Hears of death of Frédéric Bazille in November. Meets art dealer Paul Durand-Ruel in London.

1871 Exhibits his work in London. Travels to The Netherlands in June and returns to France in November. Rents a house at Argenteuil, on the River Seine west of Paris.

1872 Durand-Ruel buys a large number of Monet's paintings. Monet buys his studio boat and paints the banks of the Seine. At Le Havre, he paints *Impression, Sunrise*.

1873 Durand-Ruel buys many more of Monet's paintings and assists him with the costs of his travels. At the end of the year, financial difficulties cause Durand-Ruel to stop buying the work of the Impressionists.

1874 Contributes to the first Impressionist group exhibition, held in the rooms of the photographer, Nader, in the boulevard des Capucines, Paris; Monet's painting, *Impression, Sunrise*, gives the group its name.

1875 Financially disastrous auction of Impressionists' paintings at Hôtel Drouot, Paris.

1876 Second Impressionist exhibition. Meets Ernest Hoschedé, who commissions paintings for his house at Montgeron. Begins Gare Saint-Lazare series.

1877 Third Impressionist exhibition, at which Monet shows his Gare Saint-Lazare paintings.

1878 Ernest Hoschedé goes bankrupt, and his art collection, including sixteen paintings by Monet, is auctioned. Prices are low. Monet second son, Michel, born. Moves with his family to Vétheuil, where a house is shared with the Hoschedé family.

1879 Exhibits work in fourth Impressionist exhibition. Camille Monet dies in September.

1880 Exhibits at the Salon for the last time, but chooses not to take part in the fifth Impressionist exhibition. First one-man exhibition at the gallery of *La Vie Moderne* in Paris. Begins painting on the Normandy coast again, and will make painting trips here every year to 1886.

1881 Paul Durand-Ruel begins buying Monet's paintings

CHRONOLOGY

again, and provides funds for painting trips. In December Monet and Alice Hoschedé and their children – eight in all – move to Poissy.

1882 Takes part in seventh Impressionist exhibition.

1883 Has one-man exhibition at Durand-Ruel's gallery in Paris. Moves to Giverny, where he rents a house. Durand-Ruel holds an exhibition in Boston, U.S.A., in which he includes paintings by Monet. Makes brief trip with Renoir to the Mediterranean, where they visit Cézanne.

1884 Paints at Bordighera and Menton.

1885 Shows ten paintings at Fourth International Exhibition at the Georges Petit Gallery, Paris.

1886 Some forty works by Monet included in Durand-Ruel's New York exhibition. Paints in The Netherlands and on Belle-Ile, off the Brittany coast.

1887 First sale to Theo van Gogh, of Boussod & Valadon's Montmartre gallery. Visits James McNeill Whistler in London.

1888 Paints at Antibes, on the Mediterranean coast. Visits London again, staying with John Singer Sargent.

1889 Paints in the valley of the Creuse. Major Monet-Rodin retrospective exhibition at the Georges Petit Gallery in Paris is a great success,

1890 Organizes subscription to buy Manet's *Olympia* for the state. Buys house and garden at Giverny. Begins work on haystacks series. First painting bought by a museum, when National Gallery of Norway buys *Rain at Etretat*.

1891 Begins work on poplars series. First true series, the haystacks, exhibited at Durand-Ruel's Paris gallery.

1892 Starts work on Rouen Cathedral series. Poplars series exhibited at Durand-Ruel's gallery. Monet and Alice Hoschedé are married in a civil ceremony at Giverny.

1893 Buys land on other side of the railway line outside his house and begins planning the water garden at Giverny.

1895 Visits Norway. Exhibition at the Georges Petit

MONET

Gallery in Paris includes twenty Rouen Cathedral paintings.

1896 Works along the Normandy coast and begins 'Morning on the Seine' paintings. National Gallery, Berlin, buys a painting of Vétheuil.

1897 Builds a gardener's house with a large studio above at Giverny. Works on the Normandy coast again.

1898 One-man exhibition at the Georges Petit Gallery, including 'Cliffs' and 'Morning on the Seine' paintings. Brief visit to London, where son, Michel, is ill.

1899 Alfred Sisley dies, and Monet organizes memorial exhibition and benefit auction. Paints views of the Japanese bridge over his lily pond. In London in September–October, working on London bridges series.

1900 Several painting visits to London. Work included in Exposition Centenale, part of the Paris Exposition Universelle. Exhibits recent work at Durand-Ruel's gallery in Paris, including 12 of the Japanese bridge and one of the flower garden at Giverny.

1901 In London from the end of January to April, during which time he completes initial work on ninety-seven paintings and twenty-six pastels. Buys more land for his water garden at Giverny. Works at Vétheuil and Lavacourt.

1902 An exhibition of Monet's paintings at Durand-Ruel's gallery in New York includes a London painting, the first to be shown in public.

1903 Works in his studio on London paintings and begins the first paintings in what will become his waterlily series. Camille Pissarro dies in November.

1904 River Thames and London paintings exhibited at Durand-Ruel's Paris gallery. Visits Madrid to study the work of Velázquez.

1905 Has a trellis built over the Japanese bridge at Giverny. Has fifty-five works on show at a major Impressionist exhibition organized by Durand-Ruel in the Grafton Galleries, London. Derain, Matisse and other Fauves exhibit at the Salon d'Automne in Paris.

1906 Paul Cézanne dies in October. Monet continues to

work on his waterlily paintings, but puts off an exhibition. About this time, first begins to notice his eyesight is failing.

1907 The French state purchases a Rouen Cathedral painting.

1908 Visits Venice at end of year.

1909 Forty-eight waterlily paintings exhibited at the Durand-Ruel Gallery in Paris to great critical and popular acclaim.

1910 After severe floods at Giverny, Monet changes the shape of the lily pond.

1911 Alice Hoschedé Monet dies in May.

1912 Cataracts diagnosed in July. Son, Jean, has a stroke. Monet virtually stops painting until 1914. Twenty-nine Venice paintings exhibited at the Bernheim-Jeune Gallery in Paris; the exhibition is titled simply 'Monet Venice'.

1914 Jean Monet dies. Monet begins work on a new project: the creation of decorative panels on a large scale ($6^{1}/_{2}$ft/2m and more across). Outbreak of First World World in August.

1915 Begins construction of a new large studio to accommodate the large panels.

1918 Works constantly on the waterlily and garden panels, despite German advances that bring the war close to Giverny. After the Armistice on 11 November, offers a weeping willow painting and a waterlily decorative panel to the State to celebrate the Allied victory.

1919 Deteriorating eyesight prevents the finishing of the waterlily panels. Pierre-Auguste Renoir dies in December.

1920 Works with architect Bonnier on plans to construct a pavilion in the garden of the Hôtel Biron, home of the Musée Rodin, to house the waterlily decorations which he has agreed to gift to the State. His eightieth birthday is on 14 November.

1921 Major retrospective exhibition at Bernheim-Jeune Gallery in Paris. Depressed by failing eyesight and the difficulties involved in housing the waterlily

decorations in a circular room, decides to withdraw his gift. Is persuaded to agree to a suggestion that they be housed in the Musée de l'Orangerie.

1922 Paul Durand-Ruel dies in February. Increasingly acute eye problems causes Monet to ruin several large waterlily panels.

1923 Has two cataract operations in January and a third in July.

1925 Eyesight much improved, works on easel paintings of his house and rose garden.

1926 Claude Monet dies at Giverny on 5 December. Is buried in the cemetery at Giverny on 8 December.

1927 The *Grandes Décorations* officially inaugurated in the Orangerie in 17 May and are opened to the public on 20 May.

The publishers wish to thank the following for providing photographs, and for permission to reproduce copyright material. While every effort has been made to trace and acknowledge copyright-holders, we wish to apologise should any ommissions have been made.

Young Dandy with Monocle and Cigar, 1857
Musée Marmottan, Paris/Bridgeman Art Library, London
Page 19 right

View at Rouelles, Le Havre, 1858
Noortman (London), Ltd./Bridgeman Art Library, London
Page 23

Still Life with Bottles, 1859
Private collection/Bridgeman Art Library, London
Page 18

Petit Panthéon Théâtral, 1860
Musée Marmottan, Paris/Bridgeman Art Library, London
Page 19 left

A Corner of the Studio, 1861
Musée d'Orsay, Paris
Page 26

Trophies of the Hunt, 1862
Musée d'Orsay, Paris
Page 30

A Farmyard in Normandy, c.1863
Musée d'Orsay, Paris/Lauros-Giraudon/Bridgeman Art Library, London
Page 31

Rue de la Bavolle, Honfleur (Village Street in Normandy), 1864
Kunsthalle, Mannheim/Interfoto/Bridgeman Art Library, London
Page 33

Spring Flowers, 1864
Cleveland Museum of Art, Ohio/Lauros-Giraudon/The Bridgeman Art Library, London
Page 39

Haystacks at Chailly, 1865
San Diego Museum of Art/Bridgeman Art Library, London
Page 10

La Pointe de la Hève at Low Tide (Sainte-Adresse), 1865
Kimbell Art Museum, Fort Worth. Photographer: Michael Bodycomb, 2001. ©2003 by Kimbell Art Museum
Page 44

The Promenade (Bazille and Camille), 1865
National Gallery of Art, Washington, D.C./The Bridgeman Art Library, London
Page 50

The Road to Chailly (Le Pavé de Chailly), c. 1865
Musée d'Orsay, Paris/Lauros-Giraudon/Bridgeman Art Library, London
Page 37

The Seine Estuary at Honfleur, 1865
Norton Simon Museum, Pasadena
Page 47

Déjeuner sur l'Herbe (Left panel), 1865–66
Musée d'Orsay, Paris/Giraudon/The Bridgeman Art Library, London
Page 48

Déjeuner sur l'Herbe (Central panel), 1865–66
Musée d'Orsay, Paris/The Bridgeman Art Library, London
Page 48

MONET

Promenade near Argenteuil, 1873
Musée Marmottan, Paris/Giraudon/The Bridgeman Art Library, London
Page 122

The Railway Bridge at Argenteuil, c.1873
Musée d'Orsay, Paris/Lauros-Giraudon/The Bridgeman Art Library, London
Page 116

The Seine at Argenteuil, 1873
Musée d'Orsay, Paris/Lauros-Giraudon/The Bridgeman Art Library, London
Page 94

The Seine at Argenteuil, Autumn, 1873
Courtauld Gallery, London/The Bridgeman Art Library, London
Page 110

Wild Poppies near Argenteuil, 1873
Musée d'Orsay, Paris/The Bridgeman Art Library, London
Page 109

The Boats: Regatta at Argenteuil, 1874
Musée d'Orsay, Paris/Bulloz/The Bridgeman Art Library, London
Page 123

The Road Bridge at Argenteuil, 1874
Musée d'Orsay, Paris/Giraudon/The Bridgeman Art Library, London
Page 117

Sailing at Argenteuil, c.1874
Private collection/Giraudon/The Bridgeman Art Library, London
Page 127

The Seine Bridge at Argenteuil, 1874
New Pinakothek, Munich
Page 118

Snow Effect, c.1874
Kunstalle, Basel, Switzerland/Lauros-Giraudon/Bridgeman Art Library, London
Page 83

Argenteuil (Red Boats), 1875
Fogg Art Museum, University of Harvard Art Museums. Bequest from the Collection of Maurice Wertheim, Class 1906/The Bridgeman Art Library, London
Page 115

The Boat Studio on the Seine, 1875
Private collection
Page 113

A Corner of the Apartment, 1875
Musée d'Orsay, Paris/Bridgeman Giraudon/Lauros
Page 108

The Riverbank at Gennevilliers, c. 1875
Private collection/The Bridgeman Art Library, London
Page 130

Snow Effect with Setting Sun, 1875
Musée Marmottan, Paris/The Bridgeman Art Library, London
Page 138

Spring, 1875
Johannesburg Art Gallery, South Africa/The Bridgeman Art Library, London
Page 143

CHRONOLOGICAL LIST OF WORKS/ACKNOWLEDGEMENTS

MONET

The House of the Customs Officer, Varengeville, 1882
*Fogg Art Museum, University of Harvard Art Museums,
U.S.A., bequest of Annie Swan Coburn/The Bridgeman Art
Library, London
Page 177*

The Nets, 1882
*Haags Gemeentemuseum, The Netherlands/The Bridgeman
Art Library, London
Page 233*

Portrait of Eugénie Graff (Madame Paul), 1882
*Fogg Art Museum, Harvard University Art Museums. Gift
of the Wertheim Fund/The Bridgeman Art Library,
London
Page 175*

Sunset on the Sea at Pourville, 1882
*Private collection/Christie's Images/The Bridgeman Art
Library, London
Page 179*

View over the Sea, 1882
*Nationalmuseum, Stockholm/The Bridgeman Art Library,
London
Page 176*

Etretat, Rough Sea, 1883
*Musée des Beaux-Arts, Lyon
Page 241*

The River Epte at Giverny, 1883
*Christie's Images/The Bridgeman Art Library, London
Page 185*

The Seine at Port-Villez, 1883
*Private collection/Christie's Images/The Bridgeman Art
Library, London
Page 183*

The Valley of Falaise, 1883
*Private collection/The Bridgeman Art Library, London
Page 222*

Bordighera, 1884
*Art Institute of Chicago/Lauros-Giraudon/The Bridgeman
Art Library, London
Page 251*

Cap Martin, 1884
*Musée des Beaux-Arts, Tournai, Belgium/The Bridgeman
Art Library, London
Page 255*

Cap Martin, near Menton, 1884
*Museum of Fine Arts, Boston, Juliana Cheney Edwards
Collection
Page 252*

The Castle of Dolceaqua, 1884
*Musée Marmottan, Paris/The Bridgeman Art Library,
London
Page 254*

Haystacks at Giverny, 1884
*Private collection/Peter Willi/The Bridgeman Art Library,
London
Page 285*

Haystacks near Giverny, c.1884
*Pushkin Museum, Moscow/The Bridgeman Art Library,
London
Page 196*

Monte Carlo: View of Roquebrune, 1884
*Private collection/The Bridgeman Art Library, London
Page 257*

The Red Road, 1884
*Christie's Images/The Bridgeman Art Library, London
Page 188*

CHRONOLOGICAL LIST OF WORKS/ACKNOWLEDGEMENTS

MONET

CHRONOLOGICAL LIST OF WORKS/ACKNOWLEDGEMENTS

Haystacks: Snow Effect, 1891
National Gallery of Scotland, Edinburgh,
Paris/Giraudon/The Bridgeman Art Library, London
Page 289

Poplars, c.1891
Fitzwilliam Museum, University of Cambridge, U.K./The
Bridgeman Art Library, London
Page 301

Poplars on the Banks of the Epte, 1891
Private collection/The Bridgeman Art Library, London
Page 299

Poplars on the Epte, Autumn, 1891
Private collection/The Bridgeman Art Library, London
Page 300 right

Poplars: Three Pink Trees in Autumn, 1891
Philadelphia Museum of Art, Philadelphia. Gift of Chester
Dale
Page 298

Rouen Cathedral, 1891
Christie's Images, London/The Bridgeman Art Library,
London
Page 302

Three Poplars in Summer, 1891
National Museum of Western Art, Tokyo, Japan
Page 300 left

The Three Trees, Autumn, 1891
Private collection/Christie's Images, Paris/Giraudon/The
Bridgeman Art Library, London
Page 287

General View of Rouen from St. Catherine's Bank, c.1892
Christie's Images/The Bridgeman Art Library, London
Page 212

Haystacks at Giverny, 1893
Private collection, Paris/Giraudon/The Bridgeman Art
Library, London
Page 286

Morning on the Seine at Giverny, 1893
Christie's Images/The Bridgeman Art Library, London
Page 215

The Church of Vernon in the Mist, 1894
Private collection/The Bridgeman Art Library, London
Page 216

Rouen Cathedral, Effects of Sunlight, Sunset, 1894
Musée Marmottan, Paris/Giraudon/The Bridgeman Art
Library, London
Page 308 left

Rouen Cathedral, Foggy Weather, 1894
Private collection/The Bridgeman Art Library, London
Page 309

Rouen Cathedral in Full Sunlight: Harmony in Blue and Gold, 1894
Musée d'Orsay, Paris/Giraudon/The Bridgeman Art
Library, London
Page 307

Rouen Cathedral, Midday, 1894
Pushkin Museum, Moscow/The Bridgeman Art Library,
London
Page 306

Rouen Cathedral: Morning Sunlight, 1894
Musée d'Orsay, Paris/Peter Willi/The Bridgeman Art
Library, London
Page 308 right

MONET

CHRONOLOGICAL LIST OF WORKS/ACKNOWLEDGEMENTS

MONET

MONET

CHRONOLOGICAL LIST OF WORKS/ACKNOWLEDGEMENTS

Works by Other Artists

Gustave Courbet
The Artist's Studio, 1855
Musée d'Orsay, Paris
Page 24

Eugène Boudin
Beach Scene, Trouville, 1863
Metropolitan Museum of Art, New York
Page 22

Edouard Manet
Le Déjeuner sur l'Herbe, 1863
Musée d'Orsay, Paris
Page 34

Edouard Manet
Olympia, 1863
Musée d'Orsay, Paris/Giraudon/The Bridgeman Art
Library, London
Page 225
Charles Emile Auguste Carolus-Duran

Portrait of Claude Monet, 1867
Musée Marmottan, Paris/Bridgeman Art Library, London
Page 32

Pierre-Auguste Renoir
La Grenouillère, 1869
Pushkin Museum, Moscow
Page 66 lbelow

Frédéric Bazille
The Artist's Studio in the Rue de la Condamine, 1870
Musée d'Orsay, Paris/Lauros-Giraudon/Bridgeman Art
Library, London
Page 42

Henri Fantin-Latour
A Studio in the Batignolles Quarter, 1870
Musée d'Orsay, Paris/Lauros-Giraudon/Bridgeman Art
Library, London
Page 43

Pierre-Auguste Renoir
Claude Monet Reading a Newspaper, 1872
Musée Marmottan, Paris/Bridgeman Art Library, London
Page 9

Pierre-August Renoir
Madame Claude Monet (Camille), 1872
Musée Marmottan, Paris/Bridgeman Art Library, London
Page 13

Johan Bartold Jongkind
Rue de l'Abbé-de-l'Epée and the Church of Saint James, 1872
Musée d'Orsay, Paris
Page 29

Edouard Manet
Head of a Man (Claude Monet), 1874
Musée Marmottan, Paris/The Bridgeman Art Library,
London
Page 120

Edouard Manet
Monet Painting on His Studio Boat, 1874
Neue Pinakothek, Munich
Page 114

Pierre-Auguste Renoir
Madame Charpentier and Her Children, 1878
Metropolitan Museum of Art, New York
Page 145

Paul Cézanne
Mont Sainte-Victoire with Pine, 1886–87
Phillips's Collection
Page 247

Photographic Acknowledgements

Claude Monet in his garden at Giverny c. 1925
Musée Marmottan, Paris/Bridgeman Art Library, London
Page 9

Ferdinand Mulnier
Portrait of Alice Monet, age 35, 1879
Musée Marmottan, Paris/Bridgeman Art Library, London
Page 14

Claude Monet
Musée Marmottan, Paris.
Page 16

Claude Monet, c.1900
Musée Marmottan, Paris//The Bridgeman Art Library,
London
Page 182

Claude Monet, photographed on 25 August 1905
Musée Marmottan, Paris/The Bridgeman Art Library,
London
Page 328

Monet in his studio at Giverny, 1920s
Private collection/Roger-Viollet/The Bridgeman Art
Library, London
Page 332

Monet with a visitor on the Japanese bridge over the lily
pond at Giverny, photographed in the 1920s
Private collection/Roger-Viollet, Paris/The Bridgeman Art
Library, London
Page 333

The main pathway in the garden by the house at Giverny,
photographed in the early 1920s
Musée Marmottan, Paris/Giraudon/The Bridgeman Art
Library, London
Page 337

Monet in his water garden at Giverny
Private collection/Roger-Viollet, Paris/The Bridgeman Art
Library, London
Page 339

The waterlily pond and Japanese bridge in Monet's
garden at Giverny, photographed in the 1920s
Musée Marmottan, Paris/The Bridgeman Art Library,
London
Page 349

Claude and Alice Monet in St. Marks Square, Venice, in
October 1908
Musée Marmottan, Paris/Giraudon/The Bridgeman Art
Library, London
Page 351

Monet retouching The Rose-Covered Pergola, Giverny,
1920
Réunion des Musées Nationaux, Paris
Page 362 below

Path in Monet's garden at Giverny, photographed in the
early 1920s
Musée Marmottan, Paris/Giraudon/The Bridgeman Art
Library, London
Page 400

View of Giverny: Monet's garden in the early 20s
Musée Marmottan, Paris/The Bridgeman Art Library,
London
Page 407

George Clemenceau, Monet and Alice Butler on the
Japanese bridge in 1921
Musée Marmottan, Paris/Giraudon/The Bridgeman Art
Library, London
Page 409 left

Index

Index

MONET

Index